Thinking Through Art

How can we understand the relationship between art and thought? What kind of thought comes from art practice, and how do we define it? When the art in question is academic research, how is it situated both in terms of higher education and art practice in a wider sense?

Thinking Through Art takes an innovative look at artists' experiences of undertaking doctorates. If the making of art is not simply the formation of an object, but also the formulation of complex ideas, then what effect does academic inquiry have on art practice?

The artists, philosophers, art historians and cultural theorists contributing to *Thinking Through Art* address the complexity of interpreting art *as* research and suggest ways in which the visual in relation to the verbal could more actively engage intellectual debate.

Editors

Katy Macleod and **Lin Holdridge** collaborate at the School of Art and Performance at the University of Plymouth in the research field of higher degree culture in fine art. Their current research, which has been widely published, focuses on artists' thought processes generated by academic art research.

Contributors

Naren Barfield, Iain Biggs, Clive Cazeaux, Jeff Collins, Peter Dallow, Nicholas Davey, James Elkins, Timothy Emlyn Jones, Sir Christopher Frayling, Siún Hanrahan, Kenneth G. Hay, Lin Holdridge, Katy Macleod, Kerstin Mey, Jim Mooney, Ken Neil, Tim O'Riley, Elizabeth Price, Milos Rankovic and Gavin Renwick.

Innovations in Art and Design
Series Editor: Colin Beardon

Titles available from Routledge:

Digital Creativity
A reader
Edited by Colin Beardon and Lone Malmborg

New Visions in Performance
The impact of digital technologies
Edited by Gavin Carver and Colin Beardon

New Practices
New pedagogies
Edited by Malcolm Miles

Thinking Through Art

Reflections on art *as* research

Edited by Katy Macleod and
Lin Holdridge

LONDON AND NEW YORK

First published 2006
by Routledge
2 Park Square, Milton Park, Abingdon, Oxon OX14 4RN

Simultaneously published in the USA and Canada
by Routledge
270 Madison Ave, New York NY 10016

Routledge is an imprint of the Taylor & Francis Group

Transferred to Digital Printing 2009

Selection and editorial material © 2006 Katy Macleod and Lin Holdridge

Contributors' chapters © 2006 the contributors

Typeset in Times by Graphicraft Limited, Hong Kong

British Library Cataloguing in Publication Data
A catalogue record for this book is available from the British Library

Library of Congress Cataloging in Publication Data
Macleod, Katy, 1948–
 Thinking through art: reflections on art as research / Katy Macleod &
Lin Holdridge.
 p. cm. – (Innovations in art and design)
 Includes bibliographical references.
 ISBN 0-415-36477-9 (hardback: alk. paper) I. Art – Philosophy.
I. Holdridge, Lin, 1951– II. Title. III. Series.
 N66.M347 2005
 700′.1–dc22 2004029207

ISBN10: 0-415-36477-9 (hbk)
ISBN10: 0-415-57633-4 (pbk)

ISBN13: 978-0-415-36477-5 (hbk)
ISBN13: 978-0-415-57633-8 (pbk)

Contents

Illustrations

Contributors

Naren Barfield is Head of Research and Postgraduate Studies at Glasgow School of Art. His work is in numerous collections and he has curated several international exhibitions. He is co-author (with George Whale) of *Digital Printmaking* (A&C Black, 2001).

Iain Biggs is Reader in Visual Arts Practice and Director of Studies for the Taught Research Programme at Bristol School of Art, Media and Design at the University of the West of England. He has published *Eight Lost Songs* (Making Space, 2004) and is co-convenor of the LAN2D national network.

Clive Cazeaux is Senior Lecturer in Aesthetics at the University of Wales Institute Cardiff. He is the editor of *The Continental Aesthetics Reader* (Routledge, 2000) and author of articles on metaphor, art theory and practice, and modern European philosophy including a forthcoming book on metaphor and continental philosophy.

Jeff Collins is Lecturer in Art History and Critical and Cultural Theory at the University of Plymouth.

Peter Dallow lectures in visual media at the University of Western Sydney in Australia, where he is a member of a multidisciplinary Australian Research Council funded research team. His research ranges across visual culture, new media and arts practice.

Nicholas Davey is Professor of Philosophy at the University of Dundee. His principal research interests are in aesthetics and hermeneutics. He has published widely in the field of continental philosophy, aesthetics and hermeneutic theory and is author of a forthcoming book entitled *Translation and Transcendence: Essays on Philosophical Hermeneutics*.

James Elkins is Chair in the Department of Art History, Theory, and Criticism at the University of Chicago. He also teaches in the Department of Visual and Critical Studies, and is Head of History of Art at University College Cork, Ireland. The author of many books, his writing focuses on the history and theory of images in art, science and nature.

Timothy Emlyn Jones is Professor and Dean of Burren College of Art, Ireland. He has specialised in the development of art research and doctorates in art schools since 1987. He employs drawing as a process of inquiry and has exhibited his work internationally.

Sir Christopher Frayling is Rector of the Royal College of Art and Chairman of the Arts Council of Great Britain. He has written widely on the arts and culture and appeared on various television and radio programmes.

Siún Hanrahan is an artist and writer based in Dublin, and Acting Research Co-ordinator for the School of Art, Design and Printing at the Dublin Institute of Technology. She is on the editorial panel of the Sculptors' Society of Ireland *Printed Project* journal.

Kenneth G. Hay is Professor of Contemporary Art Practice at the University of Leeds. As an artist he has exhibited most recently in Venice (September 2004); part of the RADAR Infopoint in the Telecom Italia Future Centre. As an academic he has published widely on aesthetics, new media and Italian philosophy.

Lin Holdridge is a researcher in the field of fine art doctoral practice and collaborates with Katy Macleod. She is currently researching for the Art History RAE Unit of Assessment at the University of Plymouth and has previously undertaken research for the UK Widening Participation South West initiative in the creative and performing arts.

Katy Macleod is Senior Lecturer in Fine Art and Research at the University of Plymouth. She has researched and published in the field of fine art doctoral practice since 1996 and contributed to several books on the arts in education.

Kerstin Mey is Professor and Research Zone Leader in Art and its Location, School of Art and Design at the University of Ulster. Her publications include *Theoros III* (Peter Lang, 2005) and a special issue of the *Journal of Visual Art Practice*.

Jim Mooney is Reader in the Theory and Practice of Fine Art at Middlesex University and Research Tutor in Painting at the Royal College of Art. As an artist and writer he has exhibited and published internationally.

Ken Neil is currently establishing a new Master of Fine Art in Critical Social Art Practice at Gray's School of Art, Robert Gordon University, Aberdeen, where he was formerly Head of Fine Art and Critical Studies.

Tim O'Riley is currently an Arts and Humanities Research Council (AHRC) Research Fellow in the Creative and Performing Arts at Chelsea College of Art and Design (University of the Arts, London) and has been a lecturer at the college since 1996.

Elizabeth Price is Research Fellow in Fine Art Practice at London Metropolitan University, and Lecturer at Goldsmiths College. As an artist she has had many solo exhibitions including shows at Mobile Home, Platform and the Jerwood Space and her work has been widely reviewed.

Milos Rankovic is engaged in doctoral study at the University of Leeds (funded by the AHRC). He studies the implications of the connectionist notion of distributed representation pertaining to the distinction between the communicational and the computational components of the art practice/object.

Gavin Renwick is a post-doctoral AHRC Research Fellow in the Creative and Performing Arts at the University of Dundee, and the Canadian Subarctic. His interdisciplinary practice-led research utilises methods that honour both visual scholarship and the parity of indigenous traditional knowledge.

Foreword

A while back I wrote a paper on 'Research in Art and Design' (1993) which adapted Herbert Read's celebrated 1940s distinction between teaching to art and teaching through art and applied it to the evolving research culture of postgraduate art courses. Most art research was – and remains – research into art. Then came research through art, the equivalent of Read's 'teaching through art': research which was getting at a problem through the practices and media of art, the assumption being that the problem existed outwith the art. Then came the difficult one, art as research – where the methods and conventions and debates of research were perhaps embodied in the artefact itself. The paper has continued to prove very influential, though as this collection shows, the discussion has moved on a lot since then.

Over ten years and countless conferences later, there are still many confusions surrounding the idea of art as research. The current phrase of choice to describe this idea is practice-based research, a phrase I dislike because it simply restates the old theory/practice dichotomy in a new guise while seeming to say more. There's the confusion between research (as process) and research degrees (as qualifications). There's the confusion between advanced practice and research. There's the confusion about whether or not, or in what sense, research should result in communicable knowledge. There's the confusion about how the traditional procedures of research – finding a subject, searching the literature, selecting a perspective, contributing to knowledge and understanding – might apply in the fine art area. And there's the deep-seated confusion, around since the 1960s, about whether it is even appropriate to grant university degrees for studio practices. Discussions of these (and related issues) have usually ended up with both feet planted firmly in the air, when it has become increasingly important to plant them firmly on the ground.

Why has it become increasingly important? Why does it matter? To be pragmatic – and let's face it, many of the arguments up to now have dressed pragmatism up as principle – there is the Research Assessment Exercise, the linking of resources and research output, the rise of the Arts and Humanities Research Council, the increasing number of research students and the need for research credentials if one wishes to be promoted. All these have happened in earnest since the 1980s, and are the external drivers of at least some of the debate. But I believe there is a deeper reason to try to sort out the confusions, and more thoroughly to grasp what is meant by art as research.

That reason has to do with the teaching, learning and researching of studio arts in a university setting. Among visual artists, as among musicians, the word 'academic'

has been a pejorative since the rise of modernism. Academic has come to mean rule-bound, safe, technically proficient, competent rather than inspired. Picasso's famous interview about *Les Desmoiselles d'Avignon* left his readers in no doubt about this. Working within the academy has remained an uneasy occupation even in the era of postmodernism. It is timely, in my view, to redefine and re-evaluate the academy – which, like it or not, is where many of us are for much of our time – to emphasise the radical nature of some of its elements. Towards a radical academy. Towards a distinctive research culture within it, a culture which examines and understands its own assumptions, which produces new knowledge, and which is no longer ashamed to be located within the academy. A research culture which is distinct from advanced practice in the professional worlds of art.

Let us hope that *Thinking Through Art* – the editors have stolen my title but then again I stole it from Herbert Read – will encourage the debate to move in this general direction. Katy Macleod and Lin Holdridge are to be warmly congratulated on assembling *Thinking Through Art*, and on bringing together such a lively, varied and thoughtful group of contributors.

Professor Sir Christopher Frayling
Rector, Royal College of Art

Acknowledgements

The support and advice of colleagues has been invaluable, both during the long period of empirical research and throughout the process of preparing the book. Iain Biggs has been a particularly staunch ally, friend and adviser, whose kindness has been considerable. We would like to thank Malcolm Miles, Reader in Cultural Theory, and members of the Art History Research Seminars at the University of Plymouth in Exeter. We would especially like to thank all our contributors, many of whom we have worked with for almost a decade and to whom we owe a considerable debt. Chris Wainwright has also offered sustained support for our research. We feel fortunate indeed to have contributions from Christopher Frayling and James Elkins, both of whom have given generously of their time. Our Series Editor, Colin Beardon, has played an exemplary part, offering sound and judicious advice. We are also grateful for a funding award from the Arts and Humanities Research Council. This played an important part in furthering our research. Finally, we must acknowledge the invaluable support of the University of Plymouth without which this research would not have been possible.

Introduction

Katy Macleod and Lin Holdridge

Thinking Through Art brings together a group of artists, philosophers, cultural theorists and art historians to present a series of reflections upon art in the context of doctoral experience in fine art. One of the main purposes of the book is to question how art and the processes of art might be understood, and in particular, to pursue what art might offer intellectually when it is framed as academic research and thus how it might sit within a broader academic framework. The book is based upon almost a decade of research into student and supervisor experience and PhD submissions in fine art in the United Kingdom.[1] It highlights issues which have arisen out of this relatively new culture and discusses the tensions which undoubtedly occur within a subject which has little academic history or precedent in this context.[2] The procedural form of the fine art doctorate and the complexities of the PhD submission are concerns which are addressed throughout this book, but the authors also reflect upon the perceptual and conceptual nature of the processes of making art *per se*, the physical working through of thought involved in those processes and how this might be facilitated. Art is always in and of the world, and regardless of its positioning here within a research culture, the reflections contained in this book and the concerns they raise will have a far wider remit than the doctoral frame.[3] Indeed, the generic issues within this debate about art and how it might be said to function socially and intellectually will be of interest not only to academics in the field, but also to a broader community of artists, designers, arts administrators, aestheticians and those in the performing arts.

The debate regarding the nature and value of doctorates in fine art is currently raging in the United States, European Union and Australia, in particular, and the contributors to this book both add to and contextualise this by discussing issues which relate specifically to their longstanding and deep engagement with the UK experience in both university departments or schools and colleges of art. How far these experiences will be relevant to different cultures remains to be seen, but with doctorates in fine art established in over forty institutions, and with many exemplary PhD submissions available to be studied, it would seem timely to consider the potential of this culture. The siting of fine art within a university tradition and the status thereby conferred upon it as an academic discipline underpins many of the issues considered in this book. The doctorate is established as a very high achievement within the hierarchical framework of study, and it is promoted as such by all disciplines. The overarching aim of the PhD is to put forward a proposition, and predict an outcome which will culminate in a significant contribution to new knowledge. The research process will utilise a methodology which is appropriate to its discipline and present the results of

that research in a coherent, communicable and logical manner. The PhD is subject to the university's rules and regulations and is traditionally examined by written thesis and oral examination. This thesis is based upon a comprehensive literature trawl which is seen to establish the provenance and purpose of the research inquiry. However, the introduction of a subject such as fine art, which does not accept the primacy of textual or symbolic representation, will inevitably expose presuppositions in the way that research regulations are written and expectations formed. Any such new subject, with no previous academic research history, will, of necessity, be more experimental in its approach.[4] We will argue that it is incumbent upon the culture to explore the tensions and issues which arise rather than seek to resolve or dismiss them.

Our research shows that the predominant preoccupation of the art research community since the early 1990s has been the making/writing issue and the complex implications surrounding it; what should be the equivalence between writing and making in terms of a doctoral submission? What is the relationship between an artwork and a written submission? What kind of written submission is appropriate? Is the comprehensive review of the relevant field essential? These are just a few of the central concerns. There is as yet, no overall consensus between art institutions, although case studies would seem to indicate that the conventionally written academic thesis does not always seem appropriate for the doctorate in fine art.

The use of theory is a further cause for contention. What kind of theory? Case studies again show that fine art doctorates often dispense with the normative academic practice of basing a premise upon extant theory. Extant theory is more usually used as a stepping stone in the process of analysing and constructing visual propositions. During this process, it could be argued that new theory is constructed through and by the artwork, or in other words, the artwork becomes theorised itself. This particular use of theory is bound too into the construction of a methodology. Evidence shows that the use of exemplars from other disciplines has frequently been superseded by the need to create a methodology more appropriate to the artist's own practice.[5]

Procedural issues have also caused concern: the need to adapt academic research regulations to more appropriately accommodate the fine art doctorate has already been mentioned. The provision of suitably experienced supervisors and examiners in a relatively new culture is likewise of paramount importance, not only in terms of guidance for the duration of study, but particularly in terms of the viva. Just as outcomes are difficult to predict in doctoral art research, so the viva itself can be seen as specifically significant, with the examiner as viewer, experiencing and assessing the visual demonstration of research findings which cannot be ascertained in advance.[6]

The complexity of artists' research findings and their implications for art in a more generic sense, from various and diverse perspectives, are addressed in each of the three parts of the book. Some of the chapters specifically address the research culture; others provide more of an inquiry into the workings of art. All of these different approaches, however, contribute to the spirit of understanding how art can be understood as academic research. Many of the authors in Parts 1 and 3 have longstanding experience of working in the field of fine art education and specifically within the culture of the PhD in fine art. Others bring a formidable understanding of aesthetics to fine art. They too, have a particular interest in the art doctorate. The contributors' expertise therefore, inherently concerns this culture in particular, and the wider art culture in general. In fact it is essential to the book's purpose that the way in which artists'

inquiries lend themselves to philosophic speculation should be explored. Part 1 is therefore philosophic in character and is designed to situate the conceptual, experiential and perceptual nature of artists' research. It is also concerned with the responsiveness of art research to our current worlds.[7] Part 3 engages with the political and institutional implications of the advancement of artists' research as new knowledge. In addition, it provides an initial overview of the UK doctoral art and design culture by Timothy Emlyn Jones and an afterword by James Elkins.

Part 2 brings together for the first time a group of artist researchers, all of whom have completed an art doctorate. The nature of academic art *as* research is critically addressed here through their research writings. Several of the authors take a retrospective look at the process of their doctorate, while others engage with their chosen subject matter and the issues raised. The chapters provide a unique insight into some of the aspects of undertaking a PhD in fine art.

The ordering of chapters within each part is designed to facilitate an understanding of the ways in which they each relate. For instance in Part 1, Nicholas Davey, Clive Cazeaux and Kenneth Hay demonstrate how the binary opposition of theory to practice might be rethought through the identification of the conceptual within practice; Kenneth Hay, Ken Neil and Peter Dallow elucidate how the material practices of art both take from and return us to the world, which in the case of Neil and Dallow is characterised as the 'real'. In simple terms, that which is real is that which physically exists, and with which the processes of art engage and deploy in order to produce thought which is materially realised as art. In Part 2, the chapters by artist researchers exemplify the conceptual, perceptual and experiential problems explored through their research inquiries. Tim O'Riley and Naren Barfield pose research questions concerning the representation of space, while Elizabeth Price, Jim Mooney, Siún Hanrahan and Milos Rankovic tease out those experiences which are specifically afforded by art, such as the direct reflection on an art form or the feelings evoked by its practice. Finally, Gavin Renwick demonstrates how art might act in the service of sociopolitical thought. It is important to understand that in each case, the writing has been determined by the processes of conceiving and realising artworks – artworks which, of course, cannot be presented here. Indeed, one of the central lines of argument through our research is that artworks should not be merely illustrative to the written text.[8] The thinking which results from the process of doctoral study, however, cannot be fully contained by either the visual or the written alone. Thus each chapter must be seen as a possible (or partial) solution to the troublesome issue of how to present thought when its origination comes through the visual and/or the practice of art.

This issue underpins Part 3, which seeks to begin what will be the protracted process of negotiating an appropriate academic siting for the doctorate in fine art based on a sound understanding of its potential, its possibilities for development and its latent weaknesses. Iain Biggs, Kirsten Mey and Jeff Collins highlight prospective areas of development. However, Timothy Emlyn Jones and James Elkins indicate where there might be a need to address weaknesses within the culture. Emlyn Jones sees these as professional, while Elkins views them as scholarly.

The predominant theme which emerges from these writings remains how art and the processes of art might be understood as academic research. Integral to this theme is the function of writing within research practice and whether and how far it can be said to explore, demonstrate and amplify such research. Strongly related is a complex

of issues around theory: extant theory; theory within practice; the adaptation and renewal of theory through practice and the production of new theory. Perhaps, the most tantalising of themes is the self-consciousness of the artist researcher whose identification as artist is bound into the research inquiry and determines its initial critical evaluation.[9] Many of the conceptual and perceptual reflections here upon art stem directly from the difficult task of unravelling the nature of art *as* research. By focusing attention on the thoughts of and through art which are coming out of this relatively new culture, this book will also contribute to the much wider debate on the implications and relevance of art in current cultures.

The concept of thinking *through* art is borrowed from Christopher Frayling's (1993) influential paper on 'Research in Art and Design' written to help frame debate about the character, provenance and appropriateness of research in these disciplines.[10] Crucially it sought to define the difference between research and doctoral research. Doctoral research is characterised through three categories: research *into* art and design (historical, perceptual, cultural, iconographic etc.); research *through* art and design (materials, technological etc.) and research *for* art (*sic*). This third type of research is

> Where the end product is an artefact – where the thinking is, so to speak, *embodied in the artefact*, where the goal is not communicable knowledge in the sense of verbal communication, but in the sense of iconic or imagistic communication.[11]

Frayling indicated that research *for* art was the most problematic, 'the thorny one' as he puts it. This is because the thinking is within the research artwork; it is part of the work's functioning and determining what this might mean is extraordinarily difficult. In this context we intend to consider the phrase now posed by Frayling in the Foreword, 'research *as* art'. We will maintain that research *as* art offers the possibility of an interpretation which might lead to art research, even academic higher degree research, adhering more firmly to its own methodological purposes. We intend to run with this small conjunction *as* and briefly explore the interpretative possibilities for art *as* research. One such possibility is offered through identifying art as a theoretical practice, *as* that which

> explores the terms of visual practice in a field for which language is an unalterable given; in doing so it aims at a visuality not so much supplanted by language as possessed of an articulation or thinking internal to it. This would be what it means to speak in terms of a 'theoretical practice' or a 'theoretical object'. 'Theory' here would be less something a critic or historian brings to the work . . . than something to be traced in it, and writing would belong to such work as a part of its unfolding, a continuation of the conditions of its appearing.[12]

Here Stephen Melville asserts the 'internal thinking or articulacy' of art; he expounds how the work of the work of art is to establish itself *as* (*as* painting, sculpture, print and so on), that is the artwork must reaffirm what it is, for example a piece of sculpture must declare itself as such. It is not possible in the space available here to fully pursue Melville's complex line of reasoning. However, in his view, the *as* marks the work's unfolding and the unfolding is not simply an unfolding on to itself as 'the conditions of its appearing'; it is more generally the conditions of matter which could

be said to 'give itself over to articulation'. Melville adumbrates how theorists have grappled (particularly in France) with materiality, that is, with the material presence of art. To substantiate this he references sources which have been dismissed within much postmodern discourse, formalist criticism (Michael Fried), phenomenology (in particular, Merleau-Ponty) and aesthetics (Immanuel Kant). Melville's purpose is to identify the physicality of art, its complex, sensuous and cognitive presence or 'entity' and it is this which art as research must claim and explore if research artworks are to be understood as academic research.

There are various extraordinary problems attached to this, not least is that this entity needs to establish its meanings at the moment of viewing. Such viewing is most elegantly pursued by Melville in 'Counting/As/Painting'; he employs Fried to explore a claim for how art must operate, or act: 'the task of the modernist painter is to discover those conventions that, at a given moment, alone are capable of establishing his work *as* painting' (emphasis added).[13] This leads us, like Melville and so many of the contributors to this book, to Heidegger's notion of 'radical interpretability':

> That which is explicitly understood . . . has the structure of something *as* something . . . That which is designated is understood as that *as* which we are to take the thing in question. That which is enclosed in understanding – that which is understood – is already accessible in such a way that its '*as* which' can be made to stand out explicitly. The '*as*' makes up the structure of the explicitness of something that is understood. It constitutes the interpretation.[14]

That is, that art must provide the grounds for its own interpretation. This does not mean that it is hermetically sealed off from the world or reductively engaged in a self-referentiality, calling up spectres of Greenbergian formalism and the restrictive tenets of certain aspects of modernism. It is simply a question of an academic reckoning with what art is, as artwork and how artwork is dependent upon particular processes of making or realisation.

Following Melville, we can begin to identify and understand why so many of the artist researchers included in our studies seek recourse to phenomenology and onto-logical speculation; they might be pursuing an understanding of perceptual problems, for instance Barfield's exploration of three dimensional in relation to the fourth-dimensional reasoning. In this sense, artists are posing research problems which could be said to relate to natural phenomena or more accurately, how or *as* one thing is distinct from another. This process, as proposed by Melville, is signalled by Kant in his third critique, the *Critique of Judgement*:

> Instead we must be able to view the ocean as poets do, merely in terms of what manifests itself to the eye – e.g. If we observe it while it is calm, *as* a clear mirror of water bounded only by the sky: or if it is turbulent, *as* being like an abyss threatening to engulf everything. [emphases added][15]

This judgement of the *as* could be said to help define what *is*, what is perceived in the world. This context of phenomenology and aesthetics appears to be necessary to an appropriate contextualisation of art *as* research. However precarious such an identification, it must do for the moment, because Kantian aesthetics, in particular,

brings us to one of the most crucial of questions concerning art in the context of research and that is critical judgement; for artist researchers, evidence would indicate that research artwork must be seen by them to be good art. What is good art in the context of research? The question of judging research artwork tends to defeat attempts to produce typologies of research practice or organise ideas about how to more appropriately pursue art as research. For instance, if we return to Frayling's (1993) categorisation of research in art – research *into*, *through* and *for* art – it begs the question of how to judge art *as* research. For artist researchers this has emerged as the most crucial issue in their research inquiries: if the products of research cannot be identified by them as also art, the cost of undertaking a postgraduate degree is too high.[16] However, it must be said that for some seasoned supervisors in the field, the identification of art as research does not pose insuperable problems. One such art historian supervisor asked whether research as art could indeed be seen as a 'series of linked developing propositions . . . a developing sequence . . . As a series of propositions which are contingently true?'[17]

Another supervisor in the same study talks of the 'cognitive complexity' in the artwork, while a doctoral student talks of 'the cognitively kind of structured thinking of practice'.[18] However, a design historian supervisor poses the problem in such research as being not the 'artifact' as research outcome but 'whether we can read it': that is whether supervisors in the field have the necessary skills and training to be capable of understanding art *as* research.[19] This indeed is another of the most crucial issues in this new culture.

In this context, Macleod attempted to help frame ongoing debate in the 1990s by producing a typology of research both to sit alongside Frayling's and to begin to address art *as* research: the three categories devised were research which positions a practice (historical, cultural etc.); research which theorises a practice (takes on a specified theory, narrativity for instance) and research which reveals a practice (that is, methodologically).[20] While indicating that art *as* research remains of central importance to artists, neither Frayling's paper nor Macleod's research indicate how research artwork might be more fully understood. However, this issue shadows all research in the field.

The artists, philosophers, cultural, art or design historians contributing to this book, all have a vested interest in a more rigorous understanding of what it means to make and present art at an advanced level of academic achievement. We are all actively engaged in the construction of this new culture as supervisors, directors of research and colleagues of artist researchers. We need to know how and for what purposes art functions, not in the margins of a higher education institution but at its core: the doctorate and its cultures. However troubled the identification of appropriate research cultures might be in the broader academic field, we need perhaps to be clearer about what a consensus as to quality, standards, ethics and truth to the discipline might be.[21] It is only through some kind of consensus concerning issues of quality, of critical judgement for instance, that we can begin to raise the status of the doctorate among artists: the doctorate might be the *sine qua non* of academic achievement for students in the university but it does not hold equivalent status in the art academic communities. Here its status is equivocal and while this is the case, the university institution holds a power which curiously diminishes the culture's capacity to define its own doctoral terms: 'The question is, said Humpty Dumpty, which is to be master – that's all'.[22]

Does this mean that the doctorate could flourish in the United Kingdom only outside the university and that it will therefore be left to colleges of art to pursue the question of academic research *as* art? It would be inappropriate to pursue this point further here except to indicate that those of us who are employed in university departments, where art (fine art) enjoys an uneasy positioning in the doctoral research cultures, are aware that much is said about artists' ignorance, their lack of ability to write academic texts, to undertake comprehensive literature surveys of research terrain and to appropriately undertake research. It would seem naive to accept that this is the case.

Sustained conversations between artists, philosophers, cultural or art and design historians have shaped *Thinking Through Art*. Our discussions were often about what it is to make work: the ordinary processes of making marks on paper, or representing how a work takes shape, and so on. Talk might turn to how to maintain the practices of art in the face of institutional pressure to produce inappropriate and/or anodyne research methodologies, sources and data in order to maintain academic probity. In this we were quite obviously not alone and not original.[23] In fact, we were framing the conventional desire to keep to truths in the discipline of fine art. These conversations led to an inter-university research alliance which fostered a mutuality of research concerns as well as discipline distinctness. In consequence, this is not and never could be, a homogeneous collection of chapters. It does not conform to academic standards which predict a particular kind of mastery, rather it seeks to lay bare some of the many ways in which art is distinct in its particular and complex provocations. Art's processes are awkward in academic arenas and they are interestingly awkward within the cultures of doctoral research. One of the key findings of our research is that the findings presented through art are always a posteriori and thus, ill suited to the institution's pursuit of prescribed outcomes. Meanings are made after the event, through the act of viewing or contemplation and by the artist initially. An entirely obvious fact, but one which in the culture of academic research, is an uncomfortable truth to the discipline. Critical scrutiny cannot be conventionally prepared for, even in the case of a doctoral viva: artist and examiners need to encounter the work in that time and space, and in that encounter, all the troubled historical force of aesthetics comes into play. Can an appropriate judgement be made in these circumstances?

Artists were invited into the university in the mid-1980s in the United Kingdom, but their full entry has been much delayed: artists, teachers and supervisors still feel compelled to resist forming academic research cultures which might conventionally enhance an institution's research profile and thus justify entry. This is a painful fact, certainly for those in fine art who need to secure funding. However, the reasons for this have yet to be properly explored. Since the Royal College of Art's excellent research papers in the mid-1990s, there has been no concerted attempt to research into what Frayling, in particular, then presented. Postgraduate cultures in the United Kingdom and European Union are fully conversant with research *into* art and research *through* art, as these are in line with predictive and approved methodologies, but research *for* or *as* art remains largely unknown. Our research indicates that the defence of art, even in the context of the PhD viva, has not been a central part of training programmes: artists do not expect to robustly defend their research artwork. Art's great strength, however, is that it is always open to interpretation. It could be argued that artists' interpretations of the methodologies which produce research

artworks might help return the discipline to its own principles as well as justify the claim for art *as* research. It must be said that if advanced research study does not advance the discipline, a crucial sense of that discipline's history will be lost.

This book is shadowed by a sense of art's conventions and traditions, terms and principles, however uncertain these might be. Nevertheless, when artists opt to undertake advanced level research, their art becomes research inquiry. Whether it is also art which is publicly communicable (that is, can be exhibited) is one of those questions which, as we have indicated, lies at the heart of emerging research cultures. It is exhibited for the final doctoral examination, but is it then examined *as* art or *as* research? Does the art then play a role which is distinct from that of art? Does the art in this instance of exhibition function as systematic, sustained, lucid objects of thought? If that is the case, does this change what is conventionally understood to be art? This book does not seek to provide answers to questions like these, although they will have to be addressed by the culture. It does, however, present artists' postdoctoral writings in contexts which indicate what is at stake in one of the communities in the arts where the tenets of the discipline become vulnerable to a particular academic scrutiny. The intention is not to cast doubt on the purposes of such scrutiny, but rather to propose why artist scholars might need to more robustly defend their research practices and suggests that, in order to do so, they will need to more fully assert what it is that they do.

We will maintain that art is always in translation, because it is matter: it is materially realised ideas. It is these ideas, which in their specificity claim an interesting space for research: it could be argued that art's methods make transparent those obdurate binaries between word and deed; contemplation and action; theory and practice; feeling and cognition; intuition and reason; imagination and logic. What might be taken to be the unalterable dialectics at play in being conscious in the world, are apparently put into high relief as materially realised thought in writing and artwork collides (when the logics of each cease to 'match up' as one artist put it). Logic is not conventionally identified through imaginative realisation, nor reasoned argument with intuitive propositions. For example, the case of the unwinding of packing tape on to itself, which was presented as the object of academic research writing (by Elizabeth Price[24]), placed behavioural codes of doctoral research under scrutiny, crossed word/ deed and contemplation/action divisions. It disturbs theory/practice, feeling/cognition and imagination/logic distinctions as the artist scholar describes her feelings in making the piece, as well as reflecting theories relevant to its production (for example, Marxism and Freudian psychoanalytic theory). In this instance, the viewer (supervisor and examiner) is drawn to imaginatively engage with the uneasy relativity of such theoretical distinctions. Also, the fact that in this case of doctoral research artwork, a hoax might be involved; its long duration of winding roll after roll of tape might simply be an assertion of the written text rather than part of the produced research artwork and hence the research becomes more provocation and play than research proof.

Research in the field has demonstrated that models of doctoral practice are not being consulted, however.[25] This has led to enormous pressure being experienced by individual researchers who have felt the isolation conventionally identified with doctoral study in extremis. Their research studies are the result of explosions of conflicted purposes mostly temporarily held in balance for the examination of the work, rather

than being fully explored. In one of the first doctoral submissions documented by Macleod, the research artwork was submitted in two separate exhibitions. Visitors on the viewing night (the day after the viva) were allowed access only to the one which held four completed artworks; the exhibition which held the research documentation was kept firmly locked. Perhaps if research artwork were more fully identified with what one of the doctoral students called 'objects of thinking',[26] and contextualised and presented as such, more productive and compelling debate might be generated both within the discipline and the university.

In each of the chapters by artist scholars, it is the processes of thought which have driven the research; the research submissions are the objects of thought contextualised and determined by artists' research methodologies. This thought has addressed itself to various problems of perception: for example, how to conceive of a fourth dimension in print; how to represent illusion; how to subvert the truth of a research culture through artwork; how to refuse separation between painting, ethics and erotics, or art and science, or art and philosophy; or time and space in the face of governmental spatial determinism. The processes of thought are spun from multilayered methodologies, employing a range of disciplines, theories and authorial positions. Each is complex as artists have explored the exigencies of written text, realising artworks, representing theory, reworking a technique or any of the hybrid modes adopted. In our view, these writings begin to provide scrutiny of thought which is difficult to get at. We hope these writings will take meanings beyond the discipline: 'beyond the terms in which it would enclose itself and into a multiplicity of contiguous associations which map new fields of enquiry both intimate and alien'.[27]

According to our evidence, artists' own sense of themselves, their subjecthood, comes into play when realising research artwork. The first person singular is axiomatic as is a specific intimacy with research findings which are often seen as part of a developing and self-determining practice rather than as research inquiry. This intimacy can provide for an alienation from the normative academic. We might call this, the tone of art research.[28] This tone, quite unsurprisingly, is not available in what we might take to be the relevant literature: also, whatever the modification and criticism of theoretical constructions found in these sources, it does not appropriately renegotiate the relationship of theory to practice in the sense of art's disturbance of theory. There is little sense in current texts of such disturbance, or of a currency of ideas unfolding, or being difficult to grasp, no 'new fields of enquiry both intimate and alien'.[29] Indeed, where do we find sustained analysis of art's internal organisation, the fact that it can, like poetry, only be reread not read, since some of its structures can be perceived only retrospectively?[30] This kind of interpretation is rarely evidenced. It has been identified by Jim Mooney in his exemplary study, *Research in Fine Art by Project: General Remarks Toward Definition and Legitimation of Methodologies*,[31] in which he cites Terry Eagleton: 'A poem in fact, can only be re-read, not read, since some of its structures can only be perceived retrospectively.'[32]

Art, like poetry, is not easily read. In our search for a sense of this *rereading* and the alienating intimacy of such a process, one of the most useful sources encountered has been Mieke Bal's writing, in particular, on Louise Bourgeois's *Spider*.[33] Here a fastidious case is made for the artist's theorisation process being *through* this artwork, *Spider*. In this writing Bal enters into our intimate and alien space of epistemological anxiety; she is not sure of her ground. In her attempt to gain an intimate understanding, all the

ambiguous force of this work is brought into play: its multidimensionality, its arbitrary adoption of what might be construed as theory (for instance, psychoanalysis and narrativity) and its authorial positioning through critical autobiography. Such an interpretation is made possible because Bal has placed 'the art first'; that is before 'influence, context, iconography and historical lineage'. Attention then, can be fixed to what kind of seeing is involved in engaging with art, what the work is, means and does in the present time of viewing. One of the crucial questions asked by Bal is: 'How can we both do it [*Spider*] justice as a work of art and learn from it, as a theory on, and example of, *thought* about art?'[34]

Spider is viewed as conceptually self-reflexive and an artwork which builds rather than tells a story: 'Bourgeois' Spider as theoretical object "theorises", as sculpture "embodies", and as building "houses"'.[35] Bal explores the complexity of what is viewed and the process of viewing: 'The narrative of viewing rivals the narrative of memory, whose presence one senses but cannot grasp'.[36] These objects of attention become 'ungrasped symbolism' or 'unthought known',[37] as the apparent stories within the work and of the author of it unravel in the process of interpretative seeing. This represents, in Bal's view, a kind of unlearning which resists conventional methods of art historical research. Finally, *Spider* is, in Bal's view: 'effective in conveying, persuading, making us experience experience itself on all levels of the intellectual, the aesthetic, the mind, and the body'.[38]

Through the acuity of Bal's interpretation, like Price's research, the reader is bound into the work of the work itself and at the end of the book, retreats, gasping for air. However, do such meticulous acts of intimate interpretation generate renewed understanding of art *as* research? Do they put forward our case? Yes, of course, in terms of revealing the complex processes at work. This is important, as our empirical research indicates that until, or unless, scholars, supervisors and academics learn to see or fully read art, the case indeed, for research *as* art, may not be made.

It might be useful then to turn to another source of interpretation, this time, by a postdoctoral artist scholar.[39] In the context of writing from within the practice and the exploration of 'embodiment, tactility and the relations of being in the world', Barbara Bolt puts forward an argument for 'the productive materiality of the performative act' and makes a compelling case for 'a mutual reflection between imaging and "reality"' through painting. Bolt claims ontological effects for painting.[40] These effects result from the life of the painting which 'breathes, vibrates, pulsates, shimmers'[41] and goes beyond representation and becomes (with reference to James Elkins' work)[42] both sign and not sign. Bolt describes the responsiveness of the paintings to the world around them, how in different circumstances they appear to take on a 'very different life, a different force and intensity'. In the attempt to describe how one might view this performance, Bolt turns to Guattari:

> Objects constitute themselves in a transversal vibratory position, conferring on them a soul, a becoming ancestral, animal, vegetal, cosmic. These objectivities-subjectivities are led to work for themselves . . . they overlap each other, and invade each other to become collective entities half-thing half-soul half-man half-beast, machine and flux, matter and sign.[43]

It becomes a question of the work no longer functioning as sign but becoming the 'thing itself', offering the 'facts of matter' and 'a double transgression of language by

flesh and of flesh by language'.[44] The performative capacity of art (painting in this case) makes artists 'foreigners' in their own language as their work is both sign and 'an act of concurrent production'. Bolt traces a line through founding theory in semiotics, locating Charles Peirce's definition of a dynamic object which is determined as the 'as-yet-unseen'; it brings pressure to bear on that which is seen; it is identified as matter and sensation, that which is unspoken and defies logic. It can be aligned to what Yves Alain Bois conceives as 'worlds under construction' defined as similar: 'in their mode of existence – to nature itself'.[45] The experience of making work is replayed in Bolt's illuminating contribution through an argument for meaning to emerge 'in and through the play of the matter of objects' as well as the matter of bodies, the materials of production and the matter of discourse.[46] Bolt insists that the performative capacity of art produces rather than represents reality. She advocates a total openness to the 'being' of art which, like Bal, she sees as its work.

For Bolt, art is performance rather than representation.[47] The argument against representation is not new, but Bolt's careful exposition of the 'being' of art, its ontological resonance, its disturbing intimacy, is in tune with how other artist scholars describe their research artwork.[48] There is an inflection of thought in these writings by Bal and Bolt which helps to identify that which in art refuses predicted systematisation, the particular materiality of art which cuts across language. It might be this which drove Jean-Paul Sartre, for instance, to assert that the yellow patch of sky in Tintoretto's painting of Golgotha (Scuola di San Rocco, *c.* 1565) did not represent anguish, it was the thing itself. It might appear in this context that we have been led back to aesthetics, to an acceptance of the work of art to be a 'sensuous manifold' which might be said to undo thought.[49] But just as Kant took his consideration of aesthetics to encompass the rational capacity of the mind to come to terms with phenomena, so Bolt's account of painting as 'dynamic object' affords the chance to come to terms with thought which arises out of art and comes *through* art, through its complex matter.

Art, however, is not theory. It can be said to encompass conceptual schemata. It can perhaps be identified, as Bal and Melville argue, as theorised object. Although it is unalterably subject to language, like poetry or music, each employs the imaginative capacity which could be said to release sense-construction from the bounds of language in pursuit of the direct rendition of experience. This is brilliantly explored by John Llewelyn in *The HypoCritical Imagination*.[50] However, our research indicates that in the case of artists, imagination is rarely mentioned; it is the material realisation of ideas whose imaginative purposes they take for granted which is of crucial interest. In this, the ideas of the Italian Hegelian, Galvano Della Volpe (introduced to this book by Kenneth Hay) offer an appropriate exemplum in the theory of the C-A-C circle; this conceives of a movement of thought drawn from a materialist world as 'analysis abstractions', through which it is theorised. These abstractions are also concrete (being formed), return to and consequently 'interfere' with the world. Such interference then sets up a new process of conceptualisation: 'The movement of thought from the concrete to the abstract and back into the concrete is not an identical return, but altered and enriched by the journey.'[51] In this interpretation, the concrete intellectuality of the creative process is realised. It is this which leads Hay to predict a dialectical freedom for art, a cognitive, semantic and methodological distinctness and it is this which has generated an important context for *Thinking Through Art*, because art returns us to our materiality.

In drawing to a conclusion, we will advocate a way forward for art research cultures through the exploration of the tensions between the modes of writing and realising artwork. Tim O'Riley touched on such an exploration in his doctoral study:

> Vision is a conduit through which the world is manifested; we cannot simply step outside of the process and use vision to inspect itself, to look at itself 'looking' so to speak.[52]

O'Riley talks of the elliptical relationship between theory and art practice and how art is 'seen as having omitted a word or phrase which is needed to complete the sense of the expression'.[53] However, rather than presume that art is to be that which is subject to theoretical interpretation, it might be more useful to be drawn into the multimodal, intermedial, hybrid and dynamic forms of communication of the digital, imagined by Kerstin Mey (see Chapter 14). The uncertain negotiation across modes of communication and disciplines aptly fits our purposes. Why not see writing as a way of engaging more accurately with art research? Could it be that an elegant research soliloquy which intimately addresses the processes of making art could help to refine our understanding of art *as* thought? Could it be that in the process of more clearly addressing the making of art, we might enter into an intimate space of unknowing, which is the space of unlearning; it could also be the space of rereading, of spending more time with that which has been produced *as* research. Perhaps dealing with the many complexities of research art and its processes of production, might lead us to a more careful evaluation of what it is that students produce as thought. Taking good account of the thought which artist scholars produce would serve to build an appropriately vigorous research culture.

Thinking Through Art ultimately arises from trying to get *inside* the processes of making research artwork. Writings here are presented in the shadow of art and those discourses which are proposed arise out of, and return to, material practice. Perhaps it is time to negotiate with and through the discourse of art and its uneasy embrace of linguistic systems. We need to bring our writing nearer to our making (see Afterword).

In conclusion, this book introduces those processes of research which involve the making of artwork. It sets these processes in the context of their production, which is doctoral study, yet seeks to illuminate the ways in which the requirements of a doctorate might work against the requirements of making art. It does this in order to provoke thought about art, what it is and what it does. Our research has demonstrated that to refuse what art does is to reject its interpretative currency and criticality. In complex times which become increasingly hard to grasp, it would seem profligate to dismiss the potential of artist scholars to 'draw us beyond ourselves and throw us back upon our own subjectivity and agency',[54] despite the difficulty this might present to broader research cultures. Indeed, such intellectual endeavours could and should begin to make a difference to the way our worlds are shaped.

Notes

1 Macleod, K. (1996–2002) Qualitative research into student and supervisor experience of doctoral research including submissions/exhibitions and viva in fine art (20 institutions, UK); Holdridge, L. (1999–2000) Qualitative research into student experience of the PhD

(University of Plymouth); Macleod, K. and Holdridge, L. (2002–3) Qualitative research into PhD exemplars, AHRC funded study: Macleod, K. and Holdridge, L. (2004) 'The Doctorate in Fine Art: The Importance of Exemplars to the Research Culture', *International Journal of Art and Design Education* 23(2): 156–68.

2 For a careful account of incipient issues within a research culture waiting to emerge, see Brighton, C. R. 'Research in Fine Art: An Epistemological and Empirical Study', PhD, University of Surrey, 1993.

3 Empirical research by Macleod, K. (1996–2002) and Macleod, K. and Holdridge, L. (2002–5) indicates that the PhD submission of exhibited artwork presents issues for the doctoral culture which lie outside the remit of the PhD: the key issue is an appropriate reading of research work which exceeds the research propositions and their methodological framing.

4 While there will be an element of experimentation in the majority of PhDs, Macleod's (1996–2002) research specifically sought to encourage students to elucidate the relationship of the research artworks to the written texts. Evidence indicated inventive approaches to forging an appropriate relationship between them. See Macleod, K. (1999) '(Editorial) Special Issue', 'The Relationship of Making to Writing', *POINT 7*, Spring/Summer; Macleod, K. (2000) 'The Function of the Written Text', Research into Practice Conference, University of Hertfordshire. http:www.herts.ac.uk/artdes/simsim/conex/res2prac/wp/ Macleod, K. (2000) 'What Would Falsify an Art Practice? Research Degrees in Fine Art', in Swift, J. (ed.) *BROADSIDE 5*. Birmingham: University of Central England.

5 See Macleod, K. and Holdridge, L. (2004) 'The Doctorate in Fine Art: The Importance of Exemplars to the Research Culture' *International Journal of Art and Design Education* 23(2): 156–68.

6 The a posteriori nature of artwork is brilliantly explicated by Jim Mooney (1999) in *Research in Fine Art by Project: General Remarks toward Definition and Legitimation of Methodologies*. Middlesex University (pending publication).

7 We have found it extraordinarily difficult to find a satisfactory way of speaking about generic terms such as world and art and to use the first person without some qualification. Perhaps Irit Rogoff's illuminating exposition of what it might mean to employ 'we' and relate the first person plural to our worlds and an art which we might find there, will be useful in this context ('Words in Advance' in Lomax, Y. (2000) *Writing the Image: An Adventure with Art and Theory*. London: I.B. Taurus).

8 Macleod, K. (1996–2002) and Macleod, K. and Holdridge, L. (2002–3) have found that doctoral submissions in fine art preclude the concept of the visual illustration of the written thesis. See notes 5 and 16.

9 Research evidence indicates that in the case of the artist researcher critical evaluation of research artwork is in the nature of an aesthetic judgement. See Macleod (2000).

10 Frayling, C. (1993/4) 'Research in Art and Design', RCA Research Papers vol. 1, no. 1. London: Royal College of Art.

11 Ibid. p. 5.

12 Melville, S. (2001) Counting/As/Painting. In Armstrong, P. Lisbon L. and Melville, S. (eds) *As Painting: Division and Displacement*. Columbus, OH: Wexner Center for the Arts, MIT Press, p. 19.

13 Ibid. p. 10.

14 Ibid. p. 10.

15 Ibid. p. 10.

16 Macleod, K. (2000) 'What Would Falsify an Art Practice? Research Degrees in Fine Art', in Swift, J. (ed.) *BROADSIDE 5*. Birmingham: University of Central England.

17 Ibid. p. 13.

18 Ibid. p. 14.

19 Ibid. p. 14.

20 Macleod, K. (2000) *The Function of the Written Text in Practice-based PhD submissions* http://www.herts.ac.uk/artdes/research/papers/wpades/voll/macleod2.html

21 See Hockey, J. (1999) 'Motives and Meaning among PhD Supervisors in the Social Sciences', *British Journal of Sociology of Education* 17(4): 489–505; Hockey, J. (2003) 'Art and Design Practice-Based Research Degree Supervision Some Empirical Findings', *Arts and*

Humanities in Higher Education 2(2): 173–85. See also Hockey, J. and Allen-Collinson, J. (2005) 'Identity Change Doctoral Students in Art and Design', *Arts and Humanities in Higher Education* 4(1): 77–93.

22 Frayling (1993) p. 2.

23 Melville, S. and Readings, B. (eds) (1995) *Vision and Textuality*. Durham, NC: Duke University Press, p. 6.

24 Price, E. (2000) PhD sidekick, University of Leeds.

25 Macleod and Holdridge (2004).

26 Macleod (2000) p. 19.

27 Melville and Readings (1995).

28 On the question of tone, we are indebted to Elkins, J. (2000) *Our Beautiful, Dry, and Distant Texts*. New York and London: Routledge; Melville and Readings (1995).

29 On one level, this is, of course an outrageous claim. We have found our nearest source in terms of how we would have wished to introduce this book to be Melville and Readings (1996). It is a matter of engaging directly with subjectivity.

30 Smith, P. and Wilde, C. (eds) (2002) *A Companion to Art Theory*. Oxford: Blackwell; Harrison, C. and Wood, P. (eds) (2002) *Art in Theory: An Anthology of Changing Ideas*. Oxford: Blackwell; Arnold, D. and Iversen, M. (eds) (2003) *Art and Thought*. Oxford: Blackwell; Bryson, N., Holly, M. and Moxey, K. (1991) *Visual Theory: Painting and Interpretation*. Hanover, NH and London: Wesleyan University Press of New England; Stiles, K. and Selz, P. (1996) *Theories and Documents of Contemporary Art: A Sourcebook of Artists' Writings*. Berkeley, CA: University of California Press.

31 Mooney (1999).

32 Eagleton, T. (1983) *Literary Theory: An Introduction*. Oxford: Basil Blackwell, p. 89.

33 Bal, M. (2001) *Louise Bourgeois' Spider: The Architecture of Art-writing*. Chicago and London: University of Chicago Press.

34 Ibid. p. 3.

35 Ibid. p. 10.

36 Ibid. p. 27.

37 Ibid. p. 39.

38 Ibid. p. 122.

39 Bolt, B. (2004) 'Painting is Not a Representational Practice', in Betterton, R. (ed.) *Unframed Practices and Politics of Women's Contemporary Painting*. London: I B Taurus.

40 Ibid. p. 41.

41 Ibid. p. 42.

42 Elkins, J. (1998) *On Pictures and the Words that Fail Them*. Cambridge: Cambridge University Press, p. 45.

43 Bolt (2004) p. 43.

44 Ibid. p. 48.

45 Ibid. p. 51.

46 Ibid. p. 52.

47 See also Davies, D. (2004) *ART as Performance*. Oxford: Blackwell.

48 Macleod, K. and Holdridge, L. (2005) 'The Enactment of Thinking, Theoros III', University of Dundee papers, in Kerstin Mey (Guest ed.) 'On-Site/In-Sight'. *Journal of Visual Art Practice*, 4(1); *Theoros III*. University of Dundee (London: Peter Lang) (pending).

49 See for a marvellous reclaiming of Kant, Crowther, P. (1993) *Critical Aesthetics and Postmodernism*. Oxford: Oxford University Press.

50 Llewelyn, J. (2000) *The HypoCritical Imagination: Between Kant and Lévinas*. London and New York: Routledge.

51 Hay, K. (2002) 'Concrete Abstractions – a Della Volpean Perspective on Studio Practice as Research, Macleod, K. and Holdridge, L. (Guest eds) *Journal of Visual Art Practice* 2(1 and 2): 65.

52 In Macleod, K. and Holdridge, L. (2003) *The Doctorate in Fine Art: A Study of Eight Exemplars* (AHRC funded study, pending publication).

53 Ibid.

54 Melville and Readings (1995) p. 14.

Part I

Introduction to Part I

Katy Macleod and Lin Holdridge

The chapters in this first part of the book provide a discursive space within which the active contemplation of art can take place. The philosophers, cultural historians and artists writing here seek to enrich current understanding of the specificity of art and its various processes, because it is these which characterise *Thinking Through Art*. Each of the contributors to this part is actively engaged with doctoral art practice, and is fully conversant with the specificities of art both in this research context and in a variety of contexts which brings with them a wider application for art. They view the act of contemplating art, that which is interpretative action, as potentially shaping our conscious worlds. Such action might rupture foundational assumptions about what is 'real' and how we become conscious of that which is real. The writers here exemplify art's potential to open up possibilities for thought *and* action. Art is viewed as an active force within our cultural domains and it is this which has determined contributors' interest in examining how art might be more effectively understood within the research cultures of the university.

Chapter 1, 'Art and *theoria*' by Nicholas Davey, pursues ways in which art theory could be rethought as *theoria*, a hermeneutic notion which offers a richly appropriate means of addressing art's subject matter. He views art practice and theory as 'mutually engaged'. Within this context, he presents and argues through three aspects of art which could be said to lend themselves to such mutual engagement: first, that art addresses us, the viewer. It is through this address that we might view possibilities for ourselves such as 'shared meanings', a sharing which opens out possibilities beyond our own experience of the specific subject matters of art: 'Far from condemning our experience of art as subjective, hermeneutics contends that aesthetic experience opens us to a greater objectivity' (p. 23).

The second aspect is that art has distinct subject matters, and the third, that art is fundamentally dialogic. This dialogical aspect of art is identified as art's 'endless' conversations (and possibilities), which are 'already underway'. Davey offers a definition here of *theoria* not as theory, but as an *agent* which puts artists 'in touch' with formative processes such as the historical and cultural. The intention is not to 'overdetermine' art, but to more fully understand, and draw closer to, an appropriate experience of its intellectual and material character.

Theoria, in Davey's view, offers the possibility of disinterested contemplation which is 'actively engaged'. It is also a mode of practice, and works with aesthetics to aid the 'emergence' of what is encountered as art. He puts forward a cogent case for *theoria* to respond in hermeneutic terms to the specificities of art and its inexhaustive possibilities

for interpretation and that which has not yet been conceived. It opens up a reflective space in the tension between thinking and making to enrich the possibilities for art's subject matter.

Chapter 2, 'Interrupting the artist: theory, practice and topology in Sartre's aesthetics' by Clive Cazeaux, argues the connection between conceptual judgement and aesthetic experience through the phenomenological tradition within recent continental philosophy. Cazeaux views phenomenology as offering important lines of inquiry into writing and into our condition as beings, 'immersed in' and 'actively engaged with' the world. He asserts that conceptual judgement and aesthetic experience are conjoined through the consideration of a concept which is active in 'bringing to light' new aesthetic possibilities. He refuses the deeply rooted splitting of theory from practice; of the verbal from the visual, the objective from the subjective in pursuit of the conceptual/aesthetic. He reconciles thinking on aesthetics by David Hume and Immanuel Kant and refutes the separation of art from theory, and from words, within modernist thought. He employs continental aesthetics to identify concepts with experience. Immanuel Kant, Herman Nietzsche and Jean-Paul Sartre are marshalled to align sensuous experience with the conceptual to further understand their relationship. Writing is identified as particularly important in opening up such understanding; there is, as Cazeaux indicates, 'a rupturing from experience to writing' that is between experience and the contemplation of it. Writing can help to redefine the gap which results from such rupturing. Primarily through a close referencing of Sartrean problematics, Cazeaux presents this gap as an essential space between epistemology and the world. In this context, he presents the active interpretative experience of the artist against the 'container logic' of rational knowledge and epistemological certainty. He too enriches the discursive space for art to claim a particular kind of attention. It does, after all, provide a way of orientating ourselves to the conditions of being and as beings, who are actively engaged in the world.

In Chapter 3, 'Concrete abstractions and intersemiotic translations: the legacy of Della Volpe', Kenneth Hay argues the case for art as practical theory and theoretical practice. He views art as epistemologically equivalent to other disciplines and underlines its distinctiveness as a 'determinate abstraction'; that is, an abstraction which is also concrete and capable of acting in the world. Moreover it provides exempla of 'translations' of the material world which result in new conceptualisations. Galvano Della Volpe's thought, arising as it does from moral philosophy, philosophical logic and materialist aesthetics, presents the case for the discipline equivalence of art, while maintaining its distinctiveness. Hay also usefully employs Della Volpe's materialist and philosophical logic in order to examine the theory/practice relationship within art. Della Volpe's intention was to demonstrate the 'exemplarity' of art as a rational and material synthesis and to this end, he formulated an aesthetic of the means of expression through the C-A-C circle. This reworking of Marxist materialist logic proposes an analysis of the material world (C); from this, abstractions are formed in order to theorise this world (A). These abstractions (which are, in fact, concrete) then return to interfere with (C), which in turn, creates a new process of conceptualisation. Art is viewed here as a materialist practice which enjoys a cognitive, semantic and methodological distinctness. It employs a concrete intellectuality which should be seen as epistemologically equivalent to other disciplines. Its potential *as* theory can be traced through what Hay calls its translatability, through its concrete abstraction and its

capacity for metaphor, most appropriately explored through film. Film reveals both
the plasticity of images and a complex symbolisation, and that which Della Volpe and
Hay conceive of as the form/content dialectic which is dependant upon an ideological
structuring of thought. Hay argues through Della Volpe that art, in the medium of
film, can be identified as a 'renewed conceptualisation', as that which acts in the world.
This action arises from the logics of a material, rational and historically embedded
practice, the 'theorised practice' of art.

In Chapter 4, Ken Neil explores specific ways in which art addresses the 'real' in
'Repeat: entity and ground – Visual arts practice as critical differentiation'. Neil
employs a close reading of theories of the real from the writings of Slavoj Žižek and
Hal Foster, and most particularly, those ways in which repetition and copy in art
both screens and reveals the real. In this process, art reveals 'something of its possible
traumatic status'. Neil argues for a renewed interest in the conditions of the real and
through Žižek, exhorts us to reintegrate it in order to more fully understand its
trauma. Foster's reading of trauma in Andy Warhol's *Death in America* serve to
identify what this might mean in terms of 'critical differentiation' which is encoun-
tered as integral to the process of reintegration. Crucial here, is an understanding of
the critical thinking of artists as a process of 'acting through', rather than that which
is restrained or 'held within' the artwork. Neil asserts the particular appropriateness
of critical thinking which arises from and responds to its picturing for the 'effective
and apposite reflexive analysis of the increasingly virtualised reality'. Neil makes a
particular case for artists to be viewed as capable 'to catalyse the real'.

Through Žižek, Neil poses a mimetic role for art which reflects modes of repetition
which could be said to meet the complex challenge for a critical differentiation of
the real. This is necessary in a world which, according to Jean Baudrillard, is 'visually
obese' and involved in endless and 'inexorable self replication' without resistant critic-
ality. We have become accustomed to the 'unvariegated, simulacral' surface of an
undifferentiated real. Its numbing presence is counterbalanced by Neil's reconfiguration
of artists from those who represent to those who act as agent to define and distinguish
the real from its semblance, characterised here as 'entity and ground'. The central
exemplum explored through Žižek, is the dramatic event of the September 11 terrorist
attacks on the World Trade Center in New York City, 2001. In pursuing Žižek's
account of the event and its myriad reportings, Neil provides insight into the strange
alignment of that which is real, through its reported and increasingly fictionalised
copy, so that repeated copies could be seen as a 'complex conjoining of the real, the
symbolic and the imaginary'. Hence the real and its fictionalisation can each be complicit
in a possible recuperation of the traumatic event. Such recuperation would be charac-
terised as action, as 'differentiated' action and such action would open up critical
possibilities 'from within the very spaces of the visual replication'.

Neil refers to Andy Warhol's series of prints depicting *Death in America* as significant
examples of an artist's thinking which is both engaged in figuring a contemporary and
repeated event, while remaining curiously disengaged from it. However, Foster offers
an analysis of Warhol's resigned acceptance of the elusiveness of the real which returns
us to the plot of determining what critical differentiation might be: it is, in this instance,
a repeated mirroring of the actual event as 'meaningless signal' set against the possibility
of a 'significant message' because the repeated artworks can be said to open out a
'fissure' between event and its signification, a fissure which could be 'catalysed' as

critical space. Neil offers the exemplum of Warhol's print series of traumatic events as art which might be said to recuperate the ordinary real, that which we habitually miss through familiarity, particularly if the viewer's observation of the traumatic event is too late and therefore likely to be indifferent. However, Neil proposes that this after-the-event engagement can provoke a yearning for that which *was* real, *had* happened and incite a drive to pursue what has passed. Neil asserts an active role for the artist within current cultures:

> It is the visual artist's sympathetic magic that transfunctionalises aspects of the real through fantasy, enabling those aspects to be disclosed and perceived in a fictional mode: a mode which relies on a distinction between entity and ground and which thus avoids the fatal dangers of a flattened self-referentiality. (p. 71)

In Chapter 5, 'The virtually new: art, consciousness and form', Peter Dallow pursues artists' struggles to come to terms with the social, ethical and cultural implications of being 'present' in the world. Dallow traces the concept of the new through modernism, how the new becomes the virtual within postmodern thought and its impact on the notion of originality: 'The moment of originality . . . like the notion of the originary moment itself . . . seems to provide a metaphor for the sense of historically situated time itself' (p. 75). But it is this which is 'thought abandoned', with the advent of postmodernism. Dallow therefore argues a more 'reasoned' position for postmodern thought than that which he identifies within modernist abstraction. This is complex: expressive form and aesthetic experience seem to open up the sensation of an impossible vantage point which appears to be 'beyond reason', but doubles back to engage critical thought. Through Sartre, Dallow sees art as not providing a mirror to reality, but a negation of it because it is the situation of the artist and 'a particular intention of consciousness' which is revealed. Dallow places the particular 'point of view' of an artist at the core of his argument. It is this which produces configurations which are not drawn from that which already exists and it is this which precipitates the viewer's virtual positioning in the space of 'not-knowing': 'the matrix of semiosis spun by the artefact, however immaterial, and its web of context, however variable, places the spectator into a virtual position of having to make an "effort after meaning"' (p. 80).

Using the exempla of recent works by Sam Taylor-Wood, Dallow explores the positioning of the viewer within 'an indeterminate semiotic and sensory field' as the viewer struggles after meanings which seem to defy interpretation. However, the indeterminancy of this relationship of viewer to artwork is not without purpose. Taylor-Wood's work is seen as offering a space which is both absence and presence, and it is the experience of an absence which returns us to our 'present(ness)'. In this negotiation, what Dallow views as new hybrid forms of art are crucial to the work's aesthetic presentation: holographic projections, digital montage and interactive installations. In the technical innovations employed by these works there is an oscillation between form and content, between the denotative and connotative signification experienced by the viewer. Following Hausman, Dallow argues for novelty or what we might identify as a new or original *thing*, as that which presents a new structure: 'It exhibits a new structure which newly exemplifies a Form' (p. 82). This form cannot be explained by codes and conventions, forms and genres of art; it disengages from these in its renewed structuring of the 'real'. This structuring, however, 'retains a lack of

resolution'; it lacks closure. Yet, it returns the viewer into a closer relationship with the real: 'That is, the artist's unfamiliar take or viewpoint on the world can simulate our own sense of being situated in the familiar world, even as it unsettles our own view of the familiar world' (p. 84). The viewer thus becomes conscious of the transcience of the present, of her/his present(ness).

Dallow (quoting Peter Weibel) conceives of the uncertainty provoked by art as existential in character: 'Self-doubt to the point of dematerialization is the logical force inherent in art, and advancing its development' (p. 84). Novelty or originality, is indeterminate within the structures of what we take to *be* reality (and this concept of course is fundamentally important to an appropriate understanding of what might be the provenance of art). However, art also affords experience which reveals something 'processually' constitutive of 'the structure of consciousness' in Dallow's view. In this paradoxical push and pull of indeterminacy and structuring, the specific reflexivity of art mirrors and reveals the 'inner struggle for identity' which exists at the core of our lives.

All these chapters exemplify some of the ways in which art could be said to act in the world, to offer more than the representation of it. The philosophers, Davey and Cazeaux, and artist and critical theorist, Hay, are more concerned with how art might lend itself to what Hay terms translation. This might appear blindingly obvious within Western aesthetics. Indeed, art is endlessly talked about but does not speak; we speak for it and we do so constantly in a myriad of ways but the issue being addressed here is how might we speak when we attempt to get at what art is as an experience of that which we encounter through the familiar, the everyday, the taken for granted action, feeling, presence. Neil and Dallow take us further into the experience of the experience and the complex processes of negotiating and renegotiating that which *is* real. It is this which marks the vitality of art.

Chapter 1

Art and *theoria*

Nicholas Davey

Works of art are set in motion by patient contemplation

Theodor Adorno[1]

Introduction: disputed territories

The connection between art practice and art theory is in considerable need of being rethought. The task is a delicate one. The historical relation between these two areas of intellectual endeavour is marked out by a topography of unease. This chapter will suggest that the hermeneutic notion of *theoria* avoids the pitfalls of the traditional opposition between art theory and practice. Most important is the fact that it offers a dialogical account of how theory and practice can interact in such a way as to mutually assist in the realisation of an artwork's subject matter. The chapter will accordingly explore the confusions which have needlessly animated the longstanding animosity between art theory and art practice. It will question the assumption that certain models of theory can translate the nature of art practice into objectifiable idioms. The purpose of argument will be to outline how we might think about the relationship between art practice and theory differently.

To think about the relationship between art practice and theory differently demands that the relationship no longer be thought of in oppositional terms. The possibility of articulating a complementary relationship in which art theory and practice mutually participate in each other's endeavour demands that we free ourselves from the illusion that the modern notion of theory is the only model of theory available to us. If the roots of modern theory are traced back to the ancient Greek conception of *theoria* (contemplation) and *theoros* (participant), a path to rearticulating theory as a mode of participation in practice is opened. Unlike the modern conception of theory which stresses the detached observation of a phenomenal event, the ancient notion of *theoria* emphasises the act of witness which (as in the case of a festival or act of worship) contributes toward the emergence of the event participated in. When this conception of *theoria* is combined with the language ontology of philosophical hermeneutics, an altogether more feasible understanding of the relationship between art theory and art practice emerges.

Philosophical hermeneutics is concerned with the nature of communication and fundamental to the hermeneutical notion of language is the concept of a subject matter (*die Sache*) which a communication intends or addresses. Subject matters are

conceived as always being in excess of how they are articulated. Though no artwork or art theory can exhaust their subject matter, they can share it, and offer complementary perspectives upon it which can transform, potentially, the understanding with which each endeavour approached that subject matter in the first place. This chapter will outline how the notion of subject matter can provide a conceptual basis upon which a dialogical relationship between art theory and practice can be established. In effect, the question is not to do with how art theory and practice relate to each other but with how each relate differently to a shared subject matter.

Philosophical hermeneutics recognises that any communicative activity does not arise *ex nihilo* but is enabled by the pre-reflective historical transmission of norms, values and assumptions which constitute an inherited world-outlook. It is in the nature of art practice to be always more than it knows itself to be. There are at least two dimensions to this excess which are important to our discussion. First, that a given practice is grounded in historical horizons that cannot be fully recovered conceptually implies that no practice can be fully theorised. This, in fact, stresses the importance of the theorisation of practice for it is only by attempting to think differently about art practice, that many of its hidden assumptions can be recovered. However, such recovery aims not at placing practice at the command of theory but at releasing the potential within the latter. Second, that a given practice is rooted in what has been transmitted historically does not mean that the practice is destined to remain the same. The inheritance of a tradition or a work practice is not definitive, closed and/or resolved. To the contrary, they retain tensions, contradictions and unrealised futures. One role of theory is to uncover the possibilities that remain inherent within practices and thereby liberate them towards futures already latent within them. In this context, theory serves as a midwife to practice. Sympathetic theoretical engagement with practice can release this unfulfilled potential. Like the surprising twists and turns of a conversation, the release of such possibilities cannot be planned or predicted. Yet, it is only by continuing the conversational engagement between art theory and practice that the unexpected and transforming possibilities within practice can be brought to light. We suggest that a hermeneutical approach to the relationship between art theory and art practice offers an understanding of how practice is invariably informed by the concepts of a cultural horizon. It presents an understanding of how theory can enable practice to engage with, reflect upon and extend that horizon.

The principal argument which this chapter presents derives from my study of the practical implications of the aesthetics of Hans-Georg Gadamer (1900–2002). However, the case to be put is not Gadamer's but mine. Its arguments reflect an attempt on my part to realise the rich critical potential of philosophical hermeneutics within the teaching of art.

'Theoria': triangulating its position

No concept stands on its own. Any demonstration of the relevance of *theoria* to art practice requires that its position in relation to three specific claims made about art by philosophical hermeneutics be properly triangulated. The claims are first, that art addresses us; second, that art has distinct subject matters as its content; and, third, that the interface between ourselves and art is fundamentally dialogical. We shall take each claim in turn.

Art and its address

Philosophical hermeneutics stands on the assumption that art addresses us. Part of Gadamer's formal ambition is to articulate both 'what we undergo' and 'what comes into play' within our experience of art. When he concerns himself with the truth claims of art, he is not so much concerned with the truth of what an artwork claims as with the fact that an artwork can truly lay a claim upon us. By this he means that an experience of an artwork can be so compelling that we can neither deny nor walk away from the force of the experience. In *Truth and Method* he contends that: 'hermeneutical experience must take everything which becomes present to it as a *genuine experience*. It does (i.e. we do) not have prior freedom to select and reject' (TM 463).[2] The life-changing power of an artwork is reciprocal to its capacity to address us.

Art and its subject matters

If artworks address us, they address us about something. This brings us to the question of subject matter (*die Sache*).[3] In his assertion that artworks direct us to a subject matter, Gadamer reveals his phenomenological heritage. Consciousness is never pure but always of something, always tends towards an object. *Sache* means concern or the matter at hand. An artwork's approach to its subject matter need not be relativistic. Different works can share the same subject matter and each can address different aspects of that *Sache*'s core concerns: 'Every hermeneutical understanding', Gadamer insists, 'begins and ends with the thing-in-itself (*Sache-selbst*)'. 'All correct interpretation must let the thing take over' (TM 236) and 'be confirmed by the things themselves' (TM 235, 237), that is, by the subject matters towards which works incline. The *Sache* or subject-field which a work (utterance) addresses is 'always more' than any individual expression of it. It follows that if, like concepts, the subject matter of an artwork is 'always more' than its instances, an artwork can in this respect never be finished: 'all encounter with the language of art is an encounter with an unfinished event' (TM 99). 'There is no absolute progress and no final exhaustion of what lies in a work of art. The experience of art knows this of itself' (TM 100). Thus, if no work can exhaust its subject matter, there is always something more to be said. As we shall see, the task of *theoria* is to distil from an artwork aspects of its *Sache* that have yet to be realised. No work can claim or be proclaimed the definitive expression of a subject matter for its implicit futurity is forever open. Now the standing of an artwork is not necessarily diminished by recognising that there are always other aspects of its subject matter to be brought to the inner eye. A work might be valued not just because of the directness whereby it brings its subject matter forth but because, by doing so, it is also able to assert its own merits in contradistinction to previous exemplars of its type. Far from being an inadequacy, the incompleteness of a work's subject matter poses a creative challenge: to think on and uncover what has yet to be said.

 The notion of a work addressing a transcendent subject matter and of it being assessed in terms of what it invokes has important practical consequences for the teaching of art. It emphasises the dialogical or discursive aspects of art practice. If a subject matter is logically inexhaustible, no party can possess the right or correct view of it. Art education should involve dialogical exchanges in which different aspects of

a subject matter might be shared. Once an artist has selected his or her subject matter, certain very practical questions emerge: is the style appropriate to the subject matter? Do the chosen images effectively identify the subject matter or are they ambiguous? Does the work read clearly and, if not, what practical rectification is required? In other words, the subject matter provides a criterion whereby we can ask and re-ask questions about the level of seeing we bring to or is required by a work. Finally, the notion of subject matter helps defend aesthetic experience against the needless charge of subjectivism. There are indeed truths which may be only subjectively experienced but that these truths emerge only in subjective consciousness does not render them subjective. If we understand the distinction between meaning and expression, we will understand that when a work brings its subject matter to mind, it will bring to mind more than is initially seen. We are, in other words, led out of the immediacy of our own horizon and brought to consider other ways of seeing and thinking. Meanings for Gadamer are subject-fields, spaces in which things are related. By entering one subject-field we gain access to others. The implicit networks of meaningfulness which connect the subject-fields of art underwrite art's ability to take us beyond ourselves, out of the initial horizons of our present historical circumstance into others. The recovery of other logically possible ways of thinking allows us to look at and, hence, to feel differently about an issue. We do not so much lose ourselves in the self-forgetfulness of art historical reflection as become more ourselves. Such reflection offers the possibility of recognising in other traditions and practices the otherness of ourselves.

Once the hermeneutic implications of the notion of subject matter (*die Sache selbst*) are unravelled, aesthetics emerges not as a solitary monologue on private pleasure but as a shared discourse concerned with the realisation of meaning. By recognising different traditions of art practice and history, hermeneutical experience exposes the (subjective) limitations of our own ways of doing and seeing. Far from condemning our experience of art as subjective, hermeneutics contends that aesthetic experience opens us to a greater objectivity.

Art and dialogue

If art addresses us and if it addresses us about something, our experience and engagement with art is fundamentally dialogical. This is not a matter of reducing art to the spoken word but of recognising that the event of art is in many ways analogous to the event of conversation: both are occasions in which something happens or is brought to mind. At the root of the term dialogue is the Greek term *logos* meaning the living word. Nietzsche well understood the vitality of the word. In *The Gay Science* he suggests that truth is somewhat dialogical (if not binocular) in nature: 'One times one – With one there can never be truth but with two truth *begins*' [emphasis added].[4] If we understand that a work, a phrase or conversation points to a subject matter, we know that what is understood can be stated in many different ways. No one work can exhaust a subject matter or lay claim to definitively state what it is. However, our understanding of what a subject matter is can be deepened and extended the more perspectives we bring to bear upon it. Thus, bringing an aesthetic or historical perspective to bear on an artist's own interpretation of a subject matter extends the truth of that subject matter. A hermeneutical engagement with art and its subject matters is

fundamentally dialogical in three senses. First, we become embroiled in conversations that are already underway. The subject matters which artworks address do not emerge *ex nihilo* but are the substance of historical traditions which both inform and facilitate an artist's individual outlook. Artworks can be understood as conversational responses to their subject matters. Second, like conversations in which unexpected insights arise to the surprise of the participants, practical and theoretical engagement with an artwork's subject matter is also eventful. In ways that are difficult to anticipate, such engagement can bring unseen or overlooked aspects of a work's subject matter to light. Third, conversations have no end; just as no one person begins them, they never end but rather break off. Everything that can be said about an artwork and its subject matter is incomplete. There is always more to be said. Neither the theoretician nor the practitioner has definitive rights to closure over what an artwork has to say. Rather, by being conversational partners both become essential parties to the unfolding of what the subject matter of a work holds within itself.

The relevance of *theoria* to art practice depends on the claims that art addresses us, that art has distinct subject matters and that art is fundamentally dialogical in nature. The question now to be considered is how the notion of *theoria* serves to elucidate and make good these claims.

Theoria as go-between

The central claim of this chapter observes that *theoria*, art practice and hermeneutics are all disciplines which neither rest on pure sensibility nor upon a science of pure concepts but upon a Kantian synthesis of concepts and intuitions. Arguably, Kant's most potent point about the intelligible content of art is made in the *Critique of Pure Reason* and not in the *Critique of Judgement*:

> Without sensibility no object would be given to us, without understanding no object would be thought. Thoughts without content are empty, intuitions without concepts are blind.[5]

The import of the remark is clear: art cannot remain art if it becomes a purely theoretical contemplation of ideas for it would lose its relation to the sensuous whereby it becomes art (*poiesis*), art in the first place. The tension within all art concerns how it honours its inseparable relation with the sensuous while at the same time reflecting upon how the ideas it addresses and which give it content can be sensuously embodied. It is this defining tension which makes art so amenable to *theoria*. *Theoria* is not theory. It is not an exercise in pure concepts but a reflective practice which engages with meanings as they appear in particular incarnate form. Thus *theoria* can modify over theoretical stances towards art and demand that practice recognise and engage with the intellectual notions which inform it.

As we shall see *theoria* is not merely a theoretical contemplation of art practice but cooperates with practice in bringing what is within a work to realisation. Gadamer's reflections upon art invert the Platonic account of the relationship between art, appearance and reality. Whereas Plato considers artistic appearance to be removed from and to be a corruption of the truth of what it represents, philosophical hermeneutics esteems art as a vehicle of truth's appearance and actualisation. Gadamer contends

that through its representation in art, truth 'experiences an increase in [its] being' (TM 153), a claim that would have astounded Plato. *Theoria* is a significant agency in this ontological realisation.

Because *theoria* like art practice involves a synthesis of the ideational and material, *theoria* can assist practice. For Gadamer the question is not how practitioners shape their aesthetic judgement but what objectively shapes itself and gains objectification within their aesthetic experience: 'To start from subjectivity is to miss the point' (TM 111) for that which is 'objective' or 'substantive' is that 'historically pre-given' substantiality which grounds all that is subjective (TM 302). Part of the task of *theoria* is to put the artist in touch with the formative forces which shape her practice. A compelling feature of a hermeneutic approach to art practice is that it does not attempt an *ex cathedra* application of theoretical paradigms to artistic experience but seeks to use philosophical reflection to articulate what occurs within it: 'Hermeneutics . . . is not knowledge as domination' but a drawing out of 'what is considered valid' within experience (TM 311): 'Understanding . . . is [thus] always application' (TM 309) and interpretation the individual concretisation of what has been grasped (TM 329).

Not all the anxieties which artists harbour about theory are not unjustified. Nietzsche was not far off the mark when he maligned philosophers as conceptual taxidermists from whose hands nothing escapes alive. They exhibit a tendency to trivialise individual wisdom and experience in the name of supposedly 'universal and objective knowledge'.[6] Practitioners can be intuitively resistant to approaches to art which entomb it within an all enclosing concept of discourse. This can amputate art from the life-world, reduce art to an ideological production, and display scant regard for what both artist and work might be saying. The particularities of the work and the artist are subordinated to theoretical issues or, much rather, the work is appropriated as evidence for a thesis which does not directly address the artwork but uses the artwork as a means to addressing historical or political issues. It should be interjected that the *theoria* argument is sympathetic to the anti-theory position. After all modern hermeneutics has been shaped by such intuitions. When Berlin spoke of Herder's philosophy as:

> the triumph of the concrete over the abstract, the sharp turn towards the immediate, the given, the experienced and above all away from abstraction, theories, generalisation . . . [and] the restoration of quality to its old status above quantity[7]

he might have been characterising the intellectual tendency of Dilthey, Heidegger and Gadamer to be strongly suspicious of elevation of the formalities of theoretical reasoning over actual experience.[8] *Theoria* opposes the theoretical overdetermination of art practice and resists any theoretical under-determination of art.

Philosophical hermeneutics counters any approach to art which claims to be purely sensualist. First, Gadamer's study of Husserl commits him to the phenomenological axiom that 'pure seeing and pure hearing are dogmatic abstractions which artificially reduce phenomena' (TM 92). Whereas aesthetic formalists such as Clive Bell divorce perception from the question of meaning, Gadamer, echoing Dufrenne's insistence that 'sensuousness is always sensuousness of something',[9] maintains that 'perception always includes meaning' (TM 92).[10] Without this synthesis, the hermeneutic claim that artworks speak to us would be vacuous (TM 51). Second, hermeneutical aesthetics

opposes the aesthetics of pure sensibility for effecting a complex aesthetic alienation. Gadamer insists that 'basing aesthetics on experience [*Erlebnissen* – i.e. the immediacy of the moment] leads to an absolute series of points which annihilates the unity of the work' (TM 95). The privileging of the aesthetic moment disrupts the 'continuity [of experience] that supports human existence' (TM 96) and renders the relation between art and the lived-world difficult to grasp. The aesthetics of immediacy separates an artwork from its historical world (TM 87) and prevents us from determining the cultural location of the question it addresses. The philosophical attraction of *theoria* is its recognition of the unavoidable and indeed productive tension between art's intellectual and material character. *Theoria* is a hermeneutic go-between.

Let us now turn to the notion of *theoria* itself. We will first explore what lies within the term and then consider its connection with aesthetics. We shall briefly explore both the philosophical background to *theoria* and examine those elements of its philosophical character which make suitable for contemplating what is entailed in art practice.

Theoria, theoros and theory

Gadamer comments: 'What is historical reflection other than the continual self-correction of the present consciousness'.[11] Reminiscent of Heidegger's *Destruktion*, Gadamer's stratagem uses philological insights to open the orientations within the word theory so as to release other meanings. The aim is not to recover the forgotten *per se* but to use the difference between past and present usage to create a space in which new meanings might arise. Just as he differentiates between the subjectivity of aesthetic experience and the objective event of experiencing art, so Gadamer distinguishes between the active subjective connotations of the modern concept of theory and the passive objective entailments in the older notion of theoria. Following the Husserlian suggestion that modern (scientific) theory is shaped by the life and knowledge constitutive interest of power and control, Gadamer describes modern theory in almost Nietzschean terms:[12]

> Theoretical knowledge is ... conceived in terms of the will to dominate what exists: it is a means ... Modern theory is a tool of construction by means of which we gather experiences together in a unified way and make it possible to dominate them. We are said to construct a theory. (TM 454)

Theory is a mode of 'subjective conduct' (TM 124). It creates constructs by means of which subjective-consciousness pursues its 'anonymous domination' of the environment.[13] Its claims to truth are partial: they fail to reveal the knowledge constitutive interests upon which they rest. The notion of *theoria*, however, is not an instance of the subject manipulating what is given to it but of experience manipulating the subject.

Gadamer suggests that *theoria* involves disinterested observation, contemplation without a specific end, and a mode of participation in events which is acquired more by skilful practice than by prescribed instruction. The essay 'The Idea of a University' comments:

The Greeks never forgot that this ideal of theory [*theoria*] – of living in pure observation or thinking which sees . . . things as they are . . . is not a straightforward human inheritance but . . . a possible accomplishment [skill].[14]

In 'Science and Philosophy' it is argued that:

> The word *theoria* . . . exhibits the distinctive character of the human being . . . that in spite of his slight and finite measure he is capable of pure contemplation of the universe.[15]

The primitive meaning of *theoria* is participation in a delegation sent to a festival to honour the gods. *Theoria* entails the notion of sharing an event. It implies a being-present to the object of one's contemplation which requires a level of accomplishment achieved not by the adoption of a method but by intense practice. Unlike the technical applications of modern theory, *theoria* transcends questions of utility and purpose: it is concerned with a being 'given away to something', a being taken up by it. The object or occasion which carries away the contemplative observer 'is accessible to all . . . and is shared by all . . . so that it is not an object of dispute like all other goods but actually gains through participation'.[16] Gadamer maintains that *theoria* 'cannot be adequately understood in terms of subjectivity' (TM 125) since from 'the Greek stand-point, it is impossible to construct theories' (in the modern sense).[17] *Theoria* is the determination of the subject by what it contemplates: it is a 'true participation', not 'something active but something passive (pathos), a total involvement in and a being carried away by what one sees' (TM 124–5).

This characterisation of *theoria* is corroborated by Michael Oakeshott in *On Human Conduct*:

> *Thea*: a spectacle, the observation of a 'going-on'. *Theorein*: to distinguish, attend to and perhaps to identify a 'going-on'. *Theoros*: a spectator concerned to follow and to understand a 'going-on'; a theorist. *Theoria*: the activity of contemplating, of inquiry and of seeking to understand. And *theorema*: what emerges from this activity, an understanding of a 'going-on'.[18]

Heidegger, too, characterises theoretical observation as a mode of resigning oneself, of letting oneself be carried away by what one sees:[19]

> Resigning oneself to something is a mode peculiar to circumspectively letting it be encountered . . . The temporal structure of resigning oneself to something, lies in a non-retaining which awaitingly makes present . . . Not reckoning with something is a mode of taking into one's reckoning that which one cannot cling to.[20]

As we shall see, the themes of encountering the unanticipated and of abandoning oneself to a world that can never be mastered form part of the particular emphasis Gadamer gives to *theoria*. However, Gadamer's rendition of *theoria* requires a degree of qualification.

Are we to understand Gadamer's notion of *theoria* in the same way as Aristotle's understanding of *theoria* as participating in the movement of ideas? Aristotle argues that 'perfect happiness is a speculative activity' (*theoria*):

> But if from a living being there is taken away action, not to mention creation or production, what is left him but contemplation? We must conclude that the activity of God, which is blessed above all others, must take the form of contemplation. And from this it follows that among human activities that which is most akin to God's will bring us the greatest happiness.[21]

If God's thinking is identical with the reality it knows, thought and reality are one and the same. As Joachim comments: 'the intuitive apprehension of a reality in which the grasping is what is grasped and the real is self-manifest is *theoria* (divine contemplation)'.[22] *Theoria* in Aristotle is the spiritual activity which God timelessly is. The perfect match of form and matter is denied the human but (and this is the crucial point for Aristotle) in the activity of *theoria*, the human being comes closest to approximating divine unhindered activity. Philosophical contemplation is for Aristotle an intellectual mode of recreating the fixed order of Being in one's own mind and thereby a recharting of its unfolding. What Gadamer takes over from Aristotle is the notion of *theoria* as a contemplative participation in an ontological process of unfolding. However, he completely abandons any suggestion that what unfolds in contemplation is a fixed order of Being. Aristotle presents the exercise of *theoria* as an act of mental re-enactment of the formal unfolding of ideas which exist independently of *theoria* (i.e. Being's categories). Gadamer is decidedly more Hegelian in orientation. The ideas of art or what Gadamer prefers to call subject matters (*die Sachen*) are not timelessly fixed. Nor do they exist independently of their artistic exemplifications. They are not objects of imitation in the strict sense. Much rather, they sustain their being in and through their interpretative exemplification and even become more what they are because of our participation in their unfolding. *Theoria* entails a participatory contemplative moment in an ontological event, an event in which what art deals with (*die Sache*) unfolds itself and comes into presence in unexpected ways. We can therefore understand Gadamer's invocation of *theoria* as invoking a participation in the movement of ideas. Gadamer's notion of *theoria* is not, therefore, to be understood as a reflection or mirroring of a fixed body of ideas but rather as an activity which enables and is as a consequence intrinsic to the unfolding of a body of ideas which are far from being fully determined. However, does this mean that *theoria* handles only intellectual abstractions?

After Baumgarten (1714–16), philosophical aesthetics has invariably been associated with the sensuous apprehension of appearances rather than with their intellectual comprehension. This follows the precedent of Plato for whom *aisthesis* (perception) and *theoria* are distinct. In Platonic thought, *theoria* as a mode of *episteme* takes as its object non-sensuous unchanging universal intelligibles while *aisthesis* and its connections with visible phenomena (*phainesthai*) approaches variable sensible particulars (the objects of *doxa*). Though Gadamer's conception of *theoria* shares with Plato the notion of a will-less mode of apprehending truth, his thesis that an experience of art enables a contemplative revelation of truth points to a connection between the sensible (aesthetics) and *theoria* which Plato ruled out. Plato holds that all making produces

only images which copy an original form. Only *theoria* can intuitively apprehend the nature of the latter. In stark contrast, however, Gadamer insists that images can be grasped as originals. This reveals that Gadamer is by no means merely reinvoking classical sources *per se* but rebuilding them to the end of attaining a more adequate understanding of our experience of art. Given the distinctions between modern theory and ancient *theoria*, does a hermeneutical notion of *theoria* afford us a more appropriate and more sympathetic account of the relationship between art theory and art practice?

Hermeneutical aesthetics as *theoria*

The philosophical suggestiveness of Gadamer's approach to *theoria* lies in its ability to articulate a notion of contemplative engagement which enables that which is in a work of art: 'to come forth' (*es kommt heraus*). *Theoria* achieves this by, first, creating a contemplative space in which the distinction between how a work appears and what it allows to appear becomes apparent and, second, by being a participatory activity engaged with the subject matter of a work of art, it activates and reactivates that subject matter. *Theoria* is essentially therefore a mode of practice itself. To those who would resist such a suggestion, the question is how does the *theoria* argument avoid being another theory of art?

Gadamer immediately stresses that *theoria* is itself a mode of practice. In 'Hermeneutics as a Practical Philosophy', he asserts: '*Theoria* itself is a practice'.[23] Many commentators would repudiate such a conjunction of terms. Michael Burnyeat contrasts the disinterested mode of inquiry which he identifies as *theoria* with the practical concerns of making.[24] Barnes equates *theoria* not with production and the transitory nature of materials but with the passive contemplation of that objectivity which is supposedly eternal truth.[25] Although Gadamer appears to oppose these Anglo-Saxon renditions of Aristotle, he would sympathise with Guthrie's reading:

> What is important about *theoria* is not that it is a withdrawal or is opposed to praxis for Aristotle argues that whereas on the one hand philosophy (or *theoria*) should be practised for no ulterior end, being the best and highest of all employments, containing its end-in-itself and to be pursued even if no ulterior benefit should follow, nevertheless on the other, it will prove the best of all guides *in practical matters too*. [emphasis added][26]

Gadamer's, however, is altogether a subtler argument.

Most commentators on Plato and Aristotle fall back onto a Greek psychology of the faculties: a perceptual or cognitive activity is defined in terms of the object of its attention be it a logical truth or a crafted object. Unlike Burnet and Barnes, Gadamer follows Oakeshott's suggestion that contemplation and craft are both modes of activity and, as such, *theoria* is not a method or set of *regulae* but a skill of participatory involvement. It is a way of being thoughtfully open to art. It is not a philosophy of art. In 'The Idea of the University', Gadamer connects *theoria* and skill. *Theoria* for the Greeks was a 'possible accomplishment', never fully realisable but always capable of being extended by an ever deepening immersion in the practice itself.[27] *Theoria* is not opposed to practice but embodies a highly accomplished practice. In the essay 'On the Primordiality of Science', Gadamer reflects: 'Theoretical knowledge is originally

not opposed to practical activity but (is) its highest intensification and perfection'.[28] *Theoria* does not entail another theory of art: as a practice, *theoria* cannot be grasped as a body of logical procedures but as an activity, a knowing how to go about things which, in this case, is a knowing how to discern and engage with the subject matter of an artwork. It is knowing how to respond to such a subject matter, a speaking with that subject matter rather than speaking at it. Oakeshott's description of *scientia* makes the essential point about *theoria* as practice:

> Scientia came to be understood, not as an array of marvellous discoveries, nor as a settled doctrine about the world, but as a universe of discourse, a way of imagining and moving about images, an activity, an inquiry not specified by its current achievements but by the manner in which it was conducted. And its voice was heard to be not . . . the didactic voice of an encyclopaedia but a conversable voice.[29]

Furthermore, this conversable activity is productive not in the sense that it produced objects but in the sense that it creates an interpretative space within which that which is in an artwork can be called forth. As Gadamer's *Hermeneutics as a Practical Philosophy* suggests, the 'theoretic stance only makes us reflectively aware of what is [already] performatively at play within the practical experience of understanding art'. Like all conversable activities, *theoria* is an activity 'begun without premonition of where it would lead but acquiring for itself in the course of the engagement a specific character and manner'.[30] Gadamer notes accordingly that 'the ability to act theoretically is defined by the fact that in attending to something one is able to forget one's purposes' (TM 124). Such a giving of oneself over to the object of one's contemplation is not a means to an aesthetic end but is the end itself (TM 454). *Theoria* is 'a never-ending process of learning' and does not culminate in knowledge in any fixed sense.[31] Oakeshott remarks: 'No pre-meditated achievement is pursued, no problem is solved'.[32] Neither does the practice of *theoria* have a specific end in sight for 'at whatever point contemplation is broken off, it is never complete' nor ever can be.[33]

These remarks indicate that *theoria* attempts to articulate an experiential disposition towards art and not another theory of art. What, however, of the problems posed by the strict classical differentiation between *theoria* and *aisthesis*? A hermeneutical aesthetics conceived as *theoria* does suppose that *theoria* and *aisthesis* are incompatible. If they were at odds with each other, our argument about the ability of *theoria* to address both the intellectual and sensual dimensions of art would collapse. Were art a vehicle of ideas alone, it would cease to be art and would become philosophy. If art is relegated to dealing only with the sensuous, it is deprived of significant content. However, any phenomenological defence of *theoria* such as Gadamer's must argue for a synthesis of *theoria* and *aisthesis*. Four points of arguments can be brought forward. First, defenders of Plato's strict dichotomy between the realms of ideas (*eidos*) and *aisthesis* tend to overlook his *Theatetus*. Waterfield argues that *aisthesis* can mean either sensation or perception, because 'the Greeks could not clearly distinguish between mere non-cognitive sensation and perception which is cognitive and involves recognition of what is perceived'.[34] The *Theatetus* does not permit the conclusion that *aisthesis* concerns sensation only. Second, it is clear that Gadamer wishes to appeal to Aristotle as a moderator of the strict Platonic dualism. In *Truth and Method* he remarks:

'Aristotle . . . showed that all *aisthesis* tends towards a universal . . . even if every sense has its own specific field and thus what is immediately given in it . . . is not universal' (TM 90). He notes that aesthetic vision is certainly not characterised by hurrying to relate what one sees to a universal, the known significance, but it is clear that the sense of such vision is dependent upon a relationship with a universal. This permits the weak conclusion that for Aristotle *aisthesis* tends towards *theoria*. Third, the phenomenological voice within Gadamer is quite unequivocal: 'pure seeing and pure hearing are dogmatic abstractions' for 'perception always includes meaning' (TM 92). Husserl and Heidegger suggest to him that we cannot discover a pure experience which does not have some general significance beyond itself. Once again, *aisthesis* inclines towards *theoria*. Fourth, additional support for the fusion of *aisthesis* and *theoria* comes from Wittgenstein's aspect-theory of perception which suggests that all perception is but the echo of a thought. When I hear a minor chord, I do not want to say that I receive certain stimuli and then recognise them as a minor chord. I hear the minor chord straight away or, as Mary Warnock puts it, my hearing is already modified by the concept.[35] Regarding Wittgenstein's *Philosophical Investigations* she remarks:

> How far can we separate thought from seeing, concept-using from sensing? And if we cannot separate them, how far must we allow not only that concept-using enters into perception, but also that the power of re-perception, of presenting to ourselves perceptual objects in their absence, also enters into concept using? Not separating these things entails both that we must think of perception as containing a thought-element, and, perhaps, that we must think of thinking as containing a perception-element.[36]

As these four positions suggest, *aisthesis* and *theoria* are not incompatible. A hermeneutical aesthetics can therefore apply to art that vital fusion of understanding and sensibility which Kant outlines in his *Critique of Pure Reason*: 'thoughts without content are empty, intuitions without concepts are blind'.[37] It is, therefore, just as necessary to make our concepts sensible, that is, to add the object to them in intuition, as to make our intuitions intelligible, that is to bring them under concepts. Aesthetics-as-*theoria* stands on this commitment to the possibility of cognitive and perceptual transfer. If concepts and ideas are not capable of infusing sensibility with intelligible sense and if sensibility is unable to mediate abstract concepts and render them perceptibly incarnate, then the ability of an artwork to address us would be severely impaired.

On several occasions throughout this chapter, a parallel between Gadamer's description of *theoria* as a freeing of oneself from one's purposes and Kant's account of aesthetic disinterestedness has not been very distant. The problem posed by this parallel is straightforward. If *theoria* possesses some of the same attributes as aesthetic disinterestedness, how can the aesthetics-as-*theoria* escape what Gadamer wishes to flee, namely a form of Kantian aesthetic consciousness which is disinterested in and uninvolved with artistic representation? Gadamer's description of *theoria* as lacking purpose and as an abandoning of subjective interest encourages the parallel. Yet Gadamer insists that *theoria* 'is no participationless establishing of some neutral state of affairs or [mere] observation . . . [but] . . . rather . . . a genuine sharing in an event, a real being present'.[38] Thus, whereas for Kant aesthetic objectivity is achieved by the

knowing subject suspending its cognitive interest in things and enjoying their formal properties in and for their own sake, for Gadamer, aesthetic objectivity begins not with the renunciation of subjectivity (for how could we ever renounce the linguistic and cultural horizons which shape our individual perspective?) but with those intensely personal experiences in which the world reveals itself to be other than what we expected it to be. An experience of art can force us to see that what we thought was the world was, indeed, only an aspect of it. Art can often reveal something quite contrary to our wanting and doing. Aesthetic revelation does not entail disinterestedness or methodological neutrality but demands an intense and selfless involvement in what one sees (TM 125). *Theoria* as aesthetic contemplation is the very antithesis of disinterested detachment. This is made plain in Gadamer's account of the connections between *theoria* as contemplation and *theoros* as spectator or witness:

> *Theoros* means someone who takes part in a delegation to a festival. (TM 124)

> The true being of the spectator, who belongs to the play of art, cannot be adequately understood in terms of subjectivity . . . [for] . . . being present has the character of being outside of oneself. (TM 126)

> In fact being outside oneself is the positive possibility of being wholly with something else. (TM 126)

> Self-forgetfulness is anything but a private condition for it arises fundamentally from devoting one's full attention to the matter at hand, it is the spectator's own positive accomplishment. (TM 126)[39]

If *theoria* is not to be characterised as disinterested detachment but intense involvement, in what is the aesthetic spectator absorbed?

The question, 'In what is the aesthetic spectator involved?' is partially misleading as it supposes that the act of participation is distinct from what one participates in. However, as Gadamer's powerful analogy with games and their ontology makes clear, spectating, playing, operating rules and using sporting equipment all fuse together to form the event which is the coming into being of the game. Now clearly, the act of aesthetic contemplation is not the artwork but it is an act which facilitates the 'working' of the artwork, an act of aesthetic midwifery which allows the work to 'work'.[40] *Theoria* as aesthetics is therefore an enabling act, a necessary but not sufficient condition of the art object coming into being as an affecting and effective work. Under no circumstances is it merely a subjective reaction to artwork and by no means does the artwork exist independently of and remain unaffected by such reactions. These observations give us an insight into two claims made above: that the practice of *theoria* is productive of a certain kind of space and that *theoria* is an engaged and engaging activity.

The Greek word *theoria* has become associated with the Latin word for contemplation which in its turn implies viewing attentively. Contemplation contains the root word temple which once meant an open space for observation or thought. If *theoria* as aesthetics involves the creation of a contemplative space, what is brought together within that space? The aspect theory of perception holds an answer to this question.

Both Heidegger and Wittgenstein defend the view that seeing and hearing is seeing and hearing 'as'. We do not see an object this way and then that. If we could, we

would be required to differentiate between the object and how we see it, which we cannot do. Gadamer holds to a variant of this distinction. He argues that the world does not exist apart from our interpretations of it but is constituted by the totality of our interpretations (TM 443–7). However, there is a distinction between an implicit and explicit account of aspect perception. Heidegger and Gadamer agree that all seeing is seeing 'as'. In unreflective consciousness, however, although what I see may be an aspect of an entity that transcends the aspect I see, I remain unaware of the more beyond what I see. In other words, unreflective consciousness can succumb to the heady illusion that things are as they appear. In reflective consciousness, we learn that things are always more than they appear in any one instance. Gadamer contends that all perception transcends itself and that what is seen as a particular is always a specific particularisation of an unseen totality of meaning. He never doubts that aesthetic contemplation activates or realises the potential for transcendence within a work. What an artwork addresses – its subject matter (*die Sache selbst*) – always transcends the particular way it is handled. The importance of *theoria* as aesthetic contemplation is that it creates a perceptual space in which the difference between how such a subject matter appears in an artwork and what is beyond its initial appearance in that work, begins itself to emerge. It is in this participatory space that an artwork can commence its endless work of unfolding its inexhaustible subject matter. If as Adorno aptly remarks, 'Works of art are set in motion by patient contemplation', artworks also set in motion the subject matters with which they deal.[41] *Theoria* as aesthetics suggests that the event of art takes place in the perceptual/cognitive space it is the task of contemplation to open. It is this which permits Gadamer to offer an ontological radicalisation of Aristotle's view of *theoria* as an unfolding.

The aesthetics-as-*theoria* argument suggests that in key respects the activity of *theoria* can bring an artwork into fuller fruition. How does *theoria* assist a work of art to become more than what it is? The doctrine of *die Sache selbst* governs the argument here and Ernst Cassirer offers a suitable avenue of approach. Cassirer remarks that:

> The history of philosophy shows us very clearly that the full determination of a concept is very rarely the work of that thinker who first introduced that concept . . . The full significance of that [concept] cannot be understood so long as it is still in its first implicit state. It becomes explicit in order to comprehend its true meaning.[42]

Gadamer holds to a variant of this thesis. The meaning of the ideas or subject matters which inform an artwork are always in excess of a painter's or writer's (authorial) understanding. Although we may find, as Kant observed, that we understand authors better than they understood themselves, we are not necessarily advantaged since the work will in time always become more than what we presently understand it to be. An artist's or commentator's interpretation may light up certain dimensions of a work's subject matter but by no means will they light up all and, furthermore, neither is one privileged in relation to the other. Both stand in a dialogical relation to each other. In summary, Gadamer holds, first, that all artworks are informed by a cluster of *Sachen* or horizons of meaning. Second, in so far as these horizons reach into others in unanticipated ways, all artworks emerge from and point back to an enormous virtuality of potential yet to be activated meanings. Third, when an artwork speaks it does so

because it lights up or actualises various of the circuitries of meaning which have informed it. Fourth, that which is beyond my horizon – the transcendent *Sache selbst* – manifests itself within my horizon when it appears within the artwork. In *Truth and Method*, this interplay or cross-fertilisation of concept (*Sache*) and intuition (the material horizon of the work) is called the speculative:

> To say what one means, on the one hand, to make oneself understood, means to hold what is said together with an infinity of what is not said in the unity of one meaning . . . Someone who speaks in this way . . . [is] able to express what is unsaid and is to be said. (TM 469)

Understanding what a work communicates involves discerning how that which is not initially seen or stated is never the less implied, rendered visible or brought to presence within the work. Thus, a virtual meaning becomes actualised by an interpretation. It is this realisation of what lay within the virtual which allows an artwork to be more what it is. Interpretative involvement with an artwork (*theoria*) is a means by which that which informs a work – its subject matter – achieves a greater being.

The foregoing remarks rest upon an extraordinary connection between *theoria* and the speculative. To speculate can mean to observe (as in spectator) and also to reflect but in the sense of mirroring the object of one's reflections. Gadamer suggests in the manner of Hegel that speculative thinking is that mode of thought which lights up or actualises the substantive horizons of meaning which inform it (TM 467–70). The speculative moment in a thought or work is thus 'the shining back of what is showing itself' in that moment,[43] a disclosure of the virtuality of meaning which surpasses at any moment what has been said or shown.[44] The theoretic contemplation of art opens up a given experience of art and reveals what speculatively informs it. Furthermore, because it must approach the formative subject matter of an artwork from a contemporary perspective, the meditative act can reactivate and extend the subject matter in unexpected ways. To extend Gadamer's metaphor of *theoria* as spectatorship in a religious festival, for the gods to reappear the participants must make sacrifice and bring offerings. In order for art to speak, the contemplative theoretician (the aesthetician) has not only to sacrifice his or her (private) everyday concerns but also to offer up their immediate outlooks and horizons for sacrifice. It is, after all, only when these horizons mesh or cross-fertilise with the virtuality of meaning within an artwork that the artwork can address us. This is a chancy business. Offering up one's horizons to the deities of art, risks getting them back in a form one might not suspect. Aesthetics-as-*theoria* is far from passive. It is a participatory activity which allows an artwork to continually renew itself. *Theoria* is not the imitative unfolding of a complete and perfect divine creation (Aristotle) but is both a means to and the occasion of art's perpetual and inexhaustible unfolding. The capacity of *theoria* understood as interpretative engagement able to actualise aspects of an artwork's subject matter brings us to the core of our argument. How does *theoria* bring to realisation the subject matters within a work?

In Platonic aesthetics, that which art ought to reflect upon – the *eidos* or Ideas – exist independently of and are unaffected by the nature of artistic appearance. Art produces copies of the *eidos* allegedly corrupting any intellectual apprehension of them. *Die Sachen* are indeed like the *eidos* in that they transcend any particular

instantiation of themselves in an individual reading or tradition. They are unlike Platonic ideas in that they are historically constituted. They emerge into being (*Werden zum Sein*) yet transcend any one epoch. *Die Sachen* become increasingly realised in and through history. The key point is that they are not fixed objects which art corrupts in the copying of them but objects which achieve a greater reality because of art's mediation. By allowing that which art deals with to be activated and come into a fuller presence, aesthetics-as-*theoria* can be seen not as it would be by Aristotle and Plato (as a contemplation of a fixed order of being) but as a means to actualise that which is inherent within a subject matter. Both art practice and *theoria* activate the potentialities for meaning within the reality. Oakeshott puts the point another way:

> What Plato described as contemplation is in fact aesthetic experience but that he misdescribed it and attributed to it a character and a supremacy which it is unable to sustain. By understanding 'poetry' as a craft, and craft as an activity of imitating ideal models, he followed a false scent which led him to the unnecessary hypothesis of a non-image-making, 'wordless' experience, namely, that of beholding the ideal models to be copied. Nevertheless, the platonic contemplation, if it were admitted to be image-making, would direct our attention to an activity of image-making which would not be 'copying' and whose images would not be re-presentation.[45]

Is this not congruent with Gadamer's view that although the subject matter of an image may transcend it, that which is more than the image can still be invoked by that image and find a presence within it? The artwork becomes the simultaneous coming into picture of that which transcends it and the location whereby that transcendent finds its pictorial presence. *Theoria* as interpretative involvement neither asks us to relive or to reconstruct works but to respond, to participate in and thereby to extend the realities with which the work deals. The critical move in the argument is as follows. As soon as it is allowed that, first, image making and the contemplative summoning of images do not involve the mimetic copying of something separate and independent from those activities, and second, that image making and the contemplation of those images are not re-presentations of transcendent thematics but processes which activate such thematics, the dye is cast. It will follow that, third, *theoria* entails neither the contemplation of fixed *eidos* (Plato) nor a mental re-enactment of the order of God's creation (Aristotle) but an active participation in bringing forth what is latent within art and its actuality. Whereas Aristotelian meditation is the activity of following the order of that which has been brought forth, aesthetics-as-*theoria* establishes the very occasion of that bringing forth. In Gadamer's words: 'imitation and representation are not merely repetition, a copy, . . . but a "bringing forth," they imply a spectator as well' (TM 115).

Theoria and art practice: a programme for dialogical involvement

Our defence of *theoria* claims that its task is to bring into reflection the subject matter of an artwork and to assist in its realisation. If *theoria* entails a dialogical engagement

with an artwork's subject matter and if that engagement can allow that subject matter to become more, then, does not our understanding of that artwork and what it addresses change and, what is more, change unpredictably as a result of *theoria*'s involvement? Whereas for conventional theory the inability to confirm a hypothesis might count as a failure, for *theoria* the unexpected alteration of expectation regarding the scope and ambition of an artwork is precisely what is to be hoped for. As a conclusion, we offer a summative outline of how *theoria* and art practice can be effectively related and trust that it will encourage further dialogue.

1 *Theoria* is not exclusively concerned with the material element of a work and neither is it solely preoccupied with a work's conceptual dimensions. It focuses on what happens to us when an artwork addresses us. The occasion of this address constitutes the experience of art. *Theoria* seeks to articulate the nature of this experience and adopts it as the primary point of departure and return of its reflections. The elucidation of the art object and its subject matter is the primary focus of *theoria*.

2 *Theoria* insists that knowledge of art must remain primarily experiential, acquired by acquaintance and participation rather than by theoretical abstraction. *Theoria* devotes itself to articulating the particular syntheses of idea and sense embodied in an artwork.

3 *Theoria* has a clear philosophical foundation but does not embody a philosophy. Though it must be aware of formal grammars of ideas, *theoria*'s major concern is with how ideas are manifested in and by artworks, and with how practical matters of expression can alter an understanding of their meaning.

4 *Theoria* recognises both the transcendental and epiphanic dimensions of the experience of art. In so far as artworks are singular renditions of the subject matters they invoke, works simultaneously point beyond themselves and provide a site for that which is beyond them to come forth.

5 *Theoria* perceives the interpretation and the realisation of a subject matter to be mutually dependent. An artist's view of a subject matter is informed tradition. Reinterpretations of a subject matter uphold and renew the tradition which enables the initial expression. The being of a subject matter is neither independent of nor unaffected by interpretations of it. *Theoria* understood as a dialogical involvement with a work's subject is fundamental to the actualisation and transmission of artworks and their content.

6 As a mode of dialogical involvement, *theoria* increases the being of that with which art deals (*die Sachen*). *Theoria* is neither opposed to nor superior to practice: both are interrelated means of bring an artwork's content to fruition.

7 Cultural throwness or placement is a condition of *theoria*. Any experience of art as saying something presupposes the recognition of appropriate languages of subject matters and style. Such placement has a transcendental and epiphanic dimension. The transcendental element concerns the truth that whether we are aware of it or not, our initial cultural and linguistic placement is inextricably linked by etymology and philological transmission to other languages and practices which transcend the temporal limits of our immediate location. Our initial placement is never implicitly closed. As a form of hermeneutic inquiry, *theoria* endeavours to open art practice to its inherent connectedness with other horizons.

8 Though an artwork might appear well finished, *theoria* maintains that it can never be complete. The transcendent nature of its subject matter implies that a work cannot exhaust or totalise its thematic just as no interpretation can be definitive. *Theoria* knows that just as there is no final word, there is always something more to be said about and by an artwork.

9 *Theoria* does not promote a contemplative as opposed to a practical orientation towards art. To the contrary, it recognises an essential reciprocity between thinking and making. The material dimension of a work must be grasped as a means to the conveyance of meaning. The ideational element of art is that which imports sense into the material dimension. Discussion of practical issues should be governed by what works seek to address and discussion of the subject matter should centre upon how the latter is manifested in a work and how that work affects our apprehension of it.

10 The necessary, unavoidable, and essentially creative tension between thinking and making defines the reflective space which *theoria* opens. It is a space in which difference between subject matter and rendition is made manifest. It reveals the difference between what a work is about (its subject matter) and what a work says (its interpretation of a subject matter). This space is dialogical. It allows what is at stake in the difference between what an artwork addresses and how it addresses its subject matter to be reflectively articulated.

11 The proper co-inherence of theory and practice envisaged by *theoria* becomes apparent whenever questions such as the following are raised. Given the difference between the transcendental import of a subject matter and an artist's decision (or not) to render it from a certain perspective, what intention or circumstance led the artist to this rather than that rendition? Given the chosen subject matter, what is a work's specific contribution to it? Why in the context of such a subject matter does that work merit attention rather than another? If a work succeeds in making a fresh contribution to a subject matter, what are the material devices, visual vocabularies or rhetorics which enable it to do so? If a work fails to adequately address its subject matter, what changes in form, expressive rhetoric or mode of presentation might rectify matters?

12 *Theoria* as dialogical involvement with an artwork's subject matter entails nothing other than a deepening of aesthetic experience itself. *Theoria* has as its fulfilment not a definitive knowledge of art but an openness to artistic experience that can only be encouraged by such experience itself. Only by preserving and risking such openness can the ever imminent potentials for self-transcendence and transformation available to art practice and its articulation within *theoria* be actualised.

Acknowledgements

This chapter is based upon an unpublished paper 'Theoros, Ästhetik, und Hermeneutik' presented at the Heidelberg Hermeneutics Seminar, *Kunst als Aussage, das philosophisches Seminar, Heidelberg Universität*, 8 July 1994. Short sections of this chapter are reworkings of extracts taken from my article, Davey, N. (1995) 'Theoria and Art Education', *Annales d'Esthetique* 34: 205–21 (Athens). I have published extensively on the relationship of hermeneutics and art.

 The ideas articulated in this chapter were themselves born from my practical involvement as an aesthetician in the teaching of art practice at the University of Wales Institute Cardiff. The original paper evolved as a formal philosophical defence of ideas concerning the hermeneutical

character of both aesthetics and *theoria*, ideas which evolved into the Art and Aesthetics BA Programme in Cardiff (1994) and then, at the University of Dundee, into both the Art, Philosophy and Contemporary Practices BA (2002) and the Art and Aesthetics MPhil (2004) at the University of Dundee. The initial insights which the paper afforded also gave rise to the Theoros Project, an interdisciplinary research programme into the relationship between art practice and philosophy which between 1994 and 2000 held five conferences. The papers for the last two *Theoros* conferences will be published as Mey, Kerstin (ed.) (2005) *Art in the Making: Aesthetics, Historicity and Practice*. London: Peter Lang. They will also appear in a forthcoming issue of the *Journal of Visual Art Practice*.

Notes

1 Adorno, Theodor (1984) *Aesthetic Theory*. London: Routledge and Kegan Paul, p. 118.
2 TM is the abbreviated reference for Gadamer (1989) *Truth and Method*. Trans. J. Weinsheimer and D. G. Marshall. London: Sheed and Ward. Whenever the text is cited in this chapter, the initials TM will be followed by the appropriate page number(s).
3 See my chapter Davey, N. (1999) 'The Hermeneutics of Seeing', in Ian Heywood and Barry Sandywell (eds) *Interpreting Visual Culture: Explorations in the Hermeneutics of the Visual*. London: Routledge, pp. 3–30.
4 Nietzsche, Friedrich (1980) *Sämtliche Werke, Kritische Studienausgabe*. Berlin: Gruyter, Volume 3, s. 517 (FW 260).
5 Kant, Immanuel (1970) *Critique of Pure Reason*. Trans. N. K. Smith. London: Macmillan, (A51, B75) p. 93.
6 Feyerabend, P. (1987) *Farewell to Reason*. London: Verso, p. 68.
7 Berlin, I. (1876) *Vico and Herde*. London: Chatto and Windus, p. 15.
8 See Davey, N. (1993) 'Hermeneutics, Language and Science: Gadamer's Distinction between Discursive and Propositional Language', *Journal of the British Society for Phenomenology* 24(3): 250–64.
9 Dufrenne, M. (1973 [1953]) *The Phenomenology of Aesthetic Experience*. Trans. E. S. Casey. Evanston, IL: Northwestern University Press, pp. 313–14.
10 Gadamer certainly does not confuse perceptual with intelligible objects. Rather he appeals to Aristotle who

> showed that all *aisthesis* tends towards a universal, even if every sense has its own specific field and thus what is immediately given in it, is not universal. But the specific sensory perception of something as such is an abstraction. The fact is that we see sensory particulars in relation to something universal. (TM 90)

> Even perception conceived as an adequate response to a stimulus would never be a mere mirroring of what is there. For it would always remain an understanding of something as something. All understanding-as is an articulation of what is there, in that it looks-away-from, looks-at, sees-together-as. (TM 90–1)

11 Gadamer, H-G. (1992) in D. Misgeld and Graeme Nicholson (eds) *On Education, Poetry, and History: Applied Hermeneutics*. Albany, NY: SUNY Press, p. 24 (transcript of interviews with Gadamer).
12 For Nietzsche's argument that knowledge is the will to power, see Nietzsche, F. (1968) *The Will to Power*. Trans. W. Kaufmann. London: Weidenfeld and Nicolson, section 643.
13 Gadamer, H-G. (1990) 'Science and Philosophy', in H-G. Gadamer, *Reason in the Age of Science*. Cambridge, MA and London: MIT Press, pp. 17–18.
14 Gadamer, H-G. (1992) 'The Idea of the University', in Misgeld and Nicholson (1992), p. 56.
15 Gadamer, 'Science and Philosophy', in *Reason in the Age of Science*, pp. 17–18.
16 Ibid.
17 Ibid.
18 Oakeshott, M. (1990) *On Human Conduct*. Oxford: Clarendon Press, p. 3. Oakeshott's use of the term 'going-on' may be an ironic reference to Wittgenstein's notion of knowing how

to 'go on' within a language game but it also echoes Gadamer's idea of the on-going nature of conversation which though never conclusive nevertheless continually adds to our understanding of a subject matter. Oakeshott's deployment of going-on and its relationship to what is conversable emphasises his view that a going-on is responsive by nature, an individual intervention into an 'on-going' conversation.

19 Heidegger, M. (1967) *Being and Time*. Oxford: Blackwell, pp. 98–9.
20 Ibid. p. 406.
21 Aristotle (1976) *Ethics*. Trans. J. A. K. Thomson. London: Penguin, p. 307.
22 Joachim, H. (ed.) (1951) *Aristotle: The Nicomachean Ethics*. Oxford: Clarendon Press, pp. 293f.
23 Gadamer, H-G. (1990) 'Hermeneutics as Practical Philosophy', in *Reason in the Age of Science*, p. 90.
24 For Michael Burnyeat's remarks, see Guthrie, W. K. C. (1981) *History of Western Philosophers*. London: Cambridge University Press, pp. 396f.
25 Ibid.
26 Guthrie (1981) p. 77.
27 Gadamer, 'The Idea of the University', p. 56.
28 Gadamer, H-G. (1992) 'On the Primordiality of Science', in Misgeld and Nicholson (1992), p. 19.
29 Oakeshott, M. (1981) 'The Voice of Poetry in the Conversation of Mankind', in M. Oakeshott, *Rationalism in Politics and Other Essays*. London: Methuen, p. 213.
30 Ibid. p. 200.
31 Gadamer, 'The Idea of the University', p. 56.
32 Oakeshott, 'The Voice of Poetry in the Conversation of Mankind', p. 221.
33 Ibid. p. 222.
34 See R. A. H. Waterfield's essay in Plato (1987) *Theaetetus*. Trans. R. A. H. Waterfield. London: Penguin, pp. 142–3.
35 Warnock, M. (1976) *Imagination*. London: Faber and Faber, p. 191.
36 Ibid. p. 192.
37 Kant (1970), p. 93 (A 52, B 76).
38 Gadamer, 'Science and Philosophy', in *Reason in the Age of Science*. Cambridge, MA and London: MIT Press, pp. 17–18.
39 Notice that the references to *theoria* and *theoros* are to an accomplishment, that is to a skilled practice and not to the exercise of mere theoretical dexterity.
40 It would appear that Gadamer is committed to an aesthetic version of Berkeleyean idealism for does his argument not suggest that an artwork cannot work as a work if it is not being perceived, or if accounts or records of such perceptions are not being perceived?
41 Adorno (1984), p. 118.
42 Cassirer, E. (1980) *The Philosophy of Symbolic Forms*, Volume 1, *Language*. New Haven, CT and London: Yale University Press (see Hendel's introductory essay, p. 1).
43 Gadamer, H-G. (1976) *Hegel's Dialectic: Five Hermeneutical Studies*. Trans. P. Christopher Smith. New Haven, CT and London: Yale University Press, p. 99.
44 Ibid. p. 115.
45 Oakeshott, 'The Voice of Poetry in the Conversation of Mankind', p. 224.

Chapter 2

Interrupting the artist: theory, practice and topology in Sartre's aesthetics

Clive Cazeaux

Introduction

The relation between theory and practice is one of the most actively debated subjects in contemporary art and design research and education. That this is the case should not surprise us since the subject opens onto fundamental questions regarding values in education, definitions of subject areas, and concepts of knowledge, for example, the polarisation of academic and artistic ability, the status of art and design as forms of knowledge, and philosophical rumination on the relation between thought and sensibility. One form of the theory–practice debate draws on all three areas and manages to reduce them to a single opposition: theory is done with *words* whereas practice is done with stuff, physical media, that is, paint, stone, film, video, sound, etc. As well as distinguishing activities according to their material (or immaterial) elements, the word–stuff opposition also suggests that different kinds of ability are involved. In relation to educational categories, there are those students who are good with their hands (or eyes or ears) in contrast to those who succeed in grasping the abstract, intellectual operations performed in mathematics and the sciences. Furthermore, different kinds of experience are implied. With art practice, one is encountering the stuff of the world, the stuff of life itself, whereas words are echoes or vestiges of experience, dry, crackly leaves that have long since been drained of the sap's vital force. The thinking here is that words, because of their generality, because they have to contain an indefinite number of similar situations, cannot possibly exhibit the vivacity or immediacy of the individual thing or moment. Schopenhauer makes this observation in *The World as Will and Representation*: 'Books do not take the place of experience', he writes, 'because concepts always remain universal, and do not reach down to the particular; yet it is precisely the particular that has to be dealt with in life'.[1]

These concerns are particularly pressing for those engaged in art and design research where one not only has to determine what constitutes a contribution to knowledge in the context of practice but also has to clarify what kind of theoretical framework is appropriate to the practice in question and, in addition, how the two should interact. Much of the debate around what qualifies as research for a PhD in art or design, I suggest, is devoted to grappling with the question of how the immediacies of visual practice should stand in relation to the generalities of the theoretical in order for practice to be able to comply with the requirements set for verbal, objective knowledge, as demonstrated, for example, by a university's PhD regulations. Inevitably, these discussions look for ways in which the visual can borrow or import some aspects from the

conceptual, such as the introduction of research methodologies from other subject areas, the requirement of a substantial written component and the prediction of an outcome.

The danger of the dry leaf perspective on verbal description is that it limits the scope of the interaction which can occur between theory and practice, threatening to make the relation either an antagonistic one or one where the theory is regarded as a mere appendage attached after the fact, after the real practice, action or contribution to knowledge has taken place. For the dry leaf perspective is just that: a perspective, one way of understanding what words and experiences are. In this chapter, I outline and support an alternative view, one where words and the flow or shape of experience are shown to be mutual aspects of the fundamental relations which root the human self in the world. This view is based on Sartre's existentialist philosophy. Present in Sartre's existentialism, I argue, is a topological theory of action, that is to say, a theory which emphasises the way actions shape, sculpt and, generally, give form to experience, where the action can be anything from a physical act (something one would normally associate with the word action) to producing a description of an experience (something one perhaps would not normally associate with the word). On this account, theory and practice are still recognised as distinct activities and writing and theory are still seen as interruptions in the flow of an artist's practice. However, what is different, I maintain, is that these interruptions, from a Sartrean perspective, can be understood (a) as contributions to the materiality of the artist's practice and (b) as steps towards the location of that practice as a form of knowledge.

Sartre's existentialism

Sartre's existentialism radically rethinks the nature of the self and the self's relation to the world. Whereas Platonic and Cartesian epistemologies assert that human beings have their innermost nature, including their moral being, determined in advance of experience by metaphysical essences (with Plato) or pure rationality (with Descartes), existentialism declares that the individual constructs themselves through action an abiding, determinative moral agency. Sartre rejects outright the thesis that we are defined and motivated by a priori concepts or essences: 'the act is everything. Behind the act there is neither potency nor "hexis" nor virtue'.[2] Rather, it is only through active transformation of or engagement with the world, Sartre avows, that people and things acquire meanings. In this respect, Sartre can be regarded as developing Nietzsche's nihilistic rejection of all previous conceptions or foundations of truth and identity. We believe that there are essences underlying and motivating every kind of thing, including the human being, Nietzsche argues, when in fact the notion of an essence or any state of being in itself is purely an anthropomorphic fiction:

> we believe that we know something about the things themselves when we speak of trees, colours, snow, and flowers [and, by extension, selves]; and yet we possess nothing but metaphors for things – metaphors which correspond in no way to the original entities.[3]

If all previous conceptions of truth, i.e. those which assign truth a metaphysical or wholly rational origin, are rejected, then one is left with the situation where truth has to be made.

It is the role which action plays in Sartre's philosophy and, more especially, the topological terms in which action is set, that makes his existentialism relevant to our concerns. For, in seeking to show how the self is made through action, a set of structural relations between self and world is invoked which promotes equality between words and phenomena as shapers of experience. Sartre studies how an action makes a difference to a situation in such a way that that difference becomes an object of attention, something which represents a moment of distinction in what would otherwise be a continuous, undifferentiated flow of experience. This view of action is topological in the sense that acting, carrying out a gesture, making an impression on the world are events which rise above or drop below the flat line of inactivity. It is in terms of these ripples, bumps, crevices, and impressions, Sartre argues, that we must begin to construct our notions of meaning and personal identity.

I shall go into some detail here as Sartre's reconfiguration of the self is central to the point I want to make in relation to art theory and practice. The subject, after Nietzsche, rather than being a distinct, self-contained entity, is shown to be something so intimately intertwined with the world that any clear-cut division is problematic; this is a self that is very much in the world. Sartre's response to this is to theorise the self as a gap in the world. What is unique to consciousness, Sartre argues, is that it is the location of the perception of absence: it is only in consciousness that the impression of something not being the case can take place, for example, expecting to find thirty pounds in my wallet but finding only twenty, or waiting in a café for a friend who never turns up. As he states:

> Every question in essence posits the possibility of a negative reply. In a question we question a being about its being or its way of being. This way of being or this being is veiled; there always remains the possibility that it may unveil itself as a Nothingness. But from the very fact that we presume that an Existent can always be revealed as *nothing*, every question supposes that we realize a nihilating withdrawal in relation to the given, which becomes a simple presentation, fluctuating between being and Nothingness.
>
> It is essential therefore that the questioner have the permanent possibility of dissociating himself from the causal series which constitutes being and which can produce only being.[4]

It is the possibility of negation which disengages consciousness from the brute causal order of the world: 'this cleavage is precisely nothingness'.[5] A cleavage divides the present of consciousness from all its past: 'not as a phenomenon which it experiences, [but] rather as a structure of consciousness which it is'.[6] This rupture in the causal order of the world is the structure of consciousness for Sartre. The perception of absence or negation creates a gap in experience, and it is because of this rupture or interval that the subject is able to become aware of itself standing before a world. It also means that there can never be a moment when consciousness is identical with an abiding, substantive self which can influence or determine its actions; rather, consciousness exists in the world only as a gap or a nothingness between things.

This would seem to paint a bleak picture of our situation, but this is only because our conventional notion of subjectivity is being repudiated here. By defining subjectivity as a nothingness, Sartre is making the point that the self is constructed through its

engagement with the world, by dealing with whatever is brought before it as a bump or a rupture in the field of experience. In this regard, Sartre's writing might be described as a philosophy of confrontation, not in an antagonistic or hostile sense but in the sense that we are made to reflect upon how we might face up to a situation and all its implications. The full force of the confrontation perhaps becomes apparent only when it is recognised that this reflection has to occur in the absence of the concept of a true self, the concept which might otherwise reject certain possibilities on the grounds that we are a particular kind of person, inclined to act in certain ways.

What this topology of action brings to the theory–practice debate is a way of thinking which allows art theory and art practice to stand alongside each other as mutually supportive interventions in the development of an artwork. On this account, both theory and practice can be understood as gestures which make a difference, make something stand out, rise above or drop below an otherwise undifferentiated field of experience. While we are probably accustomed to thinking of art practice as a form of action, it needs to be borne in mind that activity, i.e. activity in general, is being viewed here from a particular, existentialist perspective. With Sartre, we are theorising the action as an event, a moment, a rupture, something which makes a difference where there was previously no difference at all, and which thereby allows the subject to orient itself in terms of the objects it encounters. Approaching the art-making process in these terms requires us to think about the way in which the work develops as a series of ruptures or saliencies, for example, the effect of a brushstroke on an area of canvas, the prominence of a particular object in the viewfinder, the accentuation of certain qualities on a ceramic surface, the masking of those elements in a location which might interfere with a site-specific work.

In actual fact, this point is not terribly new. It is simply a means of talking about the focus of the artist's attention, but with the recognition that focus belongs to our family of topological terms denoting the concentration of attention, the bringing-together to a point. However, the location of focus is particularly important for the artist-as-researcher, for enrolment on a programme of research inevitably involves the statement of aims, objectives, and methodologies, i.e. a description of the particular aspects of art which are to be the subject of research, and an account of why these aspects are being focused upon.

Sartre's theory of description

The greater amount of work to be done, it would seem, lies with the question of how the theorisation of art is accommodated within Sartre's topology of action, especially when writing about art is, in comparison to making the stuff, such a sedate occupation. Also, the form of prose itself conceals the activity of writing: a linear flow of sentences and paragraphs, arguments and conclusions, cannot reflect or display the mental effort and torment which wrought them into being. However, as I indicate above, when action is discussed in a Sartrean context, we cannot simply fall back on the conventional notion of action as physical bodies moving in space. Instead, we are now considering it as the creation of a rupture or cleavage in the flow of experience.

Writing holds a position of special significance in Sartre's philosophy precisely because it is one of the principal ways of rupturing or interrupting experience. And it is able to do this for the same reason that many people (including Schopenhauer) see

it as being removed from life: writing involves the application of concepts to experience, of generalities to particularities. The distinction between generality and particularity is crucial, Sartre thinks, because it introduces a gap between consciousness and experience. He explores this dimension of writing at length in his novel *Nausea*. The book is a study of the non-identity between words and experience. The central character, Antoine Roquentin, is living in Bouville and trying to write a biography of the late-eighteenth-century political activist Monsieur de Rollebon. However, he gives up the project when the minutiae of his own life encroach on him with ever increasing detail and sublimity, and convince him of the futility of trying to represent experience. The written word, it seems to Roquentin, will always distance you from experience, will never allow you to be identical with the present. The novel's first page outlines the diarist's dilemma:

> The best thing would be to write down everything that happens from day to day. To keep a diary in order to understand. To neglect no nuances or little details, even if they seem unimportant, and above all to classify them. I must say how I see this table, the street, people, my packet of tobacco, since <u>these</u> are the things which have changed. I must fix the exact extent and nature of this change.
>
> For example, there is a cardboard box which contains my bottle of ink. I ought to try to say how I saw it <u>before</u> and how I —— it now. Well, it's a parallelepiped rectangle standing out against – that's silly, there's nothing I can say about it. That's what I must avoid: I mustn't put strangeness where there's nothing. I think that is the danger of keeping a diary: you exaggerate everything, you are on the look-out, and you continually search the truth. On the other hand, it is certain that from one moment to the next – and precisely in connexion with this box or any other object – I may recapture this impression of the day before yesterday. I must always be prepared, or else it might slip through my fingers again. I must never —— anything but note down carefully and in the greatest detail everything that happens.[7]

The ellipses – 'how I —— it now' and 'I must never —— anything' – are acknowledged in the text with the respective footnotes: 'A word is missing here' and 'A word has been crossed out here (possibly "force" or "forge"), and another word has been written above it which is illegible'. By leaving these gaps, Sartre makes it apparent from the start that language introduces a specificity which is not present in experience. The crossings-out are important: 'force', an exertion of will or an impulse to change the state or position of an object; 'forge', on the one hand, to give shape to what was originally shapeless or, on the other, to copy, to fashion something which is inauthentic.

The task of verbal description, for Sartre, reflects the cognitive relationship between being-for-itself (*être-pour-soi*, human being) and being-in-itself (*être-en-soi*, the being of objects). Objects, Sartre asserts, exist in themselves; they belong to the in-itself. The being of objects is 'full positivity': 'an immanence which cannot realize itself, an affirmation which cannot affirm itself, an activity which cannot act, because it is glued to itself'.[8] This makes objects opaque for us. Objects resist us in the world, assert a counter-pressure against perception, because they never disclose themselves all at once. On this account, it is precisely because things are to some degree closed to us that we have consciousness at all; consciousness is the partial, sequential disclosedness of

things. Experience is successive: a continuum in which aspects appear and disappear, in which appearances are revealed and then withdrawn. Impressions move on: the object is not present to me now in the exact same way it was a moment ago. If all impressions were present in one instance, Sartre comments, the objective 'would dissolve in the subjective'.[9] However, just as the appearance and disappearance of phenomena enable the perception of absence, so the application of general categories to particular experience puts experience at a distance, creates a phenomenological opening between writer and experience. As soon as Roquentin describes the bark of the tree-root as 'black', he feels 'the word subside, empty itself of its meaning with an extraordinary speed. Black? The root was not black, it was not the black there was on that piece of wood – it was . . . something else'.[10] The perception that the generality of a word cannot capture the particularity of an object, that something is missing, thus appears, from Sartre's position, as one of the crevices in our topology of action and, therefore, as an episode that is vital to the construction of subjectivity and objectivity.

Because of the gap between universal and particular, description alters the situation. As Sartre observes, writing gives order and significance to something which is 'not yet there':

> When you are living, nothing happens. The settings change, people come in and go out, that's all. There are never any beginnings. Days are tacked on without rhyme or reason, it is an endless, monotonous addition . . . But when you tell about life, everything changes; only it's a change nobody notices: the proof of that is that people talk about true stories. As if there could possibly be such things as true stories; events take place one way and we recount them the opposite way. You appear to begin at the beginning: 'It was a fine autumn evening in 1922. I was a solicitor's clerk at Marommes.' And in fact you have begun at the end.[11]

Sartre is building on Heidegger here, in particular, the distinction he draws in *Being and Time* between 'readiness-to-hand' (*Zuhandenheit*) and 'presence-at-hand' (*Vorhandenheit*).[12] The former denotes the state of busy, immersed occupation in which we deal with everyday activities, where objects are simply zones of interaction diffused into the greater backdrop of our routine intentions. For example, you walk across the zebra-crossing on your way to work but are not aware of the exact number of stripes. In contrast, 'presence-at-hand' refers to occasions when, for whatever reason, we are stopped in our tracks and what was formerly the mere furniture of existence stands out as a thing, against a background, whose nature suddenly becomes of detached perceptual or conceptual interest. This, Sartre observes, is what writing does. Imposing a subject-predicate structure on otherwise diffuse interaction breaks (in Heidegger's idiom) the 'referential totality' of equipment and elevates the thing so that it 'announces itself afresh'.[13]

A comment often made against the description of experience is that it introduces a specificity which was not present in the original experience; grammatical structure and conceptual boundaries impose a level of organisation which is not in keeping with the lived moment. The sentence is a specific arrangement of two basic elements, a subject and a predicate, e.g. the sky is blue, in the face of a world that is otherwise indifferent

and multifarious. From all that could be said at that moment, one selection, one slice across phenomena is made: the sky is blue. What had the character of a unique and particular experience is reduced or broken down into a set of general categories. In some sense, conceptualisation does shoe-horn experience into categories which, in virtue of their generality, alter the shape of the experience, but it is wrong to be afraid of the metaphors of resistance and deformation which are implicit here. Deformation is value-laden, and easily interpreted as an act of violence against experience by the concept. However, this sense arises solely because we have the misplaced ideal of a concept that should be identical to its object, that should fit or contain it perfectly. On the contrary, I assert, the sense of resistance which accompanies conceptualisation should be embraced since it is precisely this resculpting of experience which, according to Sartre, grants language its active, salience-creating capacity.

Nausea can be regarded as the diary of someone coming to terms with the realisation that writing does not capture experience but, instead, disrupts experience, announces the existence of things, gives experience shape and form. Towards the end of the novel, Roquentin realises that the complete description of experience – when the word captures or contains the thing – is an impossibility and it is the undecidability of description which is 'the key to [his] Existence, the key to [his] Nausea'.[14] How should or could he describe the tree-root: 'snake or claw or root or vulture's talon', 'a suction-pump', its 'hard, compact sea-lion skin', its 'oily, horny, stubborn look'; 'knotty, inert, *nameless*'?[15] Similarly, when he looks at his hand spread out on the table, it seems to become first a 'crab', showing its 'under-belly', then a 'fish'; his fingers become 'paws', then 'claws'.[16]

Topology, theory and practice

What is on offer from Sartre then is a new way of understanding the relationship between concepts and experience. Instead of the conventional model of concept and experience being mutually exclusive terms where the former is held to contain or reduce the latter, the concept is presented by Sartre as a rupture or an interruption in experience, the consequence of which is that an aspect of reality is raised up before the individual as an object, as something which helps to define the subjectivity of the individual. This theory of language, and the existentialism of which it is a part, can be very useful in the context of creative practice research, I aver, on two accounts. First, rather than being regarded as separate and unrelated activities, theory and practice, from Sartre's perspective, become parallel or congruent processes on account of the fact that they both create salience or assign prominence, that is to say, they are both processes whereby new objects of attention are brought before the viewer; it is just that the one does it through the application of words, while the other does it through the manipulation of art media.

Second, Sartre's theory of description, I maintain, can inform our understanding of the way in which theory and practice interact with one another. I can best develop this claim by anticipating an objection to my argument as it stands so far. It could be objected that I am moving from talk about description to talk about theory, as if the two were identical, when of course they are not. The theoretical component in creative practice research is much more than simply the description of the work carried out as part of that research. However, the description of an artwork is vital to the

relationship between the studio practice which creates the work and the theoretical context in which that production takes place. This is because a work of art is always a work under interpretation, is always a work under aesthetic judgement.

Aesthetic judgement here appears in contradistinction to empirical judgement. To describe a work of art purely in terms of empirical judgements would be to list all those qualities about the work that are verifiable through observation and measurement, which are principally the materials used and the work's physical dimensions. While decisions about these are undeniably important for the artist-researcher, there is the question of how empirical qualities can have or acquire the significance which might make them subjects of theoretical inquiry, for empirical qualities themselves, on their own, are not the source of the meaning or significance of an artwork. Rather, this comes from the aesthetic judgements which are made about the work. For example, the size of a large-scale painting is significant not because its dimensions happen to be, say, 400 cm × 300 cm but because it has a particular aesthetic impact on the viewer, perhaps in terms of the perception of space or the human form or in relation to other large-scale media, such as advertising or film.[17] By aesthetic judgement, I don't just mean purely subjective statements of taste but also intend the term to cover all the interpretations and conceptual associations which are attached to the work, for example, the assessment of composition, the feeling or meaning evoked by the handling of form, and the way in which our perception of an object is defamiliarised by the work. My justification for this and, in fact, the basis of my approach in this paragraph is Kant's aesthetic theory, especially as it is constructed in response to Hume's aesthetics. Following Hume's struggle to try and locate the value of art – is it in the eye of the beholder or a quality rooted in the constitution of the object itself?[18] – Kant transforms this undecidability into a condition of conceptual freeplay: in short, we are impressed by works of art (Kant argues) because, in an attempt to come to terms with them, i.e. to come to terms with them conceptually, we are prompted to reflect upon the categories through which we view the world at large.[19]

Thus the way we describe artworks, the judgements we make about them and the associations we bring to them are crucial for supplying the cognitive significance which can begin to be the subject of theoretical investigation. Trying to define the nature and scope of art theory is by no means a straightforward task but, for our purposes, in the context of practice-based PhD research, perhaps its most important characteristics are, first, an attentiveness to those ideas, and links between ideas, which guide or orient developments in the studio, and second, an assessment of the relationship between the researcher's practice and the history (or histories) of the relevant ideas. For example, in the case of a practice-based PhD examining the performative nature of drawing, it might become possible to recognise certain kinds or clusters of mark-making in a drawing, e.g. sweeping, cutting, busy, frenetic, dragging. The first thing to note is that these descriptions highlight or elevate aspects that can be enlarged upon either individually or collectively in the research. The suggestion might be that, collectively, each category of mark behaves in the drawing like a character in a play, and this, in turn, might prompt the researcher to investigate both theoretically and practically the relationship between narrative structure and the structure of an image. For example, theoretically, the researcher might turn to consider art as structure in Aristotle's *Poetics*,[20] or the paradigm Dufrenne gives of the artwork as theatre

in *The Phenomenology of Aesthetic Experience*,[21] and in terms of practice, drawings might be produced wherein marks are made with particular narrative sequences in mind, which is to say that there is continuity between the verbal *elevation* noted above and the subsequent physical making; one can still distinguish between the two, but this is to distinguish between facets of the single ontological process whereby shape is given to experience.

The relevance of Sartre to art theory here, I aver, is due to the fact that his theory of language shows how description (in our case) of art can expand the cognitive possibilities which are seen in a work. The role of the concept, on this account, is not to contain its object but to create a ripple that brings a forgotten or unforeseen aspect of the work to light. As such, new or additional points of significance are created which can magnify or multiply the extent to which the work might be viewed from a theoretical perspective. This claim might seem to raise the issue of whether or not meaning is in a work or read onto it. Isn't Sartre's account (the objection might run) in danger of amounting to the claim that anything can be said of a work? I don't think so, primarily because of the existential significance he attaches to writing. The object, for Sartre, is not something which opposes description or alienates the writer but something which establishes a moral contract between itself and consciousness. I say moral because the metaphors that best describe the relationship come from the sphere of social interaction: objects invite, motivate, demand, or resist description. Whether one is confronting a bottle of ink, a tree-root, or a painting, objects can give themselves to the viewer only incompletely and, therefore, in a way that requests or demands supplementation from the viewer. The exchange is not necessarily a harmonious one though. Finding the right word is often as difficult as deciding upon the right course of action. Similarly, Roquentin's moment of revelation at the end of *Nausea*, when his hand seems to become a crab and then a fish, is not beautiful but sublime. As Sartre has shown, there can be no moment of self-present, necessary correspondence between word and thing. One has to make a representation, choose a course of action.

Another way of making this point is to recognise that many of the aesthetic judgements we make about art are metaphorical or belong to a chain of thought in which we are reassessing the use of our categories. Metaphor and the reassessment of categories are closely linked in that the former is widely regarded as the cognitive principle whereby a category is borrowed from one domain in order to be ascribed to another to which it does not literally or conventionally apply. Familiar examples of metaphorical judgements about art are descriptions of paintings in terms of emotion, sculptures in terms of movement, and soundscapes in terms of texture or architecture (e.g. the sound embraced me). As regards reflection on our application of categories, I am thinking here of aesthetic encounters when the work unsettles or destabilises our perception and we are required to construct new conceptual mappings in order to get a purchase on the work. This is often the case with the juxtapositional genres of Dada, surrealism, the installation, and the ready-made. These metaphorical judgements reflect the moral question of finding the right word in as much as the production of metaphor is a fundamentally ethical act: it is a creative use of language on the part of the individual which nevertheless, in order for it to work and be recognised as a metaphor, has to be sensitive to the linguistic and cultural associations which the hearers or readers of the metaphor are likely to share.

Conclusion

One of the main problems of epistemology is that we are always at a remove from things, that there is always a gap between the world and our knowledge of it. What Sartre does is show that this state of affairs is a condition of our rootedness in the world and not a deficiency which has to be overcome. When dealing with the situation in which we find ourselves, Sartre avers, we cannot expect the conceptual to determine or capture completely the particularity of the event. The structure of experience is such that a nothingness always insinuates itself between past and present, between concept and action, between description and experience, keeping the two apart. This structure, as I have shown, is particularly evident in writing: the descriptive sentence creates a specificity which cannot possibly be identical with experience. The significance of this for the theory–practice debate is that it changes the way we think of studio practice and art theory as kinds of activity. Whereas making and talking about making are traditionally regarded as two entirely separate activities, Sartre's existentialism presents them as parallel and related processes in so far as they both create gaps or saliencies in an otherwise uniform flow of experience. These gaps, as far as the existentialist is concerned, represent the interruptions in the subject–object relationship which disengage subjectivity from the brute causal order of the world, and which thereby allow the subject to orient themselves in the world.

Within this, perhaps the largest shift in perspective made by Sartre is with regard to our perception of the status of writing in art theory. Just how artist-researchers decide to describe their work, to claim significance for a particular way of working, to select the associations they bring to their art, will influence the way in which the work contributes to theoretical debate. This, I have argued, is because a work of art is always a work under interpretation. Sartre is instructive here because he gives us a theory of description which shows how the choices we make in forming sentences actually determine which aspects (in our case) of a work stand out or sink below the surface. Putting a situation into words, for Sartre, far from being a mere reductive gesture of containment, in actual fact alters the situation: it confers a level of specificity which is not present in the original moment, and thereby causes something either to stand up or drop away in the cognitive relationship between subject and object. On this account, description becomes almost like sculpture in that each sentence, each metaphor, each turn of phrase, chisels away at our perception of the work. As a result, determining the identity of the work, the aspect of the work which the artist selects as being most prominent for their theoretical inquiry, is seen to involve the same constructive, salience-creating decisions as the process of making itself.

While it is important to remember that theory and practice are distinct operations, what I have shown is that this distinction is not necessarily an oppositional or antithetical one. Rather, a theory of theory is possible which shows that the conceptual perspectives adopted in relation to art, together with all the decisions involved in arriving at these perspectives, can have a more vivid and tangible impact on the form and identity of a work than the dry leaf view of theory would have us believe.

Notes

1 Schopenhauer, Arthur (1969) *The World as Will and Representation*, Volume 2. Trans. E. F. J. Payne. New York: Dover, p. 74.
2 Sartre, Jean-Paul (1989 [1943]) *Being and Nothingness*. Trans. Hazel E. Barnes. London: Routledge, p. xxii. A hexis is a magical spell or impulse.
3 Nietzsche, Friedrich (2000) 'On Truth and Lie in an Extra-Moral Sense', in Clive Cazeaux (ed.) *The Continental Aesthetics Reader*. London: Routledge, p. 55.
4 Sartre (1989), p. 23.
5 Ibid. p. 27.
6 Ibid. pp. 28–9.
7 Sartre, Jean-Paul (1963) *Nausea*. Trans. Robert Baldick. London: Penguin, p. 9.
8 Sartre (1989), p. xli.
9 Ibid. p. xxxvii.
10 Sartre (1963), p. 186.
11 Ibid. pp. 61–3.
12 Heidegger, Martin (1962) *Being and Time*. Trans. John Macquarrie and Edward Robinson. Oxford: Blackwell, §§15–16, pp. 95–107.
13 Ibid. §16, pp. 105–7.
14 Sartre (1963), p. 185.
15 Ibid. pp. 185–6.
16 Ibid. pp. 143–4.
17 This, of course, is not to say that the *empirically verifiable* qualities in a work cannot become the subjects of *aesthetic* interest in the work. For example, an artist for whom the dimensions of painting are their main area of investigation will be working to produce paintings or related objects which allow the significance of this aspect to emerge, i.e. to become prominent, but – and this is the crucial point – on this account, it won't just be the measurements which are reflected upon but *the way in which the artworks point to or draw out the significance of their dimensions*. This will not be an empirically verifiable property but, instead, will be the subject of aesthetic judgement.
18 See Hume, David (1993) 'Of the Standard of Taste', in Stephen Copley and Andrew Edgar (eds) *Selected Essays*. Oxford: Oxford University Press, pp. 133–53.
19 Kant, Immanuel (1987) *Critique of Judgment*. Trans. Werner S. Pluhar. Indianapolis, In: Hackett. See, in particular, §§32–8, 44–6, 49, 56–7.
20 Aristotle (1996) *Poetics*. Trans. Malcolm Heath. London: Penguin. See, in particular, pp. 13–17 on plot.
21 Dufrenne, Mikel (1966 [1953]) *The Phenomenology of Aesthetic Experience*. Trans. E. S. Casey. Evanston, IL: Northwestern University Press. See, in particular, pp. 166–98 on the 'world' of the aesthetic object.

Chapter 3

Concrete abstractions and intersemiotic translations: the legacy of Della Volpe

Kenneth G. Hay

> In all language and linguistic creations there remains in addition to what can be conveyed, something that cannot be communicated.
>
> Walter Benjamin[1]

Roman Jakobson argues for a distinction to be drawn between three types of translation. There is, first, what he terms 'intra-lingual translation' or simple paraphrase, where we interpret one verbal sign by means of other verbal signs of the same language, for example when we give an explanation of an unknown word. Second, there is what he calls 'interlingual translation' or translation in the normal sense and the practice in which Benjamin himself was involved – the interpretation of a verbal sign with the aid of another language. But third, and most relevant here, is what Jakobson called 'intersemiotic translation' – the interpretation of a linguistic sign with the help of a non-verbal sign system (or vice versa: the interpretation of a non-verbal sign with the help of a verbal sign, such as the verbal description of a ballet or a painting).[2]

In addition to these cultural and linguistic differences common to most translations, the task of the translator who would attempt a translation between genres also has to take on board the more complex incongruities of different semiotic structures each with its own histories and traditions. It is particularly this type of translation and these sorts of difficulties which preoccupied the Italian philosopher Galvano Della Volpe (1895–1968) throughout his aesthetic reflection, which particularly illuminate the distinctiveness of art practices as constitutive of knowledge and research.[3]

Words and images: an uneasy dialectic

> Why should a description, which is admirable in a poem become ridiculous in a painting? . . . Why should the god [Neptune] whose head is so majestic in the poem (Aeneid 1, 126–7) – rising out of the waves, look like a decapitated head in a painting of the scene? How is it that something which is pleasing to our minds is yet displeasing to our eyes?[4]

> Why can't a dog simulate pain? Is he too *honest*?[5]

The tradition of unease or open conflict between the visual and the verbal stretches back a long way. Horace's famous simile, in the 'Ars poetica' – 'Ut pictura poesis'

(as is painting, so is poetry) – in fact prioritised painting over verbal discourse, by holding up the former as the example on which the latter is modelled. As R. W. Lee has argued, the dictum has been consistently mistranslated by theorists on art from Horace's day onwards such that its reverse, 'as is poetry, so is painting', became the classic definition of the relationship between the arts, the legacy of which continues to cause confusion on the part of both theorists and practitioners alike.[6] This wilful historical mischief in fact reverses the priorities which Horace had clearly outlined, and makes of visual art a mere copy of words. The debates concerning the classification of the various arts which followed from Horace have been further complicated by the fact that the medium in which they have been carried out through the centuries has been, necessarily, that of verbal language, which itself constitutes the domain of several types of art: poetry, drama, the novel or prose poems, to name a few. It is this peculiar position of the verbal as master discourse able to both constitute art, as well as the critical and analytic discourses about art, which has rendered the relationship between ordinary and poetic words, between words and music, words and dance, or, for the purposes of this chapter, words and images, so complex, and for most practitioners and critics alike, so confusing.

The great idealist attempt to classify the arts and their various competencies was Gottfried Leopold Lessing's *Laoköon*, published in 1766. For Lessing, Ariosto's poetry, for example, is overabundant in descriptive detail with the result that the purity of the poetic genre becomes occluded (*Laoköon*, XX). The central drive of the *Laoköon* was directed against just this type of artistic transgression, whether of poetry or of the figurative arts, that Horace's dictum 'Ut pictura poesis' might seem to encourage.

> When the Laocöon of Virgil shouts, who would consider that in order to shout he must have his mouth open and that this would render the figure ugly? It is enough that the 'clamores horrendos ad sidera tollit' appeals as a noble image to our ears and minds, and the visual aspect can be left to your imagination.[7]

In answer to Diderot's question, 'How is it that something which is pleasing to our minds, is yet displeasing to our eyes?', Lessing replies with his system of categorical distinctions between the proper competencies of each genre: painting can do only what painting can do; words follow different rules. It is as wrong to expect words to provide a precise equivalent for visual art as it is to expect poetry to be replaceable by dance, or architecture.

Taking his inspiration from Aristotle's observation (in the *Poetics*) of the capacity of poetry to convey a rational historical content, the Italian philosopher Galvano Della Volpe produced a radical critique of both romanticism and idealism (whether of Hegelian or Crocean origins), and a critique of vulgar materialist approaches which underestimated the formal-semantic autonomy of art, relying either on a crude socio-economic determinism or a form of contentism (such as Lukàcs' theory of realism). I should like here to touch on Della Volpe's concept of determinate or concrete abstraction in relation to filmic metaphor as an example of how a materialist analysis of non-verbal signifying practices can shed light on the problematic question of art's contribution to knowledge and thereby offer some suggestions as to what a materialist art-practice-as-research might entail.

Concrete or determinate abstractions: the plasticity of images

In August 1954, Della Volpe published a collection of ten essays on aesthetics in the *Piccola biblioteca dello spettacolo* series, published by *Filmcritica*. To these were added a further five studies in the second edition, published as a special section of *Filmcritica* in the summer of 1962. The book carried the two epigraphs from Diderot and Lessing, quoted above, relating to the classification of the arts by genres and the difficulties in translating one genre into another. The essays, on film, ideology and the interrelation of the arts, centre around the problems of a scientific aesthetics, the specificity of filmic language and the relationship between ideology and art. Declaring the need for the 'rigorous development of an anti-romantic, anti-idealist' aesthetic or 'an aesthetic of the means of expression', Della Volpe proposes a 'new Laocöon' which would recognise the diversity of artistic means of expression in a non-hierarchical way: their 'peaceful coexistence' as means of expression. Roughly summarised he proposes:

> that the representations given in a judgment, being empirical, are therefore also aesthetic and that consequently any judgment which results from these representations is as logical as it is aesthetic, hence these representations are always referable back to the object.[8]

Aesthetics is *as* cognitive as science, because it is always rooted in, and gives knowledge of, the material world.

In *Estetica in nuce* (*Aesthetics in a Nutshell*) Croce had argued that the task of the critic or reader is to

> unravel the individual history of the artwork and treat it, *not in relation to social [or civil] history, but as a world in itself* into which all of history flows from time to time, *transcended by power of the imagination*. [my italics][9]

Della Volpe quizzes how this is possible if the intellectual and the aesthetic are two different realms, separated, as Croce says, by an 'abyss'. By underrating the concrete rationality of art, Croce reaffirms the Romantic-mystical view whereby art is seen as ineffable (and thus not tenable as research). However, an ineffable art is one, to paraphrase Wittgenstein, 'about which one cannot speak', because devoid of concrete, historical content; if it is beyond history then it must also be beyond language. Croce's attempts to define taste result then, in an extreme impoverishment of taste and a denial of art's cognitive import.

In contradistinction, Della Volpe defines the tasks of criticism as first, to free itself from every type of mystificatory conception of taste, such as that offered by Idealists like Croce, and subsequently to formulate a truly scientific basis for aesthetics which would oppose and transcend the anti-rational aspects of Kant's conception of the autonomy and positivity of the aesthetic, while at the same time salvaging those rational aspects gleaned from the opposition between classicism and romanticism: What this amounts to is the search for a kind of taste which unites both feeling and rationality (deemed impossible by Idealist aesthetics). The link lies in the concept of the concrete or determinate abstraction precisely through which, he argues, art is constituted.

It is in this unity that Marx locates the real difficulty of the materialist in front of the general problem of art, in the 1857 *Introduction to the Critique of Political Economy*. Della Volpe reminds us not to lose sight of the aspects of form while examining the content, as most Marxist philosophers of art have done. (In this last note he is specifically critical not only of Zhdanov and socialist realism, but also of sociological critics like Gramsci and Lukàcs.) Neither, however, must we concentrate purely on form. A truly materialist aesthetics must carefully navigate between a crude sociology of content and an abstractly dehistoricised formalism. In doing so Croce's stress on art *as* language, that 'an image which is not expressed, which is not language ["parola"], even murmured to oneself, cannot exist',[10] can in fact be used to contradict the abstract mystical aspects of Croceanism itself, since it points towards the concrete rationality of art, its rootedness in the real material world, as rational historical discourse.

This claim, which unites all the arts as different forms of concrete rationality, or conceptual structures historically and culturally grounded in the real material world, able to be tested scientifically, while at the same time providing a critique of idealist metaphysical explanations of art, summarises the whole of Della Volpe's aesthetic project, later elaborated more fully in the *Critica del Gusto* (*Critique of Taste*).

Since the general epistemological characteristics of art (its synthesis of universality and particularity) are common to every other product of the understanding or reason, what needed to be further examined were the specific technico-semantic characteristics of the various arts, to which Della Volpe had referred in the *Introduzione a una poetica aristotelica* (*Introduction to an Aristotelian Poetics*) in the *Poetica del cinquecento* (*Sixtenth-century Poetics*), and was to pursue in the *Critica del Gusto* (*Critique of Taste*). The Kantian notion of the immediate pleasure granted by aesthetic apperception can be re-elaborated in a materialist sense to verify the generic aspect of art, its realism and hence the exemplarity as rational-material synthesis, to which Marx alluded when he talked of the 'unattainable standard' of Greek art.

Della Volpe concludes by saying that the problem of aesthetic judgement cannot be posed or resolved by means of arguments which rely on hypostases (a priori or generic abstractions) but rather on historical, functional and scientifically rigorous abstractions, which he terms 'determinate abstractions'. This notion of determinate abstraction was one of the cornerstones of Della Volpe's critique of the a priori in the *Logica come scienza positiva* (*Logic as a Positive Science*), too large a topic to be handled adequately here.[11]

Filmic metaphor as filmic realism

In the essay which lends its title to a book of film criticism (*Il Verosimile Filmico – Filmic Realism*), Della Volpe explores a suggestion of Pudovkin, that the content or script of a film, while it may offer a general idea to the director, is nevertheless different from, and powerless to dictate, its concrete form. On this apparently simple observation rests an entire theory of the epistemological specificity of the filmic image, as distinct from the literary, pictorial, musical or other image. Pudovkin, in identifying the peculiar plasticity and concreteness of the filmic image, highlights its direct capacity to function as metaphor or symbol, and hence carrier of complex ideas about the real world. In a film, it is not so much the specific wording of the script which conveys meaning as the use to which the director puts this within a filmic image. In

fact, he argues, it is the director's chief task to elaborate this filmic plasticity. Eisenstein, taking up Rudolph Arnheim's suggestion of the need for a 'new Laocöon', notes the difficulties in individuating the specificity of filmic metaphor in his comparison of painting and film:

> In painting the form is born from the abstract elements of line and colour, whereas in the cinema the material concreteness of the image-frame as an element presents the greatest difficulty of [formal] elaboration.[12]

But Della Volpe argues that filmic metaphor *is* nevertheless possible, not in terms of single frames, but conceived as a montage or juxtaposition sequence, and cites the juxtaposition of the images of the workers being killed and the slaughtered cattle in Eisenstein's *Strike* (1924) or the awakening lion sequence in *Battleship Potemkin* (1925). In the first, the concrete, rational meaning of the filmic metaphor is the equation of the cold, methodical slaughter of the ox with the gunning down of the workers in the square; in the second the juxtaposition of the images of the awakening stone lions, interspersed with images of the broadsides being fired from the Battleship convey a sense of the awakening of the spirit of rebellion in the Russian people ('even the stones rise up and shout' etc.). These images while being precise in the filmic sense are yet difficult to put into words or translate into another expressive medium.

Della Volpe argues for a conception of the filmic image as a concrete discourse which is constituted of determinate forms and ideas, just as the literary image is constituted. In this conception the traditional roles of form and content are reversed, so that content comes to refer to the concrete historical-discursive form (its symbolic-communicative aspect) which constitutes the image. The universality or objectivity of the artistic image is an attribute of the form of the concept, not of the image, and the term form implies a determinate discriminate, rationally intelligible image. A form which is unintelligible is in fact a contradiction in terms. Moreover, the content of the filmic/artistic can be none other than the concrete rationality of matter, the sensible and historically actual from which it is made and to which it refers.

A further conclusion can be drawn from this that, as the form always directs us towards the content, so the content is nothing if it does not direct us towards the form (idea), for its full objectification or expression. The structural circularity of form and content which Della Volpe formulates here leads him to conclude that there can be no successful formal transcendence of a content which is banal, academic or stereotypical (and therefore untruthful) because the content cannot *but* influence the form: where there are only stereotypes and untruths, there can be no artistic (formal) value. Della Volpe notes that the reasons for this type of failure, need not lie in the personal originality of the individual-artist and in his/her application of formal, technical norms, but rather

> in the non-dialectical use of expressive models, and that is of symbols or ideals, or ideas (forms), which have been historically (i.e. really) superseded or consumed.[13]

This, for Della Volpe, is the modern, post-Romantic problem of artistic originality. Once the mystical and irrational definitions of form and content have been rejected, one is free to see that the dyad form-content is none other than idea-matter or empirical

concept. What differentiates artistic empirical concepts from empirical concepts in the normal or scientific sense is their different expressive means and semantic techniques (*not* their rootedness in the material socio-historical world). Where film uses a dynamic-visual language, literature utilises verbal symbols and images, painting adopts static-visual-abstract symbols and images, etc. The different species of the genus art (film, painting, literature, music, etc.) can thus be conceptualised and their differing techniques analysed. Aristotle's definition of similitude as a nexus linking distant and different things, such as happens in philosophy and science, proposes that metaphor (art) is thought (although not only thought) since it is in fact a transposition (metaphor) from the genus to the species. An image, in so far as it is truthful (i.e. coherent) will have a life-like or realistic quality, even if the realism is impossible in the Aristotelian defini-tion (such as Eisenstein's stone lions awakening), that is, it is preferable to have an impossible but believable image (i.e. successfully expressed) than an incredible (i.e. incoherent) but possible one. Aristotle argues that impossible or unbelievable images in art are errors when directly connected to the technique of the artist, but not when they only have an accidental relationship to this technique. Thus the notion of prob-ability, as nexus of distant and distinct, as internal coherence, or internal rationality of the image takes on a central role as a constitutive condition of art, whether filmic, literary or pictorial, etc. Filmic probability is then the concrete form or image or filmic idea which Pudovkin intended to distinguish from literary probability. The distinction can be seen in the often crude attempts to transpose one form (a novel) into another (a film) which lack artistic unity because they have been conceived in a form outside of the new medium. The literary idea, however brilliant, is to the director, nothing more than abstract content (i.e. another material), which has only an accidental rela-tionship to the art of the director. This is a clear declaration, of the cognitive inde-pendence of different species of artistic form-making, which applies equally to the relationship of apparent (literary) and real (concrete/material) content within the visual arts (and music, etc.) which has, as Della Volpe remarked, waylaid most Marxist writers on art.

In *Ideologia e film* (*Ideology and Film*) (1958), Della Volpe observes that:

> It is clear that it is not this or that ideology (or content) which counts artistically in the work of art, but whether there is a coherent and clear ideology which can contribute (when united with imagination) to create that ensemble of meanings and values without which there can be no universality of character and action – i.e. there can be no poetry.[14]

Translatability in the *Critica del Gusto*

> The theory of the rational character of the sign, and the grounding of reason and meaning in ordinary, natural language, was developed definitively in the *Critica del Gusto*.[15]

The *Critica del Gusto* (*Critique of Taste*) is unquestionably Della Volpe's major con-tribution to the field of art theory. Its composition occupied him for around eleven years, from the first outlines of 1955 prior to its first publication in 1960, to the two subsequent reworkings of 1964 and 1966.

Taking his starting point from a suggestion of Goethe's that the 'pure and perfect content' of a poem is what remains when this is translated into prose, Della Volpe develops his notion of 'critical paraphrase' as a means of identifying the logical core of the artwork. This rational core remains after the 'dazzling exterior' of musicality or rhythm (which pertain to the signifier and are thus external to the meaning as such) has been removed, and is thus synonymous with formed content or poetic form in Della Volpe's analysis. The criterion of translation must therefore be only fidelity to the letter of the poem. This is because even the literal translation is expressively and semantically an historical product so that fidelity to the objective spirit of the poem is at the same time fidelity to its subjective spirit. Poetry is thus always capable of being translated since it is this prosaic aspect, which alone corresponds to the discursivity of polysemic discourse. That which remains ineffable or untranslatable is not the poem itself (as the Romantics would have us believe), but its euphony. For Leopardi, a perfect translation is one in which the author survives the translation process identifiable and intact, from which he concludes that poetry can be translated only by poets. The difficulty or limitation in the accomplishment of this is due to specific semantic differences between languages, such that this 'is not always possible in all languages'. The difference lies in what Saussure termed the 'linguistic value' of the word as distinct from its meaning. The value refers to the function of the word in the linguistic structure, and applies not only to words but also to grammatical entities and syntax. Since different languages have different syntactic structures and characteristic grammatical norms, it follows that a true translation (i.e. one which captures the logical core of the work) will not necessarily mimic the syntactic structures of the original, and may need to depart quite far from them. Ultimately the greatness of an author lies precisely in his/her ability to transcend these incidental aspects of language – to become eminently translatable in effect.

Cinema

For Della Volpe, cinema was not primarily a visual art nor less a sub-species of painting. Della Volpe considered the two dimensionality of film to be extrinsic and accidental to the nature of film-work. The intrinsic feature of the frame (the basic film sign) is that it is a photographic reproduction of a three-dimensional real world, hence essentially documentary in character. Even montage is a counterpointing of frames in a sequence. A film is thus composed of edited photodynamic image ideas. And colour, like the literary film score, was regarded as a contamination of the essential black and white essence. These filmic images, such as Eisenstein's stone lions in *Battleship Potemkin*, can be 'reproduced in words only with difficulty', as Pudovkin observed.[16] Any attempt to describe them, like the similar attempt to describe a dream, will be banal and impoverished by comparison with the vividness of the original, because they possess a superior 'optical-expressive force'. A similar banality would result in trying to translate a peculiarly poetic image like that of the lion in Dante's *Inferno* (I, lines 47–8) into an essentially filmic image. In both, what should be kept in mind is the criterion of semantic difference, by which each expressive (art) form has its own autonomous range of expressive/formal/technical possibilities (and no others). For Della Volpe, the structural differences between the different artistic forms are semantic/technical and the philosophical justification of the different genres is the epistemological

effect or import of their differing techniques – the fact that certain expressive aspects are *not* readily (if at all) translatable from one genre to another. Science does what science can; art practice follows different rules. But this is not to deny their distinct epistemological contributions.

Conclusion

By focusing on the problem of translatability between artistic genres (inter-semiotic translations) Della Volpe opens the way to a materialist understanding of the common material base of the arts and the sciences. The fact that there can never exist a full translation across genres does not however mean that the cognitive import of the arts cannot be grasped through words, and thus concrete knowledge, arrived at. Both the arts and sciences operate through the use of determinate abstractions through which the C-A-C circle (concrete-abstract-concrete) can be effectuated and concrete knowledge produced. His method offers insights into the interrelation of logic, meaning and aesthetics, which are open-ended and flexible while being firmly rooted in historical analysis. As such it encourages a clear appreciation of the cognitive import of artistic practice *as* concrete abstraction, able to engage with, interpret and critique material, socio-historic and gendered experience. Its dialectical subtlety gives full cognisance of the specificity of artistic genres and procedures and of the complexity and limits to translatability operating between abstract ideas and form. It provides a useful methodological paradigm for framing the operational space required of a truly experimental research culture such as that required for a PhD in studio practice. One sign of an active research culture is that curious people continue to seek after specific knowledges, building upon previous conceptions and methodologies to better understand what it is to be in the world. It is a sign of life.

Notes

1 Benjamin, W. (1973) 'The Task of the Translator', in *Illuminations*. Trans. Harry Zohn. London: Fontana, pp. 69–82, p. 79.
2 Jakobson, Roman (1981) 'Linguistiche Aspekte der Übersetzung', in Wolfram Wilss (ed.) *Übersetzungswissenschaft*. Darmstadt: Wissenschaftliche Buchgesellschaft, pp. 189–98.
3 Some themes touched upon here appeared in Hay, K. G. (1999) 'Generic Specificity and the Problem of Translation in Della Volpe', in Martin Heusser (ed.) *Text and Visuality: Word and Image Interactions III*. Amsterdam: Rodopi; Hay, K. G. (1994) 'The Visual and the Verbal in Postmodern Practice: The Truisms of Jenny Holzer', in Michel Fuchs (ed.) *Cycno: Image et Langage, Problèmes, Approches, Méthodes*, 11(1), Centre de Recherche sur les Ecritures de Langue Anglaise, Université de Nice, and formed part of a stimulating discussion day at the Courtauld Institute of Art, London, on *Visual Narrative* on 22 March 1996.
4 Diderot, D. (1978) 'Lettre sur les sourds et muets', in *Œuvres complètes de Denis Diderot*, Volume 4. Paris: Herman.
5 Wittgenstein, L. (1975 [1940]) *Philosophical Remarks*. Oxford: Basil Blackwell §250, p. 90e.
6 Lee, R. W. (1940) 'Ut Pictura Poesis: The Humanistic Theory of Painting', *Art Bulletin* XXII: 196–269.
7 Lessing, G. L. (1984 [1766]) *Laocöon or The Limits of Painting and Poetry: With Incidental Illustrations on Various Points in the History of Ancient Art*. Trans. Edward Allen McCormick. Baltimore, MD and London: Johns Hopkins Paperbacks, ch. XX, p. 77. I have developed these themes in Hay, K. G. (1996) 'Picturing Reading: Della Volpe and Lessing', special edition of *Paragraph* on Visual Narrative, UCL and University of Edinburgh Press, and in

Helsinki (1997) 'Della Volpe, Lessing and Visual Narrative', Seminar for the *Critical Theory Forum*, Helsinki Academy of Art, January.

8 Della Volpe, Galvano (1973) *Opere*, Volume 6, Editori Riuniti, Rome: pp. 13–14.
9 Croce, B. (1979) *Estetica in nuce*, Bari: Laterze, pp. 55–6.
10 Della Volpe, Galvano (1973) 'I limiti del gusto crociano', in *Opere*, Volume 5, pp. 21–2.
11 For a more detailed discussion of this in relation to Italian Materialism from the Neapolitan Hegelians to Della Volpe, see Hay, K. G. (1990) 'Italian Materialist Aesthetics', unpublished PhD thesis, University of Wales; Hay, K. G. (1995) 'Bertrando Spaventa and Italian Hegelianism', Paper for the Graduate Research Seminar, Department of Cultural Studies, University of Derby. On Della Volpe's aesthetics, see Hay, K. G. (1996) 'Della Volpe's Critique of Romantic Aesthetics', *Parallax* 1(2), Leeds. For a discussion of Della Volpe's materialist logic see Geymonat, Ludovico (1951) *La positività del molteplice, Rivista di filosofia*, xlii, vi(3), July–September.
12 Eisenstein, S. (1968 [1949]) *Film Form: Essays in Film Theory*. Trans. Jay Leyda. London: Denis Dobson, p. 60.
13 Della Volpe, Galvano (1972) 'Il verosimile filmico ed altri scritti di estetica', *Filmcritica* 121: 91, now in *Opere*, Volume 5.
14 Ibid. p. 89.
15 Fraser, J. (1977) *An Introduction to the Thought of Galvano Della Volpe*. London: Lawrence and Wishart, p. 239.
16 Pudovkin, V. I. (1958 [1949]) *Film Technique and Film Acting*. London: Vision Press, p. 116.

Chapter 4

Repeat: entity and ground

Visual arts practice as critical differentiation

Ken Neil

The dialectic of semblance and Real cannot be reduced to the rather elementary fact that the virtualization of our daily lives, the experience that we are living more and more in an artificially constructed universe, gives rise to an irresistible urge to 'return to the Real', to regain firm ground in some 'real quality'. The Real which returns has the status of a(nother) semblance: *precisely because it is real, that is, on account of its traumatic excessive character, we are unable to integrate it into our reality and are therefore compelled to experience it as a nightmarish apparition.*

Slavoj Žižek[1]

Different kinds of repetition are in play in Warhol: repetitions that fix on the traumatic real, that screen it, that produce it. And this multiplicity makes for the paradox not only of images that are both affective and affectless, but also of viewers that are neither integrated nor dissolved.

Hal Foster[2]

Modes of virtualisation

Employing and extending theories of the Real from the writing of Slavoj Žižek and Hal Foster, this chapter considers ways in which repetition and copy in the visual arts can both screen and reveal the Real, returning something of its possible traumatic status in the process. Acknowledging Žižek's implicit challenge to somehow reintegrate the Real by tempering, or at least apprehending, conditions which lead to its traumatic status and taking a lead from Foster's reading of trauma in Andy Warhol's *Death in America* screen prints, one objective in this chapter is to propose that certain practices within the visual arts can be read as urgent strategies of critical differentiation and deployed to meet this challenge of reintegration.

Another no less important objective here is connected to the premise being addressed implicitly and explicitly throughout this anthology, namely that the visual artist's critical thinking is enacted through and not simply held in visual modes of representation. This chapter upholds that important premise and moves towards one strikingly obvious but vital conclusion – although I trust the explication is less predictable – that the plastic visual end results of the complex dialectical interaction between creative critical thought and the picturing of that thought are theoretically very well placed to carry an effective and apposite reflexive analysis of the increasingly virtualised reality in which the end results, their producers and their receivers coexist. The critical visual

artist, in the enactment of his or her thinking, operates between the real and the semblance, able to mitigate against the disappearance of the real into virtualisation. In other words, the critical visual artist can catalyse a return of the real – even if (or perhaps especially if) the devices of copy and repetition are the chosen modes of production.

Within the visual arts, to repeat and to copy, are practices fundamental to mimesis and are therefore modes of picturing which conventionally warrant criticism; for to give again the appearances of the everyday can be seen, understandably, to be an artistic project devoid of critical insight or intervention; a project which de facto would seem to contribute more to the creeping virtualisation of our daily lives than it would to a stand against a syndrome of uncritical image proliferation to which Žižek alludes.

Following Žižek's model, virtualisation in the context of this chapter comprises in part and is causally linked to, the condition in which visual images contribute little more meaning than that dormant meaning which is itself but a barely meaningful confirmation of the participation of the image in a superabundance of imagery. Jean Baudrillard is, as we know, the consummate narrator of such a visual order. In writing generally about contemporary processes of signification he foreshadowed some of Žižek's sentiment. In his 1989 essay, 'The Anorexic Ruins', Baudrillard announced in a style now familiar to us all: 'I am amazed by the obesity of all current systems . . . so many messages and signals have been produced and transmitted that they will never find the time to acquire any meaning.'[3] The visual artist in particular is faced with the challenge of addressing this scenario, for, although Baudrillard does not speak exclusively about the meaninglessness of messages and signals which are images, for him the contemporary visual world is especially conducive to the quick and seemingly inevitable transformation of the image as a vessel of meaning, to the image as an empty sign – something which is seen but not read (or at least if it is read, it is read as a thing merely to be seen). Of course, within the visual arts, an image that is presented as something which is principally to be seen and not read is an image that does not meet the challenge of critical differentiation. That image which is but a copy and a repeat of the world around us is customarily accused and dismissed on these grounds.

Any visual artist whose primary concern is, in the words of Norman Bryson in his famous essay on the *trompe l'œil* competition between Zeuxis and Parrhasius, merely 'the fidelity of his registration of the world before him',[4] would appear to be complicit in some way with what Baudrillard now calls visual obesity. And this obesity might be our tasteless deviation at the far end of a visual diet which has for a long time savoured that image which gives only the appearances of objects in the world: not because to do so is to present a paradoxical critical differentiation between real and semblance, but because to do so is to celebrate a maxim for visual art which, according to Bryson, is tantamount to: 'the image [is] the resurrection of Life. Life does not mean, Life is.' Bryson elaborated on this maxim with specific reference to Renaissance painting:

> The degree to which the image, aspiring to a realm of pure Being, is mixed with meaning, with narrative, with discourse, is the degree to which it has been adulterated, sophisticated, as one 'sophisticates' wine. In its perfect state, painting approaches a point where it sheds everything that interferes with its reduplicative

mission; what painting depicts is what everyone with two eyes in his head already knows: 'universal visual experience'.[5]

Of course, as the image in painting was morphed as a result of progressively different stylistic concerns, this paradigm of Renaissance picturing lost the high ground. (Bryson had as a reference point the work of Masaccio.) The connotation still lingers that mimesis is primarily at the service of the rather uncritical tenet, look, what is, is. Cross-checking with Baudrillard, what Bryson identified fits well with the condition of images acquiring no extra meaning – no extra critical sophistication – for the unadulterated copy intends no meaning beyond itself as a celebration of an intriguing visual tautology; the copy in Bryson's explanation is but a servant, albeit a willing servant, of the visual appearances of its referent: its gambit is that nothing in the way of differentiation intercedes. In Baudrillard's late-twentieth-century extension of this, the image is a mimetic automaton, unable to be checked in its inexorable self-replication, a process which moves the image further from the real of an outward universal visual experience and closer to the real of an inward universal experience of telemedia networks.

As Žižek forewarns, there are difficulties to be encountered in trying to seek out the real on its return, therefore, something needs to be briefly said about the repressed or disappeared real which is to be recuperated. Many works of American Pop seem merely to repeat the superficial visual appearances of the real world in a manner which, at first glance, reinforces the standard postmodern notion that visual language, like any other language, cannot claim to have a privileged or rooted vantage point from which to even speculatively evaluate, let alone judge, the component parts of reality, for to repeat the appearances of the immediately available world, especially with such machine-like detachment as did Warhol, is seemingly a method of emphasising an absence of critical difference: aesthetic interpretation is thus, metonymically, defunct; all images now beheld, whether in the face of the real object or in the face of its copy, somehow share the same epistemological order. Such a world, we were told by Baudrillard among others, is one of hyper-relative visuality, a sinister regime which arises from a levelling of a once hierarchised and grounded world of distinct entities, leading to a scenario wherein artistic, social and political exchange, as summarised by Steven Best and Douglas Kellner, 'occurs at the level of signs, images, and information, thereby dissolving Marx's distinction between "superstructure" and "base," as well as Debord's distinction between appearance and reality.'[6]

Today, as we know, many artists and critics alike have moved past this quasi-anarchic postmodern position that proposes the utter deformation of textures of the real into an unvariegated, simulacral surface. Political and ethical differences between reality and appearance have been reinstated, or at least once again highlighted, through a progressive impatience with the ideology which Christopher Norris antagonistically described as the 'persuasion that "reality" is constituted through and through by the meanings, values or discourses that presently compose it, so that nothing could count as effective counterargument.'[7]

However, any return to the real which is logically precipitated by the rejection of such postmodern radicalism is, still, as it always was, a highly problematic project. The purpose of the objectives in this chapter, on one level, is to likewise continue past an uncritical position by promoting the visual artist from amidst the putative world of

the simulacral as potentially a special kind of critical and political agent, timeously capable of a critical differentiation between the real and the semblance of the real; between entity and ground. A process which resists the virtualisation of our daily lives is, naturally, not a process exclusive to the visual artist. But by concentrating here on one of the salient idiosyncratic types of visual practice (the plastic, unsophisticated replication of the real of the everyday world) I hope to dramatise a special kind of thinking through art, which is peculiar to the business of copying and repeating by way of certain visual devices.

Before that, the analysis turns to a shocking instance of the really real, with close reference to Žižek's attempt to understand the realities of the September 11 terrorist attacks from the repeated televisual reportage which followed. Importantly, such traumatic, existential events as indisputable social backdrop compel any implicit consideration of a disappearance of the real to be more than simply a theoretical conceit. On this count, the chapter acknowledges the critical position held by Peter Dews, and recommends it to the creative practitioner who actualises theoretical possibilities. In contrasting a light contemporary intellectual playfulness with the motivated and urgent playfulness of Surrealism, Dews takes issue with theory as a self-pleasing enterprise:

> Of course if the essence of play is chance and spontaneity, then Surrealism was characterized by a profound playfulness. But somehow the willed inauthenticity, the self-undercutting and suspicion of seriousness in much contemporary thought is something different. There is perhaps no clearer indication of this gulf than the curious way in which the term 'Theory', as used in the anglophone Cultural Studies milieu, has become what might be called an 'intransitive noun'. *No longer an effort at the systematic comprehension of anything, 'Theory' has become a largely self-referential structure – and one whose ostentatious deployment appears far more important than the phenomena whose disclosure it might once have been assumed to serve.* [emphasis added][8]

Moving through Žižek's analysis of the World Trade Center attack, learning from how the real can be recovered from that spectacular example, we might more clearly read the critical disclosures (the returning of the real) in those visual artworks, exemplified here by Warhol, which give again our immediately available (and shocking) visual culture and we might also be strengthening the case, analogously, for the visual artist as a critical agent engaged in the transitive aspects of theory, able to traverse the fantastical seductions of virtualisation in order to turn imagery (and theory) against its recently restrictive, self-reflexive meanings.

Brutally real seemingly

In *Welcome to the Desert of the Real*, Slavoj Žižek, with specific reference to the attack on the World Trade Center, described the difficulties encountered in reassimilating the real into our everyday lives. For Žižek, the spectacular nature of the attacks, and the manner in which they were repeatedly reported and remarked upon, brought into sharp focus the intricate and commonly imperceptible ties between the (he says, particularly American) real and its fictionalised semblances.

Žižek's analysis, characterised by the excerpt which opened the chapter, was understandably highly charged. In his critique he proposed that it was not primarily to cause actual physical damage and death that the terrorists perpetrated the act, but rather, 'for the spectacular effect of it',[9] no doubt bringing about a far more endemic sense of bereavement in each and every onlooker who harboured a belief in Western invincibility. One of his main contentions is that the terrorists somehow understood that the real might return most forcibly to us citizens of the West if the terror act generated a spectacle befitting our recognisable visual/filmic imaginings:

> And when we watched the oft-repeated shot of frightened people running towards the camera ahead of the giant cloud of dust from the collapsing tower, was not the framing of the shot itself reminiscent of spectacular shots in catastrophe movies, a special effect which outdid all others, since reality is the best appearance of itself.[10]

This is not to say that the resemblance of the reportage to the *mise-en-scène* of Hollywood disaster movies resulted in a pathological detachment of the armchair witness from the horrors of the event because he was unable but to read the visual messages and signals as the not-real, inconsequential motifs of pop filmic offerings. It is to say that in Žižek's polemical thinking the real can be carried to us only by recognisable, fictional modes. Connecting always to the language of psychoanalysis, which we will return to in conclusion, Žižek makes plain this idea of an inescapable relaying of the real through the not-real and thus the need to examine the fictional for what it might hold of the real: 'we should discern which part of reality is "transfunctionalized" through fantasy, so that, although it is part of reality, it is perceived in a fictional mode.'[11] The filmic tropes which made up the live unfolding of the collapse of the World Trade Center, and the interminable repeats of it happening, delivered something of the real to us from within its fictional casing.

As redundant as it seems it is nonetheless vital to stress that a part of reality was somewhere located within the fantastical reportage of the terrible events of that day. Otherwise, a susceptible beholder may well have called to mind, as perverse succour in the face of terror, Baudrillard's strangely prescient hyperbole from his *The Ecstasy of Communication* (1988). It is possible to find comfort of a kind in such an outlook, for, as Dews indirectly implied above, to see the event and its tele-relay as not much more than a case study of creeping virtualisation or of image obesity, is, clearly, to absolve oneself of divining real meaning from the visual debris. Yet, to the irritation of many, within Baudrillard's ominous message, there is more than a nugget of truth, and the ecstatic condition he described so famously, which may have pertained to September 11 by way of a complex *après-coup*, is worth revisiting:

> We no longer partake of the drama of alienation, but are in the ecstasy of communication. And this ecstasy is obscene. Obscene is that which eliminates the gaze, the image and every representation . . . today there is a pornography of information and communication, a pornography of circuits and networks . . . it is no longer the obscenity of the hidden, the repressed, the obscure, but that of the visible, the all-too-visible, the more-visible-than-visible; it is the obscenity of that which no longer contains a secret and is entirely soluble in information and communication.[12]

Although Žižek makes clear, through much of his writing on popular culture, that he recognises the power of the networks and circuits which Baudrillard described, he nonetheless believes, more optimistically, that there is extant a secret, so to speak, in such networked transmissions: but this secret, this secreted insolubility of the real, Žižek advises, can appear to us as yet another 'nightmarish apparition', another type of semblance. It returns to us in guise, not simply as a discernible opposite to the fantasy or fiction which assists its passage.

Despite the morbid success of the distribution of the World Trade Center atrocity through the networks and circuits of the global media, the images themselves, by being so closely bound up with the spectacularism of catastrophe movies, paradoxically reclaimed for us Western witnesses the visual identity of the attacks from the perpetrators as Others – if such a thing can be mooted. This might point to another semblance of the real that still glistens among the pornographic footage of the reportage. That the filmic administering of the terror message was carried necessarily by exaggerated Hollywood meanings is strange proof of the predominance of American media idioms and one way for the perpetrators to have inadvertently ensured that their underlying, vernacular story was to remain unseen, hence unspoken. Their local meanings, then, were strangely bonded to our identifiable filmic precedents and, paradoxically, indebted to (and at the same time restricted by) these vehicles for both the transference and disappearance of their real meaning.

The appalling visibility of all the visual elements, trapped in our loop forever televisual memories, could very well be classed as obscene, or obese, after Baudrillard, but the crux of what Žižek puts forward, which is the key inference in this section of the discussion, is that the condition of the obscene all-too-visible does not necessitate the vanishing of the real into a hyper-real simulacral surface, the condition secretes within itself something of a trace element of what is really happening, and, strangely, it can be the repetition and copy of the appearances of the event in question which can bring the nub of the real to be discernible on the surface of the screen. The conceptual heart of Žižek's investigation of the World Trade Center attack is concerned, then, with the paradoxical usefulness of a complex blend of states of the real. As Žižek pointed out in summary of the core concept of his text: 'we should be able to discern in what we experience as fiction, the hard kernel of the Real which we are able to sustain only if we fictionalize it.'[13]

In consonance with this central idea, and in response to Žižek's commentary on September 11, the American cultural theorist Susan Willis also stressed the complex conjoining of real, symbolic and imaginary, this time with regard to the impulsive acts which followed the attacks.[14] She recounted that the US Postal Service had to process a considerable amount of mail addressed to Osama Bin Laden, Afghanistan. Willis argued that 'the letters bespeak a naïve attachment to the real', going on to conclude that 'to write to Osama is to enact a form of sympathetic magic whereby the phantom terrorist, the haunting visage seen on video feeds from Al Jazeera, becomes a man of flesh and blood and bone.'[15] The empirical facts of the letters in Willis's example are compelled by their senders to render the myth of Bin Laden more concrete, as if the letters necessarily set up a similar existential link with his actual opening of them.

By sending letters to Bin Laden, 'the symbolic impinges on the imaginary so as to force the real into being – although in a version that only exists as fiction.'[16] Interestingly, even if predictably, the filmic or televisual fictionalising of the attack brings

about a meeting of the witness and the kernel of the real, a meeting which might not have necessarily taken place had the witness been an *in situ* eyewitness, so the logic runs.

It can be said, then, using Žižek's analysis of very real trauma, that the real of such an event is complicit with the fiction of it and that the carriage of the meaning of the event involves an ongoing oscillation between the real and the imaginary. In this process of the real potentially returning to us, there is a space in which the creative practitioner (a letter sender as it were) can operate in order to bear witness to and point to the component parts of what can be a recuperated Real. Taking Žižek's (and Willis's) case studies as models, the creative critical practitioner might turn his efforts to counterargument which disrupts a pathetic status quo which would otherwise have substantive meanings left unspoken, because, as Norris pointed out, certain defeatist tendencies would see any pursuit of the kernel of the real as an illogical and quaint project, hidebound by the fact that the real will prove to be but a construct of the analytical enterprise; such a real can thus never be a legitimisation of the critical inquiry. Žižek's analysis also shows very clearly the acuity of the application of theories of the real and semblance to a profound case study, modelling in the process a possibility for the creative critical artist to produce differentiated action through practice.

Related to this possibility, Žižek's work as a critical philosopher embodies an act of critical differentiation. His writings take the form of a political act no less; they compel us to sit in the psychoanalyst's chair, as private and public citizens. We are invited to question our own symbolic and imaginary so that we might reveal something of the real we to ourselves. Quoting Žižek, Sarah Kay summarises her reading of his oeuvre with reference to this overarching idea of enacting critical differentiation:

> As Žižek says in the last words of his interview 'The One Measure of True Love' following the events of September 11th, 2001: 'We face a challenge to rethink our coordinates and I hope that this will be a good result of this tragic event. That we will not just use it to do more of the same but to think about what is really changing in our world.' His recent works may not be a form of symbolic *activity* that would make the world a better place. But if they expose us to the real, provoking us to rethink our entire situation, then they are a political *act*.[17]

An acute tool available to the artist for creating a visual act of critical counterargument to the de-differentiation of the real from its ground, are the very mimetic modes of copy and repetition, normally regarded as blunt methods of approaching the real and moreover, culprits in the undifferentiated virtualisation of contemporary culture. The critical visual artist, by repeating the surfaces of the obese, replete system of images, and by copying existing idioms of filmic media, can somehow prevent an infinite slippage across that surface, interrupting the image as nothing more than a confirmation of its uncritical contribution to visual superabundance. The critical possibilities come from within the very spaces of the visual replication.

Rupturing the reduplicative screen

Without mocking the context of Žižek's and Willis's studies, the return of the real through the fictionalising of its semblance connects directly to a reading by Hal Foster of Andy Warhol's 1960s *Death in America* screen prints, put forward in the 1996

essay, 'Traumatic Realism'.[18] To revisit that essay in the light of Žižek's analysis of the ways in which the real returns surreptitiously, even in a live and truly traumatic event, can bring to a focus a role for the visual artist in the design of that art object which vents the real, allowing it to be seen – not by modifying to abstraction the deceptive appearances of the real world, but by repeating those appearances and by copying also the conventions of contemporary media display. And with Dews's caution and Žižek's act accompanying us, this somewhat paradoxical practice of critical differentiation can be seen to be an authentic process of the gleaning of the real, not simply a theoretical studio exercise.

Just as Žižek identified a sickening blend of the real and the fictionalising of the real through its imaginary precedents, Hal Foster identified a series of seemingly conflicting states in some of the notoriously shocking screen print work of Warhol – work which seemed to indicate both an engagement with the real and a resigned acceptance of its elusiveness. Foster asked:

> Can we read the *Death in America* images as referential *and* simulacral, connected *and* disconnected, affective *and* affectless, critical *and* complacent? I think we must, and we can if we read them in a third way, in terms of *traumatic realism*.[19]

Foster did not accept that Warhol was simply playing out the shock of the real in this series, without any critical insight. Indeed, it was by reckoning with the deceptive indications that the artist was simply giving again the horrors of real-life tragedy, without critical comment, that revealed the latent critical comment to Foster. Within these contradictory messages, Warhol's repetition played an instrumental role, both in terms of picturing his often-stated theories of ennui, but also in terms of traversing the traumatic nature of the scenes copied. Foster cites Warhol's own declarations on the subject of copy and repetition, and opens the way for a psychoanalytical reading of the effects of the visual replication – even the replication of the visually horrific:

> I don't want it to be essentially the same – I want it to be exactly the same. Because the more you look at the exact same thing, the more the meaning goes away, and the better and emptier you feel.[20]

Foster sees this as one form of a Freudian application of repetition as a means by which trauma is reintegrated into an intelligible order, but goes on to propose that, 'the Warhol repetitions are not restorative in this way; they are not about a mastery of trauma. More than a patient release from the object in mourning, they suggest an obsessive fixation on the object in melancholy.'[21] In Warhol's series, then, not only is trauma repeated, in pretence of its amelioration (and virtualisation?), but also Foster sees it as critically produced in the images themselves. The very repetition and copying reveals something of the kernel of the real trauma pictured.

Even in the really real case of the World Trade Center attacks, repetition in the news coverage served something of the same purpose – that is, of course, if the viewer was sensitive to this kind of paradox of virtuality. In Žižek's words once more, having now moved this idea through Foster's Warhol:

> When, days after September 11 2001, our gaze was transfixed by the images of the plane hitting one of the WTC towers, we were all forced to experience what the 'compulsion to repeat' and *jouissance* beyond the pleasure principle are: we wanted to see it again and again; the same shots were repeated *ad nauseam*, and the uncanny satisfaction we got from it was *jouissance* at its purest.[22]

Jouissance here, from Lacan as we know, is employed by Žižek more commonly as 'enjoyment',[23] to mean that which our rudimentary drives are engineered to pursue, often without conscious consideration. In the present case, a mild, subliminal *schadenfreude* is exaggerated *in extremis* in the face of the repeated pictures of the plane striking the building, and a deep-seated perversion surfaces as a surplus enjoyment of the events – but, mercifully, the repetition of the moments of attack *ad nauseam* across the surface of the screen brings about a rupture which fixes the event in an indescribable melancholy – and brings about, Žižek ruefully proposed, an unutterably idiotic but nonetheless telling realisation that, in the gaze of the exposed inner parts of the really real: 'it became possible to experience the falsity of "reality" TV shows.'[24] The witness learns to receive the really real and to relegate the symbolic masquerade which is reality as presented by the contemporary media idiom of fly on the wall.

The sinister enjoyment to be had by *voyeuring* Warhol's *White Burning Car III* (1963),[25] to use one of Foster's case studies, is given a critical dimension by way of the in-built rupture which comes as a result of the repeat of the image. Our dark enjoyment of the figure of the impaled man, and our scandalous invitation to also walk past the burning car given to us by the eyewitness in the background, are modified through the repetition of the scene; according to Foster, 'somehow in these repetitions, then, several contradictory things occur at the same time: a warding away of traumatic significance *and* an opening out to it, a defending against traumatic effect *and* a producing of it.'[26]

From moment to moment in the face of this image we are the contemporary eyewitness accustomed to spectacle who metaphorically walks past and we are the contemporary social critic who bemoans the reality of the futility and profligacy of the fetishisation of youth and speed; we are the Pop viewing machine which consumes images as efficiently as a good Pop artist fabricates them, and we are the critical consumer who understands a parallel critique of the reality of the superabundance of imagery and the pornography of the all-too-visible. It is as if the repeat of the visual actuality of the fatal scene and the copying of the media-splash presentational idiom holds the viewer in a looped groove from which he or she can see the meaningless signal on one side of the fissure and, with practice, facilitated by the repetition of the possibility, he can read the significant message on the other. To repeat, then, is not to cause slippage across a surface but to effect a staccato holding of the gaze in a critical space which the willing viewer can catalyse.

It is this dual apprehension of meaningless signal and meaningful repeat which is so closely linked to the reduplicative mission of recent visual art like Warhol's. It is as if the project of reduplicative art explained by Bryson has been taken up by artists in order to reveal meaning and significance through critically attempting the reverse of Bryson's summation, an attempt which might this time be proposed as 'look, through seeing life as "just is", life means'. (Think of Don Eddy's 1970s super-realist paintings of shop window displays or, more recently, Richard Billingham's 1990s photographs

of domestic interiors.) Once again, it is through the very duplication of the real of life that the real is approached. Of course, this method of revealing something of the real is dependent upon the viewer avoiding the trap of believing in the apparent indifference of the artist who seems merely to add to the superabundance of images: the potential criticality of such picture-making treads a fine line, which any fissure is, between the paradoxical poles of the transference of meaning and its disappearance.

Traumatic ordinariness

Warhol, then, put forward an image which, on the one hand, through the visual tactics of repetition and copy, carried an illusion of the artist's indifference to the extraordinarily shocking subject matter depicted. On the other hand, the visual tactic of repetition and copy exposed to us an aspect of the real previously hidden. At least, a rupturing of surface takes place which might allow the viewer to engage with the exposed kernel of the real, which repetition might be expected to conceal. Additionally, the repetition in Warhol's *White Burning Car III*, like the perpetually repeated moment of the planes striking the Twin Towers, brings to our attention the cultural status quo which sees the shocking enter with ease the domain of the ordinary; the pornographic availability of even the most private and tragic events results in a de-differentiation of normal and abnormal experience.

This de-differentiation, which renders the meaning of the September 11 attacks so complex and difficult to translate, is critiqued in Warhol's screen prints quite deliberately, as Foster proposed. The consequence of de-differentiation is, in a way, characterised by the elements of mortality pictured in the *Death in America* prints. The effect of inuredness widely experienced by those susceptible to the pornography of the all-too-visible is implicitly described by Warhol as a fatal syndrome which affects general critical ability; a syndrome which produces social corpses at worst, impotent passers-by at best. What Warhol's *Death in America* images and Žižek's analysis of the World Trade Center attacks share, as has been noted, is the critical point that the significant, meaningful, earthly real, is there to be seen within the reproduced spectacle of trauma, as long as one is adept at reading the fictionalised vehicles which deliver the kernel of the real to the beholder. Towards an end point for this discussion, the real might also be returned to us by way of the repetition and copy of the ordinary as well as the shocking spectacle – and the kernel of the real of the everyday is, in a sense, no less traumatic to behold than the chilling realities of Žižek's and Warhol's case studies.

In his 1973 essay 'Approaches to What?' Georges Perec cautioned us against being mesmerised by spectacular reportage of supposed real life:

> What speaks to us, seemingly, is always the big event, the untoward, the extraordinary: the front-page splash, the banner headlines. Railway trains only begin to exist when they are derailed. Aeroplanes only achieve existence when they are hijacked. The one and only destiny of motor-cars is to drive into plane trees.[27]

Perec clearly lamented the social circumstance wherein the shocking supplants the ordinary. In this condition the everyday is relegated from the limelight, to remain unobserved, usurped by attention to various styles and products of sensationalism:

'the daily papers talk of everything except the daily' he mused.[28] The car wrecks of Warhol and Perec tell us of our sinister *jouissance* as witnesses of real physical trauma and they tell us to be aware and wary of our indifference to the reality of such events – but significantly their models tell us also of a lost ordinariness and invite, therefore, a recuperation not just of the real horror of human loss and of the real anxiety brought about by terror (Žižek), or the more abstract reality of the futile fetishisation of youth and speed (Warhol), but of the quotidian real which spectacle has come to suppress.

Needless to say, recuperation of an ordinary real is positively advocated by Perec, a desire which is encapsulated in his incessant and brilliantly simple questioning of what lies behind and between instances of spectacle and exaggeration: 'what's really going on, what we're experiencing, the rest, all the rest, where is it?'[29] It is this kind of questioning which Žižek employed in front of the news footage of the collapse of the Twin Towers – and it is the answering of this kind of questioning which constitutes the political act, as indicated by Sarah Kay. Ultimately, it is this questioning which can form the basis of a critical differentiation on the part of the visual artist – an undertaking which might reveal something of the ordinary realities of what is habitual, and thus in danger of falling out of our field of vision. Such critical differentiation, which is, to remind ourselves with reference to Best and Kellner's phraseology, the contentious re-establishing of base entities from their causal (super)structural social ground, begins to respond to Perec's questioning:

> To question the habitual. But that's just it, we're habituated to it. We don't question it, it doesn't question us, it doesn't seem to pose a problem, we live it without thinking, as if it carried within it neither questions nor answers, as if it weren't the bearer of any information. We sleep through our lives in a dreamless sleep. But where is our life? Where is our body? Where is our space?[30]

And it is in the proactive respondence to Perec's questioning and in the enactment of critical thinking that the visual artist can find the modes of copy and repetition to be particularly useful. For mimesis, not as a pantheistic celebration of the divine in the detail, but as, instead, a strategic reproduction of the real in parallel to our normative existence, can effect the puncturing of the screened habitual in remarkable ways. The copy serves as an eerie control experiment, the specifics of which reveal that which is customarily over seen in the witnessing of its relevant referent at the far side of the artfully constructed fissure.

Both Žižek and Foster built their analyses upon aspects of Lacanian thinking *apropos* trauma. The traumatic encounter with the real Lacan describes as the 'tuché' – or touch – that significant moment when the thing seen seems to reach beyond its simulacral casing to contact the viewer in a pointed way: the moment that implicates the viewer, stirring him from his position as bystander. For Foster the tuché in *White Burning Car III* is the indifference of the passer-by, an element of the scene which defies its representational status: 'It is a thing that resists the symbolic';[31] it is the element which retains its closeness to the real – but only, and that is no small thing, its closeness – for the real is indeed elusive.

Might it be then that the creative critical visual artist in questioning the habitual and ordinary, phenomena which have become so through social processes of familiarity,

repetition and copy, can find 'our space' and effect a form of tuché, or trauma, which will bring us face to face with a kernel of something, which, put simply, is usually overlooked? Here we do not have a new agenda for the visual artist, as one who resists the dazzle of the sensational to point out details which are forgotten in the habitual, but it is interesting to see such an agenda return through modes of visual presentation which are complicit with the increasing virtualisation of our daily lives. Lacan, of course, tells us that Perec's questioning will only ever be that, for the real is real precisely because it cannot be apprehended – it is the opposite of the symbolic, something which will always be behind the representation. In Lacan's own words, real experience 'is situated as that which the subject is condemned to miss, but even this miss will be revelatory.'[32] This revelatory potentiality is emphasised by Žižek as, we have seen; he does not allow the real to be dissolved completely in a hyper-real scenario. But what is it that brings about the trauma of the tuché? What might it be that the critical artist reveals by an enacting of the habitual in the parallel spaces of visual art?

What needs to be recognised is that Žižek's kernel of the real is a casing for the real, not the real in itself. It is an entity which exerts outward pressure from itself and its ground; it is a component of the picture which draws attention to itself as a distorted pixel on the reduplicative screen, a bulge on the flat surface of the normative. The transcendence of the possibility which inheres in this casing, the possibility of a return of the real that is, is brought about by the viewer's acute sense of having arrived a moment too late: the kernel remains as a husk, the real has passed. As Warhol might tutor, the real passes away when one looks directly at the kernel, however many times you repeat the process. An acute sense of yearning at both the passing of the real and its still-tempting closeness might be sufficient impulse for the viewer to resist the seductive call to indifference of the all-too-visible, to pursue, instead, a critical position on what is seen: a critical position which is itself, crucially, a bulge or knot on an otherwise unvariegated social surface.

Within the context of this anthology, the enactment of the tuché by the visual artist, is the act of critical differentiation, an act of political potentiality, which can enable the viewer to see the locations of the virtual and the real, and can thus, with Dews caveat foregrounded, disclose something of both based on the contours of the kernel which are revealed through the critical visual artist's rupturing of screens. The spectacular appearances of traumatic events might then be critically decoded, and the habitual might be reclaimed from the superficial dalliance with the spectacular: in short, a tantalising and traumatic return of the real is effected.

Finally, with reference again to Willis's critique of the post September 11 letter senders, visual repetition and copy might be seen as a plastic, symbolic output which parallels the imaginary, in order to, as she noted, 'force the real into being, but in a version which only exists as fiction'. The fictional status of this returning real is championed by Žižek, for, as we recognise now, the real inevitably slips away, leaving only, but usefully, the fictional kernel as vestige. It is the visual artist's sympathetic magic that transfunctionalises aspects of the real through fantasy, enabling those aspects to be disclosed and perceived in a fictional mode: a mode which relies on a distinction between entity and ground and which thus avoids the fatal dangers of a flattened self-referentiality.

Notes

1 Žižek, Slavoj (2002) *Welcome to the Desert of the Real*. London: Verso, p. 19.
2 Foster, Hal (1996) *The Return of the Real*. Cambridge, MA: MIT Press, p. 136.
3 Baudrillard, Jean (1989) 'The Anorexic Ruins', in Dietmar Kamper and Christoph Wulf (eds) *Looking Back at the End of the World*. Trans. David Antal. New York: Semiotext(e), p. 30.
4 Bryson, Norman (1983) *Vision and Painting: The Logic of the Gaze*. London: Macmillan, p. 3.
5 Ibid.
6 Best, Steven and Kellner, Douglas (1997) 'From the Society of the Spectacle to the Realm of Simulation: Debord, Baudrillard and Postmodernity', in Best and Kellner, *The Postmodern Turn*. New York: Guilford Press, p. 98.
7 Norris, Christopher (1990) *What's Wrong with Postmodernism? Critical Theory and the Ends of Philosophy*. London: Harvester Wheatsheaf, p. 4.
8 Dews, Peter (2004) 'Resituating the Postmodern', *New Left Review* 25 (Jan.–Feb.): 144.
9 Žižek (2002), p. 11.
10 Ibid.
11 Ibid. p. 19.
12 Baudrillard, Jean (1988) *The Ecstasy of Communication*. Trans. B. Schutze and C. Schutze. Ed. S. Lotringer. New York: Semiotext(e), p. 22.
13 Žižek (2002), p. 19.
14 Willis, Susan (2003) 'Empire's Shadow', *New Left Review* 22 (July–Aug.): 59–70.
15 Ibid. p. 59.
16 Ibid. p. 60.
17 Kay, Sarah (2003) *Žižek: A Critical Introduction*. Cambridge: Polity Press, p. 157.
18 Foster, Hal (1996) 'Traumatic Realism', in Foster, *The Return of the Real*, pp. 130–6.
19 Ibid. p. 130.
20 Warhol, Andy and Hackett, Pat (1980) *POPism: The Warhol '60s*. New York: Harcourt Brace Jovanovich, p. 50.
21 Foster, 'Traumatic Realism', p. 132.
22 Žižek (2002), p. 12.
23 See Žižek, Slavoj (1989) *The Sublime Object of Ideology*. London: Verso, p. 44.
24 Žižek (2002), p. 12.
25 In this famous screen print Warhol repeated, five times, a copy of a newspaper photograph showing an overturned, burning car wreck, the dead driver hanging from a telegraph pole adjacent to the car, and a passer-by in the background, at the mid-left edge of the macabre tableau, ready to exit the scene.
26 Foster, 'Traumatic Realism', p. 132.
27 Perec, Georges (1973) 'Approaches to What?', reprinted in Perec, Georges (1997) *Species of Spaces and Other Pieces*. Trans. John Sturrock. London: Penguin, p. 205.
28 Ibid.
29 Ibid. p. 206.
30 Ibid.
31 Foster, 'Traumatic Realism', p. 138.
32 Lacan, Jacques (1978) *The Four Fundamental Concepts of Psycho-analysis*. Trans. Alan Sheridan. New York: W. W. Norton, p. 39.

Chapter 5

The virtually new: art, consciousness and form

Peter Dallow

> What defines thought in its three great forms – art, science, and philosophy – is always confronting chaos, laying out a plane, throwing a plane over chaos.
>
> Gilles Deleuze and Felix Guattari[1]

Modernism, linked as it was to capitalism in the West, and to the culture of mass production, thrived on the new. Further, modernism and the modernists promised to show us the basic fundamentals of reality. Art ceased to be representational and became abstract. That is, art became non-representational, showing us the basic elements of (visual) existence – pure (true) colour and form freed of representational content, as though there was some pre-cultural ground outside of, and free from, mere representation. This was creative cognition employed in the quest for (pre-cognitive) reality. Sensorially engaging as they could be, these were disillusions, essentially decorative illusions, now safely dispatched to the walls of architectural minimalism, and away from the contamination and excess of contemporary representational maximalism. Pop culture, unashamed of its pictorial excesses, and photomedia, capable of immense visual detail and verisimilitude, came to pre-eminence, through the work of Warhol and Rauschenberg, and later Barbara Kruger and Cindy Sherman, to take an American slant on it. As Gans put it: 'The postmoderns realize that representation is the fundamental mode of (human) being'.[2] Postmodernism gave us the meta-experience of representation.

Then the postmodern view was that we can no longer produce anything new, so we instead simulate newness, via novelty. A new (anti)aesthetic was on the rise, and with it a new aesthetic truism – being able to do anything new was impossible, so we were left in the perpetual limbo of endless repetition of what had already been done before, regardless of where it had come from. The old became new again. This 'déjà lu', as Barthes termed it,[3] had of course been visibly prefigured much earlier by Duchamp, who then gave away the art game for chess. As all aesthetic tendencies have within them the seeds of their own irrelevance if not destruction, postmodernism, seductive and emblematic as it emerged as a remodelling of the aesthetic universe, came with some serious baggage. As Gans, again, put it:

> the postmodern utopia of a real infinity of pre-existing esthetic modes is more flagrantly selfcontradictory than the modern one of a virtual infinity of potential

esthetic modes. The transcendence of history implies its own history, divided between historical time in which humanity has displayed a vast but ultimately bounded set of forms of representation, each conceived in its own time as natural and objective, and a posthistory in which we have freed ourselves from the illusion of immediacy of the preceding epoch.[4]

The postmodern denial of origin, Gans suggests, represents a return to its origin, the entry into history. Walter Benjamin had already decreed that art had become bound up with the technologies of reproduction.[5] And like so much of the advanced industrialised world, Western art turned to the emergent digital imaging, information and communications tools, which had come about through the convergence of integrated circuitry, computational science and telecommunications networks, and, by extension, modern design principles. Digital imaging and the new media literalised the pastiche of postmodernism, and quickly became the only game in town. If it did not include something about the virtual, it was not now. The possibility of doing something new in art, as elsewhere, became literally virtual. Or at least, the notion of virtuality rapidly became the focaliser through which the whole of contemporary culture was viewed.

Technology, in the broadest senses, became the fetish of the increasingly globalised marketplace within which art and culture more broadly are uneasily situated and implicated, as part of the cultural industries. This is the *3G* the third generation, as we metaphorically turn our backs on modernism (*1G*) and postmodernism (*2G*), and embrace the global reach of the post-natural, synthetically augmented, body-machine hybrid condition. The promise of cyborg heaven awaited us at the end of the biotechnological rainbow. In this circumstance, going to war seems like a rational option again, as we wage conflict with surgical (scientific) precision. Perhaps artificial intelligence has already arrived. But intelligence, like language (supplementarity in Derrida's terms),[6] always has been artificial.

The work of artists such as Patricia Piccinini, with her logically confounding cloned hybrid human-animal cartoon/animatron-like figures, bridges the popular and aesthetic imaginations as they struggle to come to terms with the social, ethical and cultural implications of our present, emergent techno-global condition, whichever neologism we cultural critics and theorists decide to employ to describe it. Piccinini describes her work (exhibited at the Venice Bienale, 2002) as being inspired by stem cell research because 'it's really changing the way you see your body, how we conceive of ourselves'.[7]

Still Life With Stem Cells, like much of my work, comes from what is going on in the real world; in fact, I see my works as relating to the present rather than the future. I respond to the discussions and debate that surround technologies such as stem cell research, however in my response I try to think about what is being promised by the technologies and then imagine something else. What if what we get from these technologies is actually really different from what we are promised? I am not trying to scare the viewer with this possibility; on the contrary, I personally find it quite exciting. However, I do try not to be too prescriptive. It is up to the viewer to formulate their own response.[8]

Whatever this current historical moment is called, the illusion of Romanticism's engagement with experimental immediacy, and with the heroic status of the artist, can be seen as having mutated or been cloned into a view of artistic practice nowadays (as with that of scientific discovery) as a metaphor for the broader dynamic human response to the freedoms and constraints of our present time/s. In this view, the moment of originality (creativeness), like the notion of the originary moment itself (creation/big bang), seems to provide a metaphor for the sense of historically situated time itself, which was thought to be abandoned with postmodernism.

For all our sense of progress and historical linearity, we have not moved that far in the refined domain of cultural practice, in (art) historical time. The illusion of experimental immediacy in artistic practice sounds remarkably close to Aristotle's definition of tragedy, and by extension a definition of classical aesthetics, as the mimesis of a praxis, or, as Gans puts it, the production of the illusion of something new being done.[9] This mimetic moment of art practice can equally be seen as related to Plato's notion of the (potentially) subversive nature of art.

Movement in art/art movements

A key trajectory of the movement in modern art was away from a concern with beauty *per se*, towards the formal investigation of the grounds for its construction. The imitation or representation of creative activity at the level of material form, ultimately produces an aesthetic effect devoid of much of the broader social, cultural and psychological basis of human cognition. It is abstracted. Abstraction, as Belting observes, implies something from which it has been abstracted, namely figuration – visual images.[10] However much images may have been exalted as the very stuff of art, from Cezanne and Van Gogh, art began to separate itself from images. Photography and the advent of other new media of the nineteenth century, and the modification of other old media (printing), had made images omnipresent throughout society. Art, Belting asserts, had 'to offer something more important than images'.[11] Galison puts it: 'Abstraction properly conducted proceeds through the formal, the logical, and the systematic. Rigorous, logical, non-intuitive reasoning is the road to knowledge'.[12]

Abstraction lays out a plane of composition, where the act of painting appears as a painting, and the moment of capture of photography appears as a photograph, and so on. It offers a finite composite sensation as though opening onto a plane of infinity, making perceptible 'the imperceptible forces that populate the world'.[13] The Zen influenced way of showing as little as possible (minimalism) to allude to everything – the cosmos, or more pointedly the Joycean 'chaosmos',[14] the 'infinite passage of chaos',[15] as Deleuze and Guattari put it – emerged: 'It is like a passage from the finite to the infinite, but also from territory to deterritorialization'.[16] It begins with the chaos of sensation and the materiality of artwork (paint, canvas, colour, photographic emulsions, two-dimensional planes, three-dimensional space, etc.) and moves towards (abstracted) opinion – reason. That is, modern art provided a seemingly conceptual representation of the cosmos. Thinking through sensation. It culminated though in emptying the canvas – the frame left bereft of content, or as content. It had evacuated all that had earlier been seen as relevant and constituitive for art, Weibel suggests, replacing art's traditional representational activity with blank gestures and 'a rhetoric and aesthetic

of absence' which 'aimed to end art'.[17] Modern art, Weibel asserts, logically created anti-art.

Postmodernism and its descendants, in the movement away from the visual abstraction of modern art, swapped the chaotic sensation of abstract composition for the more troubling plane of rational (machinic) representation, with compositions of elements commonly derived from the representational chaos of the media and popular culture. Images (which had previously been abstracted) returned, albeit in a troubled and troubling way. The fear of images in many cultural settings, is overcome, because it is acknowledged, however complicitly, that images do not offer direct access to (unmediated) reality and/or truth, but remind us of the possibility of reality, and the improbability of (visual) truth. Images, Huber suggests, refer to reality, 'although not directly to the reality of the factual, but to its possible representation'.[18] 'True images', Weibel asserts, drawing upon John Locke's account of images, 'are the direct impressions of the senses'.[19] All images, in this sense, are virtual.

Many postmodern artists, following the Duchampian variant of modernism, took the emptied plane of abstraction as an iconoclastic space to be populated with the objects of everyday life, or as a performative space for themselves, sometimes taking from the palate of interactional elements of new and older (multi)media forms into installations – neo-modern variants on the spaces of art, conceptually and physically.

Although it appears to start from a more reasoned position than that of abstract expressionism, positing the materiality of the perceptible plane/surface of composition as the sensory space of representation, postmodernist approaches to expressive form and aesthetic experience move towards the chaotic sensation that resists opinion. They seem to offer the sensation of an impossible perceptual vantage point beyond reason (deterritorialisation) – sensation through thinking and then return again, reflexively doubling back on the vantage point (reterritorialisation), which mirrors postmodern critical theory. The spectator, as conceptualism prefigured, is required to determine (venture an opinion) about whether the work is art or not. But the formal openness which returned with postmodern art could not sustain the vision of some-how being outside the conceptual range of traditional art forms, however much or how widely it borrowed. Although nothingness may be structurally constitutive of existence, as Heidegger and Sartre proposed, we cannot go outside the structures of culture, by definition, for long, if at all. There may be *black holes* within culture (our logic), as there are in the chaos of the cosmos, but there is no *no-space* in culture, no prelinguistic (or precognitive) ground outside of it, by definition.

This disruption of the ground of (postmodern) art does not necessarily mean that the creative process itself cannot occur as a continuous development. Hausman puts it: 'the concept of Novelty Proper does not wholly exclude continuities from these processes that terminate in newly exemplified Forms'.[20] The difficulty for the creative arts researcher lies in how to observe and report upon this continuity and/or dis-continuity of creative development, which must, as Hausman acknowledges, 'undergo interruption' and 'include differences at some point'.[21] If there is no disruption of the known there can be nothing unique. Identifying the nature of the continuum within which the process occurs requires the acknowledgment of something new, and hence different, in the process, or of the process, or before the process, or at least prior to the terminus of the specific continuum.

Metaphors of novelty

The movement from the known (the intelligible world), to the unknown (the unintelligible world), however transitory, constitutes a rupture in the continuity of knowledge. It represents the *arationality of spontaneity*. Were it not so, as Hausman observes:

> one would necessarily suppose newness to be present throughout the continuum, and, if all processes are continuous, newness would then be continued as present from all time, past, present, and future. Consequently, no distinction between the old and the new could be made.[22]

Although this seems to confirm postmodern theory, it might be more helpful here to identify a notion of the creative process in art as defined in part by a notion of process (continuity) which 'includes breaks with respect to its own character'.[23] This kind of definition, or attempt to make creativity intelligible, emerges in relation to discourses about the nature of chaotic systems as more mobile ways of modelling reality than more deterministic accounts. Of course deterministic models of reality, which see the world as a system of 'determinate events and objects existing in accord with enduring patterns',[24] have long been under siege, not the least from within the various branches of science. Again, according to Hausman, the emergence of some sense of structure to the creative process, initially revolves around the way metaphor is employed to exhibit novelty. That is, the examination of the metaphoric status of the new raw materials, especially where these involve cultural recycling, and the emergent metaphoric structures of the created objects provide a site for such investigation.

The public fascination with the recent series of works comprising *We are Family* by Australian artist Patricia Piccinini (Venice Bienale 2002) reveals the private symbolic power which her hybridic metaphoric notionally stem-cell derived creatures hold in relation to the uncertainty of contemporary knowledge about our physical origins (Figure 5.1).

Similarly the dramatic metaphoric space generated almost tangibly by the multiscreen works of Sam Taylor-Wood exhibit, quite literally, a soap-opera-like structure for our emotional experiences, our subjectivity. Taylor-Wood produces through her multiscreen film projections and multi-image photographic works interactive spaces (by visual analogy/metaphor) where spectator/participants become imaginatively aware of their experience of decentred consciousness, of the slipperiness of objective, social and subject distinctions (Figure 5.2). The affectivity of this externalised structure encoded into the installations in particular resonates with the internal emotional structures (affections), which triggers, via cognition, as Armstrong terms it, an 'intimate fascination',[25] that is, a compelling personal response.

In the case of the Piccinini *stem cell* figures, it is not that we believe these mutant Disneyesque figures represent something real, but that we can make the leap to imagine that they might be, based upon a loose familiarity with recent biotechnological advances as portrayed in the media, so powerfully engages us. Piccinini puts it:

> We're at a very exciting time because we're at that point when we can start to determine the ways we can make stem cells become something, and the questions that are interesting for me are – 'what in fact gets grown, what do we make out of these things?'[26]

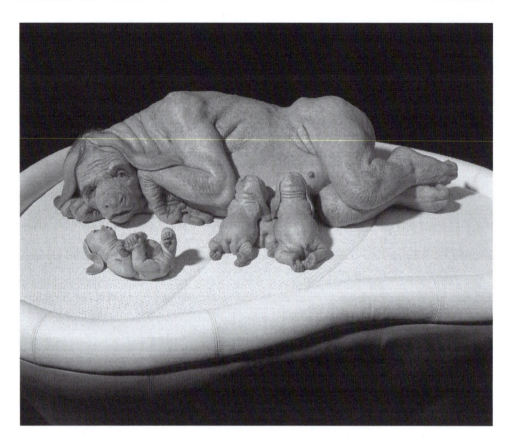

Figure 5.1 Patricia Piccinini, *The Young Family* (2002). Silicone, polyurethane, leather, human hair, dimensions variable. Photo: Graham Baring.

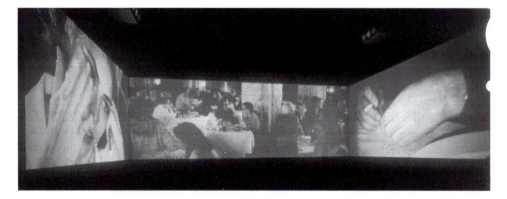

Figure 5.2 Sam Taylor-Wood, *Atlantic* (1997). Three laser discs for three projections. Duration: 10 minutes 25 seconds. © The artist. Courtesy: Jay Jopling/White Cube, London.

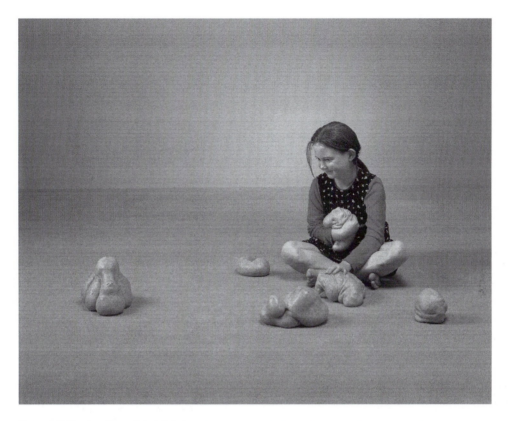

Figure 5.3 Patricia Piccinini, *Still Life with Stem Cells* (2002). Silicone, polyurethane, clothing, human hair, dimensions variable. Photo: Graham Baring.

We do not take her elusive metaphors as truth. They serve metaphorically, that is, in thought, to help us understand, via the imaginative work of Piccinini, something of the new possibilities of recent biotechnological advances (Figure 5.3). Millner suggests that Piccinini's work takes her, and us with her, 'well beyond the boundaries of the fine-artworld into the realms of science, industry and popular culture.'[27] She suggests that Piccinini's understanding, and her complex process of inflecting her work with disparate discourses, 'compels us to consider how these discourses construct our knowledge of contemporary phenomena.'[28] As such, it seems to help us understand something of the instability of our position in the contemporary world. It illustrates some of the ways in which older, mistakenly deterministic conceptions of Piaget's modelling of our awareness of our positions in the objective, social and subjective worlds, may seem to have imploded.

It is beyond the scope of this chapter, but the examination of these operations within the processes of creativity within art practice may reasonably serve a role in the broader project of attempting to construct models of intelligibility.

Keeping it real

The *unreal* work of art cannot be mistaken for the *real*. Jean-Paul Sartre:

> It is the situation-in-the-world, grasped as a concrete and individual reality of consciousness, which is the motivation for the construction of any unreal object whatever the nature of that unreal object is circumscribed by this motivation.[29]

However realistic, an image is always a work of imagination, a construction and/or selection, 'always *from a particular point of view*' (original emphasis).[30] An image is a negation of the world. What is simulated is not reality, but the situation of the artist-image maker: 'a particular intention of consciousness',[31] as Sartre puts it. As such, it also, by extension serves as a momentary trace or line across the discursive and psychological conditions, the cultural formations, around the situation within which the artist operates. To that extent then, art is, in Charles Peirce's terms, a *presentification* rather than a mere representation. That is, it is a presentation of the state of indetermination of the artist.

This indetermination gives rise in the artist to a nascent insight: 'a mere possibility of emergence', according to Braga, 'a blend of instinct and reason, instinct for the truth, or the reason of instinct'.[32] The possibility of something original 'is the fruit of the mind's potential for producing configurations which are not copied from something previous, but which spring up under the wild government of associations'.[33]

The reality of novelty is a product of instinct and reason. The materiality of the art object, offers a 'virtuality of newness'.[34] As Peirce put it: 'an external object excites an idea by a reaction upon the brain'.[35] Imagination operates for both the artist and the viewer/interpretant around the devised embodied material object. Without the original artefact, in Braga's words: 'a symbol would be a mere disembodied dream',[36] without any hope of communicative contact. Perception, being able to connect with the matrix of semiosis spun by the artefact, however immaterial, and its web of context, however variable, places the spectator into a virtual position of having to make an 'effort after meaning', as Bordwell terms it.[37]

Sam Taylor-Wood says of her installations:

> Many of my works are about being placed into difficult positions, which normally aren't public. They are hard to watch precisely because they are not part of a narrative. I'm interested in looking at how humans respond and react in moments of crisis. I want to examine the physical manifestations of anxiety.[38]

Taylor-Wood says that she has 'always worked quite instinctively', but also describes her method as follows: 'I always begin with a strong vision of how the work is going to look and function in the space and that very rarely changes'.[39] By her own description, the novelty of the work is a product of instinct and reason, as she investigates her recurrent theme of distress (Figure 5.4). Her multi-screen film and video works in particular provide an indeterminate semiotic and sensory field for the viewer who has to decide where and how to be connected to the symbolic work it imposes (Figure 5.5) and, according to Bracewell, becomes 'the mirror of our own insecurity'.[40] Bracewell suggests that:

Figure 5.4 Sam Taylor-Wood, *Pent-Up* (1996). Five screen laser disc projection with sound, shot on 16 mm. Duration: 10 minutes 30 seconds. © The artist. Courtesy: Jay Jopling/White Cube, London.

> Taylor-Wood's idiosyncratic engagement with destiny, or place in the scheme decided by conditionality or fate, becomes articulated through her art as the system that we carry around encoded on our existence.[41]

In the postmodern situation, there is frequently an attempt to present quotation or appropriation of an existing representation or familiar object as something new (or unknown). The seeming impossibility of originality (of originating something new) becomes possible by virtue of art's virtuality – the state of definitional indeterminacy of/in art. New hybrid forms, holographic projections, digital montage, interactive installations, have emerged which even more powerfully offer a space of *absence as presence*. The scene of aesthetic presentation though remains the starting point for artistic practice, where the affective structures 'constitute the sense of the object'.[42] The crux of the matter, Gans suggests, is 'whether we experience this particular newness as scandalous and painfully "cathartic", or whether we view the work with benign irony as the exhibition of its own absence'.[43] The simulation of newness, of being virtually original, of seeming to owe no debt to priority, and of originating in some way a new aesthetic modality, is bound up with the oscillation between form and content,

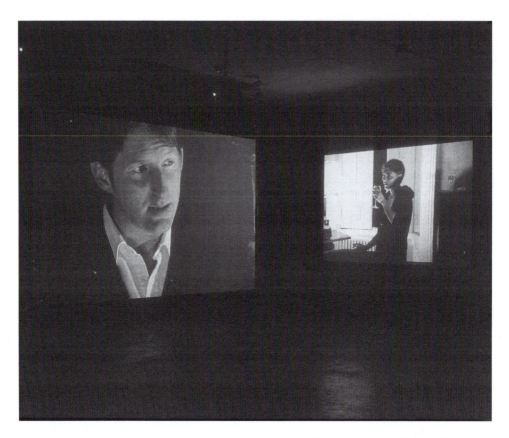

Figure 5.5 Sam Taylor-Wood, *Third Party* (1999). Seven 16 mm film projections with sound. Duration: 10 minutes. © The artist. Courtesy: Jay Jopling/White Cube, London.

between the denotative aspect of the art object and its connotative aspect in the significatory experience for the viewer 'under the wild government of associations'.[44]

> In the universe of simulated experience, the very concept of the esthetic is dissolved. It is no longer possible to speak of the formal separation of the 'work' from the world of the spectator's desire.[45]

Hausman argues that form is 'integral to the life of consciousness',[46] and Duvenage, drawing upon Habermas, proposes that art forms in particular offer 'the possibility of a discursive mediation between art and the life-world'.[47] Novelty in particular is identifiable in a special order or organisation which is/of the new thing – a different structure or form than all previous instances: 'It *exhibits* a new structure which newly *exemplifies* a Form' (original emphasis).[48]

Identifying the origins of novelty may reside within the consideration of spontaneity in individual creative processes, Hausman seems to suggest, or in the emergence within what he terms the 'stratification of reality' within which it belongs,[49] within the network of determination, as Peirce might have put it, to which it belongs. In art

criticism, the gap between the known and the unknown in *the new* can be located within the codes and conventions, the forms and genres of art, although that does not explain it. The emergence of something new, 'like spontaneity, serves at present to name but not explain the gap between causal conditions and the "new phenomenon"'.[50] Reality, then, is seen as 'not structured by continuity; rather, it is discontinuous'.[51]

Unfolding expression

Like human consciousness itself, the novelty of art cannot be resolved in terms of a categorical place within the structure of reality. Although the artist brings novelty into real being, in terms of an explanation, the lack of continuity in the apprehension of the process/es of creative practice maintains its place outside what is rational, or deterministic. The novelty factor in art may paradoxically be emblematic of human consciousness to the extent that it retains a lack of resolution or completion. It lacks *closure*, in narratological and popular cultural parlance. Perhaps if the conditions and qualities of the emergence of something new could be plotted and predicted (scientifically): 'there could be no radical breaks in the connections among Forms and structures that comprise the world'.[52]

As with the real world though, in the artworld, form cannot be separated from content or function. The composition or form of an artwork cannot be separated from its treatment. Massumi puts it: 'The artist's activity does not stand outside its "object" and operate upon it, as some alien matter'.[53] It involves a creative act, where experimental action is seen as an intensive process which 'modulates an actual emergence'.[54] Rather than merely being seen as manipulating a set of independent variables, creative practice 'brings a singular variation out into integral, unfolding expression'.[55]

In this sense, art is processual, not a thing but a creative event. The creative situation which gives rise to the 'moment of the actual',[56] Massumi suggests, 'retains a character of transitional indistinction'.[57] Massumi draws upon Paul Klee's notion of composition in proposing that the arts are not merely about construction – the combination of an abstracted set of variables – but are oriented towards composition – a moment of 'integrally experienced emergence'.[58] Composition is virtual, composing form from the *unform*:

> The virtual whole is a transformational or *transitional fringing* of the actual. It is like a halo of eventness fuzzifying solidity of form and thus confounding closure. It is the 'aura' of newness surrounding and suffusing what actually emerges. [original emphasis][59]

Newness, he proposes, is 'what is comparable only to itself'.[60] Massumi is asserting here that emergent forms bring a 'fringe of virtuality' with them,[61] regardless of course which medium has been employed. This virtuality of newness is not too far removed from Heiddegger's sense of the veil as that which veils, and as such arguably takes creative practice as a transformational act – as thinking through/as experimentation. 'The conceptual newness is there,' Massumi asserts, 'in the event, *enacted*' (original emphasis).[62]

Art practice is not necessarily bounded by established theoretical modelling, but it has actively participated, especially throughout the twentieth century, in the development of new theoretical models of art. Art practice is philosophy in action, or as

Massumi puts it, art composition is 'enacted philosophical thought'.[63] This suggests that art as 'enacted philosophical thought' is able to bring forward a variation of the emerging or prevailing worldview, if not yet articulated or thought out, into 'integral, unfolding expression'.[64]

The weakness of Western philosophy though, Debord proposed, is that the 'alienated thought'[65] of technical rationality generates a 'universe of speculation',[66] but one which is 'the perfection of separation *within* human beings' (original emphasis).[67] In particular it 'attempts to understand activity by means of the categories of vision'.[68] The focaliser of contemporary art practice though, including the imagery of sound and writing, frequently involves an outward movement of speculation which hesitantly stares back at itself, as Elkins might suggest, through the lens of technical rationality and its 'categories of vision',[69] into the ever expanding universe of human possibility. Vision, Elkins says, 'helps us to know what we are like'.[70]

Keeping it unreal

As has already been alluded to, the affective structures of and around the art object ensures the spectator's desire doubles the feelings of the artist around the representational plane or *scene*. The imagination employed in the production of something new in art (unreal) involves a kind of sleight of hand, where the unreal but known (a work of art) brings us strangely into a closer relation to the real (unknown), not of the world *per se*, but the world of consciousness of it. That is, the artist's unfamiliar take or viewpoint on the world can simulate our own sense of being situated in the familiar world, even as it unsettles our own view of the familiar world. The unreal art object can simulate, represent or stand in for the consciousness of emptiness, a consciousness 'awake to the transient states of the here and now'.[71] 'Reflection', Sartre said, 'yields us affective *consciousness*' (original emphasis),[72] the consciousness of something felt. Consciousness surpasses the real in constituting it as a world, a world the artist seeks to set before us. As has already been asserted:

> every apprehension of the real as world tends of its own accord to end up with the production of unreal objects because it is always, in one sense, a free negation of the world and that always *from a particular point of view*. [original emphasis][73]

The simulation of newness in art practice might also then be thought of as representing our modelling of the transitoriness of the experiential world, as we know it, and the existential condition of being cognisant of observing that moment, somewhere (in the studio, outside world setting or laboratory). Novelty (newness) remains indeterminate in terms of its place within the structures of reality. Uncertainty is the operating principle within, around, and about art. Weibel puts it: 'Self-doubt to the point of dematerialization is the logical force inherent in art, and advancing its development'.[74] The point of the origination of originality remains elusive, and seemingly logically absurd.

Art, language and philosophy continue to remain outside the scientific paradigm, the provable, and retain their magnetic pull as areas of high calling, for approaching the *chaosmos* – what is neither foreseen nor preconceived. It is ironic that the tools of language, reason, imagery, the tools of what Habermas termed 'communicative reason', which provide for our entry into culture, are also the tools which enable writers, philosophers and artists to go outside established culture, the known, to do something new,

to provide the reader/spectator with a glimpse of the unknown. Aesthetic mediation, according to Habermas, reaches 'into our cognitive interpretations and normative expectations and transforms the totality in which these moments are related to each other'.[75]

The doubling of the knowledge complex of art with the complex explanatory models of the critical, of thinking through the composition of visions and sensations and thinking about the ground for the issues set up by these compositions, is emblematic of the reflexivity inherent in human thought, which mirrors the processes of the inner struggle for identity at the heart of human existence. The attempt to resolve the paradox of novelty in art reveals something processually constitutive of the structure of human consciousness.

Notes

1 Deleuze, Gilles and Guattari, Felix (1994) *What is Philosophy?* Trans. G. Burchell and H. Tomlinson. London: Verso, p. 197.
2 Gans, Eric (1993) *Originary Thinking: Elements of Generative Anthropology.* Stanford, CA: Stanford University Press, p. 213.
3 Barthes, Roland (1977) *Image Music Text.* Trans. S. Heath. London: Fontana, p. 44.
4 Gans (1993), p. 215.
5 Benjamin, Walter (1973) *Illuminations.* Trans. Harry Zohn. London: Fontana, p. 212.
6 Derrida, Jacques (1976) *Of Grammatology.* Trans. Gayatri Spivak. Baltimore, MD: Johns Hopkins University Press, p. 266.
7 Piccinini, Patricia (2002) Edited transcript of interview by Julie Copeland on ABC Radio National *Sunday Morning* programme, 26 May 2002, available at http://www.abc.net.au/arts/visual/stories/s597714.htm
8 Ibid.
9 Gans (1993), p. 214.
10 Belting, Hans (2002) 'Beyond Iconoclasm: Nam June Paik, the Zen Gaze and the Escape from Representation', in Bruno Latour and Peter Weibel (eds) *Iconoclash: Beyond the Image Wars in Science, Religion, and Art.* Karlsruhe, Germany: ZKM (Centre for Art and Media); Cambridge, MA: MIT Press.
11 Ibid. p. 390.
12 Galison, Peter (2002) 'Images Scatter into Data, Data Gather into Images', in Latour and Weibel (2002), p. 300.
13 Deleuze and Guattari (1994), p. 182.
14 Ibid. p. 204.
15 Ibid. p. 180.
16 Ibid. pp. 180–1.
17 Weibel, Peter (2002) 'An End to the "End of Art"? On the Iconoclasm of Modern Art', in Latour and Weibel (2002), p. 636.
18 Huber, Jorg (2002) 'On the Credibility of World Pictures', in Latour and Weibel (2002), p. 522.
19 Weibel (2002) 'An End to the "End of Art"'? p. 589.
20 Hausman, Carl (1984) *A Discourse on Novelty and Creation.* Albany, NY: SUNY Press, p. 36.
21 Ibid. p. 37.
22 Ibid.
23 Ibid.
24 Ibid. p. 117.
25 Armstrong, John (2000) *The Intimate Philosophy of Art.* London: Allen Lane, p. 3.
26 Piccinini (2002).
27 Millner, Jacqueline (2001) 'Patricia Piccinini: Love in the Time of Intelligent Machines', *Artlink* 21(4): 42–7.
28 Ibid.

29 Sartre, Jean-Paul (1972) *The Psychology of the Imagination*. London: Routledge, p. 215.
30 Ibid. p. 215.
31 Ibid.
32 Braga, Lucia Santaella (2003) 'Why There is No Crisis of Representation, According to Peirce', *Semiotica* 1431(4): 45–52, p. 50.
33 Ibid.
34 Ibid.
35 Peirce, Charles S. (1931–66) *Collected Papers of Charles Sanders Peirce*, 8 vols, Charles Hartshome, Paul Weiss and A. W. Burks (eds). Cambridge, MA: Harvard University Press, p. 2276.
36 Braga (2003), p. 51.
37 Bordwell, David (1989) *Making Meaning: Inference and Rhetoric in the Interpretation of Cinema*. Cambridge, MA: Harvard University Press, p. 264.
38 Taylor-Wood, Sam (2002) *Sam Taylor-Wood*. Göttingen: Steidl for the Hayward Gallery, p. 7.
39 Ibid. p. 5.
40 Bracewell, Michael (2002) 'The Art of Sam Taylor-Wood', in Taylor-Wood (2002), p. 11.
41 Ibid. p. 10.
42 Sartre (1972), p. 77.
43 Gans (1993), p. 212.
44 Ibid.
45 Ibid.
46 Hausman (1984), p. 143.
47 Duvenage, Pieter (2003) *Habermas and Aesthetics: The Limits of Communicative Reason*. Cambridge: Polity Press, p. 64.
48 Hausman (1984), p. 28.
49 Ibid.
50 Ibid.
51 Ibid. p. 67.
52 Ibid. p. 69.
53 Massumi, Brian (2002) *Parables for the Virtual: Movement, Affect, Sensation*. Durham, NC and London: Duke University Press, p. 73.
54 Ibid.
55 Ibid.
56 Ibid. p. 164.
57 Ibid.
58 Ibid. p. 174.
59 Ibid. p. 175.
60 Ibid.
61 Ibid.
62 Ibid. p. 176.
63 Ibid.
64 Ibid.
65 Debord, Guy (1994) *The Society of the Spectacle*. Trans. D. Nicholson-Smith, New York: Zone Books, p. 18.
66 Ibid.
67 Ibid.
68 Ibid. p. 17.
69 Elkins, James (1997) *The Object Stares Back: On the Nature of Seeing*. San Diego, CA: Harvest, p. 201.
70 Ibid.
71 Hodgkiss, Phillip (2001) *The Making of the Modern Mind: The Surfacing of Consciousness in Social Thought*. London and New York: Athlone, p. 10.
72 Sartre (1972), p. 76.
73 Ibid. p. 215.
74 Weibel (2002) 'An End to the "End of Art"?', p. 636.
75 Habermas, Jurgen (1985) 'Questions and Counterquestions', in Duvenage (2003), p. 202.

Part 2

Introduction to Part 2

Katy Macleod and Lin Holdridge

The following chapters reflect upon the authors' doctoral submissions, where equivalent writings, together with research artworks, were presented as the research thesis. Thus the research artworks constitute part of a body of doctoral research study. Research artworks and writings are conceived to pursue advanced thought in the discipline of fine art. In each case, artist scholars have formulated a thesis which is dependent upon the exigencies of writing in relation to making or realising material work. Thus the writings cast light on word–image relations as the complex thinking in the artworks is contextualised and revisited in written form, which in turn revisits the artwork. In fact it could be argued that it is the tension between the two modes which helps to generate the depth of thought encountered in the final submissions.

The chapters in this part also reveal inventive uses of theory. Historically artists' powers have been fully exercised when they have appropriated current theories. One very obvious example would be the Surrealists' use of Freudian psychoanalytic theory. Freud's thinking on the subject of the unconscious informed their art. It could be said to be the grounding theory, for example, for their theory of automatism as well as their theoretically innovative *poèmes-objets*. It is undoubtedly true that the concept of the unconscious unleashed a fiercely inventive new theorisation within Surrealist circles, which creatively energised both their writings and their artworks. However, these works, which bear strong traces of such theory, could not be said to be literally illustrative. The marvellous flowering of Surrealist art subsequent to André Breton's close identification with Freud's *Interpretation of Dreams*, for instance, could be marked as adding to knowledge of the unconscious. In a similar way, the individual chapters here reveal the enormously inventive ways in which artist scholars have interpreted theory through artwork and writing.

We could, however, argue that the realms of theory and art practice are unalterably separate as Jim Mooney argues in his exemplary doctoral study:

> I would urge in favour of the *a priori* acceptance of the gap between theory and practice as not only inevitable but desirable in that it allows for the dislocation of complacent conventions in the respective fields.[1]

Or it might be productive to maintain a mutually hermeneutic relation between them, (which is actually the case being argued here). We could make a compelling case for such a relationship. We could suggest that the theorisation in these studies are produced *in* and *of* the gap between extant theory and artwork. How then do we begin to identify this theorisation?

The following chapters will shed light on such questions. They will also serve to illuminate the complex matter of art *as* research, as one way in which art acts. Just one example from research into doctoral studies might serve our purposes here: in the study of *Silent Painting*, after a comprehensive analysis of all the available material on silent painting and the production of artworks to investigate the concept (coined by Lucy Lippard in 1967)[2] the artist maintained that silence could be located only through feeling; there was no logical way, in his view, to identify what silence might *be*. Such identification could come only as the result of responding to the work, through a feeling response. Whatever logic and systematised thinking went into making the work, its content *as* silence could not be predicted, only experienced.[3]

With this in mind, we must turn to the individual chapters. In Chapter 6, 'Representing illusions', Tim O'Riley investigates the physical and narrative relations between image and viewer. His research serves to orchestrate the viewer's position in relation to the artwork so that he or she becomes part of the work. Thus, artwork and viewer together illuminate the theoretical principle of the representation of illusion. The viewer's role is identified as crucial in recognising a work's significance. Tracing a careful line of participant viewing from Ilya Kabakov's *The Untalented Artist and Other Characters* to Duchamp's *Rotoreliefs* and *Stereoscopie à la main*, O'Riley reveals how this works. It is the filmic image, in particular, which offers an analogy of 'internalised interpretation'. Here, in the case of Hitchcock's *Rear Window*, O'Riley traces how the viewer enters into the film's narrative and becomes caught up and implicated in the unfolding story.

O'Riley makes a compelling case for the viewer's construction of narrative, however, the research purposes are to illuminate the viewing of digital installation research artworks where 'The work's meaning . . . is to be found neither in the work itself, nor in the hands, eyes or minds of either artist or viewer. It is apparent only in the space or the difference between them' (p. 103). O'Riley adumbrates how the space of an artwork is non-space. It precludes conventional perspective and invites a curious engagement with that which does not exist but can be termed illusion. The research artworks tease the viewer into losing any sense of what might have existed (the studio, for instance) and what is purely virtual. There is then an ellipse between the material and the virtual, between that which can be counted on for some sense of the *real* and that which slips into non-space. This chapter offers some acute understanding of what it is to construct an illusion which acts to destabilise that which an instant before, had been taken to be materially real. It entices the viewer/reader to look afresh at what is around her/him.

Chapter 7, 'Spatial ontology in fine art practice' by Naren Barfield, poses questions about how artworks both exist in space and reproduce it. Barfield turns to spatial ontology as a field within which his research into non-Euclidean geometry, mathematics and the fourth dimension can reframe what he has taken to be pictorial space. With exacting reference (in his doctoral work) to Cubist research and through research in geometry and mathematics, the digital print research works call into question conventional concepts of space within the medium. Using video and digital manipulation, this study presents

> disparate events simultaneously . . . to create convincing syntheses of spatially and
> temporally distinct incidents [which] dislocate the viewer from the normal cues

used to orientate their relationship to the events seen and heard [so that the] work declares . . . that space is mutable, subjective, discontinuous, shaped by experience and characterised by both temporal and dimensional instability. (p. 118)

The reader might be in advance of the intellectual proposition, because it has been rehearsed elsewhere, but the experience of the highly unfixed nature of space, and our subjective understanding of it, within these research artworks provokes the viewer into an encounter with the fourth dimensionality which requires new perceptual reasoning to understand. This is re-enforced by the knowledge that the source medium is print and thus that which can be assumed to be two-dimensional. He or she might assume each print could be read like a loose-leaf book rather than be worked with to understand how to perceive its presence.

'sidekick' (Chapter 8) also unravels preconceptions about form and presence. Through the process of winding manufactured tape back onto itself, this doctoral study constructs a highly reflexive research soliloquy. It provides a philosophical discourse on its production. This is determined by Marxist materialism and hence by an understanding of art production as a matter of economic relations: the work's progress is termed 'a terse economy'. However, the written text is circular, arbitrarily repeated and returning on itself, refusing both popular reasoning on economic relations and the economics of research production. Reasoning here is not deductive; notions of progression are turned on their head; research protocols and methods are critiqued and set within an absurdist paradigm. The sustained soliloquy on the developing (art)work is described as possibly a 'hoax' (that maybe the artwork might be hollow). In that one word, the procedural and scholarly niceties of research, are called into question. What then is the provenance of the writing? Is it fallacious? Academic sobriety of purpose, the probity of higher degree research is taunted by this research *as* art. The research work, at some point named 'boulder', acts as a talisman for that which does not act as research, yet is clearly employed in research study.

Chapter 9, 'Painting: *poignancy and ethics*' explores how it is to experience painting, to be 'moved' by it. Jim Mooney employs a range of subtle professional, intellectual and life knowledge to enable an understanding of the work of a painting; how it can draw the viewer to feel into and experience its affect. This comes through painting's 'failure to mourn'; it comes through its capacity to be 'a world in itself', both of the world as it is experienced and simultaneously apart; its object in what Mooney calls a partial mourning is to return to itself and to ethically inscribe its works into the world from which it has temporarily (momentarily) withdrawn. Poignancy leads the viewer to a close understanding of what it is to feel intelligently: 'Poignancy moves us, redirects us, and the movement it gives rise to, leans us toward the other and inclines us toward the condition of implication where the same and the other become entwined, enfolded, enlaced' (p. 138). It also leads us to reverie and that which in research cultures is repressed: 'It is the sting of poignancy which enables such a shift; we lurch, move outside ourselves, take a step beyond, and are briefly enveloped in the rapture of the ecstatic' (p. 138). Such ecstasy is not induced by words: it belongs to painting whose affects preclude tired thinking about evidence of advanced thought because thought is also feeling. In the moment of art's embrace, thought is changed; as viewer and work elide, art 'emerges' and we too are changed: 'in a very important sense, art becomes us' (p. 142).

Chapter 10, 'Poesis' also conceives art as mirroring the very nature of our meaning-making activity. However, although Siún Hanrahan's doctoral submission examined the structural equivalence of philosophic and artistic thought, her writing here moves away from the kind of testing out which is central to both her and Rankovic's advanced study. Here, Hanrahan is engaged in understanding the 'poetics' of how art works. Like Mooney, hers is an ethically determined view:

> In making art this immense responsibility, the lack of warrant or foundation for the meanings we forge, although forcefully present at the first moment, is overcome in the beginning and, for the most part, only haunts the subsequent process. (p. 146)

Hanrahan demonstrates how we create structures to protect us from our meaningless purposes: she views art as taking on the 'form' of a conversation. Such conversation involves an active exchange and a projection of self onto relations perceived in the work itself. It is a kinaesthetic process, challenging as well as active, which generates thought; that is thought *through* this relationship and its conversations. Some of these conversations, as demonstrated by her example of a viewing experience, might not be easily acceptable to an art audience. Nonethless, these are equally conversations; they return the viewer to their own discursive sense of the world which is most actively engaged when the relevant conversation is least understood:

> What is required, therefore, in the face of the multiplicities of contemporary culture is that we develop our ability to explore conflict rather than simply seek consensus. Moving between the constellation of readings anchored by an artwork reveals the limits of what can be known from any given position and opens the possibility of exploring the relationship between the diverse perspectives anchored in a single entity. (p. 151)

There is therefore, no need to reduce diversity of readings or the complexity of experiencing, as art offers a space for their exploration.

In Chapter 11, 'Frozen complexity', Milos Rankovic examines causal explanations for the viewer's perception of art. The perception of beauty or ugliness are caused by stimuli which can be measured in relation to the viewer's need to find epistemic meaning; too much stimuli and the viewer finds the artwork ugly, for instance. What Rankovic calls the viewer's 'epistemic hunger' is a function of the limbic system which, as it were, bids the brain's 'attentional' resources. Art's function here is to offer an aesthetic experience which is intense and complex; it can be seen as 'a measure of investment in perceptual problem solving'. Experiments based on lossy compression indicate that complexity involves a trade-off between degrees of disorder. Fractal complexity whether it be in the work of art, Jackson Pollock's for example, or in nature, is part of 'our world of spatially scalable structures'. It is part of a world which is structurally dependent on random sequencing. However, unravelling how this randomness operates in relation to the aesthetic experience, even through the construction of an aesthetic selection algorithm, does not reveal where complexity lies: is it in the art? In the set of objects to which it belongs? In the endless hierarchy of scales, computational systems or indeed attitudes? Rankovic's research reveals the core of our paradoxical reasoning about art:

Complexity is not in the image in a similar way that it is not in the word. To experience an image is to live through the movement across the aesthetic landscape of images that this image is, more or less, not. As the attention rolls down the features of this landscape, the horizon of expectations whets the epistemic appetite and motivates further movement. The origin (and destination) of the perceived complexity is finally traced back to that dynamic system of expectations, or attitudes, that is variously called individual or culture. (p. 166)

However, we choose to define art's purposes or determine those ways in which it could be said to act, it is fundamental to our expectations of those cultures in which we live. Rankovic demonstrates how art's structures elicit systems of expectations and attitudes which are dynamic in the world.

Chapter 12 'Decolonising methods: reflecting upon a practice-based doctorate' presents a highly charged conversation between those concepts of space conceived by the Dogrib and Inuit peoples of north-west Canada and those designed and instituted architectural spaces imposed by successive Canadian governments on their lands. Thus land and concept of continuous space and celebration of time–space relations were repressed within indigenous cultures. Further 'conversation' mirrors the spatial determinism in the research study with that exercised by successive English governments on Scotland through the founding theory of generalism adopted by Renwick. Generalism comes out of the Scottish tradition of education and its rigorous distinctness from the social, economic and political determinism of English successive governments in Scotland. This chapter examines the ways in which knowledge and power are legitimised. The research methodology unravels assumed knowledges and power constructions and offers a different kind of social mapping in the contexts of research projects in the European Union, including Eastern Europe, and Dogrib and Inuit peoples' lands of north-west Canada. It presents this through drawing in relation to anthropological writings; journey diaries; interviews; biographies; official government and housing documents and so on. Drawings, in particular demonstrate what it is to *present* thought which is non-linear, multilayered, simultaneously complex and simple and, above all, non-prescriptive.

All these research studies offer different freedoms for thought. That is their originality. Research *as* art does not close down thought; thought *through* art opens non-predictive spaces for further thought because the artwork is still tantalisingly present and its presence hits against any potential closure in the summaries or conclusions prescribed by research cultures for the written texts. Could we, then, assume that art offers a potent space for *unknowing* and that this might be useful to advanced thought?

Notes

1 Mooney, Jim (1999) *Research in Fine Art by Project: General Remarks toward Definition and Legitimation of Methodologies*. Middlesex University (pending publication).
2 Lippard, L. R. (1967) 'The Silent Art', *Art in America* 55(1): 58–63.
3 Macleod, K. and Holdridge, L. (2003) *The Doctorate in Fine Art: A Study of Eight Exemplars* (Funded by the AHRC, pending publication).

Chapter 6

Representing illusions

Tim O'Riley

In 1989, Ilya Kabakov, exhibited a series of works at the Institute of Contemporary Arts (ICA) in London entitled *The Untalented Artist and Other Characters*. Each work depicts or tells the story of a different fictional resident in a communal apartment of the type found in large cities in the Soviet Union. In the accompanying exhibition catalogue, Kabakov describes the experience of living in such an apartment block, a place teeming with characters who argue and squabble and yet where occupants often knew little about their neighbours and what they were up to in the privacy of their own room. One work, *The Man who Flew into his Picture* (1981–8), recounts the story of a man who sits in his tiny room, faced with a large white board on which he has drawn a small picture of himself. Kabakov's text, which forms part of the work (other elements include the chair and large board mentioned in the text), explains how, as the man stares at the small grey figure he has drawn, the board appears to change at first into a white fog and then into a 'bright expanse pierced by an even, sparkling light'.[1] The man feels drawn into this expanse and feels himself merge with the little figure which then appears 'entirely alive and real (though small, many times smaller than he . . .)'. Gradually, the figure appears to move away from the surface into the depths of the light eventually becoming indiscernible from the white expanse. Yet while the artist feels himself drawn into the picture, part of him realises he is 'sitting completely immobile in his lonely room' staring at a large, badly painted board with a small drawing on it. Caught between reality and its representation, he loses track of where he actually is, in the picture or in the room? His solution to this puzzling dilemma is to invent a fictional third person, a kind of witness who understands what is happening and why it is necessary 'to sit on the chair and to fly into the depths, to be bored and to fantasise wildly'. An explanation is written for this observer and is placed next to the painting for reference.

The Man who Flew into his Picture articulates the duality involved in looking at a representation where we project ourselves imaginatively into pictorial space with the help of the figures and spaces represented but at the same time, where we remain anchored in the real world, subject to the physical necessities of everyday living. The installation, which incorporates real objects, drawings and texts in a manner redolent of a museum tableau, seems to be inviting the spectator to participate as the notional third person, the witness and validator of events. We are, perhaps, all that prevent Kabakov's artist from disappearing entirely into his picture. The work seems to be as much about the mechanics of the narrative illusion as it is about the illusion itself, being on the one hand a meditation on imaginative potential and on the other, a

poetic evocation of the gap between reality and fantasy. It also neatly posits the relationship between artwork and viewer as involving participation at one level or another.

As in Kabakov's description of the lone artist, I am interested in the idea of a picture, in a type of image which in some way represents or refers to something outside itself, perhaps mimicking the appearance of that thing. Pictures are real objects, material things, but they are deceptive in that they also show things which are absent. Pictures can also exist within one's mind. That is to say, perceptions of the visual world as well as the mental images experienced in dreams, memories or hallucinations occur somewhere within a viewer's mind. I am interested in the types of pictures which prompt us to ask where the illusion is taking place and also how that sense of place or space, the physical location of the viewer and image, can affect how the image is understood. I have regarded spectatorship as a process of constructing meaning and as an activity which is essentially private, where misapprehension, misreading or misprision, to use Harold Bloom's term, may be as important and valuable as an apparently accurate reading.[2] As Gilles Deleuze asks: 'Does not the paradox of repetition lie in the fact that one can speak of repetition only by virtue of the change or difference that it introduces into the mind which contemplates it?'[3] Bakhtin states: 'Dialogic relationships are absolutely impossible without logical relationships or relationships oriented toward a referential object, but they are not reducible to them, and they have their own specific character'.[4]

Aspects of structuralist theory and criticism have been concerned with questioning notions of the author as the originator of meaning within a work or of that work referring unambiguously to a world external to it in favour of a text whose meaning is determined by the discourse it engenders. Mikhail Bakhtin, on the other hand, acknowledges the subtle relationship between the authorial word, 'which directly embodies . . . the semantic and axiological intentions of the author' and the prevalence in the novel itself (particularly the comic novel) of a variety of different types of language which refract authorial intention.[5] He posits a relationship between normal language and these differing language strata which is essentially dialogic and uses the term *heteroglossia* to describe the coexistence of and dialogue between different types of language in the novel.[6] For Bakhtin, the author is not to be found in specific utterances (in *normal* or other language types) but makes use of them when it suits him:

> he [the author] makes use of this verbal give-and-take, this dialogue of languages at every point in his work, in order that he himself might remain as it were neutral with regard to language, a third party in a quarrel between two people, (although he might be a biased third party).[7]

Bakhtin's emphasis on dialogue as an inevitable and necessary aspect of novelistic discourse has provided a useful analogy for the relationship between the visual, conceptual and textual aspects of my own practice. This is concerned with textual sources, with historical and theoretical considerations of space, representation and the viewer, but not exclusively so. Artworks are developed from the outset in tandem with textual research and there is an inevitable and necessary interplay between the activities of thinking, reading, writing and making. If formal research is to be of use in terms of creative art practice, it must be acknowledged that the relationship between practical

and theoretical work is complex and, at times, elliptical. Visual research is generally concerned with making and also with considerations of artistic precedents and sources, the drawing of analogies with other media and disciplines. In terms of practice, there is a constant dialogue between visual and textual concerns with one activity refracting or pulling into focus ideas brought to light by the other. If a sentence is described as elliptical, it is seen as having omitted a word or phrase which is needed to complete the sense of the expression. The practice of working in parallel activities has meant that the visual has an elliptical relationship to the textual and vice versa; that is, each activity can be seen as completing or contributing to the sense of a particular train of thought, a meaning or argument indicated in the corresponding activity. Drawing on Bakhtin's use of the term, if a dialogue of sorts can occur between two activities, then the relationship between the visual and the textual is both dialogical and elliptical with either practice finishing the sentence implied by the other.

A central aim has been to consider how the construction and interpretation of a world or space from a two-dimensional image is related to the activity of seeing. Although research into vision has informed my research to a certain extent, my interest has been less in terms of the perceptual and physiological aspects of seeing than in the relation between one's perception of an artwork or picture and what could be called the narrative significance of looking. Perception is never isolated from either the psychological implications of the viewed image or its resonances within the viewer's particular cultural and emotional make-up. The viewer brings to the work an individual history, including particular sets of associations, pretexts and opinions which affect how the work is read. An artist cannot be expected to account for how his or her work may affect its audience but can effectively anticipate and structure the relationship between the two. I am broadly concerned with looking at various ways in which this can be done and with applying the insights gained to the conception and construction of specific visual works. My aim has been to investigate the relationship of the spectator to the image and consider how the spatial position and interpretive faculties of this viewer can contribute to the meaning of the image. I have been interested in how different media and strategies for representing the world control or direct the play of associations, in how the image resonates within the viewer. A representational picture presents a framed or bounded portion of space and so prevents visual access to an implied space beyond the frame. The dialogue between these two spaces, the visible and the invisible, sets up in the viewer a process of interpretation which draws on their experience of perceiving the world. If perceptual activity involves the constant, perhaps unconscious positing of hypotheses about what is seen, the perception of images and what they represent involves a similar process of decoding and projection: decoding what is apparently represented and projecting an interpretation regarding its significance.

Indeed, the physical gap between the viewer and picture surface can be as full of narrative and evocative potential as the implied space behind that surface. Distance precludes the possibility of involvement in a situation or the likelihood of changing the course of events. The picture plays on the attraction of the out-of-reach.[8] Participation takes place on two levels. We are both deluded by the illusion and yet simultaneously collude in its interpretation, that is, we willingly suspend our disbelief. To be deceived by an illusion such as a *trompe-l'œil* can be seen either as an instance of the failure of one's perception – the brain mistaking picture for pictured thing – or as

Figure 6.1 Tim O'Riley, *Four Intervals Gray* (1998). Digital C-print, 81.6 × 152 cm.

a demonstration of the brain's collusion in the construction and interpretation of perceptual events. We are somehow aware that we are looking at a picture but go along with the trickery all the same.

If an image as well as a sensation can be internal, that is, in my mind, it is usually referred to as a mental image. A problem with the notion of such an image is that it is not at all easy to point to one as we might to a real, material image – a picture of a chair, for example – or to the chair itself. A mental image which we call to mind in the absence of the object to which it refers, combines knowledge about that object (its perceived structure, colour, size, etc.) with visual aspects of it (a familiar view of it, for example) into a mental conception of the object. If we look at an object or a picture, there is a sense in which our actual perception of it is interrelated with our mental image or conception of it. That is, perception is a primary activity dealing with the relationship of external stimuli to pre-existing notions of what is perceived. In a stereoscopic image, in which we perceive spatial relationships in a manner which is analogous to our perception of actual three-dimensional space, the material picture provides the basis for the experience but the depth perception occurs somewhere within our visual array. It would be unreasonable, indeed, to say that this additional space is truly external to us even though it appears to be situated in and around the perceived picture plane.

In 'Proof of an External World', G. E. Moore attempts to counter the notion that the existence of things outside us rests on a matter of faith and to question the validity of Kant's own proof of the 'objective reality of outer intuition'. The latter implies that spatial awareness is an a priori intuition and does not result from an empirical investigation of actual space in the physical world. As Kemp maintains, Kant's 'idea of space can lay the foundation for sensory intuition but cannot be conceptually touched by perception of the exterior world.'[9] Moore uses a common-sense analytical method to separate what we understand to be the external world from any experience or any

perception we may have of it and so argues against the solipsistic notion that the self is all that exists or is all that can be known.[10] If something I might perceive is independent of my having any experience at that time, then it could be said to be external to my mind. Moore begins by defining more precisely what the term external might mean and differentiates between things which are presented in space and things which are to be met with in space suggesting that the latter expression is more precise in describing what we normally understand as external things. The after-image caused by staring at a white circle on a black ground for a prolonged period and subsequently looking at a white background is in Moore's argument, presented somewhere in space. It is not, however, really justifiable to say that it is to be met with in space as it is impossible that someone else would experience or perceive that very same after-image whereas they will perceive the very same piece of black or white paper. Similarly, a pain which I experience may appear to be located in my leg which is in itself spatially located but it cannot be felt by another person although they may experience an identically similar sensation. By stating that there are some things which we experience in a private sense and others in a more public space, Moore establishes the notion of external things by positing those aspects of experience which could be called internal.[11]

If there are experiences which occur within our perception which cannot be shared in a literal sense, then these can be differentiated from things which can be shared. If, then, these things are to be met with in space, although implying that they might be perceived, it does not follow that they are, that they ever have been or that they ever will be, by me or anyone else. Moore goes on to question the notion that such things that are to be met with in space are necessarily external to our minds by considering those things which could be said to be in our minds. After-images or pains are typical examples of such things – whereas a pain or an after-image could be said to be in my mind, my body most definitely is not, even though I may be thinking about it. Moore maintains that if I add a date to an expression about a pain I have had – last week I had a headache – it follows that I was having an experience at that time, whereas if I locate an expression about my body in time – last week I had long hair, for example – it merely provides historical or biographical data and neither establishes that there was necessarily anything in my mind nor that I was having an experience.[12] If something external to our minds (i.e. our bodies) existed at a specific time, it does not follow that we were having an experience at that time. Similarly, if something external to us experiences pain, although constituting an experience internal to it, by no means implies that we experience something. Therefore if a thing were dependent on my having an experience, it would not exist outside me, it would not be itself. Moore uses the example of a soap-bubble to make his point which is worth quoting at length:

> But if it is true that it would not be a soap-bubble, unless it could have existed at any given time without being perceived by me at that time, it is also certainly true that it would not be a soap-bubble, unless it could have existed at any given time, without its being true that I was having any experience of any kind at the time in question: it would not be a soap-bubble, unless, whatever time you take, from the proposition that it existed at that time it does not follow that I was having any experience at that time. That is to say, from the proposition with regard to anything which I am perceiving that it is a soap-bubble, there follows the proposition that it is external to my mind.[13]

It could perhaps be said to necessarily and fully exist only when perceived. The material object or image no doubt exists as it provides the basis for the experience but there is a sense in which the work is not really complete until looked at or, if one reverses the polarity, the work completes the viewer's perception of it. In the cases where such optical illusions are appropriated for the purposes of art as in Marcel Duchamp's *Rotoreliefs*, for example, this completion is an automatic or involuntary function of the viewer's perceptual system which nevertheless leads to some form of mental or conceptual projection about the artist's intentions. Duchamp's spinning discs are best viewed with one eye closed and induce a perception of rhythmically pulsating forms which appear three dimensional even though they are printed on thin card. The impression is, of course, optically based although the discs are not concerned with effect alone but with using that effect to suggest certain mental or physical states through a kind of hypnosis. The viewer is drawn into the picture almost by subterfuge while at the same time being provoked or invited to speculate on its significance. In a sense, such a work induces a primary experience, one that cannot be reproduced. One's perception of it may result, in theory, in an identically similar experience to that of someone else but this does not mean that the perceived image is the very same image perceived by that other person. Although the material image exists before, during and after the perception of it, the image in one's mind is transitory and necessarily private.[14]

Unknown reality works like a stereoscope

(Paz)[15]

The spectator makes the picture

(Duchamp)[16]

For now this spectator not only completes, as object, the subject matter of the transitive or affective work of art, but beyond that he becomes an accomplice in its aesthetic functioning.

(Shearman)[17]

Duchamp's disavowal of what he called the retinal in painting, his objection to art which stops at the retina is fundamental to his work in its appeal to the intellect. For him, art, or rather painting, is not an end in itself but a means of expressing or communicating something: 'it should have to do with the grey matter, with our urge for understanding'.[18] Moreover, this appeal to the intellect is not confined to the artist's working practice but finds a resolution through its reception in the eyes and mind of the spectator. In a talk given to the American Federation of the Arts in Houston in April 1957 entitled *The Creative Act*, Duchamp coined the term art-coefficient which he explains as the difference between the artist's intention and its subsequent realisation in the work: 'like an arithmetical relation between the unexpressed but intended and the unintentionally expressed'.[19] In Duchamp's theory, this realisation is art in its raw state which is refined by the spectator 'as pure sugar from molasses'.[20] Duchamp's creative act is therefore located not solely in the work itself but in the interaction between work and viewer for it is through this exchange that the work becomes part of the world. Octavio Paz describes this process of activation as con-stituting a difference between the artist's intention on the one hand and the viewer's interpretation on the other. He adds that implied in the viewer's refining of the initial

difference which constitutes the work is the creation of another difference while the work itself serves as a reference point for yet further differences. Paz puts it succinctly in the following: 'The work makes the eye that sees it – or at least, it is a point of departure: out of it and by means of it, the spectator invents another work'.[21]

Duchamp's *Stéréoscopie à la main* (1918–19) consists of two photographs of a seascape with small boat, placed side by side on a cardboard mount. To the photographs, Duchamp has added two identical pencil drawings which depict a diamond shaped construction, rendered in wire-frame. Although many differing examples of Victorian stereoscopic photographs exist, the illusory space in general, is primarily planar, with many views tactically incorporating objects or features of the landscape located at successive depths in order to emphasise the spatial sensation and map out the three-dimensional, virtual space. Duchamp's card, on the other hand, is resolutely flat in the sense that its only three-dimensional clue (the boat) is so far away from the photographer that the space it defines is ambiguous to say the least. Duchamp positioned his pencil drawings at different distances from the edge of the respective photographs so that when viewed through a stereoscope, the drawing is projected in front of the picture plane into real space with the seascape receding into pictorial space. The figures' perspective, however, does not imply disparity in viewpoint and so when viewed stereoscopically, there is no additional spatial quality to the drawing itself. It appears flat in the sense of a theatrical stage scenery flat. The only disparity or non-convergence is lateral in that Duchamp has simply placed the otherwise identical drawings at different positions from the edges of the photographs, enabling the drawing's projection out of pictorial space and into the viewer's space.

In his study of what he calls Duchamp's *Opticéries*,[22] Jean Clair has pointed out that the drawing could be interpreted as the visual pyramid illustrated in various seventeenth-century treatises on the art of perspective, as in *The Masters of Perspective* from Abraham Bosse's treatise on Desargues of 1648.[23] In respect of the image's perspective, the lower half of this drawing could perhaps be imagined as a reflection of the pyramid in the sea. The emphatic horizon does recall the idealised space of a perspective schema despite the fact that the photographs themselves display little or none of the spatial devices or clichés common to both stereoscopic and perspectival conventions. Embodying the kind of visual indifference not untypical of Duchamp's work, the image seems curiously related to Merleau-Ponty's enigmatic observation that 'the road which disappears toward the horizon does not really become narrower'.[24] If the stereoscopic image is taken as a metaphor for the mental image itself, Duchamp's *Stéréoscopie* stresses the cerebral aspect of both representation and perception as the experience of the three-dimensional, virtual image takes place solely within the viewer's brain and visual system. It is an event which requires participation. The picture is no longer only a 'referential illusion' implying an object or scene out there, but also a construction within the mind of the viewer.[25] Invoking the distinction Lacan makes between the *geométral* and the visual as indicative of the fundamental split between perspectival and stereoscopic systems, Clair notes that the intelligibility of the image no longer resides in the signifier (the perspectival apparatus which enables a diagrammatic reconstruction of the object) but in the signified, the virtual, sensory image 'obtained by the synthesis of abstract regular figures'.[26] The vanishing point, picture plane and ideal, monocular viewer implicated in Bosse's figures are here absorbed into the spectator's physiological make-up.

Stereoscopy provides a useful focal point for a discussion of the viewer's relationship to the picture as it emphasises the grounding of vision within the body. It constitutes a refutation of the static observer and an inversion of the perspective model in that it recreates the depicted object in terms which exploit the viewer's physiognomy. This is not to say that it is any more natural a representational form or that it provides a more truthful experience. On the contrary, the experience of viewing a stereoscopic image draws attention to its artifice. One is constantly aware of the instability of the virtual image that reflects even the slightest movement on the part of the viewer. Duchamp's somewhat sporadic use of the technique sits comfortably with his desire to move the work of art into the world. For an artist who spent much of his working life underground, as he put it, and who aimed in much of his work to put the spectator in the picture, stereoscopy would seem a fitting tool with which to achieve his ends. Bearing in mind his discussion of the creative act mentioned earlier, the difference which constitutes the work and its interpretation by the viewer finds an apt metaphor in the stereoscopic event:

> Every film trains its spectator.
>
> (Bordwell)[27]

> The text always contains an indication of the way it is to be read.
>
> (Todorov)[28]

Duchamp's cryptic assertion that 'the spectator makes the picture' applies not only to the artwork but also to the narrative spaces opened up by literature or cinema which in their differing ways point to the centrality and the temporality of the viewer's role. I want to look more closely at narrative as a structuring process in order to identify more clearly the nature of this role. Such ideas have proved useful in establishing a more direct link between theoretical and historical material research and the visual work which I have produced in conjunction with it. I am less concerned with the notion of narrative as the actual telling of stories than with narration almost as a process of thought, a way of making sense of the world. Narration is an intentional, structuring activity which, as Peter Brooks has put it, 'demarcates, encloses, establishes limits, orders'.[29] Discourse on narrative is commonly concerned with literary fiction where a story is related in a particular manner and entices the reader with its own specific logic. In terms of pictorial art, however, the function of narrative is less certain. A picture, after all, presents a stilled image which although experienced in time does not (unless it forms part of a sequence) function in the same temporal sense as an image in a novel or a film. Our perceptions of spaces and objects are coloured by our subjective relationship to them; the same goes for our perceptions of pictures. While I have not intended to look at what those subjective impressions might be, I am interested in the process of ordering the circumstances through which they arise. Narrative theory attempts to plot the ways in which not only texts but also representations of all types are structured in terms of storytelling. It would, therefore, seem fitting to look at some relevant narrative models which bring into focus some of the issues concerning the relationship of theory to practice and of viewer to artwork.

The Russian Formalist theorists such as Viktor Shklovsky developed the distinction in literary narrative between what was termed *fabula* and *syuzhet*. The *fabula*, often

translated as story, is the chronological sequence of events referred to by a narrative while the *syuzhet* is the order of events represented in that narrative. The reader of a fictional narrative, moreover, never has direct access to the *fabula* itself which is only ever a representation contrived through the *syuzhet*. That is, we construct a seemingly coherent story from the evidence presented by the *syuzhet*. In a detective novel, such as Raymond Chandler's *The Lady in the Lake*, where the story of a crime is related via the story of that crime's investigation, the *fabula* is traced and re-plotted through the *syuzhet*. The narrative strategy, Marlowe's first-person account of his investigation, provides the reader's only means of access to the concealed story of a killer's change of identity which becomes apparent at the end of the book. In a fictional story, of course, the referent or *fabula* does not exist at all. It is brought into existence through the means of its representation. As Tzvetan Todorov states:

> What exists, first of all, is the text and nothing else; it is only by subjecting the text to a particular type of reading that we construct an imaginary universe on the basis of the text. The novel does not imitate reality, it creates reality.[30]

If the reconstruction of this imaginary universe is the text's purpose, in order to be successful, a narrative should contain some indication of how it is to be read. As Goodman has discussed in respect of pictorial representation, if a narrative constructs a realistic representation which is intended to deceive, there is an implication that this reality, the world of the *fabula*, has precedence over the means of its representation, the *syuzhet*.[31] Although this is the essence of any mimetic illusion, the form which that illusion takes is never transparent and always requires the reader or viewer's co-operation. We are aware of the fabric of the medium be it novel, film or painting and therefore, are aware of the presence of the author despite the lengths he may go to in order to efface his presence. As Bakhtin has observed in his discussion of the dialogic nature of novelistic discourse:

> The author manifests himself and his point of view not only in his effect on the narrator, on his speech and his language . . . but also in his effect on the subject of the story – as a point of view that differs from the point of view of the narrator.[32]

In order for the novel or film to successfully 'create reality' as Todorov maintains, it must, of course, involve the reader or viewer. In a discussion of the relation between *fabula* and *syuzhet* in terms of film analysis, Bordwell uses a cognitive-perceptual model to suggest that the viewer constantly posits hypotheses about the depicted events which are subsequently tested against their existing interpretation of the film's narrative.[33] From isolated details they infer over time an increasingly refined whole. In the opening sequences of Alfred Hitchcock's *Rear Window* (1954), for example, the camera silently pans around the interior of the main protagonist's living room and presents the spectator with various objects – cameras, flashguns, photographs – clues to his profession. In doing so, the camera methodically discloses that he is a photographer for a leading magazine whose business involves travel and adventure although there are examples of studio work evidenced by a pile of fashion magazines which, we are invited to assume, contain examples of his work. In particular, the camera focuses on the image of a racing car crashing into a barrier. One of the car's dislodged wheels

has been frozen by the shutter as it hurtles towards both camera and photographer who it transpires is none other than the man (James Stewart) seen lying asleep with a broken leg in the next shot.

The *fabula/syuzhet* distinction is useful in that it separates the causal relationship of events from the ways in which they are represented. Chronological sequence can be sliced up, interrupted and rearranged for the purposes of the narrative which, for example, may be concerned with prolonging the outcome of the story in order to create suspense, a strategy Bordwell calls retardation. Similarly, any implied spatial coherence of the *fabula* is solely a product of the *syuzhet* which may facilitate or undermine spatial and dramatic unity where relevant. In *Rear Window*, the photographer Jeff acts as the perceptual window through which the narrative is related. From the opening scenes, we are encouraged to identify with his point of view and follow him as he subsequently weaves a story around his observations of his neighbours. The story is of a crime, the murder by a character called Thorwald of his invalid wife, both of whom live in an apartment opposite Jeff's. This crime occurs early in the film when Jeff hears (and we hear) a scream off-camera. The housebound photographer gradually pieces the passage of events together as he recuperates in his apartment. What is intriguing about *Rear Window* in terms of narrative is that the story of this investigation is both the film's *syuzhet* and simultaneously, its *fabula*. That is, it reflexively relates the concealed story of the crime by relating a story about a man who is, in turn, making up a story about what he sees. Literally immobilised, like the ideal perspective viewer: 'a man behind his own retina', as Miran Bozovic has observed,[34] Jeff has taken to watching his neighbours' activities through his window, the rear window of the title, and begins to make inferences and create stories about them. Each character is predominantly seen through their respective windows which act like little cinema screens onto which are projected silent movies, each screen having its own particular story.[35] One of these stories becomes that of the film and Jeff's increasing preoccupation with discovering the apparent truth drives its plot. His role is a model of the spectator's but in addition, he is also the director of his own film within the larger film; it is predominantly through his observations that we revisit the story of the crime if not its actual scene.

There are moments, however, when the spectator is fed more information than Jeff. While he is asleep, the camera closes in on Thorwald's window and reveals him leaving his apartment with a woman in black whose back is to the camera. It is up to us to make sense here: the woman is possibly Mrs Thorwald, alive and well, or more sinisterly, Thorwald's mistress. Such tactics retard the logical sequence of the *fabula* and disrupt our reading (if not Jeff's) of the implied story, forcing us later in the film to revisit or re-plot these events in our mental conception of the narrative. Like Jeff, we become detectives confined to a position outside the spatio-temporal world of the story. If, as Bordwell puts it, 'the narration . . . creates the narrator', then the investigation creates the detective.[36] Bearing in mind Bakhtin's comments on the author, in moments like this, Hitchcock moves from a subjective to an objective framing of the narrative. In doing so, he reveals his own shadowy presence behind his fictional counterpart as the actual controller of the *syuzhet* just as he later appears in person as a piano tuner.

Returning to the climactic moments of the narrative, Jeff, like the film's spectator, can do little more than watch as Thorwald attacks Lisa, Jeff's partner and reluctant

accomplice in the investigation. His only option is to telephone the police to report the incident and it is at this moment that the conventional relationship between film and audience is reversed as Jeff makes the transition from spectator to participant. Lisa has found the ring and surreptitiously signals to Jeff, whom she knows is watching that she has the evidence they need. Thorwald, however, sees her gesture and in a crucial shot, looks directly at the camera, that is, at Jeff who is peering through his telephoto lens. In that look, the voyeur's gaze returned, the space of the story spills over into the space of the narration. It is now Jeff who becomes objectified by another's look and who shortly will be literally thrown out of his window, flung through the screen onto which he has projected his story. In the dramatic moments leading to his defenestration, his only means of protection against Thorwald is to pop flash-bulbs at him, temporarily blinding the murderer, rendering him unable to return that gaze which has been directed on him throughout the film. In a reading of the film which draws on Lacanian notions of the gaze, Bozovic maintains that Jeff's voyeurism is a product of his narcissistic desire to see himself seeing and he remarks that the eye which reciprocates this desire is none other than Thorwald's window which looks back at him. In a particularly effective scene, for example, Thorwald's window is dark and the apartment apparently empty until Jeff sees a cigarette end glowing in the darkness, eerily signifying the murderer's presence. Like Sartre's evocation of the gaze as the rustling of branches or the sound of footsteps in a corridor, it is this blot, the burning cigarette, which signifies the gaze of the other and which objectifies and returns Jeff's own gaze; or as Bozovic quotes Sartre, '"being-seen-by-the-other" is the truth of *seeing-the-other*.'[37] After being discovered literally in Thorwald's gaze, Jeff answers the telephone and, thinking it is his detective friend, starts talking about the murderer who, it transpires, is the caller. Whereas Jeff's gaze was reciprocated, however, his words are met with a deadly silence and eventually, the gentle click of the receiver as Thorwald hangs up. Jeff awaits the latter's arrival and becomes the object of his gaze which is now manifested in the sound of a door closing downstairs in the apartment block, of footsteps on the stairs and in the switching off of the light in the hallway which can be seen in the gap under Jeff's door.

The way these telling details are combined epitomises the narrative tactics of the film as a whole and highlight the spectator's role as one of construction. As Brooks notes: 'Plots are not simply organising structures, they are also intentional structures, goal-oriented and forward-moving.'[38] Moreover, plot is as much an aspect of reading as it is of writing or telling stories. In *Rear Window*, we are constantly given clues about the implied story through the arrangement of the sequence of events which are either verified or dismissed by the characters onscreen, particularly Jeff who has a dual function as both spectator and director. That is, the work of narrative construction is represented in the film itself. We are invited to speculate on the hidden story perceptible through the narrative's filters – point-of-view, mood or sequence of events – in a manner which is analogous to the ways we construct stories about the reality – the people and situations – surrounding us. In the words of Todorov: 'One does not construct *fiction* differently from *reality*.'[39]

Returning to Duchamp's statement that 'the spectator makes the picture' and Octavio Paz's discussion of it, one finds an analogy for Todorov's account of narrative diversity.[40] As previously mentioned, Duchamp coined the term art-coefficient to describe the difference between an artist's intention and its realisation in the work itself. This

difference, he goes on to state in *The Creative Act*, is echoed in the spectator's reading of the work which initiates a further difference. At one pole we have the artist's original intention and at the other, the spectator's interpretation, not of that intention, as the viewer does not primarily judge artistic intention, but of the work itself. Paz adds that while the work is transformed by the viewer into another work through the process of looking at and thinking about it, the actual work, its material manifestation, remains as the basis for further misreadings and further differences. In this sense, the work is a machine for 'producing meanings', a particularly apposite observation given that Duchamp's two most substantial works were literally based around the notion of a self-desiring machine.[41] Both *The Large Glass* and *Etant Donnés* are intrinsically related to Duchamp's description in *The Green Box* of *The Bride Stripped Bare by her Bachelors, Even* (1915–23), a description which although cryptic, elliptical and non-linear in its sequence, creates an imaginary universe which contextualises the visual clues contained in the works themselves. The works are not precisely narrative in that they do not represent transformations which are irreversible; in the nature of machines, their movement is cyclical and repetitive. Like all pictures, they are without beginning or end and represent instead the interminable loop of desire and fulfilment. However, the narrative strategies considered here may be useful in terms of pictorial art precisely because they articulate the part played by the viewer without whom the work is incomplete. In certain pictures the centred self implied by the perspective schema or camera viewpoint may be disrupted by the gaze of a character in the picture or, indeed, the picture itself may appear to return our gaze, as if it had been lying in wait, anticipating an object to trap, as Lacan put it.[42] But just as a dialogue between people is an exchange, so both the artwork and, by extension, the artist are involved in an exchange with their spectator through which something approaching meaning is created. Bearing in mind Duchamp's art-coefficient, for each different viewer, there will be a different exchange, a different detail perceived and so a different interpretation.

As Paz states: 'the picture depends on the spectator because only he can set in motion the apparatus of signs that comprise the whole work.'[43] Apparent motion created by the film image finds an analogy in the internalised machinations of inter-pretation, where we inhabit the work as much as the work inhabits us. By reading or observing or thinking, the spectator activates the relationship between the parts in the work and makes it live, in the electrical sense of a live wire. The work's meaning, therefore, is to be found neither in the work itself, nor in the hands, eyes or minds of either artist or viewer. It is apparent only in the space or the difference between them.

Notes

1 Kabakov, Ilya (1989) *Ten Characters*. London: Institute of Contemporary Arts, p. 7.
2 Bloom, Harold (1973) *The Anxiety of Influence: A Theory of Poetry*. London and New York: Oxford University Press, pp. 19–45.
3 Deleuze, Gilles (1994 [1968]) *Difference and Repetition*. Trans. Paul Patton. London: Athlone Press, p. 70.
4 Bakhtin, Mikhail (1984) *Problems of Dostoevsky's Poetics*. Trans. and ed. Caryl Emerson. Manchester: Manchester University Press, p. 184; also Dentith, Simon (ed.) (1995) 'Bakhtin and Contemporary Criticism', in Dentith, *Bakhtinian Thought: An Introductory Reader*. London: Routledge, pp. 88–102, p. 92.

5 Bakhtin, Mikhail (1934–5) 'Heteroglossia in the Novel', in Dentith (1995) *Bakhtinian Thought*, pp. 195–224, p. 197. Originally from 'Discourse in the Novel', in Bakhtin (1981) *The Dialogic Imagination: Four Essays*. Ed. M. Holquist. Trans. C. Emerson and M. Holquist. Austin, TX: University of Texas Press, pp. 259–422.

6 *Heteroglossia* is termed in the glossary to *The Dialogic Imagination* as:

> The base condition governing the operation of meaning in any given utterance. It is that which insures the primacy of context over text . . . all utterances are heteroglot in that they are functions of a matrix of forces practically impossible to recoup, and therefore impossible to resolve.
>
> (Editors' note, *The Dialogic Imagination*, p. 428)

7 Bakhtin, 'Heteroglossia in the Novel', in Dentith (1995), p. 209.

8 The poignancy of Roland Barthes' (1984) *Camera Lucida: Reflections on Photography*. London: Fontana, in which he ruminates on the nature of photography and in particular, over photographs of his recently deceased mother, derives in part from his acknowledgement that the photograph shows us what is no longer present.

9 Kemp, Martin (1990) *The Science of Art: Optical Themes in Western Art from Brunelleschi to Seurat*. New Haven, CT and London: Yale University Press, p. 238.

10 Moore, G. E. (1993) 'Proof of an External World', in Thomas Baldwin (ed.) *Selected Writings*. London and New York: Routledge, pp. 147–70. See also Russell, Bertrand (1980 [1912]) 'The Existence of Matter', in *The Problems of Philosophy*. Oxford and New York: Oxford University Press, pp. 7–12. Russell questions the notion that an object, for example, a cat, consists only of sense-data:

> If the cat exists whether I see it or not, we can understand from our own experience how it gets hungry between one meal and the next; but if it does not exist when I am not seeing it, it seems odd that appetite should grow during non-existence as fast as during existence. And if the cat consists only of sense-data, it cannot be hungry, since no hunger but my own can be a sense-datum to me.
>
> (p. 10)

11 In a discussion of the mental image, W. J. T. Mitchell includes a diagram which superimposes, as he puts it, three separate instances of the relation between image and referent. Like Descartes' image of the enucleated eye, the diagram as a whole is misleading as model of the mind in that it represents consciousness, as Mitchell puts it, 'as an activity of pictorial production, reproduction and representation governed by mechanisms such as lenses, receptive surfaces and agencies for printing, impressing or leaving traces on surfaces.' As before, the mind is implied as a drawing surface and presupposes another mind to view it. Mitchell, W. J. T. (1986) *Iconology: Image, Text, Ideology*. Chicago and London: University of Chicago Press, pp. 16–17.

12 Moore, 'Proof of an External World', p. 102.

13 Ibid. pp. 164–5.

14 Bertrand Russell discusses the essential privacy of each individual's experience in relation to their subjective perception of time and space in (1992 [1948]) *Human Knowledge: Its Scope and Limits*. London: Routledge, p. 105.

15 Paz, Octavio (1990) '* Water Writes Always In * Plural', in *Marcel Duchamp: Appearance Stripped Bare*. Trans. R. Phillips and D. Gardner. New York: Arcade and Little, Brown, p. 147.

16 Duchamp, Marcel (1975) *Duchamp du Signe*. Paris: Flammarion, p. 105.

17 John Shearman discusses the reciprocal nature of the artwork/viewer relationship with regard to the Italian Renaissance and posits the notion of a *transitive* work which takes the *engaged* spectator as its *object*. Shearman, J. (1992) *Only Connect . . . Art and the Spectator in the Italian Renaissance*. Princeton, NJ: Princeton University Press, pp. 57–8.

18 Duchamp, Marcel (1989) *The Writings of Marcel Duchamp*, in Michael Sanouillet and Elmer Peterson (eds), unabridged republication of *Salt Seller: The Writings of Marcel Duchamp*. New York: Da Capo Press, pp. 135–6.

19 Duchamp, 'The Creative Act', in Sanouillet and Peterson (1989), pp. 138–40.
20 Ibid. pp. 138–40.
21 Paz, Octavio, 'Marcel Duchamp or The Castle of Purity', in Paz (1990), p. 86.
22 Clair, Jean (1978) 'Opticeries', *October* 5 (summer): 101–12. Originally published as a chapter in Clair (1977) *Duchamp et la photographie*. Paris: Editions du Chêne, pp. 80–93.
23 Bosse, Abraham (1648) *The Universal Manner of M. Desargues of Practising Perspective*. Paris. Clair uses an example from Jean du Breuil's (1649) *La perspective practique*, Paris.
24 Merleau-Ponty, Maurice (1951–2) 'The Experience of Others', in K. Hoeller (ed.) (1993) *Merleau-Ponty and Psychology*. Atlantic Highlands, NJ: Humanities Press, pp. 33–63, p. 38.
25 Roland Barthes uses the term *referential illusion* in his discussion of the relevance of insignificant detail in literary narrative structure. See his (1986) 'The Reality Effect', in *The Rustle of Language*. Oxford: Blackwell, pp. 141–8.
26 Clair (1978), p. 107.
27 Bordwell, David (1997 [1985]) *Narration in the Fiction Film*. London: Routledge, p. 45.
28 Todorov, Tzvetan (1995 [1978]) 'Reading as Construction', in *Genres in Discourse*. Cambridge and New York: Cambridge University Press, pp. 39–49, p. 46.
29 Brooks, Peter (1992 [1984]) *Reading for the Plot: Design and Intention in Narrative*. Cambridge, MA and London: Harvard University Press, p. 4.
30 Todorov (1995), p. 39.
31 Goodman, Nelson (1969) *Languages of Art: An Approach to a Theory of Symbols*. London: Oxford University Press, especially, pp. 3–19.
32 Bakhtin, 'Heteroglossia in the Novel', in Deutith (1995), p. 208.
33 Bordwell (1997), pp. 29–147.
34 Bozovic, Miran (1992) 'The Man behind his own Retina', in Slavoj Žižek (ed.) (1992) *All You Ever Wanted to Know about Lacan (but were too afraid to ask Hitchcock)*. London and New York: Verso, pp. 161–77.
35 It is worth noting that approximately 35 per cent of the film is entirely without dialogue. See Sharff, Stefan (1997) *The Art of Looking in Hitchcock's Rear Window*. New York: Limelight, p. 179.
36 Bordwell (1997), p. 62.
37 Bozovic, 'The Man behind his own Retina', p. 170; J-P. Sartre quotation from (1996 [1943]) *Being and Nothingness: An Essay on Phenomenological Ontology*. Trans. Hazel E. Barnes. London: Routledge, p. 257.
38 Brooks (1992), p. 12.
39 Todorov (1995), p. 48.
40 Duchamp (1975), p. 105; 'The Creative Act', in Sanouillet and Peterson (1989), pp. 138–40.
41 Paz, 'Marcel Duchamp or The Castle of Purity', in Paz (1990), p. 85.
42 Lacan, Jacques (1994 [1977]) *The Four Fundamental Concepts of Psycho-analysis*. Trans. Alan Sheridan. London: Penguin.
43 Paz (1990), p. 86.

Chapter 7

Spatial ontology in fine art practice

Naren Barfield

> Ontology. The theory of existence or, more narrowly, of what really exists, as opposed to that which appears to exist but does not, or that which can properly be said to exist but only if conceived as some complex whose constituents are the things that really exist.
>
> <div align="right">Anthony Quinton[1]</div>
>
> Everything that is real has some spatial position. Space is infinitely large, infinitely penetrable and infinitely divisible . . . despite our confidence in these strong claims, space seems elusive to the point of eeriness . . . It has no material property, no causal one, it does nothing.
>
> <div align="right">Graham Nerlich[2]</div>

The question of spatial ontology in fine art practice might seem to be eccentric – away from the centre – in debates about contemporary art generally, and the culture that has developed in recent years around fine art research specifically. The principal aim of this chapter is to propose the centrality to art practice of the relationship between spatial and ontological thinking, and the particular importance of the latter to the specificity and distinctiveness of creative practice research and what have come to be termed practice-based research degrees.[3]

Ontological speculation and the application of problems in the theory of existence to the practice of the artist, by the artist, has been characteristic of some original and fascinating recent creative practice research.[4] Whether attempting to enlarge the range of methodological strategies beyond the hard metrics models of empirical and materials research, or research into the processes of production (as opposed to the processes of thinking), with growing confidence, artist-researchers have sought to develop perspectives that foreground, rather than conceal, the dynamic relationship between knowing and being that is distinctive of some of the most interesting practice-based research. As the culture of formal research, frequently rehearsed through the rigours of doctoral study, has matured in the creative disciplines practitioners have become emboldened to develop appropriate – rather than to appropriate – methodologies for fine art research which are often distinctive and complex, designed to draw out the richness of the object of investigation, instead of distorting it to fit established paradigms.

This is not to diminish the rigour or burden of knowledge that accompanies the doctoral research submission, nor to claim for practice-based research a special status that is somehow beyond method; or, that practice is, de facto, research. It is negotiating

– and testing – these parameters that is an essential part of research training, and a significant challenge to the design of meaningful research projects that demonstrate both the capacity for generating new knowledge and the embodiment of that knowledge within the visually intelligent physical or virtual artefact.

These negotiations are highly problematic and it could be argued that the mischievous twins of methodology and knowledge represent two of the most – if not the two most – difficult aspects embodied in the creative practice research product. As a result, practitioners entering into the domain of formal research for the first time (it is never the other way around – individuals seem not to abandon research for practice) can be seen oscillating between the extremes of pure practice, which is taken to be undifferentiated from research (while uncontaminated by its methods) and dependence on clumsy, overweening methodological structures imported indiscriminately from every passing discipline.

There are undoubtedly sustained problems in research relating in particular to methodological soundness. Underlying these problems is an often unidentified, or latent tension between the demands of research and the characteristics of practice and, further, ambiguity or lack of distinction between what can be termed practice-as-research and practice *per se*, caused when they are brought into co-dependency within a formalised creative practice research structure, at the nucleus of which may lie fundamental problems of reconciling the epistemological basis for legitimising the research as a contribution to knowledge with the ontological status of the work of practice-as-research.

It seems to go with the territory that in creative practice research, newness is habitually (and frequently mistakenly) conflated with original knowledge, and it is by no means straightforward to dissociate the two – to establish where there *is* knowledge in practice; where the artefact resulting from practice-based research embodies genuine and knowable originality. The inescapable epistemological burden of the creation of new knowledge that underpins (particularly doctoral) research has no necessary counterpart in practice, where ontological concerns about the existence and experience of both artefact and practitioner may be (consciously or not) more significant, to whatever level understood and to whatever degree systematically articulated and applied.

Research, evidently, need not be concerned with practice, nor practice with the generation of knowledge. Even so, it could be argued that fine art research that is epistemologically strong while ontologically undemanding may be no more desirable for the culture of practice-based research than ontologically engaging practice that is epistemologically weak, and unsound in research terms. Consequently, while practice as such need not establish newness in terms of originality of knowledge – however new and original it might be as practice – it becomes desirable to the activity of the artist-researcher and the authority of practice-based research to establish both the contribution to knowledge and the ontological basis of the practice-as-research.

Successful (funded, approved, supported) practice-based research projects at both doctoral and postdoctoral level are built on the doctrine – now enshrined in the definitive research nomenclature[5] – of question, context, methodology: the why, what and how of research, dependent for validity on the demonstrable contribution to knowledge. Whether or not art practice can or should be quantified as knowledge,[6] there is little question that practice-based research, to be recognised and supported, is

required to be qualified as such. Where it has been stated previously that much interesting practice-based research has been concerned with revealing problems of knowledge and existence as manifest in the practical research project (as opposed to solely in the conventional text), it can be suggested that some of the most significant and meaningful practice-as-research is contingent on successful reconciliation of the epistemic and ontic states of the practical research product, adding to the mandatory epistemological requirement the interest of ontological speculation.

This returns the discussion to the initial eccentric problem of spatial ontology, or how ontological speculation is related to thinking about problems of space and, furthermore, how such problems are relevant to research in fine art practice and may be raised by, and addressed through, the activities of the artist-researcher. With reference to the opening quotations, ontology is concerned with the theory of existence, or what really exists distinct from that which is apparent but does not exist.[7] If something exists – if it is real – then it is understood to occupy space or, at least, to have a location.[8] A primary relation between ontology and space is established, as well as an intriguing problem: attempts to identify, address and understand the real are inextricably bound up with questions of space, place and location; the real is, to a very real extent, spatial. The intriguing problem arises from alternative descriptions of what is real including, within fine art, virtual reality wherein an apparent object may have a location in virtual space, as well as alternative ways of experiencing and describing space and constructing systems for its measurement.

The product of fine art practice exists in space, physical or otherwise. If the premise is accepted that everything real has a spatial position without, for the present, being concerned with the spatial system used to fix the location, then it can be asserted that spatial ontology is of interest to the field of fine art practice, at the very minimum as a problem in the philosophy of art and art objects. Furthermore, this interest is deepened where the artist is concerned with inquiry into their own – and their products' – existence in the world, in relation to other things in the world, and in questions of their own spatially experienced subjectivity; particularly so when the products of their practice are the result of such inquiry.

Ontological speculation by the artist about their being in the world must, if they are embodied (and this can be reasonably assumed, unless they are a virtual artist operating in cyberspace; although here, too, theories of virtual existence may arise as a stimulus to speculation), take account of their extension in space, a necessary property of physical or material existence. Ontological speculation that considers embodied existence (allowing for the caveat of virtual (dis)embodiment) must, therefore, consider spatially extended experience (and this experience is self-conscious; if the artist is able to make ontological speculations about being in the world, awareness of their own being-ness must be self-conscious). Spatial ontology then can be described as ontological speculation or inquiry/examination into, or of, self-conscious personal spatial extension, possibly in relation to external spatial phenomena or cues. Spatial ontology stands as shorthand for precisely this sort of speculative inquiry.[9]

Such speculations have a long pedigree, particularly associated with attempts by artists to develop alternative means of representing spatial experience. Significant evidence – by art historians Linda Dalrymple Henderson,[10] Craig Adcock,[11] Tom Gibbons,[12] and others – links the departure from the traditions of perspectival representation to the late-nineteenth- and early-twentieth-century popularity of alternative

space systems such as non-Euclidean and *n*-dimensional geometry, hyperspace philosophy and the idea of the fourth dimension, a concept which, in both its geometrical and philosophical interpretations, was held in fascination by artists in the early years of the twentieth century and was more influential upon the discourses and development of visual space in modern art than has been generally recognised.

One of the most influential late-nineteenth-century texts to popularise new thinking on space was *Flatland*,[13] first published in 1884 and regularly reprinted to the present day as an accessible introduction to the philosophy of multidimensional space, or hyperspace philosophy as it has been termed subsequently. Written by the headmaster of City of London School, Edwin Abbott Abbott, as a barely disguised satire on the social order of Victorian England, *Flatland* described the limits of spatial experience for inhabitants of a world restricted to two dimensions; it was also a literary response to contemporaneous popular and professional scientific speculations regarding the fourth dimension,[14] and wove into the narrative tools for visualising space including slicing, shadows, projection and the dimensional analogy that were to be employed by artists such as Duchamp more than a quarter of a century later.

The slicing technique, employed in modern radiology to build three-dimensional pictures from planar cross-sections of the body,[15] is introduced in *Flatland* as a means of imagining three-dimensional objects from the point of view of an inhabitant of a two-dimensional world, by piecing together discrete sections to build up an imaginative picture of the object without access to three-dimensional space. An alternative method involves reintegrating the changing shadows created over time by the projection of a three-dimensional object onto a surface as a means of building a sense of the unobtainable third dimension, such as the prisoner in Plato's cave would be forced to do.[16] Underlying the visual amusements of *Flatland* is the thesis that visualisation of three-dimensional space from a world of two dimensions is possible and that this can be extended by analogy to imagine a world of four spatial dimensions.[17] If so, just as a sphere may be regarded as a three-dimensional stack of circles, a hypersphere can be considered a four-dimensional stack of spheres;[18] while the projection of a sphere onto a perpendicular plane produces a circle, or shadow possessing no value in the third dimension, a sphere may itself be seen as an infinitesimally thin shadow of a four-dimensional hypersphere, a projection of a four-dimensional object into a three-dimensional space.

It was the dimensional analogy, which has some geometrical authority,[19] that was put to practical use by Duchamp in *La Mariée mise à nu par ses célibataires, mêmes* (*The Large Glass*, 1915–23), whose four-dimensional bride is separated from her bachelors, who remain forever trapped in the third dimension, unable to reach her.[20] Duchamp's eroticism, also, may be connected to his spatial speculations: the artist, journeying through the fourth dimension, returns mirror reversed as Rrose Sélavy, linking his alter-ego with the rotation of a three-dimensional figure through a fourth dimension in geometry.[21] Duchamp's playful space speculations also provide an elegant artistic reply to the Kantian problem of enantiomorphic pairs (that is, reflected images which are congruent but not superposable): where the philosopher had regarded the superposition of reflected images as an impossibility,[22] a property of chirality,[23] the addition of a fourth dimension makes it possible,[24] and where Kant would have been unable to consent to the addition of a fourth spatial dimension, modern physics 'predicts the precise number of dimensions: ten.'[25]

As a departure from conventional concepts of space, the fourth dimension has been used interchangeably with non-Euclidean geometry, which reached the popular imagination at roughly the same time.[26] It is possible, however, for there to be geometries of two, three or higher dimensions which are either Euclidean or non-Euclidean, the latter referring to departures from Euclid's fifth or parallel postulate.[27] It had been accepted for centuries as axiomatic that parallels in the plane never meet, until questioned by the work of the mathematicians Gauss,[28] Bolyai (in 1832),[29] and Lobachevsky (in 1829–30).[30] The two latter independently developed a negatively curved hyperbolic form of non-Euclidean geometry, followed a generation later by the positively curved elliptic geometry of Riemann,[31] a student of Gauss. Space, curiously, was curved.

References to non-Euclidean geometry and the fourth dimension are numerous throughout the literature of developments in pictorial space in the twentieth century, with Riemann being explicitly referred to in Gleizes and Metzinger's *Du Cubisme* of 1912,[32] and Apollinaire praising the new artistic potential of the fourth dimension in the same year.[33] Alternatives to conventional space have provided artists over the past century with an expanded spatial discourse and range of descriptors for speculating on their place in, and responses to, space. These include developments in cognitive psychology, where work on depth perception and the use of depth cues as indicators of space has enriched the spatial language significantly.

Whereas in 1953 Christopher Gray was able to write, in *Cubist Aesthetic Theories*, that the 'only directly perceptual mechanisms for evoking the sensation of depth is through the convergence of the axis [*sic*] of the eyes in binocular vision and the accommodation [*sic*] of the focus of the eye for the distance of an object',[34] in *Vision and the Eye*, Maurice Pirenne was able to give six potential means of depth perception, which is made possible through both linear and aerial perspective; differences in the relative sizes of objects; accommodation of the eye; displacement of the eye during movement; and stereopsis.[35] More recent studies on depth perception in cognitive psychology give at least seven monocular, and three binocular, cues to the perception of depth.[36] Monocular cues include both linear and aerial perspective (known, for obvious reasons, as pictorial cues, from which they are derived); texture (including changes in texture with distance from the viewer); interposition (where a distant object is occluded by a nearer one); shading (since two-dimensional surfaces do not cast shadows, shading is normally evidence of depth); and motion parallax (the effect which describes the movement over the retina, whether caused by the movement of the object, or of the viewer's eye). Binocular depth cues include the aforementioned accommodation and convergence, as well as stereopsis, where a different image is produced on each retina, and from which depth may be estimated.

Alongside advances in mathematics and geometry, philosophy, psychology and art theory and practice, the significant interest of artists in developing new modes of visual space to address the problems of representing spatial thoughts and experience (both ideal and material) has been accompanied since the second half of the twentieth century by the advancement of digital computer technology, and the ability to represent spatial modalities not defined by, nor limited to, either the human perceptual system or the traditions of spatial representation in Western culture.[37] Modern computer technology makes possible the visualisation of phenomena in a range of representational modes unrestricted by rules of physical property or observable veracity. Unconstrained by three-dimensional Euclidean space, since the 1960s the development of

computers has been instrumental in making visible what was once possible only through complex mathematical diagrams or an intuitive leap of the artistic imagination.[38]

As computers have become a commonplace of creative practice, however, it can be observed that this potential remains only partially realised, as the development of digital technologies has retreated into the conventional, resulting in widespread adoption of the representational models of photography, illustration, montage and Euclidean-Cartesian virtual reality within visual computing practice. Whereas in the early stages of the history of computers, artists themselves often developed both hardware and software as a means to experiment, as digital technology has become ubiquitous the majority of contemporary imaging applications now used by artists have been created primarily for commercial purposes, for the graphic design, publishing, video, animation and games industries, and with an associated range of spatial competencies, applications and limitations. As noted by Lev Manovich in *The Language of New Media*, the

> active treatment of space is the exception rather than the rule in new media. Although new media objects favor the use of space for representations of all kinds, virtual spaces are most often not true spaces but collections of separate objects. Or, to put this in a slogan: there is no space in cyberspace.[39]

Consequently, the artist seeking an appropriate means with which to mount their ontological speculations may be compelled, when working digitally, to operate within the limits of a potentially alien or obstructive paradigm which bears little or no relation to the artistic or theoretical problems with which they may be concerned. Where once the focus was on attempts to discover the properties and image-making potential of a new medium, it is now more appropriate – and, it might be argued, essential – to question what is required, by artists, of technology: in other words, how the technology might be used to serve the artist's ontological speculations about their place in the world and their relations to it. To achieve this, the artist needs to subvert the technology from its given purpose and toward their intention; this is, therefore, in opposition to McLuhan's famous mantra 'the medium is the message'.[40] The medium is not the message.

How, then, is the artist-researcher to pursue subjective space speculations through a visual arts practice that reconciles the epistemic–ontic divide? Is it, further, possible to achieve this through an interdisciplinary strategy that integrates knowledge from such disciplines as geometry, philosophy, psychology and visual computing practice with the established methods and understanding of the practitioner; and can this result in developing forms of spatially oriented practice where the physical or virtual artefact embodies knowledge and methodological distinctiveness?

Attempts to address these questions are presented with actual examples of practical work developed around the problems highlighted in the preceding discussion, in a specific area of practice concerned with investigation of the concepts and experiences of space through the material practices of digital print, video and installation, and the transforming influence of ontological speculation on the methods and processes of those material practices themselves.

The first example, *Chair* (1999) (Figure 7.1), was developed as a direct spatial intervention into the viewer's environment, causing disruption between the categories

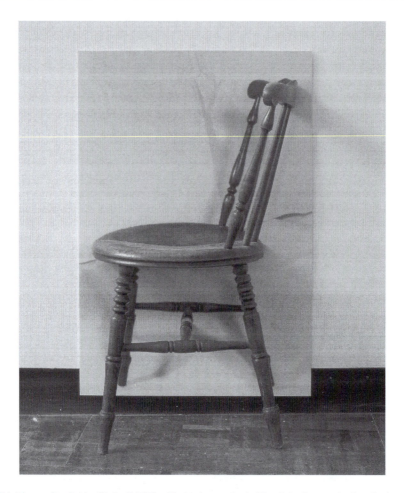

Figure 7.1 Naren Barfield, *Chair* (1999). Chair (sawn in half), digitally manipulated photograph, mounted inkjet print, 50 × 100 × 30 cm (approx).

of image and object in the observer's experience and a sense of leakage of reading between the two: image can be read as object, and vice versa; it is irresolvable since each depends on the other for its completion. All is dependent on the observer's presence, location and subjective reading of the work and their movement over time to build a mental picture of the physical object.

Chair develops a visual argument about space through a dialogue on the subject of dimensional analogies, employing slicing, shadows and projections to achieve its purpose. The work (re)unites one (three-dimensional) half of an ordinary household chair with a photographically originated two-dimensional image of its lost half: object and image are irreducibly joined. This image can be read as both a reflection (as seen in a mirror), or as a shadow, indicating its inferior spatial dimensionality. When united in the viewer's perception, the two counterparts – the two- and three-dimensional halves – make the chair whole again and the spatial experience is apparently complete. Additional shadows cast by the two-dimensional image, however, pose further spatial

problems (the reason that an image and not a mirror is used, so that the shadows are permanently fixed and the reflection is indifferent to the movement of the viewer in relation to the work), implying that the hierarchy of shadows may be taken symbolically to suggest an endless game of dimensional expansion. The conceptual and spatial complexities of *Chair* required a number of approaches in its practical development and execution, including mathematically precise distortions of the scanned digital image of the photograph of the lost half of the chair, in order to make it match the dimensions of the real chair. Careful attention was also required to match the colour between the physical and the printed components under particular gallery and lighting conditions.

Chair takes up the spatial and ontological challenge arising from (among others) Kant's *Prolegomena*, Abbott's *Flatland*, and Duchamp's *Large Glass*, which are addressed through an interdisciplinary understanding of philosophy, geometry, cognitive psychology and art history and theory, as they have been brought to bear upon practices in digital imaging, fine art print, photography and installation. The idea represented, of an object in one dimension being the shadow of (or projection from) the next higher spatial dimension has, in this work, to be seen – experienced – to be known: the epistemic and ontic states of the work are reconciled and in this sense the condition of spatial ontology as a self-conscious inquiry into spatial existence is satisfied.

A further example (Figures 7.2 to 7.7) demonstrates the development of methods for extending the traditionally two-dimensional print into physical space to create new types of large-scale sculpted or constructed works which integrate digital imaging, autographic drawing, photography, printmaking and modelling from architectural-type plan drawings. In this example, instead of more familiar depth cues to articulate the space – such as linear and aerial perspective – motion parallax and shading become central to the spatial reading, as does interposition, when at close range one part of the object occludes another. Again, the direct involvement of the observer as an active participant in the completion of the work is essential and the effects of stereopsis and convergence bring the viewer's position in space into the reading.

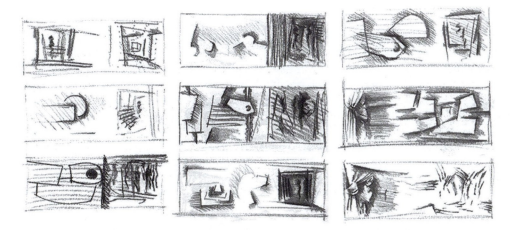

Figure 7.2 Naren Barfield, Sketches for development of small-scale maquettes.

Figure 7.3 Naren Barfield, Examples of drawings of separate component parts (with measurements) for development of small-scale maquettes.

The work was developed from a series of composite sketches (Figure 7.2) made in response to the internal spaces of public buildings (in this case, the British Museum in London), from which a number of small-scale maquettes were made using card, paper and other materials. These were used to help assess the effects in real space of the constructions.

Onto these, imagery (from sketches and photographs made on site) was drawn and painted by hand, as a trial and error method to assist with judging the eventual position, scale and distortion of digitally manipulated photographic imagery on the final larger-scale works. Accurate measurements of the resulting structures were recorded for the creation of detailed drawings (Figure 7.3), which subsequently were developed into architectural-type plans using a vector-based constructed drawing computer application (Figure 7.4). For this, each maquette was broken down into its separate component parts, or segments, each requiring an individual unfolded blueprint from which the building blocks for the eventual construction were made.

Photographs of the site were taken using a simplified method developed previously to record a concave hemispherical view, and were digitally combined using an

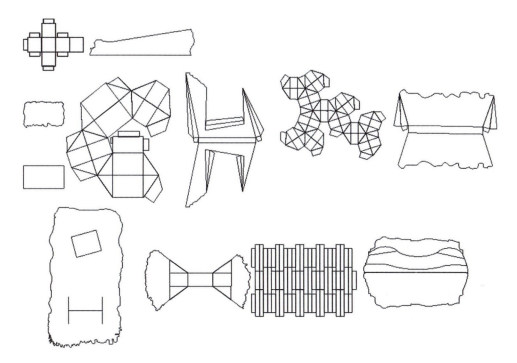

Figure 7.4 Naren Barfield, Architectural-type plans of separate component parts for development of small-scale maquettes, created using a vector-based 'constructed drawing' computer application (not to scale).

image-manipulation application. The resulting composite images were adjusted to fit accurately the shapes of the unfolded plan drawings. A third computer application (a desktop publishing program) was then used for the combination and placement of images (Figure 7.5).

The results were printed at a small scale, after which each component was cut out, folded and glued individually, before being bonded together, and the resulting constructions tested for accuracy of measurement and image placement. Using these resulting constructions as working models, modifications were then made in the drawing and image-manipulation applications, and precise scaling up to full size achieved in the page layout program, before printing. The large-scale prints were cut, folded and assembled (Figure 7.6).

Figures 7.6 and 7.7 contain a fully modelled three-dimensional representation of a projected hypercube (a four-dimensional cube), which was constructed using trigonometrical calculations so that the object could be modelled accurately from a single piece of flat paper. Similarly to *Chair*, this piece addresses the spatial problems associated with the dimensional analogy, and the use of shadows and projections as indicators of spatial relationships, particularly through embedding a modelled projected hypercube (an indicator of four-dimensional space) within a three-dimensional object which both creates shadows, and carries two-dimensional representations of three-dimensional spaces on its surfaces.

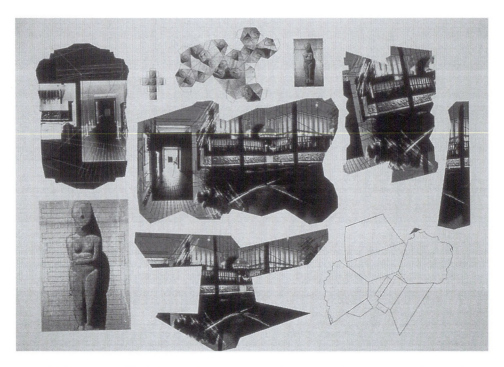

Figure 7.5 Naren Barfield, Unfolded elements combined with digitally manipulated photographs to provide discrete components for cutting, gluing and construction.

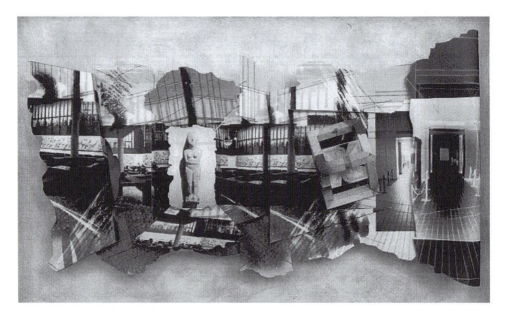

Figure 7.6 Naren Barfield, Final construction combining each of the discrete elements into a unified work.

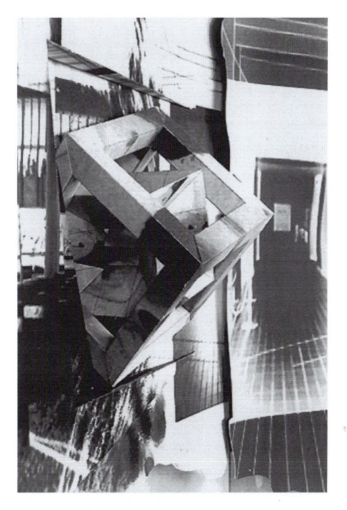

Figure 7.7 Naren Barfield, Detail of final work showing how effects of motion parallax, shading and interposition become central to the spatial reading.

The advantage of using a vector-based drawing application over traditional methods is that complicated drawings are easily modified and, being resolution independent, are scalable without loss of detail, or risk of distortion. Additional advantages arise from the new methods developed here. The computer enables the pieces to be visualised prior to construction, allowing alternatives to be considered before a final choice is made. The small-scale maquettes can be produced in relatively less time than larger pieces, and corrections can be made at that stage; scaling the component parts up or down is also easily done at the software stage. Furthermore, accurately scaling, distorting and adjusting imagery to fit across the irregular surfaces of the constructed works would be extremely difficult to achieve using other means.

A third and final example that further develops these enquiries is a video work, *The Visit* (Figure 7.8), produced for the Victoria and Albert Museum in London, as part

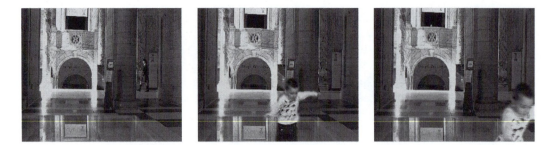

Figure 7.8 Naren Barfield, *The Visit* (stills #1, 2, 3).

of a narrative on the theme of subversion of the spatial negotiation of the museum itself. While developing the investigations of the previous examples, the addition of the time dimension introduces new means with which to examine the interior spaces of the museum and specific artefacts housed within it.

Being a time-based video work, designed for projection onto a screen or viewing via a monitor, the object is not able to intervene into the viewer's physical environment, literally, but does so through disrupting the observer's expectations of space by drawing their attention into its space. Figure 7.8 shows a sequence of three stills frozen from a short passage of the video, where within a period of approximately one second a running child appears, from nowhere, in the frame before jumping out of the picture. This of course does not describe, let alone represent, a faithful account of real events that have actually occurred as they are presented: indeed, the child never ran through that particular location at all and was videoed elsewhere; but the sequence (when seen properly, as a video work in time) presents an intriguing ontological problem to the observer who is unaware of the methods of making the work. Since the work is composed of recorded events that have taken place (because like photography, the medium, as Scruton would suggest, is transparent to its referent),[41] the video is true but difficult: one sees real things happening which cannot have happened, unless explained by rules of space different to those expected or to which one is accustomed. This, in effect, is what takes place.

While the medium does record real events, in space, over time, it also allows for intervention and manipulation in several distinctive ways: it can be edited to show disparate events simultaneously through masking and layering, to create convincing syntheses of spatially and temporally distinct incidents; decoupled audio and video tracks and multiple time codes dislocate the viewer from the normal cues used to orientate their relationship to the events seen and heard; and editing tricks including non-contiguity, repetition, omission and scale can be employed.

Whereas the medium itself is spatially flat, providing no depth cues intrinsically, the ontological crisis is generated by the alternative means described. The work declares, effectively, that space is mutable, subjective, discontinuous, shaped by experience and characterised by both temporal and dimensional instability.

To conclude the arguments considered here, it could be suggested that, eccentricity notwithstanding, attention to the relationship between spatial and ontological thinking is of direct appeal to fine art practice, and that the developing culture of practice-based

research is enriched by the addition of ontological interest to the necessary epistemological inquiry. Research can be seen as clearly distinct from practice, but the emergence of practice-based research generates a specific concern about questions of knowledge in practice, or what might be termed practice-as-research. The linking of ontological and space speculation is not without historical precedents within the sphere of art practice, but it can be proposed that research in this area is greatly enriched by the development of distinctive and appropriate methodologies that draw on knowledge advances in other disciplines including, in this case, mathematics, geometry, philosophy, psychology, art theory and visual computing practice. All, however, are related through the field of fine art.

Notes

1 Quinton, Anthony (1999) 'Ontology', in Allan Bullock and Stephen Trombley (eds) *The New Fontana Dictionary of Modern Thought*, 3rd edition. London: HarperCollins, pp. 608–9.
2 Nerlich, Graham (1994) *The Shape of Space*, 2nd edition. Cambridge: Cambridge University Press, p. 1.
3 The term *practice-based* is used here to refer to research degrees based in fine art practice, although the term is used commonly to apply to other areas of creative practice, and has a wider application encompassing other professional or practitioner-based research degrees in a number of disciplines.
4 Macleod, Katy and Holdridge, Lin (guest eds) (2002) 'The Enactment of Thinking: Creative Practice Research Degrees', *Journal of Visual Arts Practice* 2(1–2): 5ff.
5 Ibid. p. 6: 'It is, of course, axiomatic to assert that research methodology demonstrates the research premise upon which it is predicated.'
6 See Cazeaux, Clive (2002) 'Categories in Action: Sartre and the Theory–Practice Debate', in Macleod and Holdridge (2002), p. 44.
7 Bullock and Trombley (1999), pp. 608–9.
8 Nerlich (1994), p. 1.
9 This definition previously given in Barfield, N. (2000) 'Spatial Ontology and Digital Print', in Macleod and Holdridge (2002), p. 28.
10 Henderson, Linda Dalrymple (1983) *The Fourth Dimension and Non-Euclidean Geometry in Modern Art*. Princeton, NJ: Princeton University Press.
11 Adcock, Craig (1983) 'Marcel Duchamp's Notes from the "Large Glass": An N-Dimensional Analysis', in *Studies in the Fine Arts, Avant-garde* no. 40. Ann Arbor, MI: UMI Research Press.
12 Gibbons, Tom (1981) 'Cubism and "The Fourth Dimension" in the Context of the Late Nineteenth Century and Early Twentieth Century revival of Occult Idealism', *Journal of the Warburg and Courtauld Institutes* XXXXIV, Warburg Institute, University of London.
13 Abbott, Edwin Abbott (1991) *Flatland: A Romance of Many Dimensions*. Princeton, NJ: Princeton University Press.
14 Ibid. Introduction by Thomas F. Banchoff, p. xxiii: 'geometers attempted to visualize phenomena in the fourth and higher dimensions. They drew pictures and made models, and even attempted to use stereoscopic images in order to see what projections and slices of four-dimensional objects looked like.'
15 Ibid. Introduction by Thomas F. Banchoff, p. xvi.
16 Plato (1980) *The Republic*, 2nd edition, Part VII: *The Philosopher Ruler: The Simile of the Cave*, p. 316. Trans. and introd. Desmond Lee. Harmondsworth: Penguin.
17 Henderson (1983), p. 17: 'Abbott's tale is based on the premise that the meaning of the third dimension for a two-dimensional being compares to the meaning of the fourth dimension for us.'
18 Rucker, Rudolf van B. (1986) *The Fourth Dimension and How to Get There*. London: Penguin, p. 19.

19 Coxeter, H. S. M. (1973 [1963]) *Regular Polytopes*, 3rd edition. New York: Dover, p. 118:

> a certain facility in that direction may be acquired by contemplating the analogy between one and two dimensions, then two and three, and so (by a kind of extrapolation) three and four. This intuitive approach is very fruitful in suggesting what results should be expected.

20 Henderson, Linda Dalrymple, in Tony Robbin (1992) *Fourfield: Computers, Art and the Fourth Dimension*. Boston, MA: Little, Brown, p. 18:

> Duchamp's creaturely, biomechanical Bride in the upper half of the *Large Glass* was meant to be four-dimensional, forever out of reach of the Bachelor machines trapped in the three-dimensional, perspectival world below.

> Duchamp was interested in both projections and slices of higher-dimensional figures, and, in the end, he would explain the Bride as a two-dimensional projection or shadow of a three-dimensional Bride, who was to have been the shadow of the ultimate four-dimensional Bride.

21 Adcock, Craig (1989) 'Duchamp's Eroticism: A Mathematical Analysis', in Rudolf E. Kuenzli and Francis M. Naumann, *Marcel Duchamp: Artist of the Century*. Cambridge, MA: MIT Press, pp. 149–50.
22 Kant, Immanuel (1964 [1953]) §13, 'Prolegomena to any Future Metaphysics', trans. with introduction and notes by P. G. Lucas, in J. C. C. Smart (ed.) *Problems of Space and Time*. New York: Macmillan, pp. 124–5.
23 Le Poidevin, Robin (2003) *Travels in Four Dimensions: The Enigmas of Space and Time*. Oxford: Oxford University Press, pp. 63ff.
24 Banchoff, Thomas F. (1990) *Beyond the Third Dimension*. New York: Scientific American Library, p. 193.
25 Kaku, Michio (1999 [1994]) *Hyperspace: A Scientific Odyssey through the 10th Dimension*. Oxford: Oxford University Press, p. viii.
26 Ibid. p. 190:

> The ideas of non-Euclidean geometry became current at about the same time that people realised that there could be geometries of higher dimensions. Some observers lumped these two notions together and assumed that any geometry of dimension higher than three had to be non-Euclidean.

27 Postulate, V., Heath's translation of Heiberg's text, Cambridge University Press, 1908, in Roberto Bonola (1955) *Non-Euclidean Geometry*. New York: Dover, p. 1. Translated and with additional appendices by H. S. Carslaw.

> If a straight line falling on two straight lines make the interior angles on the same side less than two right angle, the two straight lines, if produced indefinitely, meet on that side on which are the angles less than the two right angles.

28 Gauss, Carl Friederich (1777–1855), German mathematician, astronomer and physicist, failed in his attempts to disprove the falsity of the parallel postulate, and never published his results.
29 Bolyai, Johann (1802–60), Hungarian author of *The Science of Absolute Space*.
30 Lobachevsky, Nicolai Ivanovich (1793–1856), Russian author of *The Theory of Parallels*.
31 Riemann, Georg Friedrich Bernhard (1826–66), German mathematician.
32 Gleizes, Albert, and Metzinger, Jean (1993) *Du Cubisme*, in Charles Harrison and Paul Wood (eds) (2002) *Art in Theory 1900–1990: An Anthology of Changing Ideas*. Oxford: Blackwell, p. 188. Originally published Paris, 1912, translated into English 1913. Present extract from R. L. Herbert (1964) *Modern Artists on Art*. New York: Prentice-Hall.

33 Apollinaire, Guillaume (1912) 'The New Painting: Art Notes', in Harrison and Wood (2002), p. 181 (originally published in *Les Soirées de Paris*, April–May 1912. Translation from Breunig).
34 Gray, Christopher (1961 [1953]) *Cubist Aesthetic Theories*. Baltimore, MD: Johns Hopkins University Press, p. 84.
35 Pirenne, Maurice (1948) *Vision and the Eye*. London: Pilot Press, pp. 161–2.
36 Eysenck, Michael, and Keane, Mark (1995) *Cognitive Psychology: A Student's Handbook*, 3rd edition. Hove, UK: Erlbaum (UK) Taylor and Francis, pp. 37ff.
37 See Brisson, David W. (1978) *Hypergraphics: Visualizing Complex Relationships in Art, Science and Technology*. AAAS Selected Symposium 24. Boulder, CO: Westview Press; Robbin (1992); and Michele Emmer (ed.) (1993) *The Visual Mind*. Cambridge, MA and London: MIT Press.
38 Abbott (1991), introduction, pp. xvi–xvii.
39 Manovich, Lev (2001) *The Language of New Media*. Cambridge, MA: MIT Press, p. 253.
40 McLuhan, Marshall (1993) 'Introduction' and 'Challenge and Collapse: The Nemesis of Creativity', in Harrison and Wood (2002), pp. 739–42.
41 Scruton, Roger (1983) 'Photography and Representation', in *The Aesthetic Understanding*. London: Methuen, pp. 102ff.

sidekick

In 1996 I started to make the artwork which is the subject of the following text. I am still working on it now. In 1997 I started to write a description of this artwork. I am still working on this too. As of January 2004, this is the most recent revision of this description.

I unwind packing tape from the roll upon which it is commercially distributed. As I unwind it from the roll, I rewind it again, but not onto a roll, only onto itself. I wind the entire roll in this way without interruption. At the conclusion of one roll I continue with another, and so on, adding each to the same mass. Gradually the mass grows larger. I maintain this process.

I apply the tape to the mass in a consistent and particular manner, which has allowed the production of a regular form. I wind the tape off the roll and around the mass. In the course of each circuit, I rotate the mass a little, and steer the tape aside, moving it around and across the surface. A circuit does not ever conclude by a return to the precise point at which it started. Because of this the tape is continuously applied to a different area of the surface.

The mass expands fairly evenly around an approximately central point of rotation and forms a vague sphere. The tape is always applied tidily. I draw it tautly over the surface of the sphere, so that it adheres well and lies flat. I also press out any small air pockets. It is not possible to entirely avoid these quirks, but I am able to minimise them to the degree that they do not disrupt the surface of the subsequent layer. On the uppermost layer they can always be seen, but they are slight, and on the whole this top layer is able to cohere as a consistent surface.

Because the tape is always applied with the adhesive on the inside, the surface of the sphere is effectively comprised of the upper-face of the tape (the shiny side). Although, as the sphere is so neatly assembled, and because the tape is a consistent material, the integrity of the tape does become a little lost to the sphere. It conglomerates, and even at quite close proximity the sphere can seem to have its own surface, which is soft, smooth and glossy. The tape is mid-brown, and so is the sphere, although in such a mass, the brown of the tape looks more like clay, or plasticine, or cheap chocolate.

The careful process of application which I employ also has other effects. The tight and precise process of winding results in a dense and highly compacted mass. The sphere is quite heavy, relative to its size. If I wound it less carefully it would obviously expand

more quickly, relative to the time and material expended; although it would probably be a less regular shape and a less stable mass. It includes a large amount of tape. I am not sure how many rolls I have wound on to it so far. I stopped counting after one hundred.

It has also consumed a considerable amount of time. The process of its production is quite labour intensive and increasingly physically demanding. When I began to make it I was keen and curious, and I worked on it for several hours every day. Now I tend to work on it more sporadically, because it does not draw nearer to a point of completion, and no distinct development ever appears to be precipitate. As it grows larger it expands more slowly, so working a little and regularly can appear to make no difference. I tend to work on it intermittently, but then very intensively, in order to be rewarded by some kind of effect. The more I work on it, the more difficult it becomes to work on. It takes more time, relatively, and becomes increasingly physically demanding. It is now quite unwieldy. It is much too heavy to lift and is quite difficult to manoeuvre. I have resorted to moving it by rolling it. Although, because it is so heavy, rolling tends to compact it. This renders progress even slower. I do work hard to wind the tape as tightly as possible. Lately I tend use the weight of the thing to aid me, pulling the tape hard against the force of this weight and folding it down quickly onto the surface. This is one respect in which the expansion of the sphere assists in the process. When it was smaller and lighter, I used to produce this stress by pulling between the sphere in one hand and the roll in the other. It was quite difficult to maintain this tension consistently. But even now that it has become a little more easy, I can still never wind the tape tightly enough.

It surprises me to observe how much the mass yields under the pressure of its own weight. It is obviously still quite slack, notwithstanding my exertion. Indeed while the sphere is dense and heavy, it is also soft, more so than on the roll. If you apply even slight pressure to a newly applied surface of the sphere, it gives way a little, and bears an impression, like damp clay.

As the sphere becomes larger, the gradual accumulation of its weight continues the process of compaction, and increases its relative effect. It is now sufficiently heavy to markedly compress the part of the surface upon which it rests. While I am working on the sphere, it continually rests upon different areas of its surface, and so this compaction is distributed more or less evenly. But if I leave it in one place for a while, then the effect is more evident, and a flat plane develops and slowly expands. Before the mass begins to settle in this way, it also shifts. Occasionally some internal movement of weight, upsets the balance and it rolls slightly, without any immediate external cause.

The sphere is quite big now. I get confused about exactly how big it is. Obviously it is always changing in size, but this scarcely happens rapidly. I have not measured it, partly because it is an irregular form, which would be difficult to measure accurately. I usually only need any kind of measurement when the sphere is not on hand to refer to, and in these cases I attempt to rely upon memory. Later on when I am able to actually observe the thing again, I am sure that I guessed wrong. I think that I usually imagine it as bigger than it really is.

But even though I do not know any measurements, the experience of physically working upon it does allow a more immediate awareness of scale. For example, it is too

large to go through some doors and it is too heavy for me to lift. It can only be situated in and worked on in places with appropriate access facilities, and lifted with assistance or equipment. On a more refined level, although it is always incrementally changing, at any point it requires a quite precise amount of physical force to roll it, and then to contain and guide this movement. It takes a specific amount of time to roll the thing around full circle, and only a certain length of tape can be pulled from the roll and laid over the accessible surface before it is necessary to pause and roll the sphere over again in order to carry on. I understand these amounts of time and stuff and force quite precisely. I am also able to employ this understanding quite consistently. I can modulate and project this understanding in tandem with the incremental development of the sphere.

I find it more difficult, however, to comprehend the relation of the thing's size, to the quantity of tape used to produce it. In this case immediate practical experience does not really help. In fact even when the sphere is immediately in front of me, and its size is manifest, I am confused about how this discloses quantity.

The roll of tape, meanwhile, clearly lends itself well to estimates of quantity. It is a distinct and apparently consistent unit. Large amounts of the material are distributed as multiples of this unit. The rolls are packaged in groups of six, shrink-wrapped together, then stacked into boxes. The roll size must be consistent to allow for this packaging. Each packed box holds six layers or thirty-six rolls of tape. Accompanying information indicates that the length of tape upon the roll is sixty-six metres. With this information I can figure how many metres of tape there are in a box. The tape is five centimetres wide, so I can calculate the square metres of tape included upon a roll, and in the box. If I accept or can verify the length and apparent consistency of the roll, then I can deduce quite explicit information about the quantity of tape upon a roll, in a box etc. But although such information is explicit, it is limited and/or selective. It accounts very effectively for certain characteristics of the roll of tape. It describes length and width, which can be extrapolated to produce knowledge of the surface quantity. This understanding is potentially useful, but clearly most apt to the particular moment of application, as the roll is unwound to produce the strip. The information alludes to this strip and the potential length and coverage. The measurements offered by the roll are a promise of the extent of use, and is tailored for those circumstances.

 But this information is not really readable or testable for the sphere. The information describes a surface for application, and the sphere is a mass. The tape upon the roll could be described in terms of mass, but the only explicit measurement I have, that of the length of tape on a roll, will not help me to deduce this. I would need to know the thickness of the tape; the number of revolutions required to wind the roll; the diameter of the cardboard core. It would be quite complicated to calculate the mass from this information, and the primary information might be inaccessible anyway.

 No information accompanies the tape as it is retailed. At the point of sale only the unit-price is disseminated. The roll does not even include any reference to the quantity it bears. I am aware of the length only because it was detailed in a goods description on an invoice from the manufacturers. (Minimum purchase 100 rolls). I could maybe find out more from this kind of source; but the absence of any kind of information about the tape upon the roll is a discouragement. It seems that such information cannot really be

important for the tape. The roll does not function to refer to an abstract amount. Its clarity is that of a unit which relies upon familiarity to be understood. It refers only to other rolls, and to cost.

And this reference works in general practice, because in common experience tape is not indexed to quantity. It is not exchanged upon a basis of size, weight or length. For it is not conventional to estimate how much tape will be required for a task, and then purchase the appropriate amount accordingly, as with many other consumables. It is not usually bought for a single use, so the actual amount used at one point is probably never considered. It tends to be used over a long period of time, for many small operations, so an entire roll is rarely used without interruption. In fact although the unit of the roll is conventionally accepted as a device for quantifying the tape, in practice it is only considered in relation to cost, in order to judge value for money. The majority of tape manufacturers utilise the same roll size, and include the same amount of tape per role so this kind of unit comparison is easy to make. Indeed it is so rarely necessary to think of tape in terms of its literal quantity and mass that experience can only allow a very vague appreciation of these things.

So though the unit of the roll is distinct, it is not particularly versatile. It is only ever a roll's-worth and this will not travel. It is not really possible to precisely understand the quantity of tape upon the sphere by exclusive reference to this unit. This sense is lost as the roll is unwound. At the same time it is not possible to properly understand the amount of tape upon the sphere by any other means, than a reference to the roll, because the roll is the only common concrete unit for the material which exists.

There are ways of measuring quantities outside of the scope of particular experience. I don't think I have ever self-consciously experienced 1,000,000 of anything, but I know what it means as an abstracted extrapolation of say 1; or 37 (my current age); or 6,126 (the total number of words included in this text). But I have not applied an abstracted system of quantity evaluation to the sphere and the roll, although I know it is possible. I could measure it in terms of weight: I could remove the tape from a single roll, weigh it, weigh the sphere, divide by the first weight and deduce how many rolls of tape it amounted to. I would know how many rolls of tape were incorporated in the sphere. I could measure the length of tape on a roll and multiply this by the sum of rolls applied. I would therefore know the length of all of the tape applied to the sphere. I could calculate the average item cost of the roll, and determine the material cost of producing the sphere. This information is more effective via experience of the roll, but it is not a prerequisite. All that is required is the knowledge of the systems used: metres, kilograms, pounds and pence sterling.

The terse economy of these equations is productive. It does reveal, but the same pointed focus which distils common and exchangeable values, is not sensitive enough to register certain crucial contingencies. For example the information such a calculation produced would be the same for a mass assembled in any way. The mass of tape, of which the sphere is made, infers particular things because of the fact it is wound. It is inflected with the conditions of its production, and implications of time, labour, action. It seems to me that the issue of the quantity emerges as a precursor to questions of labour or duration. And the mathematical detail of this mass, cannot readily be extrapolated to deduce associated issues of duration. In fact it is precisely the material effect of

protracted winding which renders it ineffective. For though an understanding of the amount of tape incorporated in the sphere may seem like a way to understand the extent of the labour of its production, any unit of tape cannot be consistently translated into a unit of labour. The quantity of tape upon a roll may remain constant, but the amount of time it takes to apply it to the sphere is not. Overall it incrementally increases with each roll. At some points the increase in scale has rendered progress provisionally quicker, and then slower again, even slower than before; so this development is not even. Also the changes in the nature of the sphere since its inception mean that the character of the labour has similarly evolved. Now it requires quite different kinds of manoeuvres, actions, levels of force, strength and energy than it did at the start. Such information would require a fairly complicated mathematical sliding scale to estimate and represent it. Obviously this is still possible, although it might prove less articulate, as an illustration of time, labour and stuff than the sphere is itself.

I actually have little idea of how much tape has been used and exactly how much time has been spent in producing the sphere. Up until about 100 rolls I kept a tally of them in my head. The information seemed interesting then, for at that point the input had a more emphatic relation with the output. But gradually the balance of sense shifted, and the sphere could less and less be comprehended by any means of a reference to the roll, which did not seem to account for what the sphere was becoming.

This did not effect an inversion of the early relationship, although I understood the roll differently because of the sphere, but the shift wasn't that tidy. They just became disengaged, one from the other, and the sphere moved out of the range of the logic of the roll.

This became explicit at around the hundredth roll, not because it was materially distinctive as a stage in the process, but because from the moment of beginning to make the sphere, I began to consider my options for ceasing it. One hundred rolls was the initial, arbitrary and predictable possibility for a conclusion of the process. So I counted the rolls as I wound them, and waited to see. It was in the process of trying to get there that it became increasingly apparent that the hundredth roll would not serve as an exit, that the more I made the sphere, the more irrelevant the unit of the roll became. Notwithstanding this though, I still kept counting to a hundred, and I was pleased when I got there, as if it was some kind of milestone. I had made some humdrum progress, albeit towards an increasingly remote end. I recognised the discrepancy between the sphere and the roll at the point of the hundredth roll in particular, because that moment was not distinct, provided no conclusion and did not reconcile the activity. It would have become apparent sooner or later, but it was my expectation which rendered it explicit right then.

A little later on, and for a while, I developed an alternative point of closure, which was derived from that declining relation between the roll and the sphere which had foiled the first attempt. This was a proposal to cease at the point when the addition of another roll to the sphere would make no perceptible difference to its size. (That is: when the relation between the expanse of the sphere's surface and the amount of tape on a roll was such, that the addition of a roll increased the size of the sphere so incrementally as to not be visible). This would be the last moment of the roll's purchase upon the sphere. However in being a point of disappearance, it was necessarily a difficult spot to discern. The difference from one roll to the next became so impossibly slight, that it could scarcely be judged visually and by memory with any confidence. And the point in question drew up so

slowly, so incrementally, that it was really only possible to say for certain that it had happened, after it had been and gone.

I have not been able to imagine another conclusion since the failure of this last, other than the forced compromise of stopping when I can no longer carry on, when the thing is just too big to work on, to keep, to move etc.

When I began to wind the tape to form the mass, it was not with the intention of producing anything. It was begun idly, and more to do with unwinding than winding at that time. In fact the winding of the tape onto itself was in many ways merely a kind of passive echo of the unwinding of it from the roll. I suppose that this is why I chose to wind it with the adhesive coated face inwards, and the glossy face outwards, as it is found on the roll. The mass of unwound tape produced in the course of this action was initially only a by-product of the action. It formed an irregular shape initially, which was spiny and angular. The tape was too broad and inflexible to wind easily onto a small convex surface, and formed sharp tucks and points. Initially the repetition of the process exacerbated this, as subsequent layers exaggerated and reinforced the contours of the previous ones, but gradually it evened things out. The surface expanded, and the tape became more apt, and easy to apply. The angles and points became lost. It became round.

It isn't really spherical though. The process isn't so tidy or natural an organisation as this might imply. In fact the clumsy accommodation of the method to the stuff leaves a lot of slack. The thing may be a straightforward result of the process, but it is clearly not apt enough to be the only one. For example, because the tape is a flat two-sided band it could be wound in a number of distinct ways. I wind it always with the adhesive-coated face inwards, and the glossy waterproof face outwards, much as it is found upon the roll. But it could be wound with the adhesive surface outwards. It could even be twisted as it was being wound, so that each face was alternately visible, (and this could incorporate a whole range of modulation). Each of these options is distinct and selective in their employment of the material; and each one constitutes an attempt to efface or extort certain of its properties.

This selectivity of this process can be understood from the sphere. It is not elegant enough to appear proper. But it becomes more forgettable through the gradual expansion of the sphere. The bigger the thing gets the more it seems to exhaust the scope of the stuff as the persistent continuation of winding in the same way lends a kind of conviction to the result, a sort of inevitability which seems to preclude other undemonstrated possibilities. In this way the crude fit between material and method is to some degree ameliorated.

The actual labour of the process is more candid. It discloses both of the general incongruities between the strip of tape and the form of the sphere, and the particular extortion of the chosen method. And this disclosure is not a factor of its increasing size. At every point in the process of producing the sphere I have been conscious to some degree of the gaucheness and rude coercion of my labour. During the early stages of working when I was less familiar with its affects, and embroiled in the actual physical clumsiness of performing it, it always seemed deliberated and sillier. So, it didn't seem so emphatic. Now it is more so, but I have become normalised to the thing, and to the principle of making it. If the process had remained the same I might have forgotten the extent of the contrivance too. It might have started to seem almost sensible. But the

repetition of the process in principle requires a continually evolving manipulation and so I am never really able to get used to the task itself. I do get better at it, but then it gets more difficult, more protracted. There have been a few occasions during the course of making it when it has actually become a little easier. For a short period of time the relation between the sphere, its size, its weight, the tape, its width, its flexibility is almost harmoniously productive. It does always become difficult again, but never for the same reasons, or in the same way.

When I started to make the sphere, although the method was gauche and unfamiliar, the object was small and light. So the process was quick and manageable. I worked with it in my lap, one hand rotating the sphere, and the other winding the tape. Then when the sphere became too large to grasp in one hand, it was placed on the floor. I would spin it there with my left hand, slowly, from the top, and wind the tape, looping around its width with my right hand. Once in the course of each loop, I would have to lift my left hand up, off the sphere, to let my right hand pass under, then replace it immediately to continue the spinning. It was possible to perform this process quite quickly as its neat rhythm allowed some momentum to develop. Later, it became too large and too heavy to spin with one hand from the top. I would rotate it by rolling it, pushing it with my hand, and nudging it with my knee to steer it in wobbly circuits around the room, while winding the tape with my other hand. After a while it became too weighty even for this, and now it is necessary to roll the sphere with both hands. I wind the tape with the roll flush to the surface of the sphere, allowing only a tiny slack of tape between them. I wind the roll to the top of the sphere, and hold it there while I push the sphere in the contrary direction to this last application of tape. I roll the sphere just enough so that the roll becomes positioned close to the bottom of the sphere, at the floor. Then I wind the tape up to the top again, steering it a little to the side of the previous strip, to keep the distribution even. I then repeat this whole process.

Often the process feels overbearing, but sometimes it does not. It seems attentive. I have become acutely aware of the nature of the material. This understanding does not really ameliorate the crudeness of the process. It has never really allowed me to parallel the discretion and ease of a more compatible procedure. But I have developed an understanding of the nature and possibility of the material which has something of that finesse. The evidence of this is slight, and is only really apparent to me in certain details of the practice. But then I am quite distinctly conscious of it. I have come to know how best to hold the tape so that I can guide and pull it tautly across the surface of the sphere, while letting the roll rotate in my grip to release the tape. I can judge how quickly to rotate the sphere while winding tape onto it, so that its shape does not become distorted. I understand the range of the flexibility of the tape, in curving across the surface of the sphere. I am familiar with the weight of the plastic of which the tape is made and the strength of the glue, and so I am able reel it off, control it, and apply it to the sphere, without it waving, or tangling, or sticking to itself randomly.

This kind of particular understanding makes the process more precise, but it does not necessarily increase the general ease of it. As the sphere grows larger it becomes more difficult to manipulate, this is an inexorable condition of the thing. To some degree this is just an issue of scale, and would pertain to other materials. But the misfit of the relation between the tape and the sphere means that at different moments, different aspects of the process slip in and out of ease and precision. Now that the sphere is large

the surface is more apt for the application of the tape, but because it is heavy it is more difficult to rotate, to allow the tape to be applied.

When I started to make the boulder (this is what I call it now), it was not really a very arduous task. At that point development was quite rapid and there was always some visible evidence of time spent. Now my labour does not produce differences from moment to moment, and even from day to day. I can work for hours and see no discernible change in the size of the thing. This experience is compounded by the knowledge that with the addition of each roll to the boulder, the degree of influence of the next is necessarily reduced. It is because of these recent developments that the task of producing it is becoming gloomy. It seems as though the relation between time and production is stretching with some kind of cartoon-like improbability out of my perceptual range.

I do know why everything is so slow and slowing down. I understand why, as time goes on, my work seems to achieve less and less. It is very simple. As the sphere becomes larger, its surface area increases, and so with every layer an increased amount of material and labour is required. As the scale of the sphere increases in relation to the tape, the addition of each roll has a decreasing relative visible/physical impact. I understand these things, they are clear to me, in principle anyway, but they do not seem to entirely account for the loss. And I am still confused to see my labour, and the matter of the tape disappear, with no distinct effect or trace. It is contrary to the humdrum logic of the world, and seems more like one of those clever devices of narrative film, used to build suspense. Like slow-motion maybe or time warp. It calls to my mind the cruel representational jokes of animation. (I think of 'Road Runner' concealing a deep gully with a representation of a continuing road, I think 'Bugs Bunny' moving the visible mouth of his burrow across the surface of the ground, without actually moving his burrow. I think of 'Pink Panther' trying to leave the clinic by the back door, only to find that as he walks out through it, he simultaneously arrives back through the front door.)

I do find it difficult not to feel a bit duped by the boulder, cheated out of the proper value of my time and the tape. I know that it is difficult to judge a sphere in terms of quantity, They are funny things to try and make such sense of. But I am still surprised that it does not reveal in even the most general way, a fairly substantial increase of mass. The stuff disappears into it, and but for the debris of boxes, shrink wrap and cardboard boxes left over, I would not know for certain that I had not dreamt up all the work I think I have done.

Sometimes when I look at the boulder it does not even seem to be very concentrated as a mass. It looks as though it could be hollow. Or at least it does not appear to be necessarily heavy. It certainly does not convincingly hold the appearance of its own weight. It is always difficult to gauge such a thing as weight by only looking; and foolish – it is the wrong test, so one should really expect to be misled. Although in practice we make such estimates all the time. In the case of boulder, given that the material of is so ubiquitous and its process of realisation so straightforward, it is difficult not to expect a correlation between how heavy it appears to be, and how heavy it is. The apparent material and making of boulder may seem to be candid to the point of being humdrum, but the effect of the object is still vague.

The actual weight is simple to test. But the only reason to test the weight would be to verify the apparent process of production. If the boulder is too light, then it could be

deduced that it was not produced entirely by winding tape. It might therefore be hollow, or include some other material. The evidence of weight is a means to gainsay, or corroborate the apparent visual evidence of the sphere. However although it is possible to test the weight, this test could still not absolutely verify the boulder. For, while only one material and method is disclosed by the boulder this does not necessarily preclude the possibility of others. The tape lends itself generously to these doubts in as much as it functions as a kind of skin which might conceal and encapsulate other materials. There is certainly nothing evident which could disprove the possibility of deception. Even if the weight were consistent with a solid mass of tape, it would not prove that this was the nature of the mass; it might simply suggest a more sophisticated hoax.

The evidence of the boulder is difficult to verify, and so it is potentially unreliable. The matter-of-fact descriptive qualities of the thing, and the descriptions of this text cannot be depended upon: they could be contrived, rather than candid. The apparent straightforwardness of both could be tactical – it could be poker-faced. Certainly, neither the thing, nor the account can be properly checked (short of re-enacting the improbable task in question in order to test the physical evidence of the object, and the detail of the text for any inconsistencies).

But although it is not possible to be sure that the boulder is made in the way I claim, this does not then assert any other thing. It is certainly not evidence of a feint. Yet the doubt precipitated by the unverifiable production of the boulder seems to tend to one end, more than the other. It substantiates the feint more than the boulder.

This prejudice occurs mainly because of the differing inference of labour. There is little other discrepancy of value between the two alternatives. It is not the notion of solid tape which seems improbable; it is the apparent evidence of how the mass of tape was produced which is more difficult to give credence to. It looks like a lot of work, and to no real effect. The labour clearly does not demonstrate itself. It is just not as likely that the boulder is produced in the way I claim, as almost any other imaginable.

Sometimes I am not sure myself if the boulder has been made in the way that I claim. I know that this text is strategic rather than ingenuous. Many things are invented or extorted, many others are effaced or excluded. How could this be otherwise, for an innocent description would be endless. But given that the text must inevitably determine some things, and that it is me who has orchestrated (much of) the political shape of my disclosure, I find it quite difficult to remember clearly the distinction between the experience and the terms in which I have chosen to relate it. I know that I have not told everything, but I cannot remember all of the things I have not told. I know that I have elaborated and misled, but I cannot distinguish for myself all of these passages. The tactics of the text have obfuscated the memory of producing the boulder. Also notwithstanding that these tactics have included attentive detail, the text does not seem to account for the thing with anything like the necessary particularity. The economies of prose: the choice and use of terms; the deployment of inference and of explicit and implicit factors; the concerns of tone, of structure and of composition, the organisation of material according to a logic of narrative (encounter this first, then this, then this, and so on) are just all too unwieldy. The nervous craft of writing (of later being read) is just not generous enough. I certainly keep trying to write this text well. I keep trying to improve it. Passages are removed, new passages are added, and then maybe removed again. But it is never very good. I am confused about its purposes, ostensible and actual.

I am concerned about its affects. It is never as sharp as the boulder, but nonetheless, it is always so much more plausible.

Such persisting discrepancies of sense and value of the boulder are exacerbated by the tape. Its material properties of adhesion, and its conventional application of enclosure suggest the possibility, if not the likelihood, of the inclusion of another material. (Even upon the roll, there is the roll.) And the conventions of its use also precipitate a hierarchy of value. The tape is always accompanied, and it is most usually accompanied by something else more worthy. The materials, objects and information it accompanies are generally of a different order and status, and so its presence is afforded by their association. The tape does not have any material autonomy, and neither does it possess significant autonomous value. It is merely an appendix, always a sidekick.

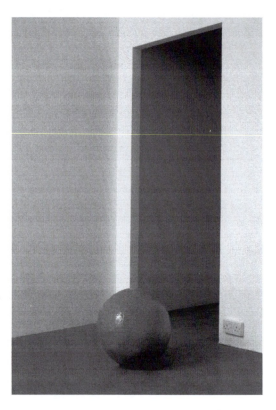

Elizabeth Price, *Boulder* (April 1997)

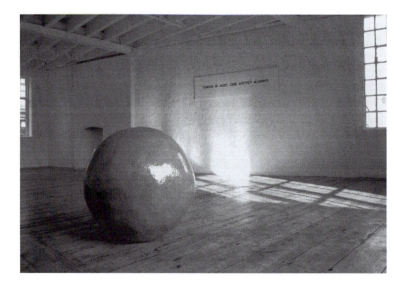

Elizabeth Price, *Boulder* (October 1999)

Chapter 9

Painting: *poignancy and ethics*

Jim Mooney

The condition of painting: how is painting doing?

> Painting is a carcass right now – it has been picked clean of all its meat . . . painting has always been about death.
>
> Lari Pittman[1]

This text seeks to explore questions which gather around the contemporary condition of painting and impact upon its future relevance as a vital and revitalised practice. The first of these questions, 'How is painting doing?' is deliberately posed in the convention we might use to enquire after an ailing friend or acquaintance. Thoughts on the state of painting's health inevitably arise in response to the seemingly perennial annunciation of its death or, at the very least, its terminal decline. It would indeed seem that when we begin to reflect upon painting thoughts of death, mortality, and finitude rarely lag far behind. Painting does certainly appear to enjoy a particularly entangled, intimate and longstanding relation to death. However, this relation might not be as morbid or settled as it first appears; instead it is a relation in endless ferment, still highly relevant, fascinating and capable of powerful illumination. It is this more profound relation to death which, paradoxically, lends painting its continued life force and defiant resistance to the writers of its many obituaries. The kind of question which seeks a response in the second section of this chapter would approximate something like, 'What is painting doing?', 'What can painting do?' or even 'What is left for painting to do?'; but most keenly, the steering question which emerges is 'What is our relation to painting?', especially indeed if, as Lari Pittman asserts, it has been picked clean of all its meat!

Death, of course, is not an event that we can ever know. In any case, it would be folly to think of death as a singular event. The only deaths we can experience are those deaths which unfold in life, which block living in life. We know our lives to be shaped by bereavements of all sorts, indeed, we metabolise bereavements slowly and they come to form part of who we are and who we will become. Culturally, however, it is the painter who has had to survive more than most. The painter has had to devise ways of facing the bereavement which follows on from the apparently interminable pronouncements of the death of the very practice which lends to her or him the name painter. Some cultural commentators would have us believe that painting, if it is to have a continued cultural role, needs to open itself to various forms of contamination by other, purportedly more vital, practices in order to renew and extend its own

vitality, in a somewhat forlorn bid to secure a foothold in the future. The demand is that painting move from some notional and moribund purity to a condition of fashionable hybridity, where painting is dilated and brings other modes of practice under the purview of its discourse. I have considerable sympathy for this ambition to reshape the territory of painting and there is no doubt something to be said for its advocacy, but I do question the ease with which this proposition is advanced as a sort of cure-all rescue remedy. I would propose that the more pressing exigency and arguably, the more challenging, would be to revitalise our understanding of painting. As we well know, painting has triumphantly survived these various death knells and currently enjoys the status of renewed cultural currency.

But how?

I'd like to propose that painting's survival is secured by a certain failure which is the failure to mourn. This failure to mourn arises from the painter's inability to detach his or her libido from the dead body of painting. Consequently, a pathological condition takes hold which prohibits the decathexis necessary to abandon this love object and wholly return to the world of the living. This condition is known to us as melancholia, a condition whereby we enter into an exhausting, yet never exhausted, dialogue with the dead. It is of course Freud who famously establishes a correlation between Mourning and Melancholia in his 1917 essay of the same name. In this essay he reveals to us a terrible yet necessary truth, that

> it is a matter of general observation that people never willingly abandon a libidinal position, not even, indeed, when a substitute is already beckoning to them.[2]

It wouldn't be a difficult undertaking to cite the array of contemporary art practices which beckon the painter, yet, obstinately, painters provide testimony to their possession by a body which is both the object and site of a failed or partial mourning. The temptation to be seduced by these other, supposedly, more vital practices, has proved to be too great for many, myself included, but not so for the painters who press ahead in their pursuits. They remain true to their first identificatory love and appear determined to kiss painting back to life. This wilful inability to let go, to relinquish possession, represents a significant victory for painting in the fraught and interminable struggle between the ego and the lost object. There is a considerable degree of ambivalence inherent in this relation and this ambivalence might be characterised as a kind of essential strife in which the painter oscillates between hate and love, between a murderous desire to 'loosen the fixation of the libido to the object',[3] and the contrary desire to nourish this affective fixation. This latter desire is expressed through the work of the theoretically engaged painter as an act of obsessive, repeated reflection, on the condition of the practice. This work of repeated reflection unfolds in the tenebrous space of liminality which the painter has come to inhabit with the love object. Contemporary painters, addressing their own specific concerns and motivations, knowingly or unknowingly, enter into an extended dialogue with the condemned body of painting, which inevitably invokes its long, distinguished and degraded history. Successful mourning would allow these painters to bring the dialogue to a close, to walk away, unburdened and untroubled, the body laid to rest. Instead, they are trapped by their failed work of mourning, which, in turn, initiates an interminable dialogue in which matters of *praxis* become endlessly complicated and importantly,

the most challenging of contemporary painters spur us on to revitalise the ways in which we think and come to understand the function of painting.

Admittedly, to speak of painting in the generic sense is a fraught business given the fractal intricacies which have come to characterise the contemporary operations of painters. Yet, there are nevertheless general remarks which can be made with regard to the function of painting to which a degree of cultural worth still attaches. It is perhaps a commonplace to assert that painting, in common with other aesthetic productions, simultaneously marks and is marked by loss. Nevertheless, it is such a fundamental condition that it is worth reiterating that the loss of the originary love object provides the painter with a necessary and vital generative impetus. Moreover, the kind of painting which furnishes us with images, functions, in part, commemoratively, and although not strictly speaking indexical, nevertheless points an index finger, as it were, to the object which the painted image now comes to substitute and resemble.

Crucially, painting is both of this world and yet simultaneously posits a world in itself, that is, a world decisively separated but nevertheless extricated from this world. In this sense it enacts a double occupancy, being both an object in this world and presenting to us a world in itself where things are identified, selected and extracted from this world and are duly accorded an *exotic* positioning; exotic, in the etymological sense of outside, *dehors*, apart from. One of the crucial functions of art and imagistic painting in particular (although photography would also be an exemplar) is this ability to separate out from this, our world, something of that world and allow the chosen image/object to stand apart in order that it can be appreciated anew and seen as if for the first time. The effect of this is to produce a sensation of things-in-themselves. In this way, objects familiar to us ring strange and are framed through the processes, treatments and attentions of painting whereby their appearance shifts, is doubled, and assumes the character of alterity.[4] But, how is this exotic reality, this fragment extracted from our world, restored to us, made accessible once more? Clearly it is through the aesthetic, and I would like to add, the ethical encounter with art that our experience and understanding of these objects is revitalised and renewed. According to Lévinas, it is through sympathy and I would wish to introduce poignancy as a vital medium for this apprehension and appreciation.

There is a world of Delacroix and a world of Victor Hugo. Artistic reality is a mind's mean of expression. Through sympathy for this soul of things or of the artist the exoticism of the work is integrated into our world. That will be so inasmuch as the alterity of the other remains as *alter ego*, accessible through sympathy.[5]

This notion of a double occupancy, this transformation of familiar object into strange and forbidding image, brings to mind Maurice Blanchot's radical likening of the status of the image to that of the cadaver which, we are instructed, is uncannily both here and nowhere. It is Blanchot who teaches us that this privileged non-site is shared by both the cadaverous presence (the presence of the unknown) and the image. He writes: 'The image does not, at first glance, resemble the corpse but the cadaver's strangeness is perhaps also that of the image'.[6] The appearance of the image, in common with that of the cadaver, depends on an immensely fragile and disturbing doubling and, most poignantly, is what is left behind when the object it resembles is gone. The work of the painter engages in the delicate process of creating apparitions which can occasionally glow and cast illumination upon this otherwise abandoned ground of dereliction.

In a particular sense, the image assumes a mediating role between the subject (viewer) and the object to which it refers. Viewed in this way, the painted substrate, the surface, facilitates and proposes this mediation. I prefer, however, to consider the carefully factured surface in terms of a differentially inclined spatial and temporal movement from inwardness to exteriority. Indeed, this very movement is the experience which I most value when I stand before a painting and the experience I most seek without ever knowing precisely what it is I seek. It is the movement which guarantees the renewal and continued cultural currency of painting. My face turns, looks before me, in a forward direction, to an exteriority, to the surface of things beyond in the transcendent spaces of the world.

I am minded to mention here Lacan's proposition cited in the *Four Fundamental Concepts* that 'in front of the picture, I am elided as subject of the geometrical plane',[7] and, if there is any merit to be found in this statement, we might fairly extend the proposition to include the painter of the picture, asserting that the screen (the geometrical plane of the canvas) now be seen as the locus of mediation between subjects, becoming a tenuous, fragile and luminous site of intersubjective exchange. We are dealing here with surfaces which face us with radically different tensions and functions which often operate simultaneously. Experience is transformed, and through our encounter with art, the transformed is returned to the realm of experience, extending our understanding of ourselves in the process. We respond to what Alphonso Lingis calls 'imperative surfaces'.[8] A surface might be wilfully hard, smooth and unyielding, equally it may be softly toothsome and absorbent, it might present a barrier to be overcome or negotiated or alternatively, it could offer an entirely welcoming and permeable skin. It could equally well be all that there is: pure surface. The surface might be virginal as in a *tabula rasa* or again, it may carry the heavy burden of saturated inscription. It can stand as the only glimpse we can apprehend of what lies behind or it can act as an aperture or passageway through to what has previously been entirely occluded. I am prompted to consider the painted surface as akin to the face of another and can be perceived as the exposed surface of a depth structure. The surface may well be all of these things, tessellated into a tightly woven mosaic of varying tensions and densities. However, let us be reminded that, in every case the surface, the (sur)face, is that which is most exposed and let us consider, in this light, Heidegger's formulation of truth as 'uncovering and uncoveredness, shedding light and light shed'.[9] This shedding of light on the uncovered, the exposure of the exposed face, produces a vulnerability which appeals (the call of the vulnerable), bringing nakedness to the surface. Standing before a painting, when conditions permit, we respond to the naked appeal of this surface and are beckoned, called upon to enter into a relation which is not nearly as forbidding, but is, nevertheless, akin to that which Lévinas calls the 'Face-to-Face'. According to Lévinas, the face is the invisible that summons from the distance of alterity. Lingis describes instances of the Face-to-Face encounter as follows:

> The face and surfaces of others afflict me, cleave to me, sear me. They solicit me, press their needs on me; they direct me, order me. The face of a stranger in the crowd turned to me is an imposition. The face of a Somalian looking at me from a newspaper intrudes into my zone of implantation; I am relieved that the

opaqueness of the paper screens me from him. In the corridors of my projects, my goals, and my reasons, the tormented laughter of the visionary and of the one lost in orgasmic abysses arrests my advance.[10]

The Face-to-Face relation carries the promise and demand of the possibility of radically reducing the distance which separates the Same from the Other. A proximity born in response to a beckoning distance, establishes itself, and takes up a precariously identified, quivering, position. Lévinas writes:

> The Other becomes my neighbour precisely through the way the face summons me, calls for me, begs for me, and in so doing recalls my responsibility, and calls me into question.[11]

This call to respond solicits a movement which is both an inclination (a leaning toward) and a shift in inclination, that is, a shift in taste, a shift in disposition. We might pose here the question, at what point in this inclination does one slip into the other? Does this slippage entail a risk? Does the risk carry a loss or a gain? The loss would be a drop in ego strength, this could persuasively be argued as a gain of a kind, or a more unalloyed gain might be a gain in understanding; a sympathetic move from one to the other, from me to you or you to me, which entails no loss on either side, but nevertheless restores an equilibrium. Moreover, we need to consider the nature and function of this distance, this gap, between one and the other. Can this gap be erased or reduced, should we seek to abolish this distance, or is it an essential gap which provides for intersubjective interplay? Should we strive to overcome this distance which separates, seek the consolations of reconciliation? What is it that occurs at this juncture, in this hiatus? What is produced in this space, this distance, this lacuna? If we are to incline toward, change our position, in response to the poignant demand which weighs so heavily upon us, were we to shift our leaning from one foot to the other in sympathetic gesture, at what point do we recognise the need to rectify, adjust, draw back, reassemble? Clearly the Face-to-Face encounter carries a threat to our settled constitution, our daily routines and equilibriums. It carries in its train a disturbance which disorders. This can be treacherous. But it might also be instructive and illuminating. The appeal of the other has the power to shatter our stabilities, shake up our quotidian habits, wrest us from our utilitarian regimes and oblige us to rethink and realign our sympathies. Lingis, understandably, seeks protection from this disturbance in the newspaper which separates him from the Somalian face which otherwise might solicit, cleave, sear and demand. The newspaper screens and blocks. Yet the photographed face nevertheless intrudes. Lingis might well drop his gaze, but he is already marked, contaminated, *touché* by the photographic *punctum* and stained by the effects of the poignant. The sting of the poignant lingers, settles in our depths and surfaces in unanticipated forms. The poignant becomes part of our very constitution. Through its inescapable effects, we are obligated. Clearly, for Lingis, this distance, interval or gap, is a clearing which provides the necessary space for things to stand out, be seen, be set apart, and most importantly, establishes and maintains the possibility of discourse, communication, conversation: 'This distance of otherness opens up the interval of discourse. Across this distance, we speak'.[12]

Poignancy and ethics: or 'What is our relation to painting?'

Following on from the preceding section which posed the question 'How is painting doing?', in the manner we might enquire after a friend, this section is subtitled 'What is our relation to painting?' I will open with a quotation from *Camera Lucida*, the germinal meditation on the photograph by Roland Barthes:

> A photograph's punctum is that accident which pricks me (but also bruises me, is poignant to me).[13]

Poignancy moves us, redirects us, and the movement it gives rise to, leans us toward the other and inclines us toward the condition of implication where the same and the other become entwined, enfolded, enlaced. It is the sting of poignancy which enables such a shift; we lurch, move outside ourselves, take a step beyond, and are briefly enveloped in the rapture of the ecstatic. This can never be expected or guaranteed, it may be sought out or hoped for, but almost always happens by accident and mostly when we are least prepared. When it does occur, it is experienced as an irrecoverable instant, a moment when our subjectivity is stretched beyond the confines of the familiar, and reaches out, gravitating toward the object of its longing. It is perhaps worth underscoring here the trace of the Greek *ekstasis* – stretching, through *ekstasis* – to make to stand, which remains resonant in the ecstatic. Moreover, and more importantly, according to Lévinas, it is: 'Through ecstasy [that] man takes up existence. Ecstasy is then found to be the very event of existence'.[14]

Language can inhabit thought in ways which blind us to its treacherous deceit, concealing its other face in our usual patterns and habits of speech and I suspect we have become all too habituated to deploying the term *poignancy* in sentimental response to the pathetic scene and tend to overlook the subtle violence of which it also speaks. I would urge that we remember the semantic determinants of *poignancy*, which pertain to weapons, and signify something as being painfully sharp and piercing. With this in mind, if, for example, we take a foil, the type of sword used in competition which inflicts a sting as opposed to a mortal wound, and consider the disturbance it provokes, we inch ever closer to the establishment of an approximation between poignancy and Roland Barthes' articulation of the *punctum*. Most daringly, we might propose that we arrive at the insinuating intricacies of an ethics of the *punctum*. The *punctum* as ethical event? Might we audaciously nudge this idea along and formulate the proposition that it is *poignancy* which introduces the *punctum* (by now almost worn-out, tired and degraded, through discussions in relation to the photograph), to painting, where it becomes lodged in the very depths of its surface?

It is due to a mobilising sympathy, aroused by poignancy, that the work becomes folded back, returned to us, incorporated once more into our world. An ethical event of this kind produces an 'initial asymmetrical intersubjectivity', the weight of our concern lies with our own selfish interests and recognition of the subjectivity of the other is impoverished, unevenly tilted; that is, until the moment poignancy produces its sting, in an instant, and a sympathetic movement is initiated which inclines us in another direction, toward 'the leaving of an inwardness for an exteriority'.[15] This event, in the order of events, is perhaps small, almost imperceptible, surreptitious

even, and threatens to fade into the obscure if it were not also talked of as the very founding event of existence.

This inclination, this departure from an inwardness to an exteriority, can be said to typify the operations of the painter as much as it could be said to describe the viewer's relation as respondent to the appellant, to the work of the painter. Consequently, we may ask if it be licit to consider that viewer and painter do no more than collude in order to create the conditions under which the work does the work's work? This double investment, this two-sided operation, speaks of a libidinous economy whereby the planar surface of the work becomes no more and no less than the site of a concentrated intersubjective exchange. This privileged site initiates a flow of grace and we might well deduce that the particular gift of the work is a gift which conveys the grace of poignancy and the poignancy of grace. I have in mind here the shed, shared, light of grace which flows from the ecstatic.

The work solicits our sympathy, our attention, and should we fall under the sway of its mute epiphany, and hear the muffled call to respond, a blossoming occurs, whereby an improbable organ of affectivity unfurls. Which, in turn, by some small miracle, reflects, as in a mirror, the very organ of affectivity which gave rise to the work in the first instance. In this way, the semblance of an intersubjective symmetry or equilibrium makes its appearance. Perhaps to speak of an organ of affectivity misleads, or leastways leads us in another direction, and I am persuaded to introduce a certain rigour which would dislodge this fancy and guide us to alight upon the notion of another improbable organ: the organ of the libido.

All painting demands to be apprehended in terms of its own seductive allure, its own particular capacity to present itself to us as a significant thing, and this is entirely appropriate. We are therefore pressed to attend to the specifics of the painted surface, the particular way in which matter is pleated and most especially, to the interlacing of matter, libido and thought.

Jaques Lacan designates a name for this organ which is not an organ in the normal sense, inasmuch as it does not require the usual nourishments and, by dint of this fact, is considered immortal. He calls it the *lamella*.[16] The lamella is characterised by an extreme flatness. It moves around a lot, flying in every direction. It has the capacity to adhere and to insinuate. It can overwhelm. It can smother. It can, of course, adhere to the surface of a painting, and then again, it can fly off. It might even strike us in the face! It sticks to painting in the way painters stick to painting. It is the very glue, the sticky substance of *jouissance* which fixes the painter on painting. It is clear we don't have much choice in the matter. We are bonded, by something like the bonds of love, to a practice which refuses to relinquish its hold. The painter is held in thrall by this interminable libidinal fixation. We, as viewers, as respondents, are in turn, enthralled by these libidinally charged surfaces which solicit and soak up some of our own libidinal pulsions. Poignancy, then, gives rise to the ethical and the libidinal in a bid to stir, to implicate our capacity to care; to respond to the call of the other, to his or her beguiling alterity. This is a movement toward the Good. We become implicated through an overcoming of the indifference which stifles response. This implication in the alterity of the other, moves us toward a questioning of our own subject positions and instigates a shift in our own capacity for recognition and it might be helpful here to recount that, according to Lévinas, 'alterity is the region where the other, susceptible and vulnerable, abides in mortality.'[17]

The dynamic oscillation between proximity and distance, provoked by this encounter, introduces subtle erotic modalities which place us, as subjects, under pressure. This pressure arises from the disturbance carried in the train of the demand to effect a repositioning, enact a shift in inclination, as we ready ourselves to face the work's face. It might appear extreme to talk of the work's face in this context and appear to stretch the notion to an untenable limit. I propose that not in all cases could it be said that the work of art is in possession of a face, however we recognise those that do by the force of the demand they carry. In support of this assertion that the work exhibits the conditions which might enable it to be in possession of a face.

This work of facing is more challenging than we might at first imagine. The first challenge is to sovereignty, to the very notion of a sovereign subject. And if this challenge is effective, it opens us to a threatening stateless state of being, to a place where we are suddenly assailable, responsive, vulnerable and questioning. The comfort of an illusory stasis of Being cedes to the more troubling flux of new becomings. When most effective and affective, paintings represent the presences of those absences which have the power to marshal all of our other absences and bring them, sometimes cruelly, poignantly, before our very presence. We are in this way, called to account; called to account for our presence in the fullness of this alterity, this presence/absence of the other.

I would like to turn my attention to that most haptic and resonant of human expressions: the caress. In particular, I want to touch upon art's caress.[18] The caress of art can convey, in an inimical way, the weight of the poignant as surface traverses surface, skin encounters skin, attachments formed. One skin inheres upon the other seeking in this caress, the powerful admixture of intelligibility in sensibility.[19] Looking is akin to the caress. It unfolds in the register of the virtual haptic. One surface travels over another, searching, desiring, seeking and promising infinite tendernesses, revelation, and on occasion, the welcome bathos of consolation. The caress must traverse one skin in order to reach another in a play of purposeful purposelessness. We respond: response generates response. A peristaltic wave is initiated and implicates us through a process of enfolding invagination, of seeking and desire. We shudder. We falter. We blush, our temperature inflamed. Response activates response. We might respond or fail to respond: turning our head, indifferent in the face of such solicitation. If the appeal of this solicitation succeeds in garnering our sympathies, we can no longer stifle response; we are moved, we lean toward, shift our ground. As our eye roves across the painting's surface, we indulge our virtual haptic desires; mute, but alert with all manner of anticipation and longing. We long because we seek even though what we seek resolutely resists disclosure. Through this longing, we seek to quell our troubling fixations and our yearnings. We continue to long in the full knowledge that what we most yearn forever eludes our grasp and, necessarily, what eludes us, in turn, nourishes our yearnings:

> The caress consists in seizing upon nothing, in soliciting what ceaselessly escapes its form toward a future never future enough, in soliciting what slips away as though it *were not yet*. It *searches*, it forages. It is not an intentionality of disclosure but of search: a movement unto the invisible. In a certain way it *expresses* love, but suffers from an inability to tell it.[20]

Through this metaphoric/metonymic caress (the virtual haptic), I open myself up to the pleasures and vicissitudes of looking, as one opens oneself to the pain of loss and

yearning; through vulnerability and risk. To risk one's vulnerability is to risk one's Self. It is most decidedly a question of *jouissance*. This condition of *jouissance* carries the threat of disorder, of undoing, unmaking; resulting in the shattering of the constitution of the subject. The act of opening up can take the form of a wound (*blessure*) or it may be a blossoming in the sense of Blanchot's *épanouissement*, both, however, result in the burgeoning of the emergent subject. It is an unfurling, an exposure enacted through gradual turning, unfolding, explication: it is nakedness. To turn the hidden face outwards, to turn to face the world, to face the other: Face-to-Face. Importantly, keenly, it is relational:

> From a real body, which was there, proceed radiations which ultimately touch me, who am here, the duration of the transmission is insignificant. . . . A sort of umbilical cord links the body of the photographed thing to my gaze: light, though impalpable, is here a carnal medium, a skin I share with anyone who has been photographed.[21]

Shared skins

In the preceding quote, Barthes is, of course, referring to his apprehension of a photograph. Surely, I would propose, much the same can be said for painting. The light which emanates from the painting becomes our shed, shared light. It is a light which reflects from the surface of the painting in a way determined by the painter in the course of the painting's production. This light becomes the light which beckons, arrests us before the work, fixates, envelops and draws us into the space of the painting. This is a space of cultural encounter, of dialogue and significance, but a priori and a posteriori, before and after all else, it is a space of sensation. A sensate space, a space of intelligibility. This encounter of surfaces (of the painting and of the skin) produces palpable physiological changes which register as much on the surface of the skin as they do on the eye of the beholder. As such, this shared light which resonates is, in every extent, equal to that of the photograph and deserves also to be nominated a carnal medium. I would not be the first to attempt to establish an analogy between the surface of a painting and the surface of the body. Indeed much has been written on the likening of the skin of the body to the skin of painting. The metaphors are clear and persuasive. At first glance, on the surface, as it were, the skin thresholds; dividing inside from outside, determining what may be shown, separating visible and invisible. Skins are uncannily versatile, can be adopted and adapted. Clothes, for example, act as our surrogate, fake, skins. They become carriers of identity and through endless permutation, project, lure, camouflage and disguise. The visible is but the skin of invisibility. Skins are multilayered, and can be shed little by little, imperceptibly, or in one go, depositing a vacated sheath behind. The sentient skin lies beneath the dead, dry, layer of epidermis. A light dusting of death. Death's pall. An infra-thin layer, where the exterior, most exterior, surface of the body meets the exterior, most exterior surface of the world, an infra-thin layer of death is encountered, chaffed and grazed by the abrasive discomfiture of the world. It necessarily follows, that what first greets us when we gaze upon the body is a dehiscent, invisibly thin cloak of death. We mostly look beyond this to a region which satisfies our search for that which is vivifying and affirmative. We seek what is moist and glistens what is smooth and appealing: hair, skin, nails. The partial objects which constantly fall from the body,

shed bodily detritus. This sensate and sensible surface, is the most extensive organ of the human body and the outermost layer is composed of dry, dead scales that are surreptitiously chaffed, rubbed away and fall to the ground as we make our passage through the world. (Picasso reputedly gathered his nail and hair clippings from the barber and stored them in paper bags throughout his life.) Usually forgotten cast-offs, sometimes discarded in the guise of works of art. The painter requires this abrasive resistance from the world in order that he or she can shed their skins in the form of the works they produce. Some skins are easily shed, others put up greater resistance. After each shedding we set to work on the new.

There are skins that cover and protect and skins that expose and endanger and skins that perform both operations simultaneously. Skins that suffocate and suppress, skins that breathe and pulsate with desire. Skins that transpire and stain. Skins that retain, hold within and swell. Skins that leak. Skin one layer thin and skin that is composed of countless layers, a palimpsest, a mute history. Skins are the surface of a depth structure. There are moments in time when the surface of the body and the surface of the work elide, become one and what is tattooed on the surface of the work is simultaneously being inscribed on the surface of the body. In this way a work of art emerges and we too are changed; in a very important sense, art becomes us.

Notes

1 Pittman, Lari, Gallery Talk at Rosamund Felsen Gallery, 4 December 1993.
2 Freud, Sigmund (1991) 'Mourning and Melancholia', in *Penguin Freud Library, Volume 11, On Metapsychology: The Theory of Psychoanalysis*. London: Penguin, p. 253.
3 Ibid. p. 267.
4 Lévinas, Emmanuel (1995) *Existence and Existents*. Trans. Alphonso Lingis. Dordrecht, Boston, MA and London: Kluwer Academic, p. 53.
5 Ibid. p. 55.
6 Blanchot, Maurice (1982) *The Two Versions of the Imaginary: The Space of Literature*. Lincoln, NE and London: University of Nebraska Press, p. 256.
7 Lacan, Jacques (1977) *What is a Picture?* in *The Four Fundamental Concepts of PsychoAnalysis*. Trans. Alan Sheridan. London: Penguin, p. 108.
8 Lingis, Alphonso (1994) *Imperative Surfaces, Foreign Bodies*. New York and London: Routledge.
9 Inwood, Michael (1997) *Heidegger*. Oxford and New York: Oxford University Press, p. 48.
10 Lingis (1994), p. 217.
11 Lévinas, Emmanuel (1989) *Ethics as First Philosophy*, in Sean Hand (ed.) *The Lévinas Reader*. Oxford: Basil Blackwell, p. 83.
12 Lingis, Alphonso (1996) 'Sensation: Intelligibility', in *Sensibility, Face-to-Face*. Atlantic Highlands, NJ: Humanities Press, p. 67.
13 Barthes, Roland (1984) *Camera Lucida: Reflections on Photography*. London: Fontana, p. 27.
14 Lévinas (1995), pp. 81–2.
15 Ibid. p. 95.
16 For an interesting discussion of the lamella in relation to the work of Francis Bacon, see Adams, Parveen (1996) 'The Violence of Paint', in *The Emptiness of the Image: Psycho-analysis and Sexual Difference*. London and New York: Routledge, pp. 118–21.
17 Lingis (1994), p. 223.
18 See Fisher, Jean (1997) 'Art's Caress', in Ine Gevers and Jeanne van Heeswijk (eds) *Beyond Ethics and Aesthetics*. Nijmegen: Uitgeverij SUN, pp. 146–67.
19 Lingis, 'Intelligibility in Sensibility', in Lingis (1996).
20 Lévinas, Emmanuel (1969) *Phenomenology of Eros, Totality and Infinity*. Pittsburgh, PA: Duquesne University Press, pp. 256–7.
21 Barthes (1984), pp. 80–1.

Poesis

Siún Hanrahan

Come, Let us Mean Some Meaning
How to start? Where to start? I picked 'a stone'.
And so I needed to single out a stone. But which
stone? A paralysing thought. How would I
identify the 'ideal stone'? Irony offered an
escape. I would pick a stone from the wall
across the road at *home*.

Even with 'endless possibility' thus shackled, I
faltered – which one – what does an 'ordinary,
unremarkable stone' look like? I tried to pick an
everyday stone. An impossible task. In the harsh
light of Dublin, it became apparent that I picked
a remarkably colourful stone (although its colour
is fading as it sits there baffling me). I picked an
oddly shaped stone. I picked a stone that is
effectively a rock – an intensely unwieldy 'stone'
that steadfastly resists my advances (I can
barely lift it).

And so it sits stubbornly – sometimes at the
centre of my attempts to make sense of my
notebook-on-the-wall. Both an anchor and a
place to perch while trying to immerse myself in
or conjure up the crosscurrents between nascent
trains of thought. It is as baffled by this state of
affairs as I am. What sense is to be made of this
context, this expectant tabula rasa (swept clean
in anticipation of meaning)? What sense is to be
made in this context, this isolation?

It had meaning. It made sense as/in/on a dry-
stone wall. I interfered. I sought other
meanings. Wrenched from its context, meaning

was confounded in the moment of dispersal. And
yet meaning is founded in the moment of
dispersal.

<div align="center">

An extract from *Babel*
An artwork in progress

</div>

Babel: meaning and poesis

Art is a powerful mode of thinking; one that confronts us with the very nature of our
meaning-making activity. And yet, art is not a singular activity. People make art in
many different ways and people think in response to art in many different ways.
Consequently, I cannot and do not attempt to offer a definitive account of the kinds
of thinking involved by art practice. In response to the invitation to reflect on art and
the kinds of thinking it involves, I decided to structure this chapter around three ideas
that capture my sense of the nature of meaning: confusion, conversation and incom-
pletion. What I propose to explore is the way in which the nature of meaning is
revealed in the making of and encounter with art.

Confusion

I

An empty studio space issues a demand: 'Come, let us mean some meaning, let us
think some thoughts'. To respond and get to work is to overcome the obstacle of
'Which thoughts and why?' And to do this in the face of the fact that neither the
studio nor anything else can ground the answer; there is no justification outside of
your own choice. There is a space to be filled with thinking and you must make a
start, somewhere, and keep going, in some direction. All of these moments are plagued
by a lack of foundation. Particular things or places or ideas call out to you but there
are few structures to hide behind in relation to the arbitrariness of their call; the sense
that you could just as easily and validly start somewhere else or go in another direc-
tion. It is all a matter of choice. You are the warrant of your work, of the meanings
you make. There is no particular reason for it to exist or not exist. You must simply
keep going through making choices . . . or not.

 The notion of warranting is quite useful in teasing out the significance of this
experience. To warrant something is to afford it justification or authority, to officially
affirm or guarantee its value. And my point is that to arrive into an empty and
expectant studio-space is to confront the fact that there is no warrant for your work
beyond your choice. And you could easily choose differently. Rather than being
peculiar to art, however, this arbitrariness in the meanings we forge through our
activities, interactions and choices is what it is to participate in meaning. Kearney
writes:

> a post-modern imagination is one which has no choice but to recognise that it
> is unfounded (*sans fondements*). It no longer seeks an ontological foundation
> *in itself* as transcendental subject, or *outside itself* in some timeless substance.[1]

The world does not present itself to the senses just as it is in-itself. Sensations, indeed all perceptions, 'are subject to a variety of characterisations [and] the range of available alternatives is a function of the conceptual systems we have constructed and mastered.'[2] Our perception of the world is shaped by our expectations and the kinds of concepts that structure our expectations. Thus, while a given situation is concrete, how the individual experiences that situation is, to some extent, a matter of choice; the individual chooses her or his position in relation to a given situation. It is always possible to view it differently, to place oneself differently in relation to it. Conception is like a torch beam in a dark room, revealing only what is in the light. Re-conception shifts the beam and changes which features of the room (or the sculpture or the world) are revealed.

Nonetheless, there is considerable intractability in perception – our perceptions are shaped by our expectations but not wholly determined by them. As physicist David Bohm suggests:

> [Although] the 'real thing' is limited by conditions that can be expressed terms of thought . . . the real thing has more in it than can ever be implied by the content of our thought about it, as can always be revealed by further observations. Moreover, our thought is not in general completely correct, so that the real thing may be expected ultimately to show behaviour or properties contradicting some of the implications of our thought about it. These are, indeed, among the main ways in which the real thing can demonstrate its basic independence from thought.[3]

Thus, the world does constrain perception and, consequently, the descriptions and meanings we forge. Yet, there is no conception-free perception. The conceptual frameworks or meanings we create and have created shape our access to the world. The world as it is in itself remains unnameable, invisible. It is not that our conceptual frameworks stand between us and the world, rather they are a relation – an act of consciousness directed to an object beyond consciousness: 'The world remains at all times transcendent of the consciousness that intends it.'[4]

As unnameable, as that which transcends any given meaning or conceptual framework, the world cannot simply be invoked to decide between the meanings we forge. It precludes some but supports many diverse and often conflicting meanings. There is no neutral basis upon which to decide between our meanings. And yet, from moment to moment we must decide between such possibilities; between the meanings we forge. As Richard Kearney writes:

> In every lived situation the ludic undecidabilities of imagination are answerable, in the first and last analysis, to the *exemplary* narratives of imagination. It is imagination that tells the difference between good and bad imaginations.[5]

Each of our imaginings or meanings serves certain interests and works to achieve certain ends. And we are responsible for the actualities we bring into being. We are each responsible for the meanings we make at any given moment.

II

In making art this immense responsibility, the lack of warrant or foundation for the meanings we forge, although forcefully present at the first moment, is overcome in beginning and, for the most part, only haunts the subsequent process.[6] Once I choose where to start and which direction to go, the activity of making/meaning generates its own momentum and its processes offer a shield from overwhelming responsibility; from the lack of warrant or foundation for the meanings emerging from my choices.

In all of our meaning-making activities, in art and in other endeavours, we create structures to protect our meanings and meaning-making activities from paralysing doubt. For better and worse, we tend to employ what Gergen refers to as 'distention devices' to manage our authorial relationship to meaning; various means – structural, linguistic, visual and more – that allow us to claim our meaning-making activity while simultaneously placing it at a distance from arbitrary whim.[7] We create spaces and structures in which our meaning-making activity appears justified. Structures that by their very existence demand a particular kind of meaning-making activity. In effect, distention devices serve to warrant our meaning-making activity.

In contemporary Western culture, the structures that warrant art and the activities of making art can seem somewhat tenuous and can certainly be experienced as fragile. So much so that it is interesting to think about the significance of a studio space, a room of one's own, in warranting an artist's activity. Sharing something of my encounter with the paintings of Ian Whittlesea may serve to anchor and enliven my reflections in this regard.[8]

Whittlesea's *Studio Paintings* take individual artists and list the addresses at which they have worked. The exhibition in which I encountered his work featured two from this series. One set of five canvases listed the thirty-five addresses at which James Joyce worked after leaving Dublin (Figure 10.1). Another canvas featured the address (singular) of Marcel Proust (Figure 10.2). The addresses are rendered in uniformly crisp, plain block capitals. And although they have been painstakingly hand-painted, the emphatically non-gestural quality of the paintwork refuses any engagement with the particularities of individual artist or locations. Individual differences are also negated by the addresses being given in English. And yet, by naming the places of work of Joyce and Proust the paintings invoke the artists, their work and particularly the making of that work in a prosaic, spatial, day-by-day sense.[9]

It strikes me that the crucial thing achieved by painstakingly painting these canvases, applying layer after layer of pigment in a gesture of intense labour for labour's sake, is that the space of the studio and its relationship to the work materialised within it is interrogated. A studio performs two main functions – it both enables and protects the thinking that happens within it. Its primary function is that it holds or anchors one's thinking in one way or another – depending upon the nature of one's practice. Spaces shape or pattern our mode of being therein and to have a studio is, in some respects, to be proactive in relation to this and to set up a space that enables you to think and act in a certain way.[10] What is startling in the juxtaposition of Whittlesea's Proust and Joyce paintings is the rooted commitment of the one and the restlessness of the other. It seems that their patterns of work and their relationship to the space in which they worked must have been quite different. With Joyce in particular I wonder about the effort it took in each new place to reclaim it for his writing; about the

Figure 10.1 Ian Whittlesea, *Studio Painting – James Joyce* (1997–2000). Five panels, each 122 × 122 cm, Liquitex on canvas. Private collection, London.

Figure 10.2 Ian Whittlesea, *Studio Painting – Marcel Proust* (2001). 35 × 112 cm, Lascaux acrylic on canvas. Private collection, Seattle, USA.

minimum talisman needed – the least number of things in place – in order to create a studio out of a room or even a corner of a room. I wonder what he needed in place in order for the space to hold his thinking, to frame it in such a way that to arrive back into the space was to pick up his train of thought precisely where he left it off. A separate studio also protects a space in which to think not only through the possibility of closing a door (even if only metaphorically) on the rest of one's daily activities but also through its very existence. A designated studio – of whatever sort – creates and authorises an expectation that a particular kind of activity will take place, for both the artist and others. A studio amplifies the voice of thinking for thinking's sake.

III

The juxtaposition of Whittlesea's Joyce and Proust paintings could also be argued to offer a portrait of these artists' practice: Proust's commitment to the one address reflecting the fact that his oeuvre consists primarily of a single massive work that reflects on a whole society but is centred on a single character, and Joyce's overwhelming multiplicity of (dis)locations reflecting the wilful disruptions of narrative within his work. And yet such connections are unlikely to have been built into the work. The parameters of the project apply equally to diverse artists so that particular consequences that arise in relation to Joyce and Proust are incidental. And yet such connections, such meanings, do emerge. And, I would suggest that this happy coincidence – this happy emergence of meaning – is not only a condition of this practice or only a condition of art but also, in fact, a condition of meaning itself.

While much of our meaning-making activity masks its construction – is transparent – the activity of both artist and viewer in constructing meaning is explicitly revealed in the encounter with the artwork. As David Bohm suggests, our meaning-making activity tends very strongly to take its own function for granted and thus leads us to concentrate almost exclusively on the content, so that little or no attention is left for the actual function of the activity itself.[11] That the artifice or composition of artworks is wholly apparent, that its meanings are clearly created rather than implicitly found, is one of its strengths as a form of thinking.

Conversation

I

Meaning emerges in the encounter between the viewer and the artwork. Meaning does not rest with or in the artwork – it is not determined solely by the artwork – and it does not rest with or in the viewer – it is not determined solely by the interests and conceptual frameworks of the viewer. It is negotiated in the conversation between viewer and artwork, in the act of relation between subject and object. The meanings that emerge in this conversation are forged through the interplay of what is intractable in perception and our infinitely variable intentions (within the limits imposed by our powers of imagination and discrimination).

As Joseph Margolis argues, artworks are culturally emergent phenomena, as are persons, words and sentences, and actions that form the body of human history.[12] As such, they are distinguished through their possession of intentional properties – such

as the expressive, the representational, the symbolic, the semiotic, and so on.[13] To recognise something as art is thus to take what Bakhtin describes as an active, responsive attitude toward it.[14] And, as an artwork, an object/event expects a response. In engaging with an artwork, there is a projection of self onto the relations discerned within the work. A certain empathy with the parts of the work as quasi individuals is called for. The process is a very kinaesthetic one;[15] the relationships between the parts are seen and felt by the viewer in terms of pushing and pulling, and this pushing and pulling is understood in terms of our interactions with and within the world. Thinking takes place through the relationships discerned within the artwork.[16]

An art form that takes conversation and amplifies its role both as a structuring device within its practices and as a metaphor for the negotiation of meaning is installation. Installation art involves a shift from the exhibition of autonomous objects to the incorporation of the site of display into the conceptual parameters of the work. It emphasises the relationship between things in space, the process of making and the process and duration of exhibition.[17] More particularly, in installation the viewer is physically implicated in the work as well as conceptually, as she or he is in all works of art. What is thus made explicit is that the viewer is charged with discovering relationships between things within the space so as to move those relationships beyond mere juxtaposition. Furthermore, because the work explicitly depends on the viewer giving attention to expand its temporality beyond the time of the exhibition, *durée* is exposed,[18] not only the duration, practice and physicality of making (beyond a founding perception) but more particularly the duration, practice and physicality of reception. Thus reception is explicitly revealed as an activity, a process of active response and remembering.

II

Engaging with the work of a particular artist rather than with installation art in general will enhance my presentation of another conversational dimension of meaning readily encountered in and through art, multiplicity.

In *at hand* (2002), American artist Ann Hamilton turned a wide, brightly lit corridor overlooking the former barrack square at the Irish Museum of Modern Art into a rectangular room with three entrances along one wall (Figure 10.3). The long white room was empty except for a carpet of paper accumulating on the floor, the occasional sheets of translucent paper drifting and darting through the air, the shallow contraptions attached to the ceiling from which these sheets were released, and the sound of a soft female voice speaking from one or another of fourteen speakers placed around the top of the room. Periodically, another sound was emitted – an intense, low-pitched whistling sound (reminiscent of the wind). Whether one took courage and stepped into the space and onto the layers of A4 paper sheets, whose red-black stained edges created a fine web of crisscrossed lines, or hovered at the perimeter of the space, leaning in to hear what was being said and watch the falling paper, the glacial translucence of the room marked your presence as did the arrival/presence of others.

My conversation with *at hand* – my animation of its relationships beyond mere juxtaposition – saw me linger before picking my way into the space, treading carefully so as not to tear the carpet underfoot, alert to the falling paper, aware of my turning to observe its course, starkly visible. I experienced the space as both melancholy and

Figure 10.3 Ann Hamilton, *at hand* (2001). Courtesy: Sean Kelly Gallery, New York. Photo: Thibault Jeanson.

wondrous. The autumnal falling of the paper (gentle and plummeting by turns) was amplified by the loss in the words spoken – a voice silences, a voice calls, a mouth sighs, a mouth craves, a hand fists. What was wondrous was the wish-granting scatter of sheaves like cherry-blossom petals in spring and the rucking of the paper carpet so that it looked like an ice-flow. The voice suggested that a mouth laughs, a mouth engages, a hand gestures, a voice calls. Upon reflection, the work seemed to suggest that language is both important and suspect, that meaning arises most forcefully from non-linguistic experience and presence.

The conversation of others within the space sometimes amplified this sense of the power of non-linguistic experience and at other times challenged the authority of my conversation. Young children danced through the space, chasing falling sheets and playing out my sense of wonder. A group of teenagers, after a briefly entranced paper chase, kicked through the paper and played rugby in their efforts to outdo each other – their disrespect was perhaps as valid a response as mine since despite themselves they were involved in the work, interpreting it, responding to the liminal space it created.

Like all artworks, *at hand* is conversational in its anchoring of distinctly different meanings – from discontinuous to incompatible. The indestructibility of art's ambivalence requires recognition of multiple continuous, discontinuous and incompatible

readings. As Umberto Eco argues, engaging with artworks or in the art-making process involves a 'continuously open process that allows one to discover ever-changing *profiles* and possibilities in a single form.'[19] The multiple readings thus anchored by an artwork may be described as a *constellation*:

> a juxtaposed rather than integrated cluster of changing elements [or versions] that resist reduction to a common denominator, essential core, or generative first principle . . . The result [is] not a relativistic chaos of unrelated factors, but a dialectical model of negations that simultaneously [construct] and [deconstruct] patterns of fluid reality.[20]

That is, the multiple versions anchored by an artwork are simultaneously present and irreducible in a way that recognises the non-absolute character of meaning – its fluidity. This multiplicity reflects a 'diversity of response' that is a part of everyday experience,[21] and thus allows the individual to engage with this feature of the world. As Eco writes:

> art suggests a way for us to see the world in which we live, and, by seeing it, to accept it and integrate it into our sensibility. The open work [i.e. an artwork anchoring multiple meanings] assumes the task of giving us an image of discontinuity. It does not narrate it; it *is* it.[22]

Of course, I could rationalise the teenagers' conversation with *at hand* in terms of my own by suggesting that it possibly revealed something of the impasse between linguistic and non-linguistic knowing. Their refusal of respect may have arisen from a sense of not being able to say what this work was about while not being able to trust that the sensuous experience was enough. That to engage with *at hand* is to experience the confrontation of a kind of carnal experience of the world and its antithesis, a rational cognitive experience of the world. But this would be to reduce another's conversations to the terms of my own and as Lyotard argues, settling differences inevitably involves repressing or denying that which cannot be couched in the language or form of the settlement. What is repressed or refused in any settlement is that which cannot be known from or included within a given position. The violence of this is not simply that of conflict between irreconcilable meanings or versions of the world, it is also our resistance to remaining in the company of the unknown.[23]

What is required, therefore, in the face of the multiplicities of contemporary culture is that we develop our ability to explore conflict rather than simply seek consensus. Moving between the constellation of readings anchored by an artwork reveals the limits of what can be known from any given position and opens the possibility of exploring the relationship between the diverse perspectives anchored in a single entity, without seeking to settle the differences between them. Art thus creates a space in which differences may be unendingly explored rather than settled and from which this understanding might be integrated into our being in the world.

Incompletion

> we make meaning. The world is unconsumed in our acts of imagining it. The meanings we discern give rise to new perceptions and the actions they entail. The

world is transformed and new possibilities emerge. These new meanings give rise to new perceptions and the actions they entail. The world is transformed and new possibilities emerge.[24]

In making meaning we are not approaching completion – a complete account of the way the world is, an adequate interpretation of what it means. Furthermore, the meanings we trace, the meanings we map, the meanings we enact are not achieved, we remake them from moment to moment. The challenge is to own this and embrace the making and remaking of meaning.

The work of Irish artist Róisín Lewis captures something of this challenge (Figure 10.4). Lewis suggests of the drawings represented here: 'Semantic meaning is teasingly suggested through the linear format of handwritten script or scribble.'[25] This possibility of meaning is both amplified by the fact that hands and tongues are the instruments of communication and thwarted by Lewis's apparently endless attention – the outline of hand or tongue is drawn and redrawn, obliterated and drawn again. Another possibility for meaning is, however, enacted by remaining present to the object or subject before us, looking as closely as one can and then looking again, and again. And doing so knowing that our looking-at and presence-to ourselves, the world and to others is an end in itself and not only a means. As Samuel Beckett wrote:

> Siege laid again to the impregnable without. Eye and hand fevering after the unself. By the hand it unceasingly changes the eye unceasingly changed. Back and forth the gaze beating against unseeable and unmakeable. Truce for a space and the marks of what it is to be and be in face of. Those deep marks to show.[26]

The world transcends any given meaning or conceptual framework, it is the reserve upon which we draw in producing meaning without thereby exhausting or containing it.[27] And it is that which demands that we produce truthful meanings. The challenge, as Donna Haraway suggests, is to forge meanings that simultaneously acknowledge their radical historical contingency, are critically self-conscious regarding the semiotic technologies through which they are forged and are wholly committed to a faithful account of a real world.[28] The commitment to representing a real world, as George Levine points out, requires openness to 'an other that we cannot manipulate with rhetorical strategies',[29] while owning the contingency of our meanings and the means by which they are forged requires, as Kearney suggests, that we hold open the horizon of possibility and remain attentive to others and to the world,[30] looking, listening and drawing over and over again.

Poesis II

I would say of art:

> It has no prescribed aim, which is not to say that it is aimless. It moves very precisely, but not to some end. It is not a project ... It is, at best, a strange structural condition, an event ... It is precisely that which is necessary to structure but evades structural analysis ... : it is the breakdown in structure that is the possibility of structure.[31]

Figure 10.4 Róisín Lewis, *Untitled* (1997). Ink on canvas, 90 × 65 cm. Courtesy of artist.

These are Mark Wigley's words, coined to describe Derrida's account of deconstruction in an article entitled 'The Translation of Architecture: The Product of Babel'. For me they speak of the ways in which the purposeful purposelessness of art holds unwanted truths about meaning: its radical contingency, its ineluctable multiplicity, that it is enacted rather than achieved and so must be made and remade unendingly. Meaning is riddled with anxiety – rather than sharing the promise of Babel, building toward omniscience, it threatens Babble. One way of coping with such anxiety is to disown its relevance to one's own meanings and activities, a defence mechanism that involves both splitting and projection. This is a mechanism that entails dividing one's experience

into differentiated elements and then locating unwanted elements in others rather than in oneself. In this vein, it seems to me that a large part of the responsibility for confronting or holding what is troublesome in meaning is given to art. The truths it holds shields other meaning-making activities from anxiety. Art is the ornament that is the very possibility of structure.

Notes

1 Kearney, Richard (1998) *Poetics of Imagining: Modern to Postmodern.* Edinburgh: Edinburgh University Press, p. 188.
2 Goodman, Nelson and Elgin, Catherine Z. (1980) *Reconceptions in Philosophy and the Other Arts and Sciences.* London: Routledge, p. 6.
3 Bohm, David (1980) *Wholeness and the Implicate Order.* London: Routledge, p. 54.
4 Kearney (1998), p. 15.
5 Ibid. p. 229.
6 For an account of the thinking involved in the art-making process that explores how its structures relate to those of scientific thinking, please see Hanrahan, Siún (2000) 'An Exploration of How Subjectivity is Practiced in Art', *Leonardo: The Journal of the International Society for the Arts, Sciences and Technology* 33(4): 267–74.
7 For better, because distancing ourselves from the lack of foundation for the meanings we create enables us to get on with making meaning, with being in relation to the world (including ourselves and others). For worse, because such distancing supports our tendency to treat the meanings we have made and are making as basically fixed truths rather than as a process, as moments in the enactment of relationship. See Gergen, K. J. (1994) 'The Mechanical Self and the Rhetoric of Objectivity', in Allan Megill (ed.), *Rethinking Objectivity*. Durham, NC: Duke University Press, pp. 265–89.
8 I encountered an exhibition of Whittlesea's work in The Temple Bar Gallery, Dublin, May 2001.
9 Proust (1871–1922) – invoked by '102 Boulevard Haussmann, Paris' – is a French novelist whose long, partly autobiographical novel *A la recherche du temps perdu* is described as one of the most complex in world literature. Joyce (1882–1941) – invoked by a string of thirty-five addresses – is one of Ireland's great literary figures, who went into voluntary exile in 1904 so as to protect the free development of his spirit and art that he felt was threatened in Ireland. Another factor in this decision may have been the lack of employment commensurable with his education available in Ireland.
10 Reflecting on Philip Johnson's famous *Glass House* in New Canaan, Connecticut, Kevin Melchionne observes that

> The fact that even nonradicals are aware of the way spaces make aesthetic demands on the body can be seen in the discomfort felt by the nonradical in the formal environment. The sense that one cannot relax or slouch in a hyperorganised environment, that one must sit up straight, reveals that even the nonradical is aware of the way some spaces seem to require our bodies [and I am suggesting our thinking also] to aesthetically conform.

Melchionne, Kevin (1998) 'Living in Glass Houses: Domesticity, Interior Decoration and Environmental Aesthetics', *Journal of Aesthetics and Art Criticism* 56(2): 193.
11 Bohm (1980), p. 31.
12 Margolis, Joseph (1980) *Art and Philosophy.* Brighton: Harvester Press, p. 5.
13 See Margolis, Joseph (2000) *What, After All, is a Work of Art?* University Park, PA: Pennsylvania State University Press; Margolis (1980).
14 See Bakhtin, Mikhail (1981) 'Discourse in the Novel', in Bakhtin, *The Dialogic Imagination: Four Essays.* Ed. M. Holquist. Trans. C. Emerson and M. Holquist. Austin, TX: University of Texas Press; Newsom, Carol A. (1996) 'Bakhtin, the Bible, and Dialogical Truth', *Journal of Religion* 76: 290–306.

15 F. David Martin's description of 'kinaesthetic' is useful in this regard:

> The terms *tactual, tactile, haptic*, and *kinaesthetic* are often used rather loosely. Under the *tactual* I include both tactile perceptions, i.e., feelings of things and events outside the skin, and haptic perceptions, i.e., feelings of things and events under the skin. By kinaesthetic perceptions I mean the feelings of movements associated with tactual perceptions.

Martin, F. David (1981) *Sculpture and Enlivened Space: Aesthetics and History*. Lexington, KY: University Press of Kentucky, p. 10.

16 Michael Polanyi's discussion of tacit knowledge is interesting in relation to this: 'In this sense we can say that when we make a thing function as the proximal term of tacit knowing, we incorporate it in our body – or extend our body to include it – so that we come to dwell in it.' Polanyi, Michael (1967) *The Tacit Dimension*. London: Routledge and Kegan Paul, p. 16.

17 See further: Reiss, Julie H. (1999) *From Margin to Center: The Spaces of Installation Art*. Cambridge, MA and London: MIT Press; Onorato, Ronald J. (1997) *Blurring the Boundaries: Installation Art 1969–1996*. San Diego, CA: Museum of Contemporary Art.

18 Norman Bryson suggests:

> Like the stylus in the mystic writing pad, the brush traces *obliteratively*, as indelible effacement; and whatever may have been the improvisational logic of the painting's construction, this existence of the image in its own time, of duration, of practice, of the body, is negated by never referring the marks on canvas to their place in the vanished sequence of local inspirations, but only to the twin axes of a temporality outside *durée*: on the other hand, the moment of origin, of the founding perception; and on the other, the moment of closure, of receptive passivity: to a transcendent temporality of the Gaze.

I do not quite agree in that I think that while the will to transcendence may be there in the creation, presentation and reception of a painting or any other work of art, the ineluctability of an artwork's *composition* – that it has been made rather than discovered – fatally undermines this. Installation art is simply more emphatic in this regard than many other art forms. Bryson, Norman (1983) *Vision and Painting: The Logic of the Gaze*. London: Macmillan, pp. 92–3.

19 Eco, Umberto (1989) *The Open Work*. Trans. Anna Cancogni. Cambridge, MA: Harvard University Press, p. 74.

20 Jay, Martin (1984) *Adorno*. London: Fontana, pp. 14–15.

21 Arnheim, Rudolf (1969) *Visual Thinking*. Berkeley, CA and London: University of California Press, p. 301.

22 Eco (1989), p. 90.

23 Lyotard, Jean-Francois (1984) *The Postmodern Condition: A Report on Knowledge*. Trans. Geoff Bennington and Brian Massumi. Minneapolis, MN: University of Minnesota Press.

24 An extract from Hanrahan, Siún (2001) *Guessing*. Belfast: Golden Thread Gallery.

25 Lewis, Róisín (2002) *Palimpsest*. Dublin: Kevin Kavanagh Gallery.

26 Róisín Lewis drew my attention to this extract from Beckett, cited in Sheridan, Noel (1996) *NCAD 250: Drawings, 1746–1996*. Dublin: National College of Art and Design, p. XXII.

27 See Norman Bryson's discussion of 'the real' in Graziose, Lisa (1997) *Mark Dion, Lisa Graziose, Miwon Kwon, Norman Bryson*. London: Phaidon, p. 96.

28 Haraway, as cited in Levine, George (1994) 'Why Science isn't Literature', in Allan Megill (ed.) *Rethinking Objectivity*. Durham, NC and London: Duke University Press, p. 71.

29 Ibid. p. 73.

30 See Kearney (1998).

31 Wigley, Mark (1990) 'The Translation of Architecture: The Product of Babel', *Architectural Design* 60(9–10): 11.

Chapter 11

Frozen complexity

Milos Rankovic

Introduction

When art is anticipated as epistemic treat then at least some of the many notions of complexity are likely to feature prominently in its criticism. In fact, the link between complexity and aesthetic experience can excite strong evaluative implications, particularly in the wake of recent quantifications of various properties of complex things. Any empirical enthusiasm, however, should be tempered by the ambiguity implicit in the very multitude of the kinds of things that are variously thought of as complex: complex structures, complex processes, experiences of complex processes, experiences of complex structures, complex experiences, complex neural events. In Michael Leyton's *Symmetry, Causality, Mind*, for example, the potential relevance of the environmental complexity to the quality of aesthetic experience is narrowed down to that of causality.[1] The following should, therefore, fast-forward this discussion by emphasising the stakes that are involved.

> [C]omplexity is the *quantification* of asymmetry.[2]

> An art-work contains the maximal amount of *asymmetry* from which a person is capable of extracting history; i.e., to which a person is capable of assigning a causal explanation.[3]

> Stimuli with more than this quantity [of asymmetry] are described as *ugly*; and stimuli with less than this quantity are described as *dull*.[4]

> [A]ny cognitive representation is a causal explanation.[5]

Notice in particular how tempting it is to pursue the logic of these quotes further to some intriguing ends, such as that the more complex an image, the more beautiful it is to a being capable of coping with its complexity. Or even that to a being of infinite (or maximal) cognitive power, no image is more beautiful than an image of infinite (or maximal) complexity. Sadly, the logic also predicts that to you and me the same image would be inexplicably ugly. However, tracing the origin of that ugly feeling is not easy. As defined – that it is aroused in response to stimuli of inexplicable complexity – it is difficult to reconcile with Leyton's notion of cognitive representation. Taken together, they seem to predict, not only that I will regard an object to be ugly if it contains complexity that I am incapable of grasping, but also that I will feel this way because of that complexity, the complexity of which I had no cognitive representation.

This, then, is not that different from saying: 'If I think it is ugly, that is because I do not know it is there.'

Leyton strongly associates 'ugliness' with 'anxiety'. Indeed, as he points out, studies on stimulus complexity do reveal a correlation between anxiety and environmental complexity.[6] Nonetheless, that it is too much of complexity that feels ugly might not necessarily be the implication. Furthermore, in relation to art, Leyton concludes that the art lover takes increasing pleasure in increasingly complex art, until such degree of complexity, that is, when the art lover's ability to come up with causal explanations is finally overwhelmed – at that moment anxiety sets in. Notice in particular that this involves, in some ways, a very tempting, and in others, a very scary notion of threshold: 'i.e., the *maximal amount of causal explanation* that a person is capable of assigning to any percept.'[7] Interestingly, as described, the too-much-ness is experienced as, not an overdose of explanations, but as inexplicability. This, however, raises the issue of whether one suffers an *absence of explanation* or an explanation of absence. As Daniel Dennett points out: 'the absence of representation is not the same as the representation of absence.'[8] The problem is, therefore, that in the absence of explanation, 'there is no one to complain',[9] no one to suffer. Yet, since Leyton believes that every cognitive representation is an explanation, he could not have been discussing the explanation of absence, either, as in that case all is explained and there is nothing inexplicable to suffer from. To deal with this distinction, Dennett introduced the concept of 'epistemic hunger',[10] which is of interest here too, as it is just the kind of a double-edged notion that might do away with the complexity threshold, by stitching the thresholded continuum of complex stimuli back together again. Presumably, the want to know more arises in response to some lack. Yet, this causal relationship explains the lack, and so the lack itself turns out to be a representation, an instance of meaning which is there and not lacking. It is experienced, and the experience is that of epistemic hunger. Moreover, epistemic hunger appears to have a lot in common with anxiety. It too relates to the unknown in the environment, and pops-up in the consciousness when the changing perceptual field no longer resonates with the existing worldview. However, epistemic hunger is not anxiety – as with any hunger, suffering it is to be motivated by it. In itself, it is not so much a passive complaint as it is a motivation. In fact, it is there, in multitude, humming gentle persuasions as an accompaniment to all perception. Its role, a vital one, is to modulate allocation of attentional *resources*. Indeed, the economy of attention is of key evolutionary significance. Take for instance how vital an issue it is, say, for a wild pig whether to have another look at that bush with black stripes that seems to be closer now than it was a moment ago (and, besides, to focus all attention on one bush means not focusing on another; nor making use of that time to eat, mate, rest, etc.).

A possible neurological correlate of the epistemic hunger is a function of the limbic system. In 'The Science of Art: A Neurological Theory of Aesthetic Experience',[11] V. S. Ramachandran and W. Hirstein argue that 'perceptual "problem solving" is also reinforcing . . . therefore ensuring that the visual system "struggles" for a solution and does not give up too easily.'[12] Reinforcement is here proposed as a possible explanation of the observed continuous, and therefore costly, two-way communication between the various perceptual modules and the limbic system. The authors suggest that a probable role of the limbic system is to either endorse or inhibit a particular bid for an increase in the allocated attentional resources. Dennett too, in fact, believes that:

'there is a competition among many concurrent contentful events in the brain.'[13] So, the limbic system might well be the organ of epistemic hunger, a forum for continuous re-evaluation of the potential significance of perceptual entities. How much complexity is perceived, then, depends on whether a particular aspect of the perceptual field is deemed relevant and therefore worth further attention. In fact, it is difficult to talk of too-much-ness where there is only an increasing subtlety of experience, or dedifferentiation, as Ehrenzweig would perhaps term such superposition of perceptual instances.[14] Similarly, as perception itself is a constituent of the universal-within, any cognitive limit, or it is never experienced in itself as there is no outside to mark the transition. This discussion is thus caught painting a particular picture of aesthetic experience in relation to the notion(s) of complexity: attention is the most precious currency. The experience of its economy is that of epistemic hunger. Its intensity is a measure of investment in perceptual problem solving. Any threshold observed, therefore, reflects the judgement of relevance rather than the capacity to assimilate complexity. It is not a limit, but a judgement. It is as much as you are prepared to invest of your (admittedly) limited attentional resources based on the promise, and the risk, of the known unknown. Works of art, then, do not contain the maximum complexity you can cope with, but do, instead, offer crumbs of order, just tempting enough, at every step of the perceptual way, teasing you ever further away from wherever you were a moment ago.[15]

Defying lossy compression

Having pictured this model of aesthetic experience, am I now ready to paint a better picture? Granted that complexity has something, even if a particular thing, to do with aesthetic experience, how does one add complexity? Or do anything else with it? It appears that, so far, I have simply recycled the intuition about complex things – that they are difficult to understand, explain, describe. Not surprisingly, though. That it is somehow associated with knowledge is probably complexity's most stable of conventions.

A notable example of this intuition is formalised in the concept of algorithmic complexity: according to Andrey Kolmogorov, a (finite) sequence is maximally complex, or maximally random, if it cannot be encoded into any sequence shorter than itself – if no better than a trivial description of it is possible.[16] If a short description is nevertheless found then the original sequence is proved not to be maximally random after all. The sequence is then understood to have contained some redundancy that can be economised with. Notice, in particular, this link between the intuition about complex things and the two antonymic partner concepts of randomness and redundancy. Indeed, in terms of incompressibility, or information capacity, randomness here appears synonymous with complexity. Redundancy, on the other hand, comes in flavours, which is reflected in the two styles of managing redundancy – those of lossless and lossy compression. To illustrate the distinction, imagine you got a book for your forty-second birthday from an artist friend. On closer inspection you realise that the book's title describes its contents: *A 100,000 'bl's, 'ah's, and 'bingo's, Distributed With Equal Probability, Except for 'bingo's Which Appear Only as Every 42nd Word*. If you ever lost such a book, but happened to remember its title (and how could you not?), you would be able to make another one, for all intents and purposes, just like it.

If then, later, you find the original book and decide to check how well the two match, you would be pleased to find that you had correctly placed every *bingo* (lossless compression) and about every other *bl* and *ah* (lossy compression). Importantly, however, you would find that your version *works* just as well. This is because the difference between the styles is not merely that some information is typically lost with lossy compression, but that the two approaches assume slightly different notions of redundancy. In lossless compression, redundancy is the very structure that should be recoverable from the description. In lossy compression, redundancy is a measure of triviality calibrated against the entire spectrum of more or less acceptable descriptions. Lossy compression, therefore, complicates the notion of redundancy through the consideration of relevance.

Consider Figure 11.1, for example. The two faces in this drawing were collaged out of the intermittent slices of a single portrait – the way the drawing used to be. In a sense, the drawing was shredded, only to be pasted together again, albeit with some reordering of the pieces. It was sliced into thin vertical stripes and then, by binding together the alternate stripes, reassembled into two elongated versions of itself – if the stripes were enumerated prior to shredding, then the left twin would have been an ordered sequence of all the odd stripes. Now, as you engage in the game of spot the difference, consider that all you see in Figure 11.1, as in any other image, is in fact some form of redundancy. Here, for example, you can see some of it the moment you realise that the twins are the same. And you can see some of it when you discover that

Figure 11.1 Milos Rankovic, Pencil and ego on paper, then shredded.

the twins are different. The similarity may be such that any distinction between them can be regarded as aesthetically trivial. Or, there might turn out to be differences just relevant enough to cause some hesitation, say, if I had to chose one and discard the other. Now, suppose I wanted to rearrange the stripes back to the way the drawing looked like before the shredding. Evidently, this means that all the similarities, and the dissimilarities, will have to merge to recreate the original appearance of the image (when, once again, it shows a single face) – each such feature of any one of the twins will come together with its counterpart in the other twin to form a unified look. In other words, both the similarities and differences between the twins come in feature pairs. There is, however, something of interest that can be said about their respective contributions. Individually, the features that belong to the distinguishing feature pairs, by the very fact that they are different from one another, make a more significant aesthetic contribution to the image as a whole. This is because it is only the distinguishing features that effectively compromise/modulate the contribution of their counterparts. On the other hand, the features that belong to the similarity pairs simply reiterate their counterparts and so contribute trivially to the appearance of the restored portrait (adding little else than width to the original image). In this way, the shredding procedure revealed some of the total redundancy in the original image in the form of similarities, and differences, between the twins. So at least that much information is likely to be lossless compressible. On the other hand, the procedure also revealed, *as* similarities between the twins, some of the redundancy in the original image that is also lossy compressible.

Figure 11.1 is just one of the outcomes of a series of related experiments aimed at gaining some insight into the relationship between scales of structure and levels of description. In the case of Figure 11.1, for example, the precise width of slices was set to inflict maximal damage on the mark. Too thin, and the twins' resolution is so fine that the mark re-emerges smoothly distributed between the stripes. Too thick, and the individual marks survive the violence of cutting, intact, within the stripes. In fact, the degree of similarity obtained, between the twin images, is a function of the stripe width. The twins would have been indistinguishable if the stripes were sufficiently fine. Like a sieve, therefore, the shredding procedure distils redundancies of different structural scales and reveals them either as similarities or differences.

Scales of structure

To consider a particular structural scale of an image is to consider some features which define that very scale. Without some features to talk about, there is also no particular structural scale to talk about. If, on the other hand, there are some features to talk about then they might as well be distributed in a maximally complex/random fashion. However, if an individual feature is presumed to correlate with some structure in the image, having features to distribute in the first place involves a degree of order. It appears, therefore, that complexity implies a trade-off between the degree of disorder at one scale of structure in favour of disorder at another. Does this mean that looking for the most complex image, the one most difficult to describe for its lack of structure on all scales, is to be looking for an image *with* structure on all scales? A statistical fractal? On the one hand, this is a tempting conclusion, especially in view of all the fractal forms that the complex adaptive systems in nature abound with. On the

other hand, notice that, as the argument above unfolded, the concept of feature appears to be overly dependant on the notion of redundancy/structure that is entirely definable from within the image file. For the moment, however, here is how Benoit Mandelbrot, the father of fractal geometry, described the motivation behind this surprisingly young science. Notice in particular how notions of complexity, disorder and scale of structure collide in yet another guise:

> [M]any patterns of Nature are so irregular and fragmented, that, compared with *Euclid* . . . Nature exhibits not simply a higher degree but an altogether different level of complexity. The number of distinct scales of length of natural patterns is for all practical purposes infinite.
>
> The existence of these patterns challenges us to study those forms that Euclid leaves aside as being 'formless', to investigate the morphology of the 'amorphous'.[17]

Briefly, fractals are typically objects of fractional dimensionality. Just as inflating a square (of dimension 2) to the x times of its original width corresponds to x^2 times increase in its original area, so does inflating an object of d dimensionality corresponds to x^d times increase in its original volume. Since objects occupy space in characteristic ways, the value of d captures some of this character. Clearly, any fractal imagery built by, and therefore encoded in, a deterministic algorithm is manifestly compressible and therefore not maximally algorithmically complex. Yet, such are not the only kinds of objects that exhibit fractal properties. In fact: 'The most useful fractals involve *chance* and both their regularities and their irregularities are statistical.'[18] R. Taylor, A. Micolich and D. Jonas, in particular, had this in mind when they measured the fractal dimension of Jackson Pollock's paintings.[19] They found, for example, that the dimensionality of the drip paintings increased steadily over the years and also revealed a structural trend in the successive layers of paint! They then went on, however, to explain the uniqueness of these pictures in terms of their dimensionality. They reasoned that the calculated values were due to Pollock's splashing technique, horizontal painting surface and the physicality of the method.[20] Notice, in particular, that it is not clear why one could not, for example, choose a fractal pattern (either natural or artificial) of a desired dimensionality and simply copy it in, say, oil on (vertical) canvas using a paintbrush in the boring old way. It is unlikely, therefore, that it is the fractal dimension that is 'the fundamental content' of Pollock's art.[21] In my own measurements, for example, I found that drawings easily approach the fractal dimension of Pollock's paintings. Even with, comparatively, such an uneventful medium as ballpoint on (smooth cartridge) paper. Nevertheless, one can still argue that, whatever else is the fundamental content of Pollock's art, its fractal dimension is indicative of the structural complexity that was required to ensure that the work is an adequately capacious epistemic vessel. Indeed, informational demands imposed on the work in progress may well vary from artist to artist. Instead of the fractal dimension, therefore, the compressibility of an artwork may reveal a more characteristic measure. For example, in one study, scientists managed to distinguish between various classical composers on the basis of compressibility of their music.[22] Indeed, that the notion of compressibility relates to art is not foreign to intuition for we do seem to value art that spurs endless re-evaluations – art impossible to compress into the final analysis.

So, which one is it – the great art that stubbornly defies the death of the final analysis – is it the nothing of randomness or the chaos of statistical fractals? In fact, the question does not even deserve an answer. It is just an echo of that narrowly conceived notion of feature, limited to the world of the image as an independent entity. To illustrate, suppose I show you a pattern of black and white pixels that is, in fact, a visual representation of a sequence of temporal gaps between the successive occurrences of a radioactive decay. I then invite you to agree with me that the pattern is, according to the quantum mechanical laws of nature, likely to be as random, and therefore, according to Kolmogorov, as complex as patterns get. You look at the white dots sprinkled over a black square and say: 'But it's just a random pattern!' Afterwards, if you wished to warn a colleague, you might simply say: 'He showed me just a random pattern and claimed that that was the most complex thing in the world.' Even worse, in a very real sense, the colleague would then genuinely know the pattern from that description, without ever having set eyes on my picture. The colleague would know that it is 'just a random pattern' in the sense that it is not any other kind of image, such as those of parachutes, presidents or planets; drawings, photographs or maps; happy, tragic. And then the colleague would know that random are the kind of images that, like pages of a foreign language book, all look the same. This is probably one of those cases when the mere appearances of things reflect the fact. Although there is a great deal of controversy regarding the very concept of randomness, some fundamental assumptions regarding the term translate into surprisingly well-defined statistics. For example, to say that a random sequence entirely lacks order, or that it is entirely unpredictable, is to say that there is no bias evidenced whatsoever. There should, therefore, be no bias in favour of any symbol in the sequence, nor in favour of any subsequence of symbols. This is a very strict requirement and is reflected in the expected statistical features of random sequence. Statistics is often, of course, a very lossy compression methodology. The fact that we find it so helpful suggests that it corresponds intimately to the way human minds cope with the stochastic facet of the environment. The very statement that something is 'just a random pattern' probably captures those same statistical features – in a very real sense. That, which is the least lossless compressible, thus becomes the most lossy compressible – hence is the uniform distribution of Kolmogorov complexity recognised by its dull uniformity.

Evidently, to be complex in some aesthetically relevant way, my black and white pattern needs more features. Perhaps some clusters of little white pixels to spur the interest? The problem is, however, that if these clusters are themselves large, comprising many pixels, then they simply inherit the problem of uniformity. Such large clusters then themselves look at best just random. I could, of course, make sure that the clusters are comparatively small – so small, in fact, that the uniformity of randomness has no room to get established among such a few constituent pixels. Then again, if the clusters are so small that there are many of them filling the space, the overall pattern of these clusters will itself be at best just random. It appears therefore that dissipating the uniformity of randomness at one scale of structure reintroduces the problem at another. On the other hand, if there were more structural scales, the entire hierarchy of them, densely packed into the image, each cluster would consist of such a few constituent sub-clusters that the uniformity of randomness would never get established. In a way, each feature/cluster would compromise some of the randomness on

one scale of structure only contribute to it on another. Within such an arrangement throughout the structural hierarchy, randomness is everywhere, only nowhere to be seen. Perhaps I might have a better chance of impressing you with the complexity of this kind of pattern – statistical fractals of the greatest possible density of structural scales per order of magnitude. I have, in fact, written a program that generates bitmap point patterns of just about this kind. Sadly, as I watched the patterns flicker on the screen, in and out of their undistinguished existence, their very multitude revealed that all I managed to do is to gently redistribute the probabilities of finding a particular bitmap image. Instead of the most complex pattern, the program generates a pattern a second. In itself, this should not necessarily be a problem. Most finite sequences are close to being algorithmically maximally complex. Because the number of possible sequences of symbols grows exponentially with the sequence length, for any given target sequence, an overwhelming majority of the candidate minimal programs (candidates for its optimal description) approach the size of the sequence itself. The chance is, therefore, that the actual minimal program for a given sequence will be of similar length. Low compressibility is thus typical. Of course, the little program is designed not to produce patterns that are random in the sense that they are lossless incompressible (such as the aforementioned radioactive decay pattern). Rather, it is growing random fractals intended to resist lossy compression. In a sense, the program is set to make random choices about the existence, or otherwise, of the features/clusters at each structural scale of the image. However, the choices made at different scales are not entirely independent of one another. A determination that there is to be no high level feature/cluster in a particular region of the image is simultaneously a ban on smaller scale features/clusters in that part of the image. Nonetheless, as the number of distinct choices multiply across the scales of structure, the total volume of possible outcomes is still vast.

Levels of description

Since these patterns did turn out to be infinitely more interesting than their radioactive decay counterparts, are they, then, the most complex bitmap images? Or if they are not, how does a maximally complex picture look like? Could the little program be improved to generate even more complex bitmap images? Indeed, can any little program generate complexity at all? Stephen Wolfram, for instance, claims that such programs are not even very rare – his *A New Kind of Science* is all about the world of simple programs, or cellular automata.[23] He distinguishes four classes of cellular automata according to the complexity of their behaviour, with Class 4 as computationally universal programs. The most exciting of Wolfram's findings is that some of the Class 4 cellular automata are extremely simple in terms of their state transition rules. He even found a Class 4 automaton among the family of 256 simplest possible cellular automata.[24] As with any example from nature, however, theirs is the complexity of behaviour. They are processes. In fact, if you are a complexologist, you would probably say that still images cannot ever be, strictly speaking, complex at all – a still image is, in the words of Paul Cilliers, 'at most a synchronic snapshot of a diachronic process.'[25] Hence, however complex an automaton's long-term dynamics, there is no reason to think that freezing it at any particular step in its evolution is to yield images of privileged complexity.

On the other hand, pictures are snapshots (though not synchronic) of a diachronic process – the process of their making. They are snapshots of agency coming into being. Their atomism is that of index, not pixel; their universe, that of gesture, not information.[26] Extracting history from a picture implicates a world beyond the image file. The complexity of a picture, as opposed to that of an isolated symbol sequence, is the complexity of experience. And it is the relevance-in-context, measured in units of epistemic hunger, that regulates the very flow of experience. Yet, the little program is designed to seek complex pictures in the raster space of bitmap images – the space of distinct pixel patterns. The relevant space, however, is that of the bitmapped parachutes, presidents or planets; drawings, photographs or maps; happy, tragic, i.e., the space of aesthetically distinct images. The little program assumes a smooth distribution of complexity across the image space, with images of similar complexity sharing same neighbourhoods of that space. Yet, there is nothing in advance of the experience that can be assumed about the mapping of information onto relevance. Hence is the little program inadequate – not because it is little, but because it assumes too much about the correlation between information and relevance; because its search space lacks the entire dimension of relevance; because it is a closed system. It is distributing information across the scales of structure, but for it to distribute representation across the levels of description it needs a collaborator and the same one that in the end evaluates the complexity of the images found.

Computer literate artists have, in fact, for some time now been exploring collaborative evolutionary algorithms – an approach that is sometimes referred to as aesthetic selection. Disappointingly, the development of that paradigm has been less remarkable than its promise.[27] In his elegant review of the field, Alan Dorin highlights,[28] as the dominant issue, the problematic (or as it turns out, not problematic enough) role of the software user:

> Evidence for the dominance of programmer over user lies in the results produced by artists using *different* pieces of software. Try to use the *Blind Watchmaker* to evolve an image like one created by *Mutator* and this is immediately apparent.[29]

Notice how this measure of quality of the user input, in terms of the software's plasticity, is analogous to the notion of computational universality of a system – its ability to emulate arbitrary other system's behaviour – and how keenly pertinent this issue is to artists in relation to their medium. In this terminology, computation corresponds to the motion through some aesthetic landscape. So, to study the computational aspect of drawing, I decided to develop an aesthetic selection algorithm as a diagnostic and modelling tool. To do so, however, it was first necessary to deal with the problem of software dominance. Dorin evidently understood it in terms of the constraint imposed on the kind of images that can ever be produced using a particular software solution. The constraint itself is here an expression of the specific genetic representation format chosen by the programmer. I was particularly interested in this apparently habitual implementation of the phenotype-genotype distinction – whether this Cartesian style dualism is truly inherent to aesthetic selection. Without a doubt, wherever one looks, it does seem intrinsic to evolution: from the logic of von Neumann's universal replicator to the extraordinary stability in the way DNA sequences are interpreted across the species and aeons. Nevertheless, a clean distinction between

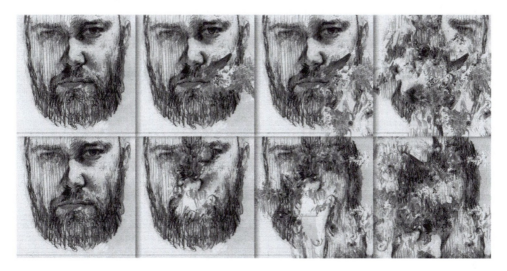

Figure 11.2 Milos Rankovic, Aesthetic selection of naked genes.

genotype and phenotype is probably due to conceptual inertia. Indeed, the actual details of the various implementations, whether natural or artificial, often problematise this duality.[30] In designing my own aesthetic selection algorithm,[31] I have begun with the metaphor of fractal image compression, hoping to expand the set of representable images as much as possible, but have eventually eliminated the encoding step altogether. Inspired by Cairns-Smith's naked genes,[32] the image itself is now all the genetic information there is. This unison of genotype and phenotype allows for an arbitrary starting point (such as a scanned drawing), and in principle, given enough generations, an arbitrary outcome (such as parachutes, presidents, planets: see Figure 11.2). Because evolving a population of images (or a single image as a population of collaborating features) continually feeds back on the search space itself, at every evolutionary step, the very horizon of expectations is implicitly redrawn. And so is the space of possible images trespassed, the sole (and extremely short-sighted) guide being that of the aesthetic scrutiny emanating from an arbitrary level of description.

Strolling through the aesthetic landscape

So where does complexity live? In Kolmogorov, it is in the object. In Shannon, it is in the set of objects to which this object belongs.[33] In Mandelbrot, it is in the endless hierarchy of scales. In Eiser, it is in the endless hierarchy of attitudes.[34] In Wolfram, it is in the computational universality of dynamic systems. In Cilliers, it is in the computational universality of self-organising connectionist/Derridean systems.[35] As for still images, when we find them complex it is not because they are inventorial nightmares (lossless incompressible), but because they defy the lossy compression of the final analysis. Just how lossy? That, more than we like, depends on what we judge to be trivial. Thus, at every turn, we find judgement of relevance creeping in.

Complexity is not in the image in a similar way that it is not in the word. To experience an image is to live through the movement across the aesthetic landscape of images that this image is, more or less, not. As the attention rolls down the features of this landscape, the horizon of expectations whets the epistemic appetite and motivates further movement. The origin (and destination) of the perceived complexity is finally traced back to that dynamic system of expectations, or attitudes, that is variously called individual or culture.

Acknowledgements

Throughout the chapter, references are made to the results of my doctoral study at the University of Leeds, which is being carried out with the financial support of the Arts and Humanities Research Council.

Notes

1 Leyton, M. (1992) *Symmetry, Causality, Mind*. Cambridge, MA: MIT Press.
2 Ibid. p. 567.
3 Ibid. p. 565.
4 Ibid. p. 580.
5 Ibid. p. 581.
6 Ibid. p. 567.
7 Ibid. p. 565.
8 Dennett, D. C. (1991) *Consciousness Explained*. London: Penguin, p. 359.
9 Ibid. p. 357.
10 Ibid.
11 Ramachandran, V. S. and Hirstein, W. (1999) 'The Science of Art: A Neurological Theory of Aesthetic Experience', *Journal of Consciousness Studies* 6(6–7): 15–51.
12 Ibid. p. 33.
13 Dennett (1991), p. 275.
14 Ehrenzweig, Anton (1967) *The Hidden Order of Art: A Study in the Psychology of Artistic Imagination*. Berkeley, CA: University of California Press.
15 Even when art is said to be ugly, or offensive, or disturbing, it is not claimed to be so because it contains complexity the *art lover* cannot cope with. Rather, it is always some *cognitive representation* that is disgust, or offence, or threat. There is a difference between the *shock of the new* and the repulsion of the mimetic ugly, or the insult of the class-aesthetic condescension, or the torment of the oppressive expert culture.
16 Li, M. and Vitányi, P. (1993) *An Introduction to Kolmogorov Complexity and its Applications*. New York: Springer-Verlag.
17 Mandelbrot, B. B. (1983) *The Fractal Geometry of Nature*. Oxford: Freeman, p. 6.
18 Ibid.
19 Taylor, R. P., Micolich, A. P. and Jonas, D. (1999) 'Fractal Analysis of Pollock's Drip Paintings', *Nature* June: 422.
20 Ibid.
21 Ibid. (quoted from the abstract of the paper).
22 Cilibrasi, R., Vitányi, P. and de Wolf, R. (2003) *Algorithmic Clustering of Music*. http://arxiv.org/abs/cs.SD/0303025
23 Wolfram, Stephen (2002) *A New Kind of Science*. Champaign, IL: Wolfram Media.
24 Ibid.
25 Cilliers, Paul (1998) *Complexity and Postmodernism: Understanding Complex Systems*. London: Routledge, p. 4. Cilliers here refers to the studies of complex phenomena that ignore the time dimension. Elsewhere, however, he discusses other 'complicated' structures, such as snowflakes and mathematical fractals, in similar terms.

26 On abductive inferences of agency from the index/artwork, see Gell, A. (1998) *Art and Agency: An Anthropological Theory*. Oxford: Clarendon Press.
27 Historically, aesthetic selection can be traced back to Dawkins, Richard (1987) *The Blind Watchmaker*. London: Longman Scientific and Technical. For a general introduction to this area, see Bentley, P. J. and Corne, D. W. (eds) (2002) *Creative Evolutionary Systems*. San Francisco, CA: Morgan Kaufmann; London: Academic.
28 Dorin, A. (2001) 'Aesthetic Fitness and Artificial Evolution for the Selection of Imagery from the Mythical Infinite Library', in Josef Kelemen and Petr Sosík (eds) *Advances in Artificial Life: Proceedings of the Sixth European Conference on Artificial Life* (Prague, September). Berlin and London: Springer, pp. 659–68.
29 Ibid. p. 662.
30 For example, see Griffiths, P. E. and Gray, R. D. (1994) 'Developmental Systems and Evolutionary Explanations', *Journal of Philosophy* 91: 277–304.
31 *ASNakedGene*, the computer program I am referring to here, is being developed as a part of my doctoral study at the University of Leeds.
32 Cairns-Smith, A. G. (1985) *Seven Clues to the Origin of Life*. Cambridge: Cambridge University Press.
33 Shannon, C. E. and Weaver, W. (1963 [1949]) *The Mathematical Theory of Communication*. Urbana, IL: University of Illinois Press.
34 Eiser, R. J. (1995) *Attitudes, Chaos and the Connectionist Mind*. Oxford: Blackwell.
35 Cilliers (1998).

Chapter 12

Decolonising methods: reflecting upon a practice-based doctorate

Gavin Renwick

In the spirit of both visual communication and oral tradition, my PhD thesis 'Spatial Determinism in the Canadian North: A Theoretical Overview and Practice-based Response' was not presented in linear fashion, each section having autonomy, being self-contained, while very much part of the whole. It strove to facilitate a set of parallel readings of the one issue, from either the general to the particular or from the micro to the macro.

The research domain: decolonising methodologies

As the doctorate project evolved, it became clear that its primary concern was what or who legitimises knowledge. Through being 'freed of the notion of the "field" as a spatialized [and objective] site of research',[1] one realises the potency of creative practice and its methods as research. For me, and I believe the general artist-researcher, there is commonality with research undertaken out with of the university and its procedures for authorising knowledge. Through discussions with the director of the Dogrib Traditional Knowledge Project, with whom the research in Canada was partly affiliated, the commonalities became apparent. As a consequence an initial but vital question evolved; where does an artist undertaking a so-called practice-based doctorate and a Canadian First Nation project contributing knowledge and information towards future self-government share common concerns?

> Fieldwork defined through spatial practices of travel and dwelling, through the disciplined, embodied interactions of participant-observation, is being rerouted by 'indigenous,' 'postcolonial,' 'diasporic,' 'border,' 'minority,' 'activist,' and 'community-based' scholars.[2]

To this I would add the artist-researcher.

My own starting point was close to home. Within Scotland a synergy between the evolving practice-based doctorate and epistemological traditions can be seen to exist. Some art and design doctorate research now being undertaken in both Scottish and English art schools involves 'aggregating research into tools, materials and processes so as to develop and adapt them for artistic purposes'.[3] But for me the interest lies in the opposite proposition, how to do research using procedures implicit to art and design. The opportunity lies in how to formally organise a research methodology that understands and works with a complexity conveniently negated by most traditional

specialised research methods, 'contributing a comprehensive and connected view of things that have been learned separately'.[4] The current loose consensus (in Scotland and England) on practice-based doctorates in art and design can firmly place itself within Scottish educational traditions of democratic intellectualism, generalism, and visual thinking.[5] Inheriting in some ways the 'link between the perceptual and the conceptual [that was] a commonplace of Scottish Philosophy.'[6]

In Scotland the need for methodological innovation, and academic clarification, within the evolving art and design doctorate could be partly met through recognising the tradition of visual thinking as an integral tool of intellectual inquiry. In addition, my own approach to the practice-led research degree can, I believe, be seen to inherit the Scottish epistemological tradition of democratic intellectualism.[7] It can continue what R. D. Anderson says of the nineteenth-century Scottish university curriculum, which 'enabled students to choose between options suited to intellectual interests and vocational needs'.[8] Such methodology can allow dialogue where none would otherwise exist, while acknowledging a commonality, where superficially none may exist: 'encompassing generalism, appreciation for lay scholarship, and the simultaneous practice of technical and practical competence'.[9]

The philosophical breadth of good art and design inquiry can be seen as a powerful methodological tool in itself with, if recognised, an already established philosophical canon. In addition to the formal original contribution such research must of course make to its own discipline, its sympathy to interdisciplinarity and potentially, the 'intermarriage of intellectual traditions',[10] makes such art and design research potentially more appropriate for ongoing societal application through synergy with, for example, evolving community development tools and participatory action research (potentially making it, to quote architect Giancarlo de Carlo: 'a communal organ of research and investigation into the real problems of social life').[11]

How art and design relates, or fails to relate to knowledge is a crucial point in the practice-based doctorate. As with the Dogrib Traditional Knowledge Project in Canada, the critical questions are: 'What is the nature of knowledge?' and 'What is the nature of the contribution?' We can start to answer these questions through beginning to consider the difference between a profession (being 'the application of general principles to specific problems'), and an avocation (which is 'based upon customary activities and modified by the trial and error of individual practice').[12]

There is however a desire to recognise a relatively secure idea of what art, or design, is.[13] The elusiveness of an answer has been why the applied humanities were generally seen as inferior within the hierarchy of the academy (after all historically art, design, and even architecture were not studied *academically*). Thus art and design are not perceived to be a concern of other disciplines, the consequence being that they have been isolated from the lives that they can assist. In addition scientific and sociological research is not properly questioned because of their defined, tried and tested models: 'grounded in systematic, fundamental knowledge, of which scientific knowledge is the prototype'.[14]

As non-Western postcolonial cultures are currently struggling, within land claim negotiations, with the contradiction of qualifying traditional knowledge within imposed – and presumed omnipotent – Western scientific theories of knowledge, so metaphorically, must the practice-based doctorate struggle against the dominant epistemological model of technical rationality. An inheritance of positivism, it fostered the academic orthodoxy within which:

a philosophy emerged which sought both to give an account of the triumphs of science and technology and to purge mankind of the residues of religion, mysticism, and metaphysics which still prevented scientific thought and technical practice from wholly ruling over the affairs of man.[15]

The parallel development of the professions and their domination of the academy (and relevantly their consequent distancing from labour – that is the division of theory and making), resulted in practice being perceived as an anomaly within academia. As art and design 'neither narrates nor numbers (though it may utilise either or both they are taken up only as tools, not as essential characteristics)',[16] so art and design research should openly challenge science's

> nominal acquiescence to the Real [for such reflective research can set] in play both actions and concepts which transcend the dichotomies that the former depends upon . . . As Gillian Rose puts it [such research recognises] our transformative or productive activity [and] has a special claim as a mode of acknowledging actuality which transcends the dichotomies between theoretical and practical reason, between positing and posited.[17]

The separation of research and practice, academic and making, following the convention of technical rationality must be fully understood, for the potential consequence is loss of both the real power and potential elegance of the practice-based doctorate.[18] There should be no need to either seek a legitimacy, according to the dominant research disciplines of the academy, or justify an exclusive field of knowledge.

Engineering, for example, built itself a deep trench through evolving wholly abstract research divorced from practice, i.e. in being taught as engineering science, a science that can be generally seen to fall between elusive highly specialised systematic research and that which is directed by commercial interests. Its consequent PhD largely encourages the narrowing of perspectives. Here we can perceive an argument, for consequently science can be seen as having difficulties with relations, while art and design mediates. Thus where the sciences are weakest, within the context of subject–object relations, art and design research should be at its strongest, and this strength can be utilised to, among other things, contest the 'intellectual colonisation of technology by science'.[19]

Specifically, fine art has, I believe, the greatest chance of fulfilling the potential of the practice-based doctorate. Unlike most other academic disciplines, and even design, fine art can benefit from its lack of formal professional accreditation. For it is the nature of professional knowledge to separate practice and research:

> researchers are supposed to provide the basic and applied science . . . practitioners are supposed to furnish researchers with problems for study . . . the researcher's role is distinct from, and usually considered superior to, the role of the practitioner.[20]

Thus design, and especially architecture, could potentially suffer for having fully participated in the epistemology of technical rationality that has formed the contemporary Western university.

Anatomy of a sketchbook: the origin of method

> I know that I am not a category, a hybrid specialisation,
> I am not a thing – a noun.
> I seem to be a verb – an evolutionary process,
> an integral function of the universe,
> and so are you.
>
> (R. Buckminster Fuller)[21]

This idea of breadth fits in with George Davie's social interpretation of the Scottish school of common sense, that is, perceiving it as a unifying element, a sixth sense to the other five. Or, most useful to the creative practitioner, what he calls 'reflective analysis'.[22]

> We share understandings through the common philosophical sense, not through specialism: the artist and the mathematician can talk to each other, not through technical details of theorems or techniques, but through a philosophical understanding of the purposes and methods of mathematics and of art.[23]

The preliminary explorations within the approach exemplified latterly by the PhD were situated in an interdisciplinary partnership initiated directly after graduating in 1989. It provided a personal opportunity where no alternative seemed to exist. Starting with a premise for research-based practice, and moving out from what Robert Sommer called 'pre-empirical intuitive' creative practice,[24] the partnership naively started to insinuate experiments and findings through methods embedded within inventive collaboration.

As Richard Buckminster Fuller says within the introduction to his book *Synergetics: Explorations in the Geometry of Thinking*:

> Dare to be naive.[25]

Within the laboratory of our practice we evolved a methodology that was initially a visual negotiation. Just as a reviewer of a new travel book made reference to 'how often an expedition into the unknown actually ends up in the familiar',[26] so our formative individual drawing within the visual milieu can be easily identified among the collaborative whole.

Individual marks are layered, complementing and challenging that which went before. Each consequent drawing becoming respite within a semantic debate, the minutes of which are documented within the sketchbook.

As my collaborator Wendy Gunn states in her article, 'The Story of a Line',[27] about our first project:

> There were many lines on the page but only some that could have meaning. Its weight, its direction said much more with less. Each of us was fighting with predetermined approaches, methods and responses and the difficulty lay in allowing some ideas to be forgotten, in order to respond to our new context and a new way of working. We continued to draw by shifting between the immediate and

local to think of the relationship between this formal practice and a larger situational context, involving a continual process of communication with individuals and groups . . . by means of fax and telephone. I was concerned with your need to know, before you could discover. You were concerned with my discovering without knowing. At issue was the need for plans, a need to prescribe a final form. On a larger scale you placed great emphasis on knowing exactly what was going to happen prior to the event actually happening. It is essential, you said, for the construction, essential for the craftsmen, essential for local planning authorities in gaining permission to build – but what was so essential? The convergence of lines seemed to begin a process from which a sense of clarity emerged. Each sketch made it possible for a discussion to happen, an exchange to take place.[28]

Looking back, with hindsight, this first sketchbook (Figure 12.1) becomes a cognitive map illustrating our tentative process towards a legitimate 'intermarriage of intellectual traditions'.[29] The situation helped evolve dialogue where none may otherwise have existed, each acknowledging a commonality and 'contributing a comprehensive and connected view of things that [had] been learned separately'.[30]

Towards the end of development of the first piece of work in Istanbul, I reminded Gunn that we had no final drawing that could be said to be an image of the final form.[31] This not only implied the fluidity of our process and, importantly, one requisite of the project – to emphasise a strategy beyond the produced artefact – but also was, in many ways, resultant of the polyglotic visual discourse and co-operation between

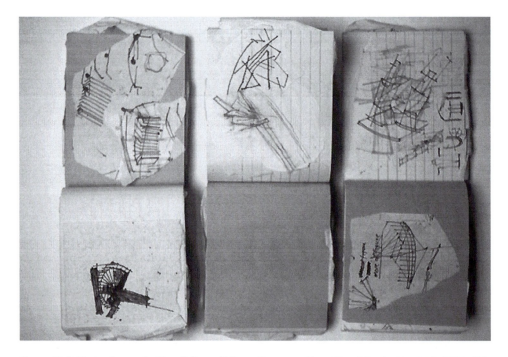

Figure 12.1 Gavin Renwick, Detail from *Whaur Extremes Meet* Sketchbook, Istanbul (1989–90). In collaboration with the artist Wendy Gunn.

each discipline involved in realising the consequent physical manifestation, each individual assuming their own propriety for their part of the whole. Visual communication was the necessary interface during this phase, between the engineers and ourselves, and the necessity between the Turkish artisans and ourselves – with the absence of a shared oral language.

Arbitrarily looking back and reflecting upon this formulative work, with a jogged memory filtered through hindsight, helped interpret the documented moments in time as the creation of a pictogram vocabulary. It reminded me that the most informal mark had been retained and included in the documentation, like the harbinger of an evolving syntax.

The schematic art of the sketchbook, our own 'explorations in communication',[32] made me reconsider the possibilities behind the title of an article by anthropologist Dorothy Lee, 'Lineal and Nonlineal Codifications of Reality', within which she states that reality isn't relative, but can be 'differently punctuated and categorised'.[33]

Our activity symbolically defined a working practice fully appropriate to our collaboration. An evolved sense of joint propriety of method which can ironically now be understood through Vitruvius's definition, 'a perfection of style which comes when a work is authoritatively constructed on approved principles',[34] although for the first time the principles were our own.

NO W HERE (Beyond Eden?): precursor to practice – a Canadian travelogue

Undertaking research partly through creative practice makes one conscious of limiting oneself to a particular convention and means of communication. It can also lead one to further question the dominant role of the written component in traditional research (for that matter within much fine art research, despite initial practice-based intentions). In addition, considering the particular context of my own research, this view coincided with the contradiction of solely analysing orally transmitted traditions and non-agrarian cultures through literate means. Utilising, and subsequently presenting, practice-based research methods as a conduit for other forms of knowledge thus became a vital part of my doctorate, as did the influence of parallel undertakings, in both the postcolonial and non-literate worlds, by non-academic researchers that challenge Eurocentric scientific rationalism and linear analysis.

One section of the PhD took the form of parallel travelogues, one written, the other visual, linking the different worlds I operated in throughout my doctorate research. (Specifically, it detailed a symbolic journey from the Scottish farmer to the Dogrib hunter.) As with the use of the visual within the doctorate degree, did the utilisation of travelogue as a research tool need some qualification? Considering the etymological, and epistemological, origin of the word theory, maybe not:

> Hecataeus' travels were a *theoria*, for Herodotus says of Solon, the great Athenian poet and legislator, that 'he, having made laws for the Athenians at their request, left his home for ten years and set out on a voyage to see the world,' and the single Greek word, repeated again a few lines later, that is covered in the English translation by 'to see the world' is *theories*. Solon left Athens to 'theorise,' to be a *theoros*.[35]

The idea of a 'situated scholar not neutral observer' makes me think of the whole tradition of Scottish nomadic intellectualism,[36] from George Buchanan in the sixteenth century to Kenneth White in the twentieth:

> He's always got to go a bit further on; that's his only home.[37]

Like most, my introduction to the Canadian Arctic was through travel literature, particularly explorers' narratives. This in many ways was an early introduction to a colonial perception and sense of northern place described through highly subjective means, where the prejudices and foibles of the author were only too transparent. For one interested in ideas of home this was doubly interesting, saying as much about the travellers' homeland as their new found land. This is indicative of a European dichotomy implicit to their overwhelming *success* in their new world:

> On the one hand, a passion to settle, on the other, a fierce restlessness; a need to find and have and hold an Eden, alongside a preparedness to go out and roam the world; an attachment to all that is meant by home.[38]

It was aesthetic ideas originating in the fashion and class of a temperate place that, of course, informed the perception of this new world and created the 'image of the British nation-state as a body politic in a body geographic'.[39]

Personally, my travelogues provided the method for producing an overview that creatively engaged with place and was presented in order to contextualise my subsequent practice. Indeed it was a research tool that precedes and parallels practice. (A reverse of James Clifford's idea of 'fieldwork as a travel practice'.)[40] The text was not an endpoint but a form of mapping, that is, guiding my way towards the situated activity. For a practice-based researcher, it placed experience and perception over abstract theory, subject over object, and posited me as the

> performative subject, whose own presence determines the conflictual evidence of subject consciousness and research objects of knowledge and hence, draws attention to the complicated and paradoxical nature of practice, theory about practice and theorised practice . . . the process of theorisation reaffirms our cognitive purchase on the world; . . . and this is fundamentally important in bringing to light new aspects of our experience.[41]

Like the Arctic landscape itself, it allowed space for the imagination.

The journey presumed a degree of ritual. With the point of origin being agrarian and point of arrival being traditionally nomadic the travelogue allowed me to physically and, in part, theoretically pass though Cartesian space towards a more organic and fluid universe, i.e. to leave the farmer's world and approach the hunter's. (Such a journey beyond the agrarian world can only make one question the particular nature of one's own Western temperate identity and, indeed, template of home.) The travelogue as fieldwork describes me leaving the presumed fixed space of home towards experiencing what anthropologists would call the field, only 'the "field" as a habitus rather than a place, a cluster of embodied dispositions and practices'.[42]

Consequently being invited onto a land that is itself considered home, where a 'territory is made perfect by knowledge' and for many the only 'imaginable home',[43] made me recollect an Antonin Artaud quote:

> Real culture can only be learned in space. Space culture means the culture of mind that breathes and has its being in space, and that calls into itself all the bodies that move in space, making them the very objects of its thought.[44]

Reading the travel journals separate from the experience made me extremely aware of my own culturally constructed sense of place, a suitable critical position to start from. This, in addition, increased my sensitivity towards the transplanted familiar, the imported idea of house and home within the Eurocanadian north.

Both travelogues were collective narratives linked in their gradating nordicity and the continuity of experience if not, like a traditional oral narrative, necessarily representing a single passage of time.

Tlicho De as home (Dogrib land as home)

As stated, a vital part of my research in the Canadian Subarctic has been undertaking work for the Dogrib Dene, a Canadian First Nation people. The Dogrib are currently in the process of negotiating self-government and land claim with Canada. However, as traditionally a hunter-gatherer culture, they were initially reluctant to base their claim solely upon Western conceptions of territory. Within the context of extensive research into Dogrib habitat, undertaken by the Traditional Knowledge Project (TKP) towards providing culturally appropriate baseline data that could help inform comprehensive land claim negotiations, I was invited by the director and elders' committee of the project to work with them on the traditional Dogrib idea of home. (This research was in parallel to other larger scale habitat projects detailing the full extent of Dogrib environmental understanding.) As well as documenting traditional knowledge, the work of the TKP helped qualify parallel understandings while facilitating an equitable dialogue between epistemologies. This ambition originated with the dedication of the elders' committee 'to finding a way for all people to know both sets of knowledge: the Tlicho knowledge and the knowledge of the dominant society'.[45] As Zimi Bino (Chief Jimmy Bureau) said:

> If we are to remain a strong people we must educate our children and grand-children in both the white and the Tlicho ways. They must be strong like two people.[46]

Prior to my research for the Dogrib, concepts of home had not been extensively studied through oral tradition, although the concept of land as home has emerged within other studies by Dogrib researchers and their associates. My given responsibility was to work on documenting Dogrib oral traditions concerning home, primarily through interviews with elders both in the settlement and on the land. (This informed, subsequent and ongoing work extrapolates these concepts through practice-based research procedures that can begin to insinuate traditional knowledge within the contemporary, postcolonial, built environment.)

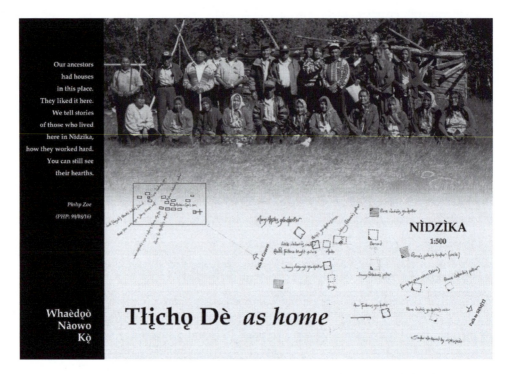

Figure 12.2 Gavin Renwick, Dogrib Land as Home: Nidziki survey document. A 75 × 52 cm poster distributed to all Dogrib households with a request to add information.

An understandable probationary period meant that it was several years before I was given the opportunity of working alone on the land with elders (Figure 12.2). Thus, when in Canada, initial visits onto Dogrib land largely comprised being a peripheral part of the established team while being introduced to both Dogrib culture and ways of researching.

Being on the land is implicit towards any understanding of Dogrib culture. This intimate relationship becomes evident when noting the similarities between the term for 'their footsteps' and 'their knowledge':

> Long time . . . our ancestors went through hard times and to this day we are still following ginaowo [their footsteps] and to this day the people use ginaowo [their knowledge] in order to survive. Andrew Gon, 1994.[47]

Acculturation *by design*

During the summer of 1990 my time was spent travelling through central Europe with an experimental art and architecture project called *Whaur Extremes Meet*. This involved constructing a debating chamber in seven cities, most of which were in that immediate transitory state that follows revolution. For many people in locations like Prague, this structure became a utilitarian symbol performing part of their

transformative activity. Thus the ambition of such practice was not so much a question of experimental form as liberating people.

The artist Joseph Beuys declared that culture relates to freedom because culture implies freedom. Yet the former Czechoslovakian president, playwright Vaclav Havel, commented that:

> because of the materialistic . . . and science based nature of modern civilisation, *culture* . . . has been taken out of context, robbed of its broader and deeper meaning. [However, he goes on to say]: there was a time when culture was scarcely ever mentioned as a separate sphere of human activity. The reason for this was simple: culture was part of daily life.[48]

On Dogrib land, culture is part of daily life, indeed life is interwoven into the fabric of the whole day. While on the land work is neither compressed into prescribed hours nor spatially isolated. As with camp life the architecture of the bush does not permanently spatially determine, or isolate, an activity.

In essence, this illustrates the dichotomy between the Western idea of house (as a spatial unit in the built environment) and the Dogrib idea of home. In Western convention, a 'house is a physical unit that defines and delineates space for the members of a household. It provides shelter and protection for domestic activities'.[49] The ensuing static enclosure negates the idea of home as anything other than 'a territorial core, an ordering of space [as opposed to] a complex entity that defines and is defined by cultural, sociodemographic, psychological, political and economic factors'.[50]

Within Dogrib culture the complexity of localised environmental orientation can be evidenced by linking archaeological and cultural landscapes through extrapolating oral tradition. Land use and occupancy is shown to be inextricably linked, and 'home' can be shown to be lived and understood as an expansive experience, not a contained one.

As Gameti elder Romie Wetrade describes: 'when we say home it is as if the land is that home. This is why we worked hard and took care of our home.' This illustrates the relationship between camp and land. Spatial prepositions like *in* or *out* are superfluous, as both camp and land are understood as home. You are always *on* the land. The consequence of such a geographically expansive domestic intimacy presumes not being locked into (a fixed) place and illustrates the inextricable link between hearth and cosmos, home and world. (This lack of separation from the land not only changes spatial relationships but also changes the entire concept of ownership and the responsibility that comes with it.)

Architecture has traditionally been a tool of assimilation in the Canadian North, where the general global change from self-reliance to dependence on culturally inappropriate, and geographically distant, industrial processes has been particularly concentrated (Figure 12.3). Many people have experienced 'all or most of the variety of forms that we label modernization',[51] in considerably less than a single lifetime. In 1970 the territorial government started construction on Dogrib land of a new town called Edzo.[52] The intention, as with the planners and engineers involved, was improvement on government terms, in this case to relocate the largest Dogrib Dene community of Rae away from the shores of Marion Lake and into a land-bound township which could be linked to the main north–south highway. Conceived by

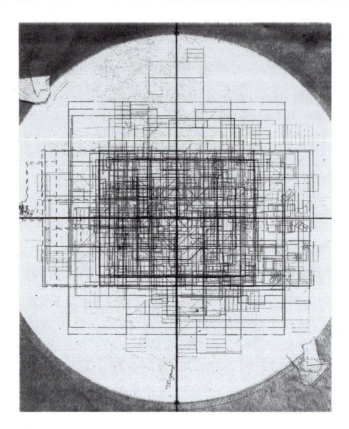

Figure 12.3 Gavin Renwick, Tyranny of the Four Foot Grid: Government house plans for the Northwest Territories, 1959–96.

a town planner from the south [it comprised] neatly rowed houses, cul-de-sacs, and open plan park areas. It was to be the showpiece of the north. The responsible public officials, many of whom had technical backgrounds themselves and none of whom were native, were impressed. Everyone had the best of intentions.[53]

They failed however to hear or at least to listen to Chief Jimmy Bruneau, who opposed the move:

Bruneau said that he would not object to the settlement moving south of Marian Lake, but that he himself would remain in Rae. He wanted to be near his boat.[54]

The engineers failed to understand the importance of the boat as part of the Chief's home. Nor did they comprehend that if the Chief said he would not move, no one else would. He was their leader.

With the dedication of a true convert, one engineer involved subsequently articulated his criticism of the applied science that conceived Edzo, particularly the presumed superiority over indigenous knowledge and lifestyle. At the time many recognised that Rae did have its infrastructural problems connected with a growing population, however

the recanting engineer acknowledged that scant regard had been paid to its historic resonance and sense of place. Thus the primary reasons why a community might desire to stay where it was were denied and Edzo was built, even though, as he now recognises 'the public health and other related problems . . . could have been solved within that community at a substantially lower cost than that required to build Edzo'.[55]

In Rae the original self-built log cabins were placed in direct proximity to the lake, clustered according to kinship groupings and orientated towards their particular traditional hunting territory, the cabins not segregating either home from homeland or hearth from cosmos. (At present it is still mainly those who hunt that occupy these houses.) Marion Lake itself provided direct access for canoe or sledge, boat or skidoo, to the linked lakes and portages that are the Idaa Trail – the historic highway across Dogrib land that connected the Great Slave and Great Bear Lakes. Thus the traditionally expansive idea of home was sustained, the static cabins being conceived spatially and strategically in relation to homeland and family.

Endnote

The PhD thesis 'Spatial Determinism in the Canadian North: A Theoretical Overview and Practice-Based Response' was submitted in September 2002. It was as much a visual document as a verbal/written one, and the reader/viewer was asked to recognise this from the outset.

Part of the research was undertaken for a Canadian First Nation culture where knowledge has been transmitted orally. As a fine art PhD candidate working in this Subarctic context, it was soon recognised that a parity between legitimate, but alternative, forms of knowledge existed as an alternative to the dominant worldview, that of the absolutism of scientific rationalism. In many ways the thesis followed the premise of the Tlicho (Dogrib) Dene elders, that 'those who learn both ways [Dene and Western] will . . . be strong . . . [The elders] want their knowledge written down so it will be believed, and the differences and similarities between types of knowledge will be understood'.[56] As the former *Dogrib Treaty 11 Traditional Knowledge Project* director Allice Legat states:

> The oldest of Gameti elders consistently explained that a person should only talk about what they know. You can only 'know' information because someone who has experienced it knows it and explains to you . . . This is the only way I can put information together given my experiences, assumptions, and knowledge at this time.[57]

Afterword: house, homeland and self-determination

I am presently in Gameti, Northwest Territories, a one-hour flight north of the territorial capital of Yellowknife (Figure 12.4). This time last week it was minus 43 degrees, today it is minus 15 degrees and it feels like spring, although you can never predict the demise of winter here – a reprise is always presumed. The light is returning but the sun is still low and the shadows long. A PhD has now become a postdoctorate fellowship. Practice-based research has seamlessly transformed into research-based practice (the outcome being the issue).

Figure 12.4 Gavin Renwick, Birdseye View of Gameti, Northwest Territories.

Part of the doctorate research has developed into the community-led *Gameti Ko* (the Rae Lakes home) project. Its purpose is to further elucidate the distinct Dogrib idea of home and help Gameti First Nation elders and youth develop culturally appropriate house designs, thereby defining a post-land claim domestic environment relevant to Dogrib hunter-gatherer traditions. For a decade the elders of Gameti, initially through the *Dogrib Treaty 11 Traditional Knowledge Project*, have been formally researching and documenting their traditional knowledge, skills and values for future generations. They feel it is now essential to demonstrate how their traditional knowledge is relevant to life in the twenty-first-century settlement – particularly to those who will be the future. Within the framework of *Gameti Ko* the elders of Gameti are working with their young people to develop a project that will engage everyone in helping renew their community (Figure 12.5).

As Chief Archie Wetrade has stated:

> in Dogrib, *Ko* means *home*, this project has been created to document our view of the land as home and develop this traditional knowledge into a modern structure that has the same values. This way we remain strong like two people – in our traditions and in the modern world.[58]

For me, this is an appropriate demonstration that the potential of practice-based research is in bridging theory and practice, while confirming that the practice-based doctorate should have the confidence to presume its own modus operandi. Unlike the protected specialisms of most academic disciplines, by naturally crossing strict divisions, both academic and cultural, an epistemological challenge for practice-based research becomes to synthesise.

Figure 12.5 Gavin Renwick, Tlicho Spatial Configurations for Living 'North of Normal' – one of a series of eighty-three drawings of Gameti.

I'll ha'e nae half-way hoose
But aye be whaur extremes meet – it's the only way I ken
To dodge the curst conceit o' bein' richt
That damns the vast majority o' men.[59]

Notes

1 Clifford, James (1997) *Routes: Travel and Translation in the Late Twentieth Century*. Cambridge, MA: Harvard University Press, p. 88.
2 Ibid. pp. 76–7.
3 Cornock, Stroud (1988) 'Using Research Tools in a School of Fine Art', in Jeni Bougourd, Stuart Evans and Tag Gronberg (eds) *The Matrix of Research in Art and Design Education*. London: The London Institute, p. 39.
4 Mill, John Stuart (1867) Rectorial Address, p. 8. Quoted in Paterson, Lindsay (1993) 'Democracy and the Curriculum in Scotland', *Edinburgh Review 90 (summer): 21–8*, p. 22.
5 See UK Council for Graduate Education (1997) *Practice-Based Doctorates in the Creative and Performing Arts and Design*. London: UK Council for Graduate Education.
6 MacDonald, Murdo (1992) 'Patrick Geddes: Educator, Ecologist, Visual Thinker', *Edinburgh Review* 88: 113–19.
7 'Epistemological' is a word first coined by St Andrews philosopher James Frederick Ferrier. Cited in Kelman, James (1990) Foreword to George Davie (1991) *The Scottish Enlightenment and Other Essays*. Edinburgh: Polygon. Quoted by MacDonald, Murdo (1997) 'The Englishness of British Art' (unpublished), p. 4.
8 Paterson, 'Democracy and the Curriculum in Scotland', p. 26.
9 Robinson, Mike (1997) 'Championing the Democratic Intellect', *Arctic* 50(3) (Calgary, Alta: Arctic Institute of North America), p. iii.

10 Ibid.

11 Ward, Colin (1990) *Talking Houses*. London: Freedom Press, p. 124.

12 Schön, Donald (1991) *The Reflective Practitioner: How Professionals Think in Action*. Aldershot: Arena, p. 22.

13 Here it should be recognised that art and design history makes little contribution towards understanding this question.

14 Schön (1991), p. 23.

15 Ibid. p. 32.

16 Dilnot, Clive (1999) 'The Science of Uncertainty: The Potential Contribution of Design to Knowledge', in R. Buchanan, D. Doordan, L. Justice and V. Margolin (eds) *Doctoral Education in Design*. Pittsburgh, PA: Carnegie Mellon University, p. 68.

17 Ibid. p. 69.

18 It is presumed that the demise of the technical rationality is necessary for the practice-based doctorate to fully flourish, but in Scotland, and recently at the University of Dundee, this has not been the case.

19 Dilnot, 'The Science of Uncertainty', p. 77. After all, as he goes on to say: 'technology today means the application of the natural sciences to the analytical comprehension of artefacts treated projectively as if they were natural phenomena'.

20 Schön (1991), p. 26.

21 Fuller, R. Buckminster (1975) *Synergetics: Explorations in the Geometry of Thinking*. New York: Macmillan, p. xix.

22 Davie, George (1991) 'The Social Significance of the Scottish Philosophy of Common Sense', in *The Scottish Enlightenment and Other Essays*. Edinburgh: Polygon.

23 Paterson, 'Democracy and the Curriculum in Scotland', p. 22.

24 Sommer, Robert (1972) *Design Awareness*. Austin, TX: Holt, Rinehart and Winston.

25 Fuller (1975), p. xix.

26 Dyer, Geoff (1999) *The Guardian (Saturday Review)*, 27 February: 8.

27 Refers to Figure 12.1.

28 Gunn, Wendy (1999) 'The Story of a Line', in Robert Kronenburg (1999) *Transportable Environments: Theory, Context, Design and Technology*. London: E and FN Spon, p. 148.

29 Robinson, Mike (1997) 'Championing the Democratic Intellect', *Arctic* 50(3): iii.

30 Mill, Rectorial Address, p. 22.

31 Gunn, 'The Story of a Line', p. 154.

32 A phrase borrowed from the title of the book edited by Carpenter, Edmund and McLuhan, Marshall (1970) *Explorations in Communication*. London: Jonathan Cape.

33 Lee, Dorothy (1970) 'Lineal and Nonlineal Codifications of Reality', in Carpenter and McLuhan (1970), pp. 136–54.

34 Ingraham, Catherine (1998) *Architecture and the Burdens of Linearity*. New Haven, CT: Yale University Press, p. 13.

35 McEwen, Indra Kagis (1997) *Socrates' Ancestor: An Essay on Architectural Beginning*. Cambridge, MA: MIT Press, pp. 29–30.

36 Clifford (1997), p. 81.

37 Bataille, Georges, in Kenneth White (1983) *The Blue Road*. Edinburgh: Mainstream, p. 6.

38 Brody, Hugh (2000) *The Other Side of Eden: Hunters, Farmers and the Shaping of the World*. Vancouver: Douglas and McIntyre, p. 87.

39 Olwig, Kenneth, in P. D. Smith (2002) 'Best wear a good skirt', *Guardian (Review)*, 22 June: 11.

40 Clifford (1997), p. 8.

41 Macleod, Katy (1999) 'The Relationship of Making to Writing', *POINT* 7 (spring/summer): 7.

42 Clifford (1997), p. 69.

43 Brody (2000), p. 35.

44 White (1983), p. 6.

45 Legat, Allice and Sally Ann Zoe (2000) *Tlicho Traditional Governance*. Dogrib Treaty 11 Traditional Knowledge Project, Rae-Edzo, p. 2.

46 Ibid. p. 21.
47 Ibid. p. 23.
48 Havel, Vaclav (2004) 'The Culture of Enterprise', *Walrus* Feb.–Mar.: 38.
49 Lawrence, Roderick J. (1987) 'What Makes a House a Home?', *Environment and Behavior*, 19(2): 154–68.
50 Ibid.
51 Pelto, Pertti (1978) 'Ecology, Delocalisation and Social Change', in *Consequences of Economic Change in the Arctic*. Edmonton, Alta: Boreal Institute for Northern Affairs, University of Alberta, p. 32.
52 Ironically, the planned community, now largely occupied by whites (a proportion of whom work at the Edzo-based school), is named after a great Dogrib leader, while Rae, the place with a history of aboriginal occupancy, is named after a Scottish fur trader.
53 Gamble, Donald J. (1986) 'Crushing of Cultures: Western Applied Science in Northern Societies', *Arctic* 39(1): 21.
54 Grainge, Jack (1999) *The Changing North*. Edmonton, Alta: Canadian Circumpolar Institute Press, p. 180.
55 Ibid. p. 21.
56 Legat et al. (2000), p. 2.
57 Ibid. p. 3.
58 Chief Archie Wetrade personal communication, 25 January 2004.
59 MacDiarmid, Hugh (1926) 'A Drunk Man Looks at the Thistle', lines 141–4, in Alan Riach and Michael Grieve (eds) (1992) *The Selected Poetry of Hugh MacDiarmid*. Manchester: Carcanet Press, p. 30.

Part 3

Introduction to Part 3

Katy Macleod and Lin Holdridge

In relation to concerns involved in Part 2, we can pose the following questions: how might artist researchers' thought about the perceptual and conceptual problems involved in identifying the fourth dimension, spatial illusion or a renegotiation of spatial determinism, take us to a critical differentiation of what is to be valued (what is real) in the university environment? Is it possible to simultaneously have tenure within the university and sustain a usefully critical independence from it? These are blunt and perhaps even futile questions, but they need to be asked as it is only through the proof of independent and critical thought that any assertion of discipline distinctness can be maintained. A more appropriate question might be, how might we make provision for such proof? The individual chapters in Part 2 by artist scholars can give no more than a fleeting glimpse of such critical independence of thought because we cannot present the artwork and thus only a partial demonstration of that which we have characterised as thought *through* art is given. In this third part, we begin to address how, as educators, we might appropriately foster critically independent thought in the context of art *as* research.

Iain Biggs, Kerstin Mey and Jeff Collins, all of whom have considerable experience of teaching, examine writing as a key to unlock false divisions between writing and making. The business of writing is central to the purposes of any university as the publication of research evidence secures its status. However, as our universities aspire to an increased pursuit of status, so those forms of writing employed to secure its advancement seek the expediency of the known, the conventional and that which will be immediately recognised as being valued in the broader research communities. It might be timely then to consider writing as a discipline which could, more effectively, address the purposes of art as well as those of the university.

In Chapter 13, '*Hybrid texts* and academic authority: the wager in creative practice research', Iain Biggs presents the hybrid form as appropriate to writing in relation to the purposes of art. He identifies art with that which 'exceeds the authority of the university' and its excess, as it were, speaks truthfully about issues of power. It is his view that the poetic reasonings of art, its 'thinking through feeling' is diminished in the university's pursuit of objective knowledge. He marshals embodied conflicts of thought through the conceit of the Dionysian and Apollonian, in order to argue the case for a more fluid and more life enriching approach to writing. He advocates that students should be able to 'create work that supports us, both intellectually and with feeling, in being poets of our own lives' (p. 191). In this, Biggs moves outside the superficial use of such sources in the slim literature on research in fine art. This he sees

as diminishing the Dionysian in the face of the 'dominant academic perspective', which he aligns to 'reason and necessity'. He wishes to see the university valuing 'the space of the particular/ethical authority of the student's own unfolding identity in relation to the poetic'. In Biggs's view, it is important that we understand those forms of authority to which our students are subject, in order to promote an alternative reflexivity to reasoned objectivity. Such reflexivity would be poetic and Dionysian in character. It would then be seen as contrary to the more regulatory offices of the university whose doctorates he characterises as a gatekeeping exercise, where the Apollonian, subject to the authority of Athene, holds sway. Here the purposes of the imagination, the poetic, the magical even, enjoy a precarious siting. It does not fit 'the composite authoritative fantasy that governs the university's traditional self-image, along with some of its implications for the future of types of art practice . . . polytheistic, reflexive and hybrid' (p. 193).

Following Geraldine Finn's concept of art both exceeding and falling short of the dominant constructions of knowledge, Biggs formulates what we take to be the appropriate citing of art, 'between an assumption of the adequacy of professional mastery . . . and an open acknowledgement of our "inevitable inadequacy" in the face of "the contingent and changing concrete world"' (p. 193). This is this space of 'becoming', the space we in-habit. Biggs carefully examines key examples of relevant literature which might be said to reveal such a space, that space which is critically and conceptually different, because it is both within and outside the university simultaneously. He finds only a glimmer of evidence that such a space is being recognised as necessary to support the hybrid and poetic reasoning of artists' research and so turns to his own exemplum, *Between Carterhaugh and Tamshiel Rig: a borderline episode:* occupying a 'space between'. In his own research project, the complex processes of forming an identity, of remembering as a form of cultural history and the constancy of self-production are all employed in the development of a project that incorporates the formation of identity into the purposes of art. Following Elkins, he begins to demonstrate how it might be to come to terms with 'what we are, what kind of writing we are producing, and how we spend our lives' (p. 197).

The ethical engagement of art with lived experience is again adumbrated here. Following Janet Wolff's concept of the 'personal' cultural moment, Biggs poses a most crucial question in his research:

> Is it possible to represent something of the complexity of our contemporary understanding of identity by working with a hybrid research model; one that weaves various types of creative and scholarly material in such a way as to explore and critically reflect on issues of the roles of memory and place in the construction of identity?

To this end he has produced a hybrid artist's book which explores different aspects of the relationship of memory to place through the use of devices such as folkloric song, dance and ritual. The book also reflects the complexity of the development of a contemporary identity through autobiographic writings. The various forms of writing employed are thus both academically conventional as well as poetic, involving folklore local to a particular personal landscape and traditional in terms of communalities of lived experience. This is a publication where the academic 'defers to the poetic' and

so reverses the status of the Apollonian and the Dionysian. It also deflects critical and reasoned judgement in favour of the 'heartfelt', thus asserting that the operations of a feeling intelligence can more appropriately deal 'with our most pressing questions'. In Bigg's view, it is these which are most appropriately formed by authoritative, poetic research artworks.

Through 'The gesture of writing', Kerstin Mey in Chapter 14 also develops a thesis for research artwork to work more fully to its strengths of a particular responsiveness to the currency of contemporary cultures. In this instance, Mey advocates writing in the contexts of doctoral research as being responsive to the 'multimedial', that which has been produced by the multiple processes of digitisation at work in our cultures. Mey, like Biggs, anticipates the appropriateness of the hybrid form. She posits that only a complex and manifold hybridity can deal with the experience of language; this is language which is becoming increasingly audible through teletexting and mobile communications. It is this dimension, among others, which can be deemed to be omitted from the curricula for art students and the subject benchmarking to which (in the United Kingdom), it is accountable. Mey makes a most cogent and compelling case for writing as facilitating and engendering situated knowledge. This is identified as highly reflective knowledge which can be acted through. As such, it stands in stark contrast to those forms of writing advocated by subject benchmarking. This seeks to restrain writing to the tasks of explicating what is essentially modernist in orientation, while the cultures encountered by students are postmodernist in the sense of the 'multimodal, intermedial, hybrid and dynamic' modes of the digital. Here the world on screen is different from the world on paper. As educators we must surely, as Mey proposes, address these issues in our work with students 'In the age of digitisation, intermedia, hypermedia and of dissolving genres, we are witnessing and becoming accustomed to an incredible cross-referencing of scopic regimes and cross-fertilisation of visual imageries' (p. 204).

There is a need to look beyond 'institutional discursive spaces, structures and conventions' to aid the development of speculative and conjectural ideas and incorporate what, through Vilem Flusser, Mey identifies as an 'entire being in our worlds' through writing. In brief, it is a question of listening to words, of an understanding that each 'language has its own atmosphere, it is a biotope, a cultural universe in itself' (p. 206). Language and words provide a 'home for being'. Mey enters into the excitement of language: its dialectic between word and I; between the spoken and written and the different rhythms, nuances, inflexions and changes of syntactical ploy in each. In the full elaboration of how writing works, Mey begins to define how it can be seen as a *gesture* of thought and once that is the case, how gestures of thought need not be confined to conventional forms of writing. This is important, as in a telematic society, a dialogue between people might assume supreme value. Such a dialogue might be facilitated by non-divergent thinking, critical and philosophic reflection; it will need to address the multilayered and multidimensional aspects of current cultures. This should take place inside the university, where the academic essay could be replaced, for example, by research reports, workbooks, creative writing, multimedia presentations and critical discussions: 'Art education institutions are ideally situated and equipped to respond creatively to the challenges that the current situation poses' (p. 211). Mey advocates a timely rethinking of what we teach and how we teach it.

It could be argued that 'Derrida's "two paintings in painting": a note on art, discourse and the trace' (Chapter 15) equally advocates a change of approach to pedagogic practice. Jeff Collins meticulously unpicks Derrida's complex thought on the question of 'thinking posed between art and discourse on art'. This is thought which lies between artworks and linguistic texts. It is as if art and discourse on art force between them a 'presence' evoked by the enactment of their different genres, which is reflective of the constitution of the field in which the embattling of art and discourse on art take place.

Derridean thinking does not, however, advocate or exhort: it exposes the muteness of art, so intimately bound into theoretical and philosophical suppositions, or what Collins calls its 'voluble counterpart', which is subject to discourse and 'reproduces the phonocentric schema on which the metaphysics of presence is founded'. This metaphysics of presence privileges speech over writing. In his defence of non-linear forms of writing, Derrida looks to the non-phonetic, to picto-ideograms and beyond, for example, cinematography, choreography or musical or sculptural writing, to the telematic. Derrida sees both artworks and texts about art *as* writing. His endeavour is to radicalise the concept of writing so that it becomes 'the paradoxical thought of differentiation as articulation'. This is exciting: according to Collins, Derrida's claim is for a 'recapturing' of the 'unity' of gesture and speech, body and language, tool and thought, before the separate distinctiveness of each is articulated; that is, through what he calls the 'trace'. This is a condition of possibility which is 'unthought'; it is anterior to Heidegger's ideas about ontological difference; it is a derivative of differ-ence. The notion of the trace might encourage a rethinking of the condition of writing as 'at once visual, auditory, motile, tactile', that is the condition of possibility. Also, 'discreteness, spacing, the blank and the interval, indeed non-knowledge and non-sense, that which borders or interrupts intelligibility and sense' (p. 223). At the root of art and discourse lies this 'emergent' possibility.

In Chapter 16, Timothy Emlyn Jones carefully maps out the recent development of research and doctoral research degrees in art and design, in order to discuss some key emergent issues in 'A method of search for reality'. This chapter engages with the principles of inquiry in art and design and calls for a new research paradigm to accom-modate these principles. It provides a critical and historical overview of the development of research and higher degree research, which is subject to the Research Assessment Exercise and the Arts and Humanities Research Council, as well as to the research pro-tocols and procedures of individual universities. It provides a clear view of the need to address the problems within the emerging research cultures in relation to the managing of change. In this context, Emlyn Jones calls for greater clarity in explications of the methods of research in these disciplines and an increased professionalisation of their practices in order to create parity with, for instance, the medical profession. He maps out the professional situation of the doctorate and advocates a pragmatics of research training. In order to secure the professional practices of art, he outlines a very sensible and strategic solution, which is the doctorate in fine art (DFA). This will provide the subject community with greater 'self-knowledge' and self-confidence and provide for its 'own inquiry-based paradigm'. The DFA would also provide a unique opportunity to deal with those issues arising from higher degree research. Emlyn Jones opines: 'That we do not have a unitary theoretical stance on knowledge and research . . . should be seen as our strength not our weakness within a new pluralistic paradigm' (p. 238).

He believes that both the doctorate and the DFA might, if we become more generously motivated, be valued within the university, and also beyond.

Through the 'Afterword: on beyond research and new knowledge', James Elkins also provides a pragmatics of research for art: art which could combine with other disciplines: food processing, restorative dentistry or economics, for instance. He advocates the exclusion of words such as 'research' and 'knowledge' which he thinks add nothing to an adequate understanding of 'a subject as complicated (and interesting) as this'. Elkins views the citing of studio art as central to a consideration of the topic of research in art. He views with suspicion the use of notions which might predict a shift in an author's concerns simply because she or he is addressing the concepts of knowledge and research. In this context, he finds that accepted understandings of research and new knowledge are reconceived or rewritten in order to fit the authors' purposes; or, they are bypassed in favour of concepts and methods which are more fitting to studio art instruction, in order to find a voice for art in the university which speaks its concerns. Elkins also takes issue with the conceptual being reconciled with the non-conceptual (that is reflection on and with the experience of art); or, indeed, with theory being abandoned in favour of practice. All these attempts, as exemplified in the preceding chapters, in Elkins' view, reveal problems: in the reconciling of the conceptual with the non-conceptual for instance, there is an unsystematic referencing of sources and similarly, in the primary placing of practice there is an uncertain approach to citation. What is to be done? Nothing? It is the elusiveness of any attempt at *theorising* which interrupts any systematic attempts to re-envisage art.

However, in contrast to Elkins' view, we propose that 'thought through art' is not a sign of the rootlessness of art, it is a sign of its rootlessness within the university. Art exists outside any institution. Indeed it flourishes. Art addresses the worlds in which we live, those spaces we inhabit as making sense for us; it is highly reflective, responsive and mercurial. But it is not rootless: it is rhizomatic, spreading, proliferating; it pulls into its forms many different modes of making sense to the point where we begin to question how we began to attempt the project in the first place. Art can only be reread. Its internal communication is not easily available to the conventional academic mind and its processes do not easily conform to the edicts of comprehensive or stable knowledge. It is time to talk more openly about how we make art; how it feels to realise ideas in material form and in relation to what is taking shape, which may bear no apparent relationship to what has already been conceived. Indeed, when we learn to talk more openly in this way about the processes of making artwork (including reflection upon it), we will become more able to cogently refute the conventional scholarly mindset which cannot easily grasp art *as* research. Consequently, art *as* research will cast light on those systems of thought which refuse any reconciliation of concept with affect among many other of art's potential purposes.

Chapter 13

Hybrid texts and academic authority: the wager in creative practice research

Iain Biggs

Contexts and perspectives: an abnormal view

This chapter is the product of almost a decade spent listening to discussions about creative practice research at doctoral level. It addresses a topic rarely made explicit in those discussions, that of thinking with feeling in relationship to tensions between academic authority and creative practice research. It seeks to do so in a way that both acknowledges that one function of the artist is to speak truth to power and the complexity of the issue of authority and the power that flows from it.

Martin Davis, quoting Nietzsche, reminds us that we may value art because through it, we are supported in 'thinking with our feelings' – where I understand with as used in the sense of going with the grain – and as an aid to becoming 'poets of our own lives'.[1] The understanding of the poetic used below is derived from Paul Ricoeur's view that hermeneutics depends on a wager, one that those texts we call art require us to engage with, since 'as a reader, I find myself only by losing myself.'[2] Ricoeur's argument is that 'metaphoric language . . . provides *new knowledge*, but in a way that makes us arrive at it *through the work of interpretation*' (emphasis added).[3] He also emphasises the centrality of intuition and imagination, stressing the generative power of any genuine poetics.[4] Such a poetics is located within the social since, as Ricoeur has made very clear, it involves the 'political imagination' central to addressing the most pressing issues of our time.[5]

It is because certain types of creative practice research work poetically in this sense that they are fundamentally different from research that, implicitly or explicitly, derives from scientific models. Despite statements to the contrary, it remains the case that the dominant perception of doctoral research is still grounded in an implicit assumption that the terms science, research and knowledge are interchangeable, with the result that there is still a sense that 'to be involved in non-scientific knowledge production is to place oneself beyond the pale'.[6] The new knowledge made available through types of creative practice, and only accessible through the work of interpretation appropriate to the poetic, is distinct from the objective knowledge usually taken as the norm in the context of doctoral work. My first concern here is to ask why there is a very real, if often largely tacit, resistance to accepting the validity of this poetics and the new knowledge it can bring within the university.

I will begin with a claim by Alex Seago that the 'epistemological polarisation' of Dionysian and Apollonian positions in art and design research is finally untenable, part of an attempt to normalise the relationship between conflicting approaches to

practice-based research at the Royal College of Art in the early 1990s.[7] This argument includes a reference to the anti-academic writing of James Hillman, located in the Dionysian camp, and I have taken this as an invitation to examine Seago's argument through Hillman's eyes; to see the normal academic culture from an abnormal perspective. Consequently what follows is written from a perspective that honours, without identifying with, the Dionysian perspective – given that that perspective asks that we accept no perspective as 'definitive and final'.[8]

Like Seago, I am concerned that creative practice research be framed in ways that allow it to avoid 'the oppressive institutional networks of . . . research cultures which validate and bless as methodologically worthy the research of novices'.[9] Doctoral study in the arts should not be seen primarily as a schooling in research methodologies, but rather as a means of empowering students to deepen their work poetically and in so doing, create new knowledge as Ricoeur understands it. Since the aim of such practice is to create work that supports us, both intellectually and with feeling, in being poets of our own lives, students working in this way at doctoral level must engage in a dual dialogue. That is, both with specific practices and subject areas taught in the university and with the way in which these relate to their own life experience and, in turn, that of society at large, thus working between two sets of regulatory authority. On one hand the professional/academic authority that governs formal studentship, on the other the particular/ethical authority, however provisional, of the student's own unfolding identity in relation to a poetics. However, while Seago's position purports to honour both 'rigorous methodology *and* the following up of intuitive, imaginative hunches', locating both within a single spectrum of action, this apparently sensible approach actually masks the issue of a dual orientation to authority.[10]

Seago's resolution of the tensions between Dionysian and Apollonian perspectives is, from a Dionysian perspective, an intellectual sleight of hand. This is the case because his own perspective, presumed by him to be neutral, is also archetypally determined and has its own bias. Once identified as typical of the interventionist thinking that balances reason and necessity from the perspective of Athene, its limitations with respect to the Dionysian become apparent. The Athenian perspective is closely associated with both that of her father Zeus and of Apollo. It represents a 'consciousness that is institutional, one linked to secular brotherhoods, the conventions of like-minded men, the nomothetic standards of science, government and their unavoidable norms of inclusion and exclusion'.[11] Seago's view is thus a variant of the dominant, normative perspective that, by definition will minimise or misrepresent the value of what it regards in this context as abnormal – in this case any insistence on valuing the space of the particular/ethical authority of the student's own unfolding identity in relation to the poetic. Consequently Seago's account, while declaring its own even-handedness, actually subordinates the Dionysian to the dominant academic perspective and in doing so, perpetuates academia's blindness to its own limitations.

There are three points to be made here. First, if we want to understand what is at stake in current debates about certain types of creative practice research, we need to acknowledge and respect the real differences between the types of authority to which the student must answer. Second, we need to read alternative approaches such as Hillman's not as anti-academic but as offering the basis for an alternative reflexivity, one that allows us to name and acknowledge, from a perspective which does not treat the poetic as abnormal, in the complex dynamics of the university. Third, we have

little hope of addressing issues involving the value of creative practice research unless we give different perspectives, including the Dionysian, equal status within the universe of education.

These observations need to be put in context. Those who work in universities are accountable to their institutions and in that respect, active in validating and regulating the dominant perspectives that the university sector, funded and increasingly regulated by governmental and industrial interests, is charged with both maintaining and expanding. They must, in consequence, acknowledge the legitimate authority of perspectives associated with Zeus (legislative and executive power, effective action and managerial prowess); Apollo (the precisely logical articulation of knowledge framed by a scientific rationality); Athene (rational mediation and practical administration that interweaves normative and objective thinking); and Hestia (the gathering, retention and organisation of useful information). This remains the case even if, for example, their intellectual output consists of radical, Dionysian critiques of oppressive forms of institutional power. We may seek to reform the university system from within but, by taking employment within it, we must accept that our attempts to do so are constrained by certain conventional limits, a position also associated with Athene.[12]

Similarly, as supervisors of research students we are expected to uphold certain priorities and standards determined by the dominant complex of perspectives. We may encourage the pursuit of intuitive, imaginative hunches while acknowledging that the successful student will need to learn to make these serve a rational rather than poetic account, if he or she is enrolled on a conventional PhD. (The DFA is another matter.) If we acknowledge Seago's Dionysian perspective (in actuality he appears to conflate perspectives associated with Hermes, Aphrodite and Dionysus) we do so in the knowledge that a doctoral degree is both a qualification awarded to an individual and, simultaneously, a potentially problematic gatekeeping exercise. In this second respect the use of the conventional doctoral system, as it increasingly operates as a condition of employment for artists in higher education, discriminates against any artist/researcher whose poetics contests the traditional university's authoritative fantasy about itself. (Ironically enough, used in this way it diminishes the university's capacity for reflexive, ongoing self-understanding, the very capacity upon which its own claim to legitimate authority as a system of education largely depends.)

Seago's argument assumes a position of objectivity regarding research practices, but fails to acknowledge its own enactment of the traditional university's fantasy of itself, one in my view at variance with our richer, more complex and ambivalent experience of the university as a contemporary institution. This assumption is problematic precisely because, as Hillman reminds us: 'the appeal to normality conceals a defence against other archetypal enactments which then must perforce be judged abnormal'.[13] From such a normative perspective, any privileging of imagination, and in particular of imagination's own forms of authority, will tend to be seen as 'abnormal – as anti-academic, irrational, shady, quasi-mystical, or messianic',[14] a departure from all that the university assumes itself to represent. It is in this context that we might understand the claim that 'to the extent that a particular way of producing knowledge is dominant, all other claims will be judged with reference to it. In the extreme case, nothing recognisable as knowledge can be produced outside of the socially dominant form'.[15] This statement neatly locates the larger wager at stake in the issue of creative practice research at doctoral level.

The account above offers a snapshot of the composite authoritative fantasy that governs the university's traditional self-image, along with some of its implications for the future of types of art practice. It can also suggest how artists/academics, whose own practice privileges poetic or interpretative over rationalist approaches to knowledge, are able to function productively in what might otherwise appear to be a hostile environment. It seems that they learn to recognise the different divinities at play in the system, to play the proper role appropriate to each without cynicism, discovering which must be served when and how best to honour or placate them. To fulfil both their obligations and their particular calling, they avoid identifying with any one divinity and instead become polytheists.

This suggests that, if a creative practice doctoral degree is the rite of passage for an artist who wishes to teach within the academy, then the regulations that govern its production should allow for a poetic hybridity supportive of a reflexive polytheism, one sufficiently fluid and open to allow students to honour and move between the various authorities (academic and otherwise) they need to honour. We need a polytheistic, reflexive and hybrid framework for creative practice research, one that does not subordinate poetic values associated with Dionysus, Aphrodite and Hermes to the dominant interests of Zeus, Apollo, Athene and Hestia. (Would such an approach turn out to be closer in spirit to that of the old polytechnics?) To gain acceptance for such a framework, we must continue to question the interweaving of normative and objective thinking, one blind to its own archetypal perspective and so unable to acknowledge that the dominant fantasy it enacts is but one among many.

The ethical and educational dimensions of this argument can be derived from a position identified by Geraldine Finn, who asks that we always remember that 'the contingent and changing concrete world always exceeds the ideal categories of thought within which we attempt to express or contain it'.[16] I understand this as supporting the view that creative practice research must be located in relation to a perspective that both exceeds and falls short of the dominant constructions of knowledge, codified by the university, upon which its authority rests. It follows that, as researchers *and* educators employed by the university, who may variously define themselves as artists, scholars, managers, researchers, administrators or, almost certainly, some compound of those categories, we are as educators paradoxically also required to be 'always both more and less than the categories which name and divide us'.[17]

As I have argued elsewhere, this requires that as artists/academics we work between an assumption of the adequacy of professional mastery (and of the legitimate professional authority that mastery bestows) and an open acknowledgement of our 'inevitable inadequacy' in the face of 'the contingent and changing concrete world', one that always exceeds our attempts to gain a categorical command over it.[18] The particular wager to which my title refers, an extension of that proposed by Ricoeur, asks to what extent we allow ourselves as artist/educators to give up the authority of professional mastery in order to inhabit what Finn refers to as 'the space of becoming . . . the *space between* experience and expression, reality and representation, existence and essence: the concrete fertile pre-thematic and an-archic space *where we actually live*'.[19]

A space we must share with our students in order to act as educators as well as teachers of knowledge already mastered. This also requires that we maintain our own relationship with the authority of the university seen as guardian of 'categories which render us knowable and/or already known'.[20] This, as I will show in relation to the

work of Janet Wolff, requires a polytheistic pedagogy oriented by the figure of the *bricoleur* and thus an approach to creative practice research appropriate to our lived experience as hybrid – as, at the very least, artists, educators and scholars.

I will now turn to ways in which arguments representative of the dominant complex can exclude, for example, the radical, carnival energy of Dionysus, the delight in the aesthetic of Aphrodite and the *metis* or intuitive intelligence of Hermes. In 1996 Christopher Frayling, developing an earlier paper, argued for a radical separatism by claiming that 'we need a definition of fine art within the academy . . . which is conceptually different from what everyone else is doing outside'.[21] Given the degree to which the arts have been suffering from over-commercialisation and the addictive careerism, delusions of grandeur and rampant personalism of the artist-as-celebrity, this desire for a degree of critical distance would appear entirely appropriate.

However, the image of the ideal artist/academic Frayling proposes is that of a surgeon – significantly the hero figure of Apollonian, scientific medicine – working in a teaching hospital. The artist/academic is envisaged as someone 'doing their work as best they can in the light of the latest developments, dependence on established bodies of knowledge and passing on that body of knowledge', while at the same time contributing to those developments as a researcher.[22] This image implicitly but authoritatively precludes the opportunistic playfulness of Hermetic imagination, Aphroditian delight in the sensuous wonder of appearances, or Dionysian re-evaluation of inferiority, vulnerability and weakness. However, Frayling's image separates the sober, responsible work of the academy from a polyglot, fanciful artworld preoccupied with professionalism and glitz and uninterested in academic research, the dissemination of new knowledge or teaching only by denying important poetic modes of creative practice research. There is no sense that aspiring artists/academics might also need to locate themselves reflexively in relation to the archetypal culture of the university, precisely in a space between perspectives, and simultaneously within and outside the university.

My objections to this radical separatism should by now be clear. Given that the university sector has a monopoly on art teaching in higher education, it is counterproductive to require artists who aspire to teach there to undergo a schooling that denies the poetic by treating doctoral research as primarily a 'research training . . . an apprenticeship in research thinking and in learning to use particular research philosophies, approaches and techniques under the direction of experienced research supervisors'.[23] Implicit in this traditional approach is the belief that research involves sitting at the feet of a master who alone has the authority to determine what is or is not worth knowing without, however, addressing either the educational or epistemological issues raised by this assumption. This approach perpetuates an Enlightenment tradition, now seriously in question, in which intellectuals are seen to constitute knowledge as power and to establish 'a privileged, foolproof access to right knowledge as the legitimation of the right to tell others, deprived of such an access, what to do, how to behave, what ends to pursue and by what means'.[24] While various attempts have been made to avoid this approach – in which what is relevant as new knowledge in relation to research degrees is ultimately determined by major stakeholders in existing epistemological and research models upon which their personal status finally depends – there is as yet no consensus as to a generally accepted alternative.

While Frayling's argument proceeded on the basis of a common-sense adaptation of Herbert Read's educational writing on art in the 1930s, Sally Morgan has established a wider historical context in which to consider the creative research PhD, one that explicitly identifies the culture of academic contempt for the arts, which is, she suggests, still a factor in debates about creative practice research. She also provides perhaps the most clearly articulated refutation of aspects of Frayling's argument, via her analysis of a statement by an unnamed director of research who, in an extreme version of Frayling's own position on the expressive tradition, champions the theory associated with the academic doctorate on one hand over art identified as spontaneous outpouring on the other. Working through both historical and philosophic positions Morgan, in an argument that draws on Ricoeur, Dewey and Croce, argues that art practice generates texts that are seen as inseparable from thought and theory, constituting 'the place where the material of reflection is incorporated into objects as their meaning.'[25] This leads her to adopt the view that 'a substantial one-person show, accompanied by a viva, adds up to the same thing as a published dissertation plus viva.'[26]

Countering Frayling's radical, Apollonian separatism, Morgan proposes an alternative approach where a professional discourse around visuality, broadly understood, is situated in relation to other approaches to *text* more generally practised in the university. Morgan's insistence that the work of art be seen as a visual text, and on an equal footing with other texts, is in my view both well argued and, in a number of respects, a useful advance in terms of our thinking about the nature and status of creative practice research. However, like Seago, she too assumes an authority based on reasonableness that in my view obscures current problems associated with reading visual texts in the faction-ridden context of creative practice research. This assumption of consensus, signalled by her use of the authorial 'we fine artists', in turn masks diverse positions and areas of disagreement, as a brief analysis of a paper by Fiona Candlin demonstrates.

Like Morgan, Candlin works from a historical position but, rather than seeing the development of creative practice research in terms of a long, rich and intellectually diverse debate within cultural histories and practices, Candlin bases her argument entirely on what she sees as the recent overcoming of earlier deficiencies in art education. These have, she suggests, been corrected by the rigorous application of 'social art history, conceptual art, feminist theory and post-structuralism', all deployed as a means to 'deconstruct the silent ideologies of modernism'.[27] While apparently acknowledging that the 'university or art college system is not univocal', it is clear that she regards the practice-based PhD as valid only when it has 'some adversarial potential against the staunch defenders of the purity of art against social histories', those who 'dread the contamination of the visual by the verbal'.[28] While her argument in certain respects follows a similar trajectory to that underpinning Morgan's position, her insistence that the only legitimate creative practice research is inseparable for a particular adversarial potential in relation to certain ideologies clearly undermines Morgan's assumption of any consensus among 'we artists/academics'.

There are I think two reasons why Candlin's approach is inappropriate in the context of a polytheistic approach to creative practice research. The first is that historically speaking, any reduction of the five or six often antipathetic movements sometimes collectively referred to as *early* modernism – and by implication the teaching styles

they initiated – to a monolithic, homogenous, *bad* past is historically dubious (not least because it appears to take at face value the reductive, Greenbergian definition of modernism it seeks to oppose). The second is that any such monolithic reading of the (bad, modernist) past reduces to a single bad, voice all those other histories, which might seek to differentiate themselves from it, which are thus effectively silenced. Such a position, in my understanding, contradicts the lessons of both feminism and post structuralism from which Candlin claims to derive authority. My concern, however, is less with the internal contradictions of her position than the way in which it seeks to claim a monolithic, univocal authority, similar to Morgan's 'we artists', in the face of the diversity of practices and ways of thinking within contemporary art practice. Candlin's argument supports another form of academic gatekeeping, typically articulated in terms of a politically progressive coalition, which ultimately replicates the repressive authoritarianism of the high modernist ideology she opposes.

In contrast to the authors mentioned above, I see Katy Macleod and Lin Holdridge as adopting what I would characterise as a polytheistic position, one that allows researchers to see through (in both senses of that phrase) particular archetypal perspectives. They do so by insisting that it is the 'material positioning of the artist as the subject of his/her own inquiry, as well as subject to semantic systems of social signification', that are central to creative practice research.[29] For this reason, and following Geraldine Finn, I would concur with their claim that 'we can now properly conceive of enacted thinking as having the *potential* to be both academically *and* culturally transformative' (emphasis added).[30] However, there is, as they point out, a substantive risk or wager involved in attempting to realise that potential. This is best identified in terms of their insistence that ambiguity, anathema to conventional doctoral thinking, is

> entirely appropriate to art practice research, where there is, as Eagleton asserts for poetry, an *internal communication*: a poem can only be re-read because of its *condensed systems of communication contain tensions, parallelisms, repetitions and oppositions* which continually modify each other.[31]

This insistence on the centrality of poetic ambiguity, and on the hybrid interweaving of 'condensed systems of communication' involved in creating a space between, and always subject to interpretation, is fundamental to any genuinely creative practice research. It allows the mirroring of the complexity of our lived experience as both within and outside the realm of authority belonging to academic knowledge and consequently, promotes a polytheistic understanding more appropriate to the complexity of our lived experience.

For Macleod and Holdridge it would appear that the risk involved in this approach appears on two levels. The first, inseparable from poetic ambiguity, lies in the interrelated demands faced by both candidate and supervisor/examiner. In the case of the artist/researcher this is focused by the unknowingness that exists prior to completion, due to the '*a posteriori* nature of art knowledge' where the enactment of visual thinking in 'live time' is 'revealed and understood only at the moment of the Viva, when the examiner/viewer interacts with the *alaetheic* quality and power of the artist/researcher's visual thinking.'[32] For the supervisor the demand lies in the problem of reading: the encounter with visual thinking itself, an understanding I take to be congruent with that I derive from Ricoeur.[33] At a second level, and as an extension of these

demands, there is the ethical event of their meeting as subjects; a meeting that exceeds the context of institutional regulation under which they officially come face to face. Jim Mooney addresses this second level in his discussion of the foundational event of ethics as understood by Lévinas in relation to painting.[34]

Between Carterhaugh and Tamshiel Rig: a borderline episode: occupying a 'space between'

At this point, I want to turn to the practical issue of effecting change within the doctoral culture. We will best effect such change not through argument in committee but by challenging and extending those existing academic models most hospitable to creative practice research.

Janet Wolff's 'Eddie Cochran, Donna Anna and the Dark Sister: Personal Experience and Cultural History' is apparently focused by two related academic concerns,[35] 'the role of culture in the formation of identity' and 'the memoir as cultural history', seen as a means of 'using the personal and subjective as access to social phenomena'.[36] However, at the heart of the chapter are three cultural images or moments drawn from personal experience of music.[37] Around these images Wolff orchestrates a meeting of theory, social history and particular personal experience that allows her to reflect on 'a way of doing cultural studies'.[38] What is striking is the way in which every aspect of the chapter – which she describes as 'cultural *bricolage*' – contributes to demonstrating 'the ways in which we use bits of culture in the incessant production of self'.[39]

For reasons set out above, I share Wolff's view that we need to deploy a 'necessarily *eclectic* use of theory' as a means to avoid the 'level of philosophical abstraction' that, while ensuring 'theoretical purity', does not enable the artist to resist 'the distortions of theoretical orthodoxy' that inevitably arise when such orthodoxy is applied to creative practice. Following Wolff, I too would advocate a 'dual eclecticism'; the use of those theories that seem to work when exploring the formation of art and identity as a means to engage with the 'bricolage of cultural events and moments through which the experience of culture is mediated and in which it is encapsulated'.[40]

Creative practice research at doctoral level will, in my view, almost always involve producing a written text. To load the whole weight of doctoral examination onto exhibition and viva – as Morgan argues we might legitimately do – will normally place too great a burden of interpretation on examiners and too great an emphasis on getting it right on the day on the candidate. Given the arguments set out by Macleod and Holdridge, what then is an appropriate form of writing in this context? Following James Elkins, I would argue that dominant modes of interaction with visual images – conventional psychoanalysis, semiotics and gender studies – are often repressive in so far as they prevent us 'from coming to terms with what we are, what kind of writing we are producing, and how we spend our lives'.[41] As David Maclagan has recognised, Elkins' challenge to his fellow art historians can also be read as a call for a major revision of the function of 'analytical, critical or academic writing in relation to all our dealing with aesthetic experience in its broadest sense, a claim clearly relevant to the issues addressed.'[42] Wolff's chapter offers a model on which such a revision might draw, one I have been engaged with since 1999, when I began a project which became a book, entitled *Between Carterhaugh and Tamshiel Rig: a borderline episode*.[43]

In May 2003 the AHRC awarded the project the required funding on the basis of a proposal from which the information in the following two paragraphs is abstracted:

Research context

The project draws on a number of different contexts. Practically speaking, it draws on my experience as an artist working with issues of memory, place and identity through the production of artist's books, and on related visual material already exhibited. Philosophically, the project is underpinned by a reading of Paul Ricoeur's concept of 'narrative identity' and by the work of a number of feminist writers, in particular Janet Wolff and Geraldine Finn. A key reference has been Wolff's 'Eddie Cochran, Donna Anna and the Dark Sister: Personal Experience and History' in Resident Alien, Polity Press 1995.

Research methods

Methodological context

The project for which funding is being requested is the central aspect of a larger project, one that explores the relationship between memory, place and identity using analogies between Tam Lin and the particular Borders landscape in the parish of Southdean as its starting point. This larger project has involved traditional research methodologies; a literature search, background reading on core topics, fieldwork, documentation, etc., with creative writing and the production of a wide range of visual images. What is distinct in relation to this aspect of the project is the concrete interweaving of various forms of writing and visual reflections, creating a complex representation of the relationship between memory, place and identity. The roles of history, imagination, dream, of specialist knowledge, practical exploration and personal memory (evoked by song and place) in the process of constructing and reconstructing identity will be explored by deliberately blurring the boundaries which conventionally separate literature, visual poetics and academic scholarship and analysis.

The nature and aims of this project are, I hope, largely self-explanatory in relation to my concerns here. The outcome of the project, a hybrid created by crossing the book as artwork with the academic thesis, is intended both to mimic and reflect on a sense of self that crosses and recrosses borderlines between socially constructed and unique aspects of contemporary identity from the position of an artist/academic. The book takes Wolff's chapter as one starting point, drawing in particular on her use of music as a bridge between personal and social history. It differs from Wolff's model, however, in one fundamental respect. Rather than using cultural images or moments – often reconstructed with a degree of poetic licence – as a basis for a fragmentary cultural history made the subject of reflection and critique, it constructs a hybrid narrative that deliberately puts in question its own academic authority, while still remaining in close dialogue with scholarly research, argument and critical reflection. The wager here focuses on letting go of the authority vested in theory, however eclectic, which underpins Wolff's work as cultural criticism. My concern in reversing her strategy has

been to create a text in which the academic elements defer to a poetic authority that does not, however, merely render them subservient (as would be the case in, for example, an historical novel). What is in question is both the appropriateness of the project's poetics – its self-reflexive *bricolage* of events, voices, history, imagination, dream, specialist knowledge, images, practical exploration and personal memory – to its topic, and the text's ability to successfully occupy a space between that will 'capture or unveil a meaning which until then had never been objectified.'[44] Succeed, in terms of providing the reader with new knowledge in Ricoeur's sense, will depend on the degree to which the book provokes readers' engagement in the transformative work of self-interpretation in relation to the broader culture in which they live. This returns us, via Hillman's reading of Aphrodite's *aesthesis*, 'where judgements are heartfelt responses, not merely critical mental reflections',[45] to Nietzsche's concern with thinking with our feelings as an aid to becoming poets of our own lives. It may be we should look to John Llewelyn in *The HypoCritical Imagination* to understanding why philosophical meditation – the privileged activity that, it is claimed, gives authority to the traditional PhD – is inadequate in the face of our most pressing questions and, in consequence, why the *HypoCritical Imagination* and its 'stupidity' – both 'more and less than conceptual Critique' – offers us another kind of understanding from which to rethink creative practice research.[46] Alternatively, wearied by the weight of exclusive abstract argument, we might return to those forms of hybrid creative practice research which give us authoritative, poetic works of art.

Notes

1 Davis, Martin L. (2002) 'Talking about Art', in J. Swift and J. Swift (eds) *Disciplines, Fields and Change in Art Education. Volume 4: Soundings and Reflections*. Birmingham: ARTicle Press, pp. 108–9.
2 Ricoeur, P. (1991) *From Text to Action: Essays in Hermeneutics II*. Trans. K. Blarney and J. Thompson. London: Athlone, p. 88.
3 Ibid.
4 Simms, K. (2003) *Paul Ricoeur*. London: Routledge, pp. 73–4.
5 Ricoeur, P. (1996) 'Reflections for a New Ethos in Europe', in Richard Kearney (ed.) *Paul Ricoeur: The Hermeneutics of Action*. London: Sage, pp. 3–13.
6 Gibbons, M., Limoges, C., Nowotny, H., Schwartsman, S., Scott, P. and Trow, M. (1994) *The New Production of Knowledge: The Dynamics of Science and Research in Contemporary Societies*. London: Sage, p. 2.
7 Seago, A. (1994–5) 'Research Methods for MPhil and PhD Students in Art and Design: Contrasts and Conflicts', *Royal College of Art Research Papers* 1(3). London: RCA.
8 Paris, G. (1990) *Pagan Grace*. New York: Spring, pp. 49–50.
9 Seago, 'Research Methods', p. 5.
10 Ibid.
11 Hillman, James (1980) 'On the Necessity of Abnormal Psychology: Ananke and Athene', in Hillman (ed.) *Facing the Gods*. New York: Spring, p. 28.
12 Ibid. p. 12.
13 Ibid. p. 32.
14 Seago, 'Research Methods', p. 2.
15 Gibbons et al. (1994), pp. 1–2.
16 Finn, G. (1992) 'The Politics of Spirituality: The Spirituality of Politics', in P. Berry and A. Wernick (eds) *Shadow of Spirit: Postmodernism and Religion*. London: Routledge, p. 113.
17 Ibid. p. 113.

18 Biggs, I. (1994) 'Peripheral Vision', in N. de Ville and S. Foster (eds) *The Artist and the Academy: Issues in Fine Art Education and the Wider Cultural Context*. Southampton: John Hansard Gallery, pp. 127–8.
19 Finn, 'Polities of Spirituality', pp. 112–13.
20 Ibid.
21 Frayling, Christopher (1996) 'Nourishing the Academy', *Drawing Fire* 1(3): 116–22.
22 Ibid.
23 Van der Lem, Paul (1996) 'PhD or DFA: Measuring Research in Fine Art', *Drawing Fire* 1(3): 23–5.
24 Bauman, Z. (1992) *Intimations of Postmodernity*. London: Routledge, p. 9.
25 Morgan, S. (2001) 'A Terminal Degree: Fine Art and the PhD', *Journal of Visual Art Practice* 1(1): 6–15.
26 Ibid. p. 15.
27 Candlin, F. (2001) 'A Dual Inheritance: The Politics of Educational Reform and PhDs in Art and Design', *International Journal of Art and Design Education* 20(3): 306.
28 Ibid.
29 Macleod, K. and Holdridge, L. (2002) 'The Enactment of Thinking: Creative Practice Research Degrees', in K. Macleod and L. Holdridge (guest eds) *Journal of Visual Art Practice* 2(1–2): 5–11.
30 Ibid. p. 6.
31 Ibid. p. 8.
32 Ibid. p. 7.
33 Kearney (1996), p. 9.
34 Mooney, J. (2002) 'Painting: Poignancy and Ethics', *Journal of Visual Art Practice* 2(1–2): 57–63.
35 Wolff, J. (1995) 'Eddie Cochran, Donna Anna and the Dark Sister: Personal Experience and Cultural History', in Wolff, *Resident Alien: Feminist Cultural Criticism*. Cambridge: Polity Press.
36 Ibid.
37 Ibid. p. 28.
38 Ibid. p. 29.
39 Ibid. p. 32.
40 Ibid. p. 35.
41 Elkins, James (1997) *Our Beautiful, Dry, and Distant Texts*. University Park, PA: Pennsylvania State University Press, p. xvii.
42 Maclagan, David (2001) *Psychological Aesthetics: Painting, Feeling and Making Sense*. London and Philadelphia, PA: Jessica Kingsley, p. 111.
43 Biggs, Iain (ed.) (2004) *Between Carterhaugh and Tamshiel Rig: a borderline episode*. Bristol: Wild Conversation Press.
44 Macleod and Holdridge (2002), p. 10.
45 Hillman, James (1981) *The Thought of the Heart*. New York: Spring, p. 34.
46 Llewelyn, J. (2000) *The HypoCritical Imagination: Between Kant and Lévinas*. London: Routledge, pp. 196, 203–4, 233.

Chapter 14

The gesture of writing

Kerstin Mey

Language: forest with all roots/audible.

<div align="right">Hélène Cixous[1]</div>

We must imagine a way in which to teach [. . .] both the poem and the theorem.

<div align="right">Michel Serres[2]</div>

Chance favours only the prepared mind.

<div align="right">Louis Pasteur[3]</div>

Hélène Cixous likens language to a forest in all its richness and diversity: roots and undergrowth, tree trunks, crowns and foliage; shrubs, ferns and flowers.[4] Flora and fauna create a dense and layered, awe-inspiring and uncanny topography. Images by Casper David Friedrich and Thomas Cole may spring to mind, or the imaginative paintings by Henry Rousseau. The rooted forest is a complex and multidimensional place constituted through a subtle yet resilient balance of interdependencies, symbiotic and parasitic relationships and cross-fertilisations; a biotope in a dynamic process of constant change, of becoming, regeneration and decay. Its distinct cycle of vegetation is shaped by, adapts to and moulds the environment in which it is situated and with which it interacts. Yet, after all, the forest is by no means wild and untouched by wo-man, but a product of culture, legislation and power, a locus of myths and identity. And so is language.

Through the syntactical positioning of the audible in the elliptic statement, Cixous emphasises the sonorous character of the forest. In other words, she points to the sonic elements of language, to that which lies outside of the sense of vision. This is an important aspect to note in so far as the visual has been increasingly privileged in Western culture since the Renaissance, as manifested for instance in the dominance of reading and writing over speaking and listening in the discourses of power and in the production of knowledge. Metaphorically, language is being equated with the nuanced polyphony of sounds and subtlety of noises through which the forest communicates its richness to the attentive, tuned-in listener. The analogy highlights the phonetic and audible dimension of human language and thus alludes to the oral tradition as a resource of representation, which precedes the evolution of written symbols by a long time. Yet, the sound of speech and written language has always been kept in touch through the alphabet, which functions as some sort of transcription system (there is a different case for character-based languages such as Chinese).

> The alphabet focuses its users on language as sound: in one of its guises (and probably, historically, its early use) the alphabet represents sound. Users of the alphabet therefore tend to think of language first and foremost as a system of sounds.[5]

Text messaging as one of the most popular forms of current mobile communication repronounces and reshapes that link between sound, morpheme and syllable. Cixous's metaphor of language as forest speaks *of* the intricately woven and weathered, gauzy yet systemic growth of *langue* – not a wilderness but a cultivated, textured and rooted structure. It points to the accumulated layers of linguistic history, social conventions and strata of power, innovation and transformation, decline and renewal.

This chapter seeks to draw out some thoughts on the function and the forms of writing in relation to art practice within the institutional structure and the curriculum of art education at tertiary level. It brings together critical insights into writing (on art), subject-specific benchmarking and the perspectives of both art students and teachers in order to develop a cultural and pedagogic argument for the rethinking of current places and practices of writing and its contribution to the establishment of art as a higher order thinking within current academic structures and discourses. Motivated by the aim to promote advanced and integrated models of teaching and learning, which build on current cultural practices and adhere to professional requirements and promote academic standards, the chapter considers a number of issues to bring into the twenty-first century critical writing which reflects on the making of art and its contexts. Their aim is to be relevant to students' own experience and educational expectations and in tune with their literacy practices, their ways of thinking and communicating.

My own experience of teaching art history and theory within fine-art-led programmes at both undergraduate and postgraduate level in art school settings has shaped my awareness for the contested position that text-based practices still occupy. Within the broader territory of textual inquiries I will concentrate on those areas which could in general terms be described as reflection on practice, where the concerns of creative practice, theoretical speculation, wider contextual issues and historical circumstances are closely interlinked. Whether object-based or process-driven, art critically or philosophically motivated, the specific quality of such a reflection-in-action resides in the focus on the instrumental problems of practice, on the material and conceptual processes that constitute the production of art and its outcomes. That is not to say, that the written reflection on aesthetic production and processes fulfils a purely utilitarian purpose promoting and furthering the creative practice-based undertaking. Rather, writing on art needs to be understood as a practice in its own right, which articulates a specific relationship between learning as situated understanding, knowledge-in-action and reflective thought.

How is the writing on art institutionally framed at present and where is it positioned within the academic discipline(s)? The carefully phrased subject benchmark statement for art and design identifies in its introduction key experiences students gain by completing the programme.[6] While art (and design) education aims primarily at the development of visual literacy based on a range of discipline-specific and technical skills and abilities such as drawing, composition and conceptual/divergent thinking, critical writing is considered an important instrument through which students acquire

and communicate contextual insights and self-critical awareness. It necessitates distance from and an engagement with the object written about and develops skills in transforming complex responses to the visual work or process into a communicable (and durable) form. The subject benchmark emphasises that an understanding of the context of creative practice is essential to ensure that the outcomes of the study and practice of art and design contribute to both the cultural development and the economic well-being of the individual and society.[7] Contextual studies, in which the practices of writing on art are commonly embedded, and which can be considered broadly congruent with the domains of history or theory of art (and design) or visual culture, serves a twofold purpose: they enhance students' intellect through critical awareness and provide knowledge regarding the position of individual practice in relation to the practices of others, which is the cornerstone of originality and personal expression.[8] The modernist slant of this statement aside, the subject benchmarking not only appears to recognise the ongoing revision of the academic disciplines of art and design under the influence of shifting societal trends and interests, and cultural attitudes, but also emphasises that contemporary art practice itself demands the ability on the part of the artist to position the individual's practice within an appropriate critical discourse and contextual framework.[9]

However, the contemporary cultural situation has provoked a noticeable shift in terms of engagement of prospective art and design practitioners in the 'historical, theoretical and critical dimension of their discipline(s)',[10] and in the positioning of this endeavour within the overall programme of study. In the past, it was considered vital that students attain a knowledge of the history of their discipline. This component was frequently taught and assessed as a separate subject. Quite a number of art and design undergraduate programmes still pursue this approach, as manifest in a distinct module for art history and/or theory, and expressed by a weighting between them of commonly 80 to 20 per cent.[11] Although 'other contextual and theoretical concerns and approaches have come to supplement or supersede an exclusively historical concern and aim to foster an integration of practice and theory/history',[12] this has not necessarily been translated into a revised course or modular structures and appropriate and effective assessment formats. Contextual studies remain in many instances a discrete complementary domain of inquiry and debate widely assessed by essay and at degree level by dissertation.[13] In other words, the general situation of art education is ambivalent at present, to say the least. On the one hand, we find ourselves in a situation where the debate and commentary on current art and visual practices still struggle to be recognised as a wholesome academic endeavour. On the other hand, higher learning remains largely a text- and symbol-based curriculum.

In their introduction to *Practices of Looking*, Marita Sturken and Lisa Cartwright pronounce that visual culture should be understood in an analytical way and not only by art historians and other image specialists, but by

> all of us who increasingly encounter a startling array of images in our daily lives. At the same time, many theorists of visual culture have argued that foregrounding the visual in visual culture does not mean separating images from writing, speech, language, or other modes of representation and experience. Images are often integrated with words, as in much contemporary art and in the history of advertising.[14]

However, although the image was always present, a renewed emergence of the image in the domain of public communication as a full means of representing ideas, knowledge and information can be observed. The increasing prevalence of images will have profound effects on writing. The major one among these effects derives from 'the functional specialisation of modes', as Kress calls it.

> If two modes – say, image and writing – are available and are being used for representing and communicating, it is most likely that they will be used for distinct purposes: each will be used for that which does it best and is therefore best used for. Two consequences arise: one, each mode carries only a part of the informational 'load'; no mode fully carries all the meaning. Two, each of the modes will be used for specialised tasks, the tasks which are best done with that mode. As a consequence, writing is no longer a full carrier either of all the meaning, or all types of meaning.[15]

On the other hand, processes of digitisation have blurred and eroded traditional media boundaries and generic practices and paved the way for hybrid modes of meaning making.[16]

Digital literacy practices, that is, modes of producing meaning, based on electronic technology and in particular digital media, potentially engage with a multiplicity of channels. They work across and integrate a diversity of significant modes of representation, such as text, image, sound, space and body language. Digital literacies are multimodal, intermedial, hybrid and dynamic. In other words, new electronic technologies are changing the way we think and live, produce and consume, communicate and know. They potentially alter knowledge parameters, how we acquire and use information, how we gain an understanding of the world around us, how we access and experience culture including art, how we express and share our creativity.

The ubiquity of the computer screen has led to 'cinematic ways of seeing the world, structuring time, of narrating a story, and linking one experience to the next'.[17] Moreover, computer-generated databases provide a 'new symbolic form' of the digital age:[18] 'a new way to structure our experience of ourselves and of the world'.[19] In other words, the world on paper looks different from the world on (computer) screen and unfolds differently from the world online. In a contemporary culture which is increasingly permeated by and saturated with images; images that support a multitude of purposes and a variety of effects, there is a growing fascination with and investment of power in images, fluid images empowered to move across and in-between different cultural and social domains.

In the age of digitisation, intermedia, hypermedia and of dissolving genres, we are witnessing and becoming accustomed to an incredible cross-referencing of scopic regimes and cross-fertilisation of visual imageries. This situation of visualisation and a remediation of traditional media through new media – the typewriter through the computer for instance – leads to tangible ambiguities and conflicts vis-à-vis existing institutional practices, sedimentations, hierarchies and canons. The contestation and erosion of forms of public (authoritative) and formats of expression may in turn effect changes in institutional discursive spaces, structures and conventions. Determined reading conventions and arrangements of knowledge seem to disappear in the open, modular, hyperlink-networked and flowing space of the Web, where every (visual,

textual, audible and spatial) information can be quickly accessed and downloaded from its database pool.

Within the framework of tertiary art education, the articulation of a critical understanding of speculative or conjectural ideas and insights in written form has been confined to a limited range of standard formats of formal discourse: mainly the essay or extended essay, and the dissertation. The dissertation, which is commonly rather rigidly defined by an academic template that exists within the sciences, or the (extended) essay accompany and complement a body of visual/creative work presented for the first academic degree examination. While a weak dissertation or essay may be compensatable through excellence in the practice-based component, the reverse is usually prevented due to the weighting between the practice and theory assessment elements. The standard formats of writing in art education share their association with traditional academic inquiry and learning, and corresponding systematised bodies of knowledge and appreciative systems. The discussion of those forms of written utterances addresses conceptual and methodological issues, pragmatic aspects such as the target audience, and respective matters of style and presentation in the age of new media. It asks what it means to write critically about creative aesthetic strategies and processes in the age of digital information and communication technologies.

Written reflection on art presupposes and develops a range of generic as well as personal and transferable skills. It contributes to the generation of subject specific and generic knowledge. Therefore it is worth undertaking two excursions: the first one looks at writing as a gesture, a cultural product and as part of the production of culture. The second one discusses the discursive and epistemological function of the essay within the academic context.

Excursion one: the gesture of writing

Vilém Flusser in his seminal text 'Die Geste des Schreibens' engages with the process of mark-making as a specific human activity.[20] His point of departure is the concrete individual phenomenon, which he considers in an extemporal manner before he sketches out its historical embeddedness and significance. Writing as a specific form of mark making constitutes a gesture. Gestures can be thought of as symbolic movements of the body through which human beings connect and are being connected consciously with others. They are codified and conventionalised expressions of freedom. Codification lends gesture meaning. A gesture articulates or expresses what they represent symbolically. In other words, writing is a resource of representation, of meaning making. It is based on engraving structures into a surface – writing literally means inscription and thus is regarded as an *eindringende* (invasive, penetrating) as much as an *eindringliche* (insistent) gesture. It is marked by heterogeneity in term of levels of reality, in that writing occurs when surface (paper), a writing tool (pen), signs (letters or characters), conventions (meaning of groups of letters – lexemes – or characters) and linguistic signification meet with a message or an idea. Writing unfolds on a page.

Flusser considers the linearity of writing as the product of a historical accident, which has come to literally inform an entire dimension of our being in the world. The mechanised tools of writing – the typewriter – brings to the fore the gesture of writing as it hammers the signs on the paper surface and achieves a higher degree of penetration of the surface. Writing in Flusser's terms is a phenomenologisation of thinking.

He speculates that the keyboard of the word processor intensifies this phenomeno-logisation of thinking even further in that one sees what one thinks and how one thinks. Introspections allow the writer to break open the ideological term of thinking and makes it more precise. She who writes expresses – relieves an internal pressure by exerting pressure externally (on the pen, on the keys of the typewriter or the word processor). Flusser is interested in the internal layers that had to be penetrated, and the obstacles and resistances that had to be overcome in order to surface as pressure on the keys to express, translate and thus transform a hidden virtuality into materiality. (Before the evolution of writing this virtuality might have been expressed as music, painting or orally.)[21]

Writing puts a resistance against words, words that are stored in one's memory. In order to select the words that fit the virtuality of one's thought, one needs or wants to express, one has to listen to words. Each language has its own atmosphere, it is a biotope, a cultural universe in itself. We are governed and culturally and socially programmed by a language, by moving in a language or across several.[22] Language means to give into the magic of words and yet to keep control over them. Language provides a home for being, a habitat. Moving from one language to another bears an analogy to moving from one habitation to another. This includes that during periods of prolonged or permanent absence from a linguistic habitat – even if it is the native one – the memory of how it may have functioned or what it looked liked, what atmosphere radiated from it, may fade (away). As Hélène Cixous puts it:

> When 'I' speak it is always at least 'we', the language and I in it, with it, and it in me who speak. To write is to have such pointy pricked-up ears that we hear what language says (to us) inside our own words at the very moment of enunciation.[23]

Flusser conceives of writing as the *sotto voce* of a whispered language and oneself. The dialectics between word and I, between what a word (with its memory of historical wisdom and custom) says and what I want to say changes when one speaks instead of writes.[24] There is a different resistance between word and their written or spoken utterance, a shift from one logic to another, and one's work starts only after the decision to write words rather than to utter them orally: *langue* and *parole* – the fixity or flux of rules and conventions; possibilities of play, intuition, chance and imagina-tion; considerations of projection, reach, immediacy, permanence and framing. There occurs a shift from the emphasis of the performative/pragmatic use of the voice: stress, pace, rhythm, pitch, intonation and accent, to the syntactic framing through word-order, embedding and the structural and emotive application of punctuation; from linear, sequential order of chains of discrete, simple clauses to the production of larger and more complex semantic units, which are syntactically and textually framed; from a high degree of redundancy and noise to a lower more condensed and conven-tionalised way of conveying information 'from sound in temporary sequence to graphic marks disposed in a linear-spatial order'.[25]

Writing does not fix thinking, it is a specific way of thinking that requires and relies on specific literacy competences. There is no thinking that is not articulated through a gesture. Thinking before articulation is only virtuality.[26] It is realised as and through gestures. The gesture of writing is a gesture of work that realises thoughts in the form of texts. Writing with its specific linearity and its inherent dialectics between word and

their meanings has been taking a special place among all other gestures of thinking. It is the official, the authoritative thinking of the occident. Occidental thinking happens through writing. Flusser considers writing as the beginning and end of history, or should one appropriately say *his-story*, since the thinking of an increasingly important elite is now being expressed in the programming of cybernetic databases and processors which have different structures compared to writing.[27] Writing is losing its status as privileged gesture and mode in which information/knowledge has been generated, communicated and stored. We are currently experiencing an epochal shift from linear thinking (based on writing) towards a new form of multidimensional (network) thinking embodied by digital imaging technologies. In reconnecting writing to its underlying historical and cultural conditions, Flusser concludes with a degree of melancholy, that writing not only has lost its privileged position in Western culture but also is becoming an archaic gesture. This paradigmatic shift has not just come into being through technological progress (digitisation and mediatisation in particular) but has been driven and empowered by the global operations of capital. The emergent modes and technologies of communication may make possible a telematic society, a society in which dialogue between people becomes of supreme value. The notion of *dia-logos*, as Flusser points out, is rooted in the original meaning of the Greek *logoi* – an exchange of values. The notion of dialogue entails a comparison of ordered models communicated in different codes. Dialogue results in the building up and modification of patterns and standards of thinking by which we attempt to approximate relative truth.[28] Yet, the new information and communication technologies and their techno-images may also pose an enormous and inevitable threat in that the autonomous and automised nature of those techno-images may envelope us totally[29] – a vision that has been so hauntingly expounded in the film trilogy *The Matrix*.

Excursion two: the discursive and epistemological function of the essay

The essay has its etymological roots in the Old French *essaier*, an attempt, a test or trial, an endeavour. The word evolved from the Late Latin *exagium* a weighing, from Latin agree to do, compel, influenced by *exigere* to investigate.[30] The essay came into being as a literary *non-genre*, as a sketch, a rough draft, a verbal and intellectual experiment. It was a category of writing that deliberately suspended rhetorical formality in favour of a personal monologue making no claims of authority and was famously employed by authors such as Montaigne and Bacon,[31] and later Rousseau and Nietzsche. The evolution of the essay can be historically linked to the secularisation of society and interconnected epistemological shifts through which language ceased to be the encyclopedia of all knowledge. When language became regarded as a set of signs only, representing a knowledge which exists outside it rather than being the source of knowledge, a replacement of rhetoric formula through transparent language production was required.[32] Originally, the essay was neither a deterministic game nor a set of verbal gestures, but deployed its powers freely.

> It is a discourse as discourse, discoursivity as such, textuality untrammeled by generic boundedness. Its objective is unintended . . . and undestined. An essay's unprogrammatic identity is freedom to sport negations, to disorient, to play, to

abnegate the self by constructing a voice out of ceaseless discourse the very drift of which is to disclose what becomes as its contradictions and diversities destroy what seems to be. The art of essay is liberationist artifice . . . the language of the essay mimes nothing but itself and aims at no superiority of value over its endless plain of discourse.[33]

The characteristics Snyder draws out for the essay as literary non-genre, conflict with the notion of essay-writing that has developed within the education system in Britain (and beyond) since the early nineteenth century, when the essay 'started to become the dominant form of English composition in school',[34] as it seemed to offer a 'perfect discursive space' because of its 'lack of formal and functional specification',[35] its detached stance and mildly reflective and argumentative intention – a fair, mediocratic expression of one's familiarity with a 'systematised body of knowledge', one's 'general level of intellectual culture' and even one's 'moral character'.[36] In the early twenty-first century, the essay still holds this position within the English curriculum and remains the default format for assessment of academic studies – ironically, a highly functional pedagogic tool. In fact, it has come to signify an array of students' writing that is being produced as part of their course requirements, in response to set questions or instructions. A guide for students to *Reading, Writing and Reasoning* defines the various purposes of the essay as follows:

> Some are intended to give students the opportunity to demonstrate how much they have learned about an area of study. Others are intended to find out how well they can think about a particular conceptual or practical problem. All offer the student the opportunity to show that he has read work relating to the topic and more importantly, that he can think, and has thought, about it . . . Essays may be grouped in different ways according to what they expect of students. One possible way of doing this is to categorise them as involving description, evaluation or comparison.[37]

Essay writing (as well as the dissertation) as assessment tool is saturated with contradictions. While the student is expected to demonstrate her autonomy as a thinker by generating original responses, fresh views and independent thought, she is equally required to conform to an academic code of practice, that is, to use an appropriate language and employ a conventionalised form of composition, to construct a balanced argument and to support it with evidence generated through sound research of primary and secondary sources.

> In learning to write in this way, students are drawn into a complex negotiation between individuality and authority, message and code, their own words and the words of others. That is they construct themselves as speaking subjects within the approved discourse of a cultural elite. The idea is that these two motives should coalesce, such that expressing one's individuality and affirming one's membership of the elite become effectively identical.[38]

In times of relative stability of economic and social power relations, notions of who the cultural elite is and what cultural forms of expression they employ are being considered equally stable. However,

[o]ur world, our lives, are being shaped by the conflicting trends of globalisation and identity. The information technology revolution, and the restructuring of capitalism, have induced a new form of society, the network society.[39]

The transformation of social relationships will affect the ownership and forms of cultural capital and power in an information society.

What consequences evolve from the loss of authoritative power of the gesture of writing in the production of knowledge in the context of the influence of other modes of producing meaning, as well as in connection with growing network power and increasing informality of much of public discourse, on the one hand and the tensions that grow from a narrow focus on overly rigid standardised formats of academic writing on art, from the perspective of an emphasis on individuality and divergent thinking in contemporary tertiary art education, on the other hand?

In structural terms, there is a pressing need to overcome the myopic perspective with which critical, historical and contextual knowledge, skills and understanding are being taught and assessed. The perpetuated misconceptions about written assignments, if not about writing in general, as a supplementary element of the art (and design) programmes, with which students enter art school, is being affirmed in many cases by the mapped out instrumental function of critical writing and its discursive territory and taxonomy. A whole-hearted rather than tokenistic integration of critical reasoning and philosophical reflection into the study of visual working practices, aesthetic strategies and conceptual horizons would support the creation of a more hospitable climate for discursive, linguistic practices instead of reinforcing anxious and hostile attitudes towards them. It would allow students to focus on the similarities of different resources and modes of making meaning/expression such as their cultural constructedness and the matrix of social power, their historicity and transcendent character, their communicative and epistemological function. The concept of hospitability also enables us to frame the limits of each resource and mode as openings that invite a mutually enriching dialogue for instance between and across image and text production; a dialogue that heightens awareness for the specificity of image and text from the perspective of the functional specialisation of modes.

An awareness of the dynamic functional specialisations of modes of meaning making would help to generate a deeper understanding that moves away from the tensions created by juxtaposing text and image. As digital media increasingly generate interwoven and less fixed representations of information, we need to build on students' own cultural literacies and enhance their ability to transcribe information from one or more symbolic media into other(s), and to synthesise them. The ability to transcribe, the principle of transcriptivity (*Transcriptivität*), as Lutz Jäger coins it, describes the 'cognitive level of telematic societies'. It 'will be measured by the extent to which transcriptive intelligence is being created as the potential to generate strategies for the semantic exploration of segments of the world through bringing-into-play different symbolic media'.[40] The intersection of the specific patterns, temporalities and spaces of the visual, textual and audible creates the conditions for a productive writing into practice and out of it, and thus enables a more adequate response to the network of images, texts, sounds, gestures, spaces etc. that make up our experience of an increasingly mediated and complex reality. Thus, a diversity of tools and spaces for reflection on practice which accommodate and promote the complex and precise articulation of ideas in terms of resources for producing meaning and modes needs to be explored

and experimented with beyond the standard format of academic writing: web design, video, CD-Rom, web-broadcast among others, blended and hybridised forms that combine text, still and moving images, sound, space and gesture into complex polydimensional performances of thought.

Methodically, know-how needs to be taught: applicable methods and instruments of thinking and its articulation. Students do not only need to acquire applicable knowledge and understanding of the codes, function and contextual framing of images in the broader cultural and social sphere: 'In the face of the rapid and profound global changes of communication and knowledge production students' thinking needs remediation as much as their writing'.[41] It has to be taken into account, that current and future generations of students are growing up with and being socialised in and through changing social and discursive power systems and mediascapes. These will affect the relationship of thought and language – internally and externally – and change the way they are going to interact with the material world.[42]

Students have to be acquainted – as a foundation for a highly developed and complex cultural literacy – with media critique as critical practice. At stake are those crucial insights on the fundamental influence of looking, reading, writing and listening practices on the shaping of our lives beyond the understanding of particular (audio-) visual images, texts and music. This must include a reconsideration of the pragmatic dimensions, the assumptions and projections of the speaking subject and the addressee that are inscribed in the various formats of academic discourse for learning, teaching and examination purposes, as the functional specialisation of modes stresses the audience as an essential pragmatic factor.

Where before all information was conveyed in writing, now there is a decision to be made: which information for which audience is best conveyed in image and which in writing.[43]

Or a combination of both or with other modes. Renewed consideration to the audience(s) and the forms of presentation is required. Are the essay or dissertation still the most appropriate forms to reflect on practice? Who reads them? Is there scope to modify the format towards a greater interaction between writing and image? Could critical awareness of the situatedness and contexts of individual creative practice be instilled, presented and assessed in other, perhaps more immediate, functional and/or dialogic formats such as the viva, workbooks, research reports and creative writing, multimedia presentations and critical discussions such as reviews of exhibitions, films and books, talks or papers for exhibition situations, etc.?

From a pragmatic perspective, if we want to confront and actively shape values rather than imposing them we have to create a dialogue, a dialogic space. The new and emergent telematic technologies and digital network structures (such as virtual learning environments or VLEs) offer a unique opportunity to create multidimensional and multilayered dialogues. It is our task to explore their affordances and potential and to make them productive for bringing together practice and theory through and in (enhanced) dialogic spaces. This is more than placing lecture notes into VLEs. It requires considerable pedagogic research, and instructional and interface design effort.

Didactically, to name but one of the issues, integration instead of separation between practice and theory, making and critical reflection, would assist in transforming students' external motivation for engaging in writing – to produce and pass an

assignment and thus obtain module credits and a degree – into an internal motivation that drives their learning through inquiry. It is along these lines that formative and summative assessment formats have to be critically rethought.[44] There is a perceived need to reassess the affordances and appropriateness of written formal discourse in terms of an instrumental reflection on practice and the development of students' articulateness and critical (self-)awareness not least with a professional/vocational perspective in mind. Considering the social and epistemological matrix of the essay and the dissertation, we have to ask to what extent they are productive as teaching and assessment tools by asking what knowledge and skills need to be assessed and how it can be effectively done. Can it remediate students' thinking and worldview effectively, or has it become an academic 'dinosaur'?

> Theory without practice is empty; practice without theory is blind. The ongoing challenge is to bring theory and practice together in such a way that we can theorise our practice and practise our theories. This has never been more important than in the moment of complexity. As we have discovered, emerging network culture is transforming the social, political, economic, and cultural fabric of life. The same information and telematic technologies responsible for a shift from an industrial to a post-industrial economy are bringing higher education to the tipping point where unpredictable change becomes unavoidable. While it is impossible to predict the precise rate and scope of these changes, there can be no doubt that in the near future colleges and universities will look very different than they do today.[45]

Art education institutions are ideally situated and equipped to respond creatively to the challenges that the current situation poses. It is time to radically rethink what we teach and how we teach it.

Notes

1 Cixous, Hélène and Calle-Gruber, Mirelle (1997) rootprints. London and New York: Routledge, p. 84.
2 Serres, Michel (1989) 'Literature and the Exact Sciences', *SubStance* 18(2): 34.
3 *The Oxford Minidictionary of Quotations* (1983) Oxford and New York: Oxford University Press, p. 265.
4 Cixous, Hélène and Calle-Gruber, Mirelle (1997) *rootprints*. London and New York: Routledge, p. 84.
5 Kress, Gunther (2003) *Literacy in the New Media Age*. London and New York: Routledge, p. 29.
6 Quality Assurance Agency for Higher Education (2002) *Subject Benchmark Statements Academic Standards – Art and Design*, www.qaa.ac.uk/crntwork/benchmark/phase2/artanddesign.htm
7 Ibid. p. 3.
8 Ibid. p. 3.
9 Ibid.
10 Ibid.
11 See Shakeshaft, Paul and Perutz, Vivien (2002–3) '*Assessing Critical and Contextual Understanding in the Final Year of the BA Fine Art Degree Course*'. Anglia Polytechnic University for the ADC-LTSN (unpublished).
12 Kress (2003), pp. 20–1.

13 The authors of the above report identify the essay and dissertation as standard formats for the assessment of 'contextual and critical awareness' at degree level in fine art.

14 Sturken, Maria and Cartwright, Lisa (2001) *Practices of Looking: An Introduction to Visual Culture*. Oxford: Oxford University Press, p. 4.

15 Kress (2003), pp. 20–1.

16 Digitisation means the conversion of continuous data into a numerical representation and requires sampling and quantisation, through which continuous data turned into discrete data which consist of distinct units such as pixels. These quantified discrete numerical codes – stored in databases – can be translated into and assembled by any digital resource of representation in variable ways whether visual, audio-visual, still or animated. See Manovich, Lev (2001) *The Language of New Media*. Cambridge, MA: MIT Press, pp. 29–30, 218–21.

17 Ibid. p. 76.

18 Ibid. p. 219.

19 Ibid.

20 Flusser, Vilém (1994) 'Die Geste des Schreibens', in Vilém Flusser, *Gesten. Versuch einer Phänomenologie*. Frankfurt/Main: Fischer Taschenbuchverlag, pp. 32–40.

21 Ibid. p. 35.

22 Ibid. pp. 35–6.

23 Cixous and Calle-Gruber (1997), pp. 84–5.

24 Flusser (1994), pp. 36–7.

25 Ibid. p. 38.

26 Kress (2003), pp. 126–7.

27 Ibid. p. 127.

28 Flusser, Vilém (2000) *Kommunikologie*. Frankfurt/Main, Fischer Taschenbuch, p. 301.

29 Ibid. p. 303.

30 See Collins (1994) *Collins English Dictionary*, 3rd updated edition. Glasgow: HarperCollins, p. 531.

31 Womack, Peter (1993) 'What are Essays for?', *English in Education*, 27(2): 43.

32 See Foucault, Michel (1993) *Die Ordnung der Dinge*. Frankfurt/Main: Suhrkamp, pp. 359–63.

33 Snyder, John (1991) *Prospects of Power: Tragedy, Satire, the Essay and the Theory of Genre*. Lexington, KY: University Press of Kentucky, p. 150.

34 Womack, 'What are Essays for?', p. 45.

35 Ibid.

36 Ibid.

37 Fairbairn, Gavin J. and Winch, Christopher (1991) *Reading, Writing and Reasoning: A Guide for Students*. Buckingham and Philadelphia, PA: Open University Press, p. 43.

38 Womack, 'What are Essays for?', p. 45.

39 Castells, Manuel (1997) *The Power of Identity*. Oxford: Blackwell, p. 1.

40 Jäger, L. (2002) 'Transcriptivität: Zur medialen Logik der kulturellen Semantik', in L. Jäger and G. Stanitzek (eds) *Transkribieren. Medien/Lektüre*. Munich: Fink, p. 35 (my translation). I would like to thank Christina Maier for drawing my attention to this.

41 Bizell, Patricia (1992) 'Cognition, Convention and Certainty: What We Need to Know about Writing', in Bizell, *Academic Discourse and Critical Consciousness*. Pittsburgh, PA and London: University of Pittsburgh Press, p. 75.

42 Ibid. p. 85.

43 Kress (2003), p. 21.

44 For a discussion of alternative formats of assessments see Shakeshaft and Perutz (2002–3); Universities and Colleges Members Group of the Association of Art Historians (AAH) in response to the (2001) Special Education Needs and Disability Act (SENDA) (2003) *Teaching Art and Design History: Working with Students with Disabilities*. London: AAH. See also http://www.thinkingwriting.qmul.ac.uk

45 Taylor, Mark C. (2001) *The Moment of Complexity: Emerging Network Culture*. Chicago and London: University of Chicago Press, pp. 233–4.

Derrida's 'two paintings in painting': a note on art, discourse and the trace

Jeff Collins

Derrida proposes an inquiry of an unusual or exorbitant order into the relationships between spatial and other signifying systems. Thinking is implicated in this, but in a way that might be said to pose it between the spatial arts – idiomatically the arts of tactile materials, of lighting and vision – and discourse on them, the arts of the voice, of time and the word.

Derrida offers a particular case of this, an architectural thinking. It would not however start out from an initial separation of architecture from thinking, taking architecture then to represent thought in space.[1] That model – the most familiar one – owes its authority to the separation of *theorem* and *pratum*, grounding architecture as a simple technique essentially detached from thought, capable only of secondary, exterior reflection of it, while removing architecturality from theoretical or philosophical language in all but its residue as architectural metaphors: grounds, foundations, the arch and the keystone, etc. This opposition, and the distribution it authorises, has been instituted as if self-evident, coming to seem the only viable institutional model. In the mundane warfare of the visible and the verbal, it is discourse that is attributed a certain authority, taken it as the more, or only, proper and rigorous field of conceptuality, intellection, argumentation, communication, or transmission of knowledge. Yet we might consider with Bernard Stiegler the possibility of a 'rigorous practice of the image', one that might match the rigour usually associated with philosophy, theory and the sciences.[2]

Without predetermining a response to that situation, Derrida's treatment of the spatial arts questions the constitution of the field itself in which this everyday warfare takes place. In the case of architecture, he proposes an architectural thinking of another kind: architecture as the possibility *of* thought. It would be perhaps an 'undiscovered way of thinking belonging to the architectural moment', maybe productive of new diversities: 'other heterogeneities than the existing ones'.[3] And it would appeal to a before state, a condition preceding the separation of theory and practice. That condition, which in Derrida's account connects together questions of language and ontology, is the concern of this chapter.

Mutism and volubility

Derrida's view of the current or received condition of the spatial arts is sketched out in a brief statement in '+R', an essay on Valerio Adami's paintings and drawings. He indicates a certain failure of discourse in the face of artworks. Bidding for mastery, it confronts that which resists it or exceeds it:

As for painting, any discourse on it, beside it or above, always strikes me as silly, both didactic and incantatory, programmed, worked by the compulsion of mastery, be it poetical or philosophical, always, and the more so when it is pertinent, in the position of chit-chat, unequal and unproductive in the sight of what, at a stroke [*d'un trait*], does without or goes beyond this language, remaining heterogeneous to it or denying it any overview.[4]

This statement might seem unexceptional, even to affirm a self-evident fact: artworks resist words, will not be absorbed by discourse nor reduced to it. And it could invite explanation through some familiar models of art theory or philosophies of art, those for instance which take art and discourse to be grounded in essential properties of medium or form, or in categories of perception and cognition, the visual and the verbal, that are held to be irreducibly distinct. But that is neither the source nor the type of failure that Derrida is indicating. He adds a note, again very brief, which offers a rather different picture of the determination of the artwork:

And then, if I must simplify shamelessly, it is as if there had been, for me, two paintings in painting. One, taking the breath away, a stranger to all discourse, doomed to the presumed mutism of 'the-thing-itself', restores, in authoritarian silence, an order of presence. It motivates or deploys, then, while totally denying it, a poem or philosopheme whose code seems to me to be exhausted. The other, therefore the same, voluble, inexhaustible, reproduces virtually an old language, belated with respect to the thrusting point of a text which interests me.[5]

Two paintings in painting: that which is deemed silent, needing no words, the thing itself in its mute presence, and that painting which reproduces, virtually but clamorously, a worn-out language. As an account of the artwork – and there is no reason here to restrict it to painting – this is not easily assimilable to the usual models. It suggests rather that the traditional determinations of the artwork have always been bound up with language, with words, whether the work is held to be dominated by words or even resistant to them. And it also suggests a certain dissatisfaction with this, with the particular ways in which that condition has arisen and become instituted. This is not a picture of some settled or essential condition of painting, but a redescription of what we think we know in order to open it up for transformation.

Some of Derrida's major concerns are gathered together in this metaphor, in very concentrated fashion. The artwork is held within a certain problematic of language, which is also the Western understanding of language, meaning and interpretation. This is not for Derrida something purely linguistic or semiotic. It draws in as well the question of the constitution of the artwork as object, which is also a question of the constitution of objects in general. And both of these imply for Derrida questions of ontology, of possible responses to the inquiry, 'What is it?' That concern with ontological questions might be least evident in the metaphor, but it is signalled in several ways, perhaps especially in the term presence. If we ask what is it?, the answer is customarily an assurance, there is a presence. In Derrida's view, a constraint or closure arises in this, an instatement of a limit that has to be interrogated and perhaps exceeded.

Presence

The connection between ontological inquiry and presence is made by Heidegger, whose fundamental ontology, or later his thinking on being, is distinctive in that it is not concerned primarily with substances and attributes or forms and modes of material existences. Holding to the distinction of being or beingness from beings, in which the former is the necessary condition of the latter, he took being to precede all constituted beings, therefore all objects, subjects, and discourse on them, all that makes up the supposedly familiar stable world that appears. And beings, as Heidegger first notes in *Being and Time*, are always grasped as presence.[6] This is both temporal presence, as in Heidegger's initial emphasis – beings are grasped in immediacy, in the present as the present moment – and also spatial presence or immanence. As developed in later texts,[7] the problematic of presence in general is seen as having dominated metaphysics, the Greek-Western inquiry into being and beings.

That, effectively, is the problematic that Derrida interrogates: the metaphysics of presence, and the possibility of thinking beyond it. In his view, presence has been granted an extraordinary right. Not only does it seem self-evident and impossible to question, but also in governing the constitution and institution of disciplinary fields, their concepts, procedures and values, it has authorised 'the entire history of philosophy', and by extension, any thinking influenced by it.[8] Artworks and discourse on art are in no way exempt, since presence has governed the prevailing concepts of objects, perception, consciousness, experience, meaning and interpretation. If there is a disquiet or dissatisfaction with the *two paintings in painting*, it arises from the complicity of both with the metaphysics of presence.

The artwork as thing-itself, seeming to refuse words in an ineluctable silent performance of itself, is a presence. And it does not simply escape discourse. It is bound into an entire network of philosophical and theoretical suppositions, for instance those of the Cartesian *res extensa*, the extended thing given to the perception and cognition of a thinking subject, the Kantian thing-in-itself as noumenal object, or the Husserlian intentional object, governed by a principle of principles: what turns up in consciousness, the intentional objects as the things themselves, are philosophy's only proper objects and its only reliable evidence. In spite of their differences, all such schemas depend on presence, in whatever modality. Derrida includes within this the presence of the object to sight, presence as substance or essence, eventuation in a present moment, givenness to a present consciousness or experience of a subject, and so on.[9]

Painting's voluble counterpart is also instated in the order of presence. Reproducing an old language, it reproduces the logocentric and phonocentric schema which for Derrida has been a necessity of the metaphysics of presence. The word as *logos*, the word bound up in a particular mode of interpretation governed by presence, has been privileged among other types of sign.[10] It has seemed to offer the possibility of a concept, a signified, independent of any system or apparatus of signification, simply present for thought. In its history, from Stoic logic and Scholasticism onwards, that pure intelligibility has carried also an authority. In Derrida's account, the signified is granted a direct relationship to a referent, an entity itself in immanent relation to the 'eternal present of the divine *logos*' that 'first created, thought or spoke it', therefore in principle needing no spatial detour through any external signifier.[11] This persists in

modern forms, Derrida argues, in notions of interior meaning, present to the consciousness of a subject and thinkable in principle before any exterior expression – as in Husserl's phenomenology, for instance. The word is not then merely a sign that represents something in particular, it is a model of meaning and understanding. And since it is the spoken word that has seemed most to grant the plenitude of co-presence for the subject, consciousness and meaning, it is speech that has been granted centrality, as the pre-eminent modality of the word. The thesis is then familiar: the privilege of the linguistic system as pre-eminently a phonic system, and therefore the privilege of speech over writing and of phonetic writing over every other system of inscription.

The voluble painting which reproduces this language is installed within a particular order of the sign and of interpretation, dominated by a linguistic model which has privileged the word. Derrida has argued that this interpretative regime has also governed the constitution of art in general. In *The Truth in Painting*, he suggests that even to pose the traditional philosophical question 'What is art?' is to make art, in general, into an object, a prior unity with an already-established meaning waiting to be drawn out or discovered: the hypostasised signified of the logocentric schema.[12] And he notes the collusion arising between that question and the hierarchical classification of the arts and of the senses. If the constitutive model of art has been the phonocentric model of language, it has already been subjected to discourse, voice and *logos*.[13] Hence, among many other cases, Kant's affiliation of poetry to reason, privileging it over the arts of bodily sensation, and Hegel's elevation of hearing above the other senses: sound can most fully achieve the dialectical, 'spiritualisation of the sensuous', in music and in speech, and in poetry especially, spoken poetry above all.[14] The traditional problematic of art, the great philosophical legacy, arises in a subjugation of all the arts to a particular model of language and meaning, the heritage of an old or belated language which speaks in, and of, the word in its privilege.

The image of the *two paintings* in painting epitomises the visual and the verbal, word and image, caught in the closures of this metaphysical problematic. While one seems to secure the presence of the thing-in-itself, supposedly silent and impervious to discourse, the other constitutes art on the model of discourse, offering art its only chance in the determinative and interpretative protocols of a logo-phonocentric system. Derrida's response has been to propose the decomposition of the word and a thinking on the trace.

Sign and script

Derrida challenges the traditional privilege of the word and speech by disrupting the usual concept of the sign: a stable two-sided unity of signifier and signified. In its classic formulations this depends on oppositions which mark out, for instance, interior from exterior, sensible from intelligible, arbitrary from motivated, phonetic from non-phonetic. But in Derrida's account, neither the sign nor its components have any unique location or identity, grounded with assurance within these fields.[15] For instance, the signifier as a sensible entity has to be identifiable in its form, but the identification of an isolatable form in a sensible field is already conceptual; it is already an ideality, taking part in the side of the signified.[16] Equally, any pure interiority of the signified is unsustainable if the sign is to function arbitrarily. In that case it has to be instituted in a culture, articulated in codes or conventions, in a distribution that needs not only

duration but also spatialisation.[17] In that spatial distribution the signified cannot remain a pure interiority, an independent intelligibility. Derrida proposes as well, following Peirce, that there is always a movement between the arbitrary and the motivated (where the latter is not, for Derrida, tied to anything natural), and that there is no absolute referent beyond signification to provide a point at which the signifying system is arrested. (This latter move bears on the thing-itself, which has always, in Derrida's view, functioned as an absolute referent, a presence outside language. But the thing-itself in his account would be another sign, subject to the vicissitudes of all other signs, and not a final referent, a unique present entity whose existence has already been granted, innocent of signification and of complexity.)[18]

The sign, then, is a non-self-identity which refers always to another sign, another non-self-identity, and it has perhaps something of the *teratological* about it: Saussure's term, reserved by him to condemn writing, specifically, as an ill-formed monstrosity or perversion. But this condition of the sign, its lack of centre, unity and identity, its de-recomposability, is in Derrida's view the necessary condition of all signs. And this impacts on the separation and hierarchies of signifying systems. It suggests that they have characteristics in common which are necessary to all of them, therefore forbidding any essential distinctions among them on the basis of substances or forms of expression. And the particular privilege of speech is challenged. If spoken words require spatialised distribution, and have no privileged relation to a pure interior meaning, then they are in the condition of all other signs, including written signs.

This opens a critical investigation of what might usually be understood by writing: the phonetic (and most often alphabetic) scripting of words. That this should have come to take precedence over other forms of script is not for Derrida a historical accident, but a necessity, a requirement of the order of presence. Phonetic-alphabetic writing is the alleged representative of the voice and it is linear, both in its insistent spatial order and in its obedience to the notion of time as an irreversible linear succession of present moments. In Derrida's argument this has only ever been an ideal model: there has never been a completely phonetic script, a writing which could exhaustively cover all accents of pronunciation, all vocal inflections, and in which the white spaces, the gaps and blanks of the surface on which literative marks and linear chains depend, could be rendered as utterances. The phonetic ideal has however closed off or obscured the other possibilities of writing. Derrida has been particularly interested in non- or semi-phonetic scripts, usually perjorised in the Western tradition (he notes the critical projects of Kant, Hegel, Saussure, among others). These include hieroglyphic writing, ideograms and pictograms, algebras and arithmetical symbolisations, and some of the artificial languages invented since the seventeenth century, the pasigraphic systems for instance in which Leibniz tried to inscribe a universally intelligible and immutable logic.[19] All of these have a certain emphasis on the spatial, on graphic layout on a surface, sometimes in non-linear fashion, and they can set up as well various kinds of dynamic interplay between the phonetic and the non-phonetic, the pictural and the figurative. For instance in cuneiform scripts, elements can be at once phonetic and ideogrammatic (taking an ideogram here as a non-phonetic semantic symbol: e.g. + $ &, or sometimes a pictorial representation). But cuneiform elements cannot be neatly classified into two corresponding groups, phonetic and non-phonetic, since each one can have those two values simultaneously, offering in reading an alternating play between ideogram and phonetic mark. As a

further complexity, there can be more than one phonetic value for an element, and the script is furnished with phonetic complements that cannot themselves be read, phonetically. There are similar interplays in other scripts, including the pictographic writing at work in the rebus and the abbreviated, decomposed pictograms of Mayan script, which radically challenge the linear ideal in their possibilities of insertion above, below, between or even inside other pictograms, along with phonetic elements.[20]

Derrida has at least three emphases here. There is no essential distinction between alphabetic and other kinds of inscription, since phonetic or non-phonetic qualities are not inherent in particular types of sign or sign-system; they can always in principle occur or fall away, thus opening up inquiry into which elements of any signifying field might take on a phonetic value – and in what manner, with what force – or not. He is also concerned with the possibilities of a 'pluri-dimensional' writing, a spatialising writing not bound by the linear order of the voice, of continuous movement from present to present, and not bound to a single centre, a concept present to the consciousness of a subject. And so he proposes as well, in this decentring of the sign, a passage of writing through the unconscious. In *Freud and the Scene of Writing*, he notes Freud's use of metaphors of writing, describing the unconscious as an 'optical machine' and later, 'mystic writing pad'.[21] This is a graphematic unconscious: according to Freud, it forms its dream-content in the manner of hieroglyphs or comic-book captions, pictograms, rebuses, non-phonetic writing in general. Radically polycentric, dream-writing exceeds both phonetic writing and speech as usually understood, working beyond or between the distinctions of dream, memory, perception, and consciousness.[22]

Artworks and writing

In the divided fields of art and discourse, Derrida's inquiry might claim attention at least because the scripts he adduces have long been held to have prominent visual characteristics. He does not, however, remain within the limits of writing-as-scripting as normally thought. Given the privilege accorded to speech and the phonetic, he argues that the concept of writing should be both generalised and radicalised.

Writing is generalised in that its condition, its operation by way of absences, non-immediacy and distance, is held to be the general condition for all systems of signification, all inscription and institution of signs, including spoken words. Writing becomes a name for that which generates signification: the play of movements, neither linear nor centred, which gives to signs of all kinds their possibilities. Writing in this expanded sense is also a thought of what might exceed the Western concept of language. It encompasses all language and discourse, all forms and types of signification, and as Derrida puts it, 'all that gives rise to an inscription in general', whether literal or not, and even if alien to the voice, 'cinematography, choreography, of course, but also pictorial, musical, and sculptural writing.'[23] Across later texts as well, Derrida adduces cybernetic systems, television and other telematic apparatuses, as a picto-ideogrammatic writing which excedes the limits of phoneticism.[24] Generalised in this way, writing is also an arche-writing, a proto-signification that is always-already under way before distinctions are made between materials, forms or systems of signification. In this account, artworks and discursive texts are both writing.

The trace

Derrida's proposal for a generalised concept of writing might do much to recapture a parity of signifying systems, but his emphasis lies on its radicalisation. He proposes that all systems of signification have what might be called a 'common root'.[25] This is described as a 'secret power' or resource,[26] which ensures a kind of 'synergy and fundamental synaesthesia'.[27] This synergy or synaesthesia is not however a determinable psychological phenomenon, arising in acts of consciousness or in the experience of a subject, nor more generally does it belong to the anthropological. It is available neither to empirical, scientific-objectivist inquiry – it escapes the orders of evidence – nor to rationalist conceptualisation. Perhaps characteristically, what Derrida proposes is neither a new concept of synaesthesia nor a new theory of language or signification. What he describes is exorbitant, escaping description or mastery in the terms of a science or theoretical discourse. In a sense it does not exist, since in Derrida's descriptions it is not and could not be a present entity, for instance a thing with substance or material or a concept in the usual sense, present to consciousness.[28] However, for Derrida it is the necessary condition of possibility of any present entity, and therefore originary at least in the sense that it precedes the categorial distinctions, the oppositional schemas and other determinations, within which presences can be encountered as empirical facts or as concepts. As their condition of possibility, it gives rise to them, as something like effects but without a cause of the usual kind.[29] The naming of this common root is difficult, caught up inescapably in the determinative procedures of metaphysics, but terms that Derrida has used include trace, or trait, mark, etc., and also, *différance*.

Derrida's descriptions of the trace indicate why, perhaps, its recalcitrance or exorbitance needs emphasis and why the trace could not be in any easy sense a philosopheme or a term of art theory or art history. The account he offers in *Of Grammatology* is offered as a response or extension to Saussure's concept of arbitrariness, which requires difference as the source of linguistic value: the well-known dictum that 'in language there are only differences'.[30] The positive terms of language, the elements that appear and give rise to determined meanings, cannot function without differences. And yet, Derrida emphasises, difference itself is not a sensible plenitude: it cannot be seen or touched, or appear for other senses. It might be possible to see that two things differ, but what cannot be seen is the difference. There is an essential incorporeality in difference which exceeds the embodying substances of signification, such that signifiers can never be constituted purely or entirely on the basis of their phonic, graphic or other materials. The so-called sensible signifier is dependent on the non-sensible. Constituted not only in, but also as, a regulated play of differences, the vocal signifier cannot simply be heard, nor the graphic signifier seen. This has a bearing on any conceptual project which erects hierarchical distinctions between signifying systems. If all such systems are dependent on difference, then difference comes first. The supposedly essential or natural grounds of distinction – substances or forms, or psychological or physiological processes – are at best secondary. At the root, they are untenable.

The trace, then, is a name for the movement of difference. It is *différance*, the 'pure movement' of difference that gives rise to spatial separations and distinctions as well as temporal deferrals or delays.[31] This grants to the trace a certain genetic force, since

it provides the possibility of signification, the appearance of distinguishable and identifiable elements. There is however an ontological charge in this. Since Derrida holds that no entity achieves presence outside of signification, there is no presence – 'before and outside semiological difference',[32] – the trace is the condition of possibility of any present entity. It precedes identifiable, appearing entities, while itself having neither identity nor appearance. It is not a sensible plenitude, and has no dependency on one. It is not, where it is falls under the governance of presence.

This recalcitrance of the trace to presence is also emphasised in Derrida's further descriptions of it. Against the usual oppositional schemas, he couples genesis, forces of historical origin, with structure, as systems of static configuration. The trace as genetic force has also the 'structure of the relationship with the other', an introduction of alterity which prevents unique identity or self-sameness.[33] Derrida describes this as a structure of retained difference and it is required for signification. No element can be present in or of itself, as if it could be identified by referring it only to itself. It must refer to the other elements of the chain or system, which are not and could not be simply present in the time and space of its appearance. Those others are retained, not present but not simply absent. Since in its structure, 'the completely other is announced as such within what it is not', the trace, Derrida notes, 'is not acceptable to the logic of identity'.[34] And the trace has also a temporal movement, though one that, following Heidegger's identifications, resists presence in its common temporal mode: the simplicity of the present moment, the now or instant in time.[35] Derrida focuses particularly on Husserl's privileging of the living present in the analysis of time consciousness. Husserl introduces into the concept of the present moment of experience the activities of memory (retention) and futural projection (protension), but these in Derrida's view are merely complications or modifications of the present. They divide the living present internally, taking up residence within it as past presents and future presents – modified presents – while allowing the present to retain its authority as the essential element in an order of continuous linear succession. The trace disallows any possibility of a unique present moment whose sedimented evidence can be reactivated, its presence restored, in memory. Adopting a term from Lévinas, Derrida describes the past of the trace as the absolute past, the past that never was or could have been a unified, homogeneous prior moment.[36]

In Derrida's descriptions, the trace connects the relationship with the other to the movement of temporalisation and also, to writing. Writing, in the expanded sense, is writing as tracing. This points towards a beyond or a before of the sign, of what the sign has implied in both its structures and its functions. The trace, Derrida suggests, is neither more nor less intelligible than sensible, interior than exterior, psychic than physical. Its movement ensures a becoming-arbitrary and becoming-motivated of the sign. It belongs no more to time than to space, to light than to sound.[37] It is, rather, the zone or network in which such differences arise, allowing the constitution of any text, work, signifying structure, fabric or performance. The trace does not belong to or privilege any region of the senses, any specifiable medium or repertoire of forms of expression. It plays its part in all modes of inscription, none of which would appear without it.

Derrida writes of the trace as that in which differences, such as those between space and time, can be articulated. It makes possible the articulation of signs, either their composition within the same order, for instance phonic or graphic, or the collocation

of different orders, phonic and graphic, tactile-visual, gestural-aural.[38] As it does this, it differentiates. And in this is the paradoxical thought of differentiation as articulation, the thought of the hinge or *brisure* as the site or mechanism of separating and yet joining: the hinge separates with a rift or fissure, and connects together.[39] As such, it offers a unity, but one which combines in the manner of division. This fracturing juncture, if it can be called that, of the tactile, spatial, vocal and temporal is also a juncture which brings together technics and body. Derrida calls for an attempt to 'recapture the unity of gesture and speech, body and language, tool and thought', before they are distinguished in orders of opposition, before thinking and doing, theory and practice.[40] There is at the root no profound gulf, no essential or simple division, between spatial and temporal arts, the arts of the word or the image.

Transcendental criticism

The radicalisation of the concept of writing is rather more than a strategic manoeuvre among linguistic or other theories. Derrida's thinking on the trace is proposed as a questioning of metaphysics itself. As a radicalisation of thinking it has a difficult status, since it undercuts or goes back behind the conceptual traditions – semiotic, hermeneutic, formalist, aesthetic, socio-historical, etc. – that have offered the usual determinations of art, discourse and their relations. This raises some difficult questions about the status of the trace, since its retention of the other, its temporalising movements and its tracing-writing all remove it from the adjudications and the comprehension, of more familiar modes of discourse (to note again, Derrida's discourse concerns a scarcely nameable non-thing that is not a presence and therefore is not). We could ask, as Derrida does, where and when the trace narrows itself down to writing or painting in the usual senses, something that makes itself available to empirical or theoretical inquiries.[41] But his response is to propose a radical incommensurability between such questions and a thinking on the trace. Both are necessary, but they cannot be weighed up against each other.

Perhaps the greatest difficulty lies in the sense in which the trace is both originary and transcendental. Derrida describes the trace as a transcendental origin, a condition of possibility of presences.[42] As a highly overdetermined concept the transcendental has had many senses, including those of the Cartesian subject's transcendence to its objects, and of a single infinite being's 'trancendence of all other beings' (the infinitist theological schema that for Derrida is always logocentric):[43] an infinite being reduces difference, and reduces the trace. But there is another sense, recalling the procedures of transcendental idealisms. Kant, for instance, took transcendentals to be the conditions of possibility for knowledge or experience of objects, and Husserl's reductions were designed to isolate constitutive acts of consciousness, and ultimately the Transcendental Ego, as the conditions of possibility of a meaningful world. In both, the conditions transcend what they make possible. In Derrida's view, Kant and Husserl were both drawing on a particular sense of the transcendental, the most persistent and perhaps rigorous in Western philosophy since Aristotle, in which it designates the transcategorial. The transcendental is that which transcends every genre or category.[44]

Heidegger's early ontology derived its notion of being as transcendental from that Aristotelian sense: being transcends all categories of beings. But in Derrida's reading – one in fact suggested and provoked by Heidegger's later texts – that schema is

logocentric, still bound into the order of presence. Advancing its privileged name-word 'being', it makes being into a transcendental signified, an overarching, prior meaning, independent of historical languages and cultures, awaiting only the patient and thoughtful thinker who can hear and understand its word. Heidegger never quite abandoned that, but he did begin to question it. Not only is the privileged word deformed, treated to crossings-out, archaic spellings and defamiliarising etymologies, but also being is proposed as that which produces the transcendental, and transcendentality itself: before the word, before any transcendental meaning, before presence. What is to be inquired into is no longer transcendental as previously understood.

And that informs Derrida's thought of the trace, which proposes an entirely other logic of the transcendental origin. The trace might be described as originary in the sense that it is the precondition of presences, and therefore the origin of all origins as usually thought: presences determined in an order of succession and derivation. But the originarity of the trace is compromised by its retention of the other, its movements of temporalisation and spacing. As a *différance* that differs from and defers itself, it has no centre, simplicity or self-identity, nor any determinable place in an order of succession. As origin it is never itself, it is a non-origin or quasi-origin, which is nevertheless originary. As Derrida puts it, it has to constantly dissimulate or erase itself.[45] The trace is then an insufficiency, because it can never quite accede to the role or status of a transcendental origin. But it also goes beyond it. Derrida considers it as prior not only to the transcendentals of Kant and Husserl, but also perhaps to ontological difference, Heidegger's thought of the difference between being and beings. He proposes a difference perhaps *older* and 'still more unthought' than ontological difference,[46] the movement of *différance*, as that which 'would be the first or last trace, if one could still speak of origin and end'.[47] Ontic-ontological difference is derivative of difference and of the differing-deferring movement of the trace.

Derrida, then, attributes to the trace a transcendentality that is simultaneously placed in question. What he proposes is both 'short-of and beyond transcendental criticism'.[48] It calls on a thought of the transcendental origin to exceed the limits of metaphysical objectivisms and idealisms, borrowing the resources of interrogation and subversion from the available traditions. But pursuing a consistent strategy, Derrida also treats the origin as aporetic, as internally divided, a non-systematic coherence at odds with itself, and incommensurable with the kinds of power or authority usually accorded to it.

Incompetence and non-mastery

The thought of the trace does not replace or supplant empirical and theoretical studies, both of which, Derrida has insisted, have to be pursued as rigorously and as far as possible.[49] Nor does it propose an elision or eradication of traditional theoretical distinctions and concepts.[50] What is proposed is rather an interrogation of their limits, and of their treatment within the systems in which they are installed. They are, to summarise drastically, not so much wrong or dispensable as limited. They can engage and explicate only that which is derivative in relation to the originary trace or *différance*: constituted differences, determinable content with identifiable existence, functions and effects. As such, they might bid for mastery, but always in a condition of incompetence in relation to that which exceeds them, denies them any overview.

Other trajectories or movements might be possible, as Derrida's writings on the spatial arts have suggested. These texts could be read as explorations of the play between the bid for mastery, on the one hand, and attention to trace, mark, writing, on the other. On that other hand is what might exceed or fall short of the two-paintings-in-painting, the thing in its presence, the object of the logo-phonocentric order. These are not eradicable, they appear – presence is the world we grasp, that we think we have and know – but in Derrida's texts they are offered a treatment which investigates their limits. Valerio Adami's drawings, for instance, have elements that in Derrida's account disrupt the order of the sign: *Gl*, *tr* or *+R*, barely pronounceable writing unacceptable to the categories of linguistics, neither quite morphemes nor phonemes, phonetic or non-phonetic, meaningful or not, folding and refolding the linguistic and the graphic, rebels to the 'appeased commerce', the 'regulated exchange' of the lexical and pictural.[51] And perhaps the entire play of passages and movements might be found, Derrida suggests, in writing-without-seeing. He examines the case of Diderot's love letter, written according to its author in the dark, disobedient to the principle that writing must be seen, putting that off until its forms can appear in the light.[52] This is a writing of tactility, the movement of the hand, but sight is not simply absent: it has its supplement in memory, the recall of hand movements and scripted signs. In this writing, the guiding functions of the eye are passed to the hand. And its words as vocable can be heard, too. It is a writing to listen to, taking up time for the writer as well as space. If the words are readable and interpretable, in potential, *via* the sense of sight, they are no less readable and understandable at the point of hearing-writing them.

Derrida finds in these collusive structures and movements a schema that 'crosses all the borders separating the senses . . . at once visual and auditory, motile and tactile.'[53] And this distributed writing has no commanding centre. It is not there all at once, grounded in an essential region or *locus*, owing its possibilities to a simple origin. That lack of a dominant centre offers itself not as a disempowerment, Derrida suggests, but as the work of the secret synergetic power that he has called trace.

Institutionally, this proposes an unfamiliar procedure. In Derrida's view, only presence is mastered; the task is rather that of searching out, across and between what appears in the order of presence, the possibilities of the non-masterable. It is not then a bid for mastering competence, which can only enact closure or limitation, but neither are its movements powerless. Institutionally, this thinking is not a rejection of demands for increase of knowledge or of acuity of meaning and understanding. However, its procedure is different. As Derrida puts it, it seeks the extension of fields of intelligibility, knowledge and meaning, but in a movement that extends those fields by insisting on the accommodation within them of their opposite effects: discreteness, spacing, the blank and the interval, indeed non-knowledge and non-sense, that which borders or interrupts intelligibility and sense.[54] An increase of knowledge which did not do this would scarcely be an increase, and would scarcely have any transformative power on the condition of artworks and discourse.

Notes

1 Derrida, Jacques and Meyer, Eva (1986) 'Architettura ove il desiderio può abitare', *Domus* 671 (April): 16.

2 Derrida, Jacques and Stiegler, Bernard (2002) *Echographies of Television: Filmed Interviews*. Trans. Jennifer Bajorek. Cambridge: Polity Press, p. 143.
3 Derrida and Meyer, 'Architettura ove il desiderio può abitare', p. 24.
4 Derrida, Jacques (1987) *The Truth in Painting*. Trans. Geoff Bennington and Ian McLeod. Chicago: University of Chicago Press, p. 155.
5 Ibid. pp. 155–6.
6 Heidegger, Martin (1962 [1927]) *Being and Time*. Trans. John Macquarrie and Edward Robinson. London: SCM Press, pp. 500–1.
7 Perhaps especially Heidegger, Martin (1975) *Early Greek Thinking*. Trans. David Farrell Krell and Frank Capuzzi. New York: Harper and Row.
8 Derrida, Jacques (1982) *Margins of Philosophy*. Trans. Alan Bass. Brighton: Harvester Press, pp. 34 and 38.
9 Derrida, Jacques (1998) *Of Grammatology*. Trans. Gayatri Spivak. Baltimore, MD: Johns Hopkins University Press, p. 12.
10 Derrida, Jacques and Ferraris, Maurizio (2001) *A Taste for the Secret*. Trans. Giacomo Donis. Cambridge: Polity Press, p. 77.
11 Derrida, *Of Grammatology*, p. 73.
12 Derrida, *The Truth in Painting*, p. 20.
13 Ibid. p. 22.
14 Derrida, *Margins of Philosophy*, pp. 92–3.
15 Derrida, *Of Grammatology*, p. 91.
16 Ibid. p. 29.
17 Ibid. p. 44.
18 Ibid. pp. 46–50.
19 Ibid. pp. 75ff.
20 Ibid. pp. 89–90.
21 Derrida, Jacques (1978) *Writing and Difference*. Trans. Alan Bass. London: Routledge, pp. 200 and 215ff.
22 Ibid. p. 217.
23 Derrida, *Of Grammatology*, p. 9.
24 Derrida and Stiegler, *Echographies of Television*.
25 Derrida, *Of Grammatology*, p. 52.
26 Ibid. p. 93.
27 Derrida, Jacques (1993) *Memoirs of the Blind: The Self-Portrait and Other Ruins*. Trans. Pascale-Anne Brault and Michael Naas. Chicago: University of Chicago Press, pp. 3–4.
28 Derrida, *Of Grammatology*, p. 47.
29 Derrida, *Margins of Philosophy*, pp. 11–12.
30 Ibid. pp. 10–11; Derrida, *Of Grammatology*, pp. 52–4.
31 Derrida, *Of Grammatology*, pp. 62–3.
32 Derrida, *Margins of Philosophy*, p. 12.
33 Ibid. p. 47.
34 Ibid.
35 Ibid. pp. 66–7.
36 Ibid. p. 66.
37 Ibid. pp. 47–8.
38 Ibid. p. 63.
39 Ibid. pp. 65ff.
40 Ibid. p. 85.
41 Ibid. pp. 75 and 28.
42 Ibid. p. 61.
43 Ibid. p. 71.
44 Derrida, *Margins of Philosophy*, p. 195.
45 Derrida, *Of Grammatology*, p. 61.
46 Derrida, *Margins of Philosophy*, p. 67.
47 Ibid. pp. 22–3.
48 Derrida, *Of Grammatology*, p. 61.

A method of search for reality: research and research degrees in art and design

Timothy Emlyn Jones

> After all one's art is not the chief end of life but an accident in one's search for reality or rather perhaps one's method of search.
>
> W. B. Yeats to Ezra Pound[1]

Introduction

This chapter surveys the recent development of research and doctoral research degrees in art and design and discusses some key emergent issues.

Higher education in art and design has changed rapidly since 1990 and thinking about research is fundamental to this change. In spite of the subject of where and how research thinking sits in art and design, it is possible to suggest that a new research paradigm for artistic production and art education is emerging. However, any contribution to the debate has to be recognised as provisional and conditional since no comprehensive overview has yet been published. The need to review and revise the modernist project in terms of the principles of inquiry leads to a topic too large to be encompassed by this short chapter; however, I intend to tease out key issues emerging from my own experience and knowledge of a field in which a great deal needs to be done. This first attempt at an overview, therefore, is a work in progress.

Even in the mid- to late 1980s, the idea that the generation of new knowledge in art and design might be deemed research seemed novel even though there are many historical precedents for the idea in the modern period, of which Yeats's is only one. The idea of art or design practice *as research* can still be said to be monstrous,[2] and the credibility of research degrees in art and design still seems open to dismissal.[3]

Most art schools and art and design university faculties in the United Kingdom, Australia and New Zealand have or are developing PhD programmes, many with funded studentships (only the United States and Ireland remain in the English-speaking world still to do so and there are already some significant initiatives in both of these countries). Doctorates are also well developed in a number of European countries. There is, then, a significant and growing number of art and design doctors in circulation. Recent graduates no longer think it strange that a doctoral programme might be an option for them on graduation or completion of a master's, and many of them recognise that the doctorate is conventional among their peers in other subjects. This is significant: the doctorate has had a crucial position in university-level education in the past five centuries.

In examining these issues in some detail I draw upon my own engagement with promoting, overseeing, managing, supervising and examining doctorates over two decades at Stourbridge College, the University of Wolverhampton, Wimbledon School of Art and Glasgow School of Art. I draw widely on discussions with colleagues from these institutions and from those with my associates at the Hungarian Academy of Fine Art, Budapest, the Central Academy of Fine Art, Beijing, the DRS Symposium,[4] the Association of Independent Colleges of Art and Design, USA and the National University of Ireland, Galway.

Art and design practice considered as research

The problem about regarding creative practice as research seems to centre on confusion about the place of knowledge in practice when seen in distinction from that in theory. That art and design as well as the performing arts are practical is self-evident, but that does not mean that they are not also and simultaneously theoretically based in ways that go beyond know how. The idea of the reflective practitioner as developed by Donald Schön involves a distinction between 'knowledge on reflection' and 'knowledge in action'.[5] Knowledge on reflection involves stepping back from practical activity in a way that is widely recognised in the art and design undergraduate curriculum, conventionally in a ratio of practical work to theory (80:20). But the idea of knowledge in action supposes that practical activity is itself intrinsically intelligent. It supposes thinking through art. It also stands against the absurdity of the theory/practice dichotomy which seems to imply that you must switch your brain off in order to make art or design (or whatever) and then switch it on again in order to reflect on what you have made. In his pursuit of an 'epistemology of practice', Schön argues that:

> universities are not devoted to the production and distribution of fundamental knowledge in general. They are institutions committed, for the most part, to a *particular* epistemology . . . that fosters selective inattention to practical competence and professional artistry.[6]

He goes some way to theorising intuition in arguing that the mental buzz that is constant throughout creative activity – what he calls 'the dialogue with the situation' – is itself crucial to the generation of new knowledge obtained through practice. This is what makes practice creative practice This is what distinguishes 'knowledge building' from 'knowledge use', as Paul van der Lem demonstrates. [7]

That some practical activities of art and design are eligible to be counted as research activities in the UK Research Assessment Exercise (RAE)[8] can be attributed in part to the sustained arguments of Colin Painter, the former principal of Wimbledon School of Art. Painter's social constructivist argument was essentially that if research is a process of inquiry that generates new knowledge,[9] then any such process of inquiry in a subject that performs that task is eligible for consideration as research, even if it appears dissimilar from research in other subjects. This could be seen as an argument for the equivalence of art and design to research and rather sidesteps the identification and analysis of this research field. Painter's position, however, does provide a basis for reconsidering what is understood to be research in its constructivist requirement that we take research to be what we find it to be rather than the

embodiment of a methodological formula taken from the natural or social sciences. In this context, Christopher Frayling's distinction of three kinds of research 'into', 'through' and 'for' art and design provided some valuable research distinctions,[10] and his survey of the key issues cleared important ground.[11] However, it is not fully clear how 'practice-based' research should be articulated in relation to 'theory-based' or 'history-based' research, or research based on other approaches. It could be argued that practice-based research is too loose a term to be useful. It might be more useful to recognise that those differences in doctorates in art and design should be valued by researchers in other subjects – an idea to which I return later in this chapter.

The UK Research Assessment Exercise, RAE2001, was more concerned by how the research content of practice is made explicit than in the RAE96, which seemed less analytic of outcomes. The issue of how new knowledge may be embodied in or represented by art and design objects (by which I mean objects-of-attention rather than exclusively material artefacts) remains an alternative way of giving account of practice outcomes as research outcomes. Gilbert Ryle's distinction of 'know how' from the knowledge described as 'know that' does provide for works of art to be seen as evidence of the generation of knowledge;[12] however, we still need to engage with the object itself and its meaning. Paul H. Hirst's idea of 'knowledge-of-the object' goes a long way to propose an account of knowledge appropriate to works of art and design,[13] and such a distinction is necessary if we are to understand them as art or design and not as circumstantial evidence of something else. Recently, there has been increasing recognition that the characterisation of knowledge embodied in or represented by an object needs to be made explicit within a developing research culture,[14] and more needs to be done.

While much has been published on the epistemology of art, both from the perspective of education theory and philosophical aesthetics, and authoritative texts such as Wollheim's are often embedded within taught courses,[15] this material has yet to be fully drawn down to the developing art and design research paradigm. There is a need for an authoritative literature review to map this: we should be explicit about how knowledge may be generated and embodied within the practical dimension of artistic and design production. There is a need for more theory about practice coming out of what artists and designers actually do methodologically. We need to know how we think through art. The requirements of the Arts and Humanities Research Council (AHRC),[16] that research proposals be specified in terms of humanities and social sciences style research questions, in ways that tend to exclude open-ended curiosity, is one indication of how research in our field is being distorted. We need to look further afield than the humanities for useful comparators, the natural sciences and their predisposal for experiment and *blue skies* research offering many useful points of reference. If the UK Engineering Sciences and Physics Research Council (ESPRC) can be comfortable with this open approach to research, then so should the AHRC.

Art practitioners have been slow to recognise the need for artworks to have to embody or represent new knowledge to count as research. Design might seem to be ahead of art in this respect, with the Le Clusaz Conference of 2000 and the DRS discussion list having clarified many of the necessary distinctions.[17] The need for such a forum in fine art is immense. This distinction between research-based and market-based practice takes us right to the centre of the long-standing problem of how value judgements are made in the production and evaluation of works of art and design. An

inquiry-based perspective on creative practice will have much to contribute to our larger understanding of art and design; a new paradigm for research in our subject is necessary.

Relationships of research and practice

Since the mid-1990s there has been a much argued differentiation of research and practice in which the latter is taken to imply either the conduct of a professional service in the manner of a medical or legal practitioner, or the character of art and design as being intrinsically practical as distinct from being scholarly.

Just as research implies the generation of knowledge, practice in the former sense implies the application of knowledge, a distinction that should hold true across disciplines be they artistic or scientific. Here the distinction is clear and meaningful and the idea of the professional designer as practitioner as distinct from researcher is well founded; indeed it is supported by the establishment of professional bodies such as the Chartered Society of Designers in the United Kingdom in a way that begins to be comparable to the medical and legal professional bodies. That fine art be considered professional in this way is less straightforward.

In fine art the latter meaning of practice serves to both confuse and enrich the issue. Here the idea of practice is widely seen to be innovative and seldom routine, an idea supported by Schön when he deliberately interrelates and conflates ideas of practice and research in dealing with 'knowledge in action'. Here practice can be seen to fulfil many of the criteria of research and it is in this respect that an important distinction between fine art and design emerges.

The term practice has been adopted, however, by many visual artists since the 1980s in a way that mimics the professionalism just considered, but without adopting its standards or norms. When a fine artist talks of professional practice, the standards of the professions such as medicine and law do not apply in any direct sense. This professionalistic creativity seeks to adopt the respectability but not the operational reality of professional conduct. This phenomenon has an historical basis in which fine art's purportedly radical paradigm of avant-garde bohemianism often meets and sometimes elides with that of bourgeois aestheticism and its patronage. This would seem to be a class-specific phenomenon that might be better understood were a sociology of artists, artists' audiences and artistic patronage to be developed – an argument best developed elsewhere than here.

Research and art and design research

In considering the problematics of research development it is worth considering the early days of physics or medical research when the idea of scientific method was worked out over a long period of time, borrowing and transforming ideas drawn from the world of letters and when minimal research ethics were sufficiently elastic to allow systematic grave robbing. Even now scientific method is not unproblematic.[18]

Such a comparison validates the apparent shortcomings of art and design research as being reflective of the current state of development of the field rather than as being intrinsic to weaknesses in the subject. In this early stage of development we need to clarify what is not yet known but necessary to the further development of art and

design research. Such an agenda for development, in my view, could usefully include the following: a full literature review; a review of examples of inquiry through artistic endeavour in modern history; a sociology of artists; a theoretical basis for intuition; an advanced theorisation of how knowledge may be embodied in or represented by a work of art; an aesthetics of artistic method as distinct from one of artistic style; a comparative methodology of artistic production across cultures; and an international consensus in the definitions and boundaries of those subjects loosely bunched as art and design, so that debate of specialism and interdisciplinarity might be better facilitated. Such an agenda for thinking through art and design (as distinct from thinking about art and design) is more an indicator of the relevant state of development of art and design research than of any unsuitability of the subject as a field of research.

The fields of inquiry of art and design research

Once it is accepted that art and design are capable of generating new knowledge or new contributions to understanding then the question arises as to the subject of which kind of knowledge is generated. The answers differ for art and for design and these differences may prove significant in clearing much of the confusion in the theorisation of creative work in a field which is not unified.

Crucial to an epistemology of art is the way or ways in which art, like literature, theatre, cinema and philosophy, expand and extend our understanding of ourselves and the ways in which we know of ourselves. It could reasonably be argued that the subject of art research is human consciousness, or 'reality' as expressed by W. B. Yeats in the epigraph for this chapter. Happening upon the emerging university discipline of consciousness studies, David Lodge argues that: 'The idea of human nature enshrined in the Judeo-Christian religious tradition' and 'the Enlightenment idea of man' are being challenged by the appropriation of inquiry into consciousness by newly emerging scientific subjects.[19] Rather, he suggests, the highest level of understanding of consciousness that we have to date comes not from this emerging scientific discipline, described by the editors of the *Journal of Consciousness Studies* as being at 'a chaotic, pre-paradigm state – somewhat akin to nuclear physics at the beginning of this century', but from literature.[20] By extension this can be said to apply also to the other arts: 'a record of human consciousness, the richest and most comprehensive we have', Lodge argues, is in literature.[21] He supports his claim through reference to the writing of Dickens, Henry James, Kingsley Amis and Martin Amis, as well as to Kierkegaard. The claim could be extended for art through numerous examples in the modern period, Monet, Seurat and Signac, for example, having researched perception in ways that extend far beyond the physics and psychology of perception but which, nevertheless, depend upon them. Lodge argues for the complementarity of consciousness research through literature and the sciences, and Proust's inquiry into memory in *Research into Lost Time* can be seen as distinct from scientific understanding of remembering, yet dependent on the idea of memory as a subject of inquiry drawn from the sciences.[22] Similarly, James Joyce's concept of stream of consciousness in *Ulysses*[23] gives us a deep and unique understanding of the mind while based on William James' engagement with consciousness.[24] Artistic knowledge and scientific knowledge emerge as necessarily intertwined. It may be that neither has the better claim to

providing an intellectual base to consciousness as a discipline, the cause being lodged with neither but with the distinction of art and science as a limited methodological distinction of inquiry.[25]

Design may be seen as diverging from art in its epistemological basis. If art research is associated with the exploration and understanding of consciousness, then design may be seen as active in a different way, associated with knowledge of and through use, and with the understanding of utilitarianism. Both art and design research can be seen to have a procedural dimension that lends itself well to formal inquiry once the Romantic paradigm of inspired action is sidestepped, but they are contextualised in different ways. This differentiation of art and design may prove helpful to their mutual support and engagement as distinct disciplines with a shared interest in aesthetic knowledge and the principles of making and doing. In this way art and design might emerge as a unified and enriched subject field rather than the homogeneity of historical circumstances.

The place of the doctorate in higher education

The problem posed by the doctorate is not that it is a doctorate, but that it is relatively new to our subject. Across university education, the doctorate is the key to understanding research-based education at both postgraduate and undergraduate levels as it distils many of its issues. This may not yet be obvious in art and design, for largely historical reasons.

Historically, the doctorate is probably the oldest degree to be awarded in European higher education, having been a licence to practise law or medicine since the thirteenth century, and in many of the ancient universities it has long been a licence to teach. The PhD developed in Germany in the nineteenth century as a research training, and it is now regarded as a prerequisite to teaching in most higher education subjects world-wide. The training of teachers of undergraduate and postgraduate courses through the research methods of the PhD, with the expectation that they will then teach a simplified form of those methods, means that taught courses are imbued with an essential research flavour.

The research basis of taught courses in art and design is less easy to identify since the history of art and design research is virtually the inverse of that of the subjects conventionally identified with the ancient universities. Art schools in the United Kingdom largely (but not exclusively) grew out of the industrial revolution to meet the craft, design and drawing needs of the emerging industries in the nineteenth century. The initial development of art schools in the United States (as distinct from liberal arts colleges) and several European countries was not dissimilar. Ours was initially a vocational education, a craft, and many of the objections to art and design doctorates are informed and limited by that craft perspective on the subject. Initial training in art and design was given degree-equivalent status in the United Kingdom only in the 1960s, this having been a turning point as it locked art and design in the United Kingdom and the United States into university education in a way not taken up throughout Europe. I think there is no turning back. The British BA(Hons) and the American BFA in studio art and design date only from the 1970s, and UK postgraduate courses did not proliferate beyond the London 'Three Schools'[26] and a smattering of provincial centres until the mid-1980s at which time the first PhDs

began to emerge at the CNAA's behest. US doctorates in studio art were developed at the University of Ohio and at New York University much earlier but were subsequently abandoned after the Master of Fine Arts (MFA) was determined by the College Art Association of America (CAA) to be the terminal degree, equivalent to other terminal degrees such as the PhD in 1977.[27] The validity of this position is now under question given the emerging generation of studio-based doctorates in a number of US art schools in response to developments elsewhere in the English-speaking world. These are clearly of a different order of academic award from the MFA. Curiously, from a European point of view the American debate has been largely based on the principle of credentialising art teachers in higher education rather than those of research development and it will be interesting to see whether a credible academic debate can be sustained on that premise.[28] A further American initiative, Re-Envisioning the PhD, unfortunately bypassed this debate and the opportunities that exist within it, but established national norms comparable to those of Europe.[29] The first cohort of ten studio-based PhD students enrolled at the Central Academy of Fine Arts in Beijing in autumn 2003, with a strongly national orientation in its research methods training which takes aesthetics and archaeology as its key components. Norway too is advancing cautiously, with the state funding a pilot scheme of two doctoral students in each of the three third level art schools, at Oslo, Bergen and Trondheim, for three years. The first UK PhDs to be examined without a substantial written thesis emerged only in the late 1990s and a DFA that is substantially different in more than name from the PhD has only recently materialised at Goldsmiths College, London, although the DFA and the DLA has developed in Australasia and in some European countries such as Hungary and the Czech Republic. In several European countries, such as France, art and design education remains outside the university system with a different provenance, different expectations and different possibilities.

The French model is possible in the English-speaking world given art and design's integration in university education and there is no turning back towards a craft-led education; it is only once the doctorate is commonplace and doctors abundant in art and design schools that the development of higher education research culture within art and design education will become mature.

The practice-based PhD

This section of the chapter deals with issues that seem insufficiently known by many within our subject community. Until there is truly widespread common understanding, however, the PhD in art and design will remain misunderstood, and so it seems appropriate to recapitulate these points.

The PhD provides a training in research methods and methodology that is achieved through a programme of inquiry, a project, that leads to new knowledge or understanding. That is to say, the learning of how to do research is as indispensable to a PhD as the new knowledge that is generated by means of it. More specifically, I would describe the project as a self-reflective supervised programme of inquiry leading to new knowledge. Every PhD has at least the same standard four elements or ingredients: a research question or topic; a programme of study inquiring into that question or topic; supervisory arrangements whereby the student's research is undertaken under

the supervision of a senior researcher; and the examination of the conclusions of the programme of research. Conventionally a PhD concludes with a thesis or argument which if persuasive is agreed to represent new knowledge, whatever form it may take. For art and design a particular issue arises here, for while it may be possible to explain how an object embodies new knowledge of the knowledge-of-kind, it is less clear how an object can be said in itself to embody a thesis or argument. It may be appropriate to consider the objects that constitute the conclusions of the project as equivalent to or in lieu of a thesis rather than as a thesis in themselves. Alternatively, it might be possible to argue that an object, particularly in fine art does have such an active capacity, but such a case has yet to be argued and won.

It is worth considering in some detail the issues emerging for art and design from each of those four elements. First, what is meant by a research question? A research question may inquire into a problem to be solved; a creative opportunity to be explored or exploited; or an issue to be examined, whether any of these be technical, procedural, philosophical, theoretical, or historical. Whichever of these a research question may be, it must also take the form of a query such as: what; what if; how; when; why; why not; for whom; by whom; or any other form of question. How the question may be framed is the real challenge for art and design since there has historically been in taught courses a conservative separation of theory and practice, and where the idea of intrinsically intelligent practice, or praxis, is still relatively new, even if the idea of praxis goes a long way back to Gramsci.[30] The need for clarity in the early definition of the PhD student's registration of a project becomes subsequently apparent at the time of examination when, for that process to be fair and equitable, that benchmark for the measure of success is required. This should not be difficult in a subject in which most undergraduate and postgraduate learning and teaching is project based, and research degrees could well learn from and refine the idea of working to a self-set brief that is already common in taught courses.

It is also worth considering critically what is meant by a PhD programme of research. Here too there is a fairly standard set of ingredients.

- *A review*, sometimes called a literature review, is a scoping of the knowledge current within the field of inquiry undertaken to confirm that the research has not already been undertaken and the PhD therefore unnecessary. This is particularly problematic in art and design, notably in fine art where it is simply not possible to determine all that has been done, because not all creative practice of this kind has been externally referenced let alone refereed. We need to develop a consensus of the kind of review that is most appropriate to our subject.
- *Research methods*, which are ways of doing something, and research methodology which is the study of methods, both being equally necessary to the research student. Often the two are conflated as if a methodology was a super-luxury method. This is especially problematic in our subjects since, while there is a great deal of literature on quantitative and qualitative research methods in the humanities and sciences, there is little consensus in art and design and other creative and performing arts. In my view this is one of the most fertile areas for development in art and design research. If we are able to devise explicit ways of describing and analysing how artists, designers, dramatists, choreographers and performers generate new knowledge from both primary and secondary sources, then we may have developed

a new research-based theorisation of not only artistic production, but also intuition. In this way there is the possibility of constructing the much needed new paradigm for art; a new aesthetics of method.

- *The inquiry* is the core of a research programme. Many artists will have problems with characterising what they do as inquiry rather than expression, or social intervention, and whether it is in any way programmatic. However, if our subject is to have a place at the higher levels of higher education then it would seem a necessary pursuit to identify in what ways art and design do generate knowledge through inquiry. This issue is an extension of what I have just said about methods and methodology, but on a larger scale, what Schön calls 'an epistemology of practice'.[31] It seems to me that the challenge is to make explicit that which is unique to art and design. We need to be more explicit about what is meant by an inquiring mind in our subject at university level, and this need is in itself an indictment of the subject's conservatives who argue for a tacit knowledge of theory among artists – seemingly an argument for the unintelligence of art.

- *Recording the process* is also a standard element of the PhD and the logbook or journal is a conventional means in research yet not one immediately obvious in art and design. The term 'journal' in its eighteenth-century literary sense was a day-book or diary – a literary convention. If we return to that age of letters then the sketchbook, as a means of recording a journey such as the grand tour, may provide a way of getting to grips with this idea. The purpose of the record in a PhD is to facilitate a dialogue between researcher and supervisor and a point of reference in reviewing progress and reflecting on further development of it. It enables the meta-inquiry, the way in which the process of research becomes a means of learning about research. The challenge here is to make academic rigour explicit within our subjects in ways that have not always been the case.

- The *conclusion* of a PhD presented in appropriate form is crucial to the examination regime. Conventionally an argument or case is described as a thesis, but that the term thesis can also mean a large number of words typed double spaced can confuse the issue. There are many precedents for the submission of practical outcomes that embody or represent new knowledge or understanding for examination demonstrates. Whether practical material should be submitted for examination as a thesis, or in lieu of a thesis is a moot point, but it should embody or represent the new knowledge or understanding in whatever form. What has been achieved should be capable, however, of being described if not summarised in text that together with the documented outcomes is presented in some form that can be accessed by future researchers. Conventionally, such a supplementary text has been described as a summary, and it may be necessary to use that term rather broadly in the case of art and design.

Once the programme is complete it is subject to examination and the way in which the processes and outcomes are examined reveals some key issues. Three elements of the PhD examination process may be apparent:

- value judgement
- fulfilment of previously specified criteria
- defence of a thesis.

These three quite different forms of engagement might easily be confused. There has yet to develop sufficient custom and practice for there to be in art and design a consensus of how these elements interrelate in a PhD examination. The connoisseurial value judgement would arguably seem out of place as in any criterion referenced educational process, yet a decision as to whether a PhD programme has attained doctoral level does need to be made, and through the opinion of experts in the field. The risk that such a judgement could revert to one of taste does exist and such a value judgement needs to be moderated by an examination for the fulfilment of the criteria specified in the initial registration of the programme of research, that is to say examination of the outcomes against the benchmark of the initial intention. The PhD student is required to defend his or her thesis: here the autonomy of what has been achieved by the student is tested for its robustness, and the judgements of value and criteria-fulfilment are set into the context of the project outcomes in their own terms. Thesis defence, therefore, puts the viva examination into a crucial position in the examination process. A proper understanding of what is being examined in a PhD should resolve the perennial dilemma of the relation of material outcomes of artistic or design production to written material.

Early practice-based PhDs, in many universities and colleges gave students some dispensation in the word length of the written thesis that had to accompany the work. The second generation of practice-based PhDs, such as those initiated in the mid-1990s at Wimbledon School of Art, did not prescribe a word count as such and envisioned a sliding scale of portfolio and text, while retaining a requirement for the written element. This resolved the duplication of effort previously required (and still required by some universities) and it made the PhD feasible in the same sort of timescale and with the same sort of workload as that expected of PhDs across other disciplines. Nevertheless, some ambiguity of the purpose of the written element remained: is it examinable research content, or evidence of the research content for the use of future researchers, or both? The conflation of the two purposes tends to compromise the epistemological character of the new knowledge generated by a PhD project.

A third generation of practice-based PhDs emerged in 2000 at the Glasgow School of Art, based on the distinction of a number of different possible relationships between material outcomes and textual outcomes, and the different purposes that might be expected of the text. A distinction was also made between the material submitted for examination and the documentation of it for the purposes of future reference to the research content. In this third generation it was possible to say that the difference between an art and design PhD and any other PhD is not in the type of doctorate, but in the ways in which the research outcomes are presented for examination.

At Glasgow four categories of submission for examination have been identified in regulations. In providing for the different purposes that might be expected of material and text, the range of these categories was also thought to provide for likely differences in projects in fine art, the decorative arts, and design in a wide range of subjects including visual communication, product design and architecture. These categories suppose different relationships between text and material evidence and were subsequently taken up in modified form by another Scottish HEI to provide for music doctorates and may be more widely applicable. They are as follows:

- *A written thesis*, which may take any of a number of forms including a theoretical exegesis, an historical analysis, a report of a project, or whatever. That it is written does not mean that it cannot be practice-based since it may be an account of research conducted by means of practice.
- *A dissertation and portfolio*, which suppose an equal weight given to the visual/material outcomes of practice and the discussion of the knowledge, suited to those instances where the knowledge is intelligible only when considered in the context of what is written, often text of a theoretical character. That there are two elements to the submission supposes that together they represent the new knowledge or understanding (and that they do not each do so separately since that would be a double PhD).
- *A portfolio with commentary* in which the new knowledge is presented largely in its own right but with a body of written information necessary to a full understanding of the portfolio, typically an account of procedural or contextual information.
- *A portfolio with documentation and a summary* (all forms of submission requiring a summary) in which the new knowledge is presented in its own right but documented sufficiently clearly, including the use of text, for there to be a record of the research process and its outcomes for future reference.[32]

One learning point across these three approaches has been that the less text that is submitted the more rigorous the thesis defence A further point to emerge is the problem of supervision by subject experts of whom few are formally qualified to supervise. Many institutions adopt a team approach to supervision and while this does provide for the inclusion of non-qualified subject experts alongside qualified supervisors from other disciplines, it can imply the transfer into art and design of inappropriate methods from other disciplines in the name of academic responsibility.

In my view, it emerges that the PhD in art and design differs from PhDs in other subjects in terms of the way in which research topics may be defined and most crucially in the examination regime being adjusted for the inclusion of a portfolio or exhibition in lieu of a written thesis. In most other respects it is the same; a PhD is a PhD. What is needed is an examination regime that will allow for additional or alternative modes of examination. Indeed, if we were to depend on the face to face engagement of the candidate and the examiners as the primary form of examination, then the whole discussion of text versus object would take secondary place and thereby lose much of its controversy.

In this discussion of the four elements of a PhD, I have outlined some of the key developmental issues for the PhD in our subject. Further discussion relates to the position advocated by Colin Painter, and lucidly argued by Andrew Harrison,[33] with reference to Kant's theory, that the knowledge at stake, 'the medium of communication (of knowledge) must ultimately be works themselves, not descriptions of them or assertions about them.' This would seem to represent a basis for considering works of art as the embodiment, representation or lodgement of the knowledge that art has to bear.

Towards a professional doctorate in fine art

While the PhD is conventionally thought of as a training in research methods in a subject, professional doctorates such as those in medicine and law are normally thought

of as preparation for high-level professional practice in that subject. Here, the distinction of research from practice is not simple since processes of inquiry are essential to the conduct of these high-level professions, which continuously build knowledge. A professional doctorate in art and design that is commensurate with those of medicine and law has yet to emerge although some notional DFAs that differ from PhDs mainly in name are available in several Australasian universities. Such a degree might have the additional merit of articulating readily with the kind of education by inquiry through action that art and design schools have made their own; the key to such a doctorate being Schön's argument for knowledge in action as the basis of research.

Such a doctorate is beginning to emerge in Ireland at the Burren College of Art which, in conjunction with its accrediting agency, the National University of Ireland, Galway, now intends to offer an integrated MFA/DFA programme in which a student may register for an MFA with the possibility of progression to a DFA. Within this proposed scheme, MFA and DFA students will share a common first year in which introduction to the methods and methodology of studio art figure strongly. At the end of the first year students will either continue for one year's additional study towards an MFA as currently understood, or they may continue to two additional years' study towards a DFA. The difference between the two is that the MFA represents coherent professional competence as an artist, while the DFA will represent the capacity to go beyond professionalism into the innovatory generation of new knowledge of art and human consciousness or new contributions to understanding in or of this field, as normally associated with a doctorate. The difference between the MFA and DFA is one of academic level, the DFA being comparable in level to doctorates in other subjects, and distinctly a research degree. Such a development would represent a step change beyond the Wimbledon and Glasgow models of PhD to a doctorate truly based on the idea of thinking through art as distinct from thinking about art.

It is my view, that the DFA discussed here might well represent the confluence of the thinking of the European doctoral systems with the financial realities represented in American education.

Conclusion: doctorates and the search for reality

If, as a subject community, we are able to establish a shared understanding of how knowledge is generated through inquiry and communicated in or by works of art or design, then we should have grounds for confidence in our developing research culture since it is in the forms of knowledge that our subject differs from other subjects. In fact we have a great deal of knowledge about the knowledge basis of art and design, but much of our knowing about knowledge is operational and anecdotal and undertheorised. This makes many of us apologetic for not being able to define the knowledge simply; this lack of confidence is unnecessary in my view. That the RAE2001 failed to return any of the highest ratings (5*) for any UK art school or department at the height of the world-leading, art school generated, YBA (Young British Artists) phenomenon demonstrates an aptitude for systemic low esteem among those appointed as the assessors and arbiters of British art and design.

Given the theoretical, contextual and practical differences between the wide range of specialisms in art and design and the wide range of perspectives that may be taken of them, it would seem unreasonable to suppose that any single epistemological

position can be taken for art and design. Would it be reasonable to assume that knowledge associated with a designed artefact such as a kettle, a designed system such as a software package, a work of fine art such as a painting, or an architectural design such as a house should be thought to have the same character or basis? I think not; we need a pluralist approach to knowledge and one that allows for situation specific circumstances.

If, as well as a shared view of the communication of knowledge, we can also come to a common understanding of how artistic and design knowledge is formed, that is to say by what processes and with what methods, then our institutional self-confidence should increase, because in that way our subject would have something to contribute to other practice-related research fields. We would then have several epistemologies of practice. We would, however, be looking at a range of positions and not a single art or design method, although I think it reasonable to say that drawing is likely to figure strongly as a practice-based research method across the board. Because of its explicit engagement with methods and methodology the doctorate seems a most appropriate arena in which to develop such an understanding of what Gramsci calls the patterns of formation of knowledge in art and design. This is the arena for understanding art and design research.

If we are able to engage with the knowledge base of our subject pluralistically as I propose, our subject will finally have come of age with its own research paradigm, equal to but different from other university-level subjects. We would also have a basis for practitioner-referenced standards that would be relevant to much of the university sector which is struggling to engage with the principle of learning through doing which is crucial to the idea of a knowledge economy. Would it not be crazy to take art and design in the other direction, to become more like science and technology, just at a time when science and technology are trying to become more like art and design with their valuing of value judgements, intuition, imagination and creativity, and their well-established advances into understanding human consciousness and the intelligence of doing?

I conclude, therefore, with the suggestion that what our subject community most needs in developing its research culture is greater self-knowledge and self-confidence in its distinctiveness from other subjects, in its own inquiry-based paradigm. If we do not establish our own pluralistic research-based paradigm for art and design we will not be able to resist the coercion to fit into the research paradigms of other subjects that are currently more explicit, whose ways of thinking have led the way in which research grants are conceptualised. This financial dimension may become irresistible, and as the AHRC develops as a research council it is to be hoped that it will accept its responsibilities for recognising and promoting the differences and diversity of practice-based research alongside other forms of research, and for taking a lead for a new paradigm where there is currently little leadership.

Knowledge in all university subjects is intrinsically problematic and contested in our postmodern world. We are no different from other subjects in this respect. That we do not have a unitary theoretical stance on knowledge and research in art and design should be seen as our strength not our weakness within a new pluralistic paradigm of art and design research. We should be reassured, not frightened, by the vigour and rigour of debates and knowledge contests, and the insecurities they generate. The PhD (and the DFA) in art and design provide unique opportunities to get to

grips with these issues in building such a new paradigm. In providing a foundation for practice-referenced academic standards we would have created something for the benefit of university education as a whole. What we – as a subject community in art and design, and in cognate fields such as performance, architecture and maybe literature – can most gain here is the ability to give; for it is by our relevance to other disciplines and our generosity towards them that our own disciplines will become valued within university education, indispensable to it and valued by the world beyond.

Acknowledgements

This chapter is based on a paper presented at the European League of Institutes of the Arts (ELIA) Conference, Dublin, October 2002. The paper was subsequently presented at a joint conference of the Royal Academy of Fine Arts, Brussels and the Department of Philosophy and Letters, Université Libre de Bruxelles in 2003, and then as the basis of a presentation to the 2003 Symposium of the Association of Independent Colleges of Art and Design at the Disney Hall in Los Angeles. It is currently being translated into Serbo-Croat for presentation at the University of the Arts, Belgrade. With each iteration of the presentation and discussion, the argument of the paper has developed and I am most grateful to a number of colleagues who have assisted me in this developmental process

Notes

1 W. B. Yeats to Ezra Pound (15 July 1918) Yale, cited in Foster, R. F. (2003) *W. B. Yeats: A Life – The Arch Poet 1915–1939*. Oxford: Oxford University Press.
2 Comhar, the Seventh ELIA conference, Dublin, Ireland, October 2002 took the theme Monstrous Thinking: On Practice-based Research (K. Macleod and L. Holdridge, co-organisers) as one of its ten conference symposia, reflecting a widespread view that this topic was in some way intrinsically controversial.
3 Thompson, Jon (1999) 'A Case of Double Jeopardy', in Antonia Payne (ed.) (2000) *Research and the Artist: Considering the Role of the Art School*. Oxford: Ruskin School of Drawing and Fine Art, University of Oxford, in an edition of 750. The paper was presented to an invited audience at the University of Oxford, 28 May 1999.
4 Biggs, Michael, et al. (2002) 'Practice-based Doctorates in Design and the Creative and Performing Arts: A Symposium', in David Durling, Ken Friedman and Paul Gutherson (eds) *The 'Practice-based' PhD*, special issue of the *Journal of Design Science and Technology* (in preparation).
5 Schön, Donald (1983) *The Reflective Practitioner: How Professionals Think in Action*. Ashgate: Arena.
6 Ibid. p. vii.
7 van der Lem, Paul (2001) 'The Development of the PhD for the Visual Arts', in Exchange 2000 Conference, Watershed Media Centre, Bristol, at www.media.uwe.ac.uk/exchange_online/exch2_article2.php3
8 Research Assessment Exercise submissions may be seen on www.hero.ac.uk/rae
9 Painter, Colin (1991) 'Fine Art Practice, Research and Doctoral Awards: Part 1', in *Proceedings of the National Research Conference Art and Design in Education*. Brighton: Fribble Information Systems with National Society for Education in Art and Design. See also Cornock, Stroud (1991) 'Fine Art Practice, Research and Doctoral Awards: Part 2' in ibid., written in partnership with Colin Painter.
10 Frayling, Christopher (1991) 'Searching and Researching in Art and Design', in *Proceedings of the National Research Conference Art and Design in Education*. Brighton: Fribble Information Systems with National Society for Education in Art and Design.
11 UK Council for Graduate Education (1997) *Practice-Based Doctorates in The Creative and Performing Arts and Design*. Prepared by a working group convened by Professor Sir Christopher Frayling.

12 Ryle, Gilbert (1984 [1949]) *The Concept of Mind.* London: Hutchinson.
13 Hirst, Paul H. (1974) *Knowledge and the Curriculum.* London: Routledge and Kegan Paul.
14 The Research into Practice Conference 2002, University of Hertfordshire and that planned for 2004 consider epistemology and knowledge in art and design. For the 2002 papers see http://www.herts.ac.uk/artdes/simsim/rtos/. The 2003 AICAD Deans' Meeting held in the Disney Hall, Los Angeles initiated this debate in the United States and it seems set to be developed by NASAD and the CAA.
15 Wollheim, Richard (1968) *Art and its Objects.* New York: Harper and Row.
16 Arts and Humanities Research Council, www.ahrc.ac.uk
17 See Durling, David and Friedman, Ken (2000) *Foundations for the Future, Doctoral Education in Design.* Conference proceedings, La Clusaz, France. Stoke-on-Trent: Staffordshire University Press. See the email discussion list of the Design Research Society led by Ken Friedman at www.jiscmail.ac.uk/archives/phd-design.html; also of interest in this respect is www.jiscmail.ac.uk/lists/RTI.html
18 See Medawar, Peter (1984) *The Limits of Science.* New York: Harper and Row. See also his (1967) *The Art of the Soluble.* London: Methuen.
19 Lodge, David (2002) *Consciousness and the Novel.* London: Secker and Warburg p. 2.
20 Editorial (1997) 'The Future of Consciousness Studies', *Journal of Consciousness Studies* 4(5–6): 385–8; see www.imprint.co.uk/jcs.html
21 Lodge (2002), p. 10.
22 Proust, M. (1913–27) *À la recherche du temps perdu,* translated as *Remembrance of Things Past* by C. K. Scott Moncrieff and Terence Kilmartin, New York: Random House, 1981 and as *In Search of Lost Time* by Christopher Prendergast and others, London: Allen Lane, 2002. The translation of the title as *Research into Lost Time* is my own.
23 Joyce, J. (1922) *Ulysses.* Paris: Shakespeare & Co.
24 James, William (1892) 'The Stream of Consciousness', in *Psychology* (Ch. 11). Cleveland and New York: World Books.
25 Medawar (1984).
26 The 'Three Schools' are: Royal College of Art, London; Royal Academy of Art, London; and, Slade School of Fine Art, London.
27 CAA Board of Directors (1991 [1977]) *MFA Standards.* New York: College Art Association.
28 The recent American debate of the development of doctoral programmes in studio art has focused largely on the effect such a doctorate might have on the status of the MFA as the *terminal degree,* and the effect of any such change on the terms of employment of art teachers. This debate was reopened in 2003 by the Symposium of the Association of Independent Colleges of Art and Design and in the CAA Professional Practices Committee debate: Nelson, Kristi (Chair) (2004) 'Credentializing in the Arts' CAA Conference Seattle, University of Cincinnati (not included in the published conference abstracts).
29 Re-Envisioning the PhD, www.grad.washington.edu/envision/project_resources/national_recommend.html
30 Gramsci, Antonio (1971) *Selections from the Prison Notebooks of Antonio Gramsci.* Ed. and trans. Q. Hoare and G. Nowell-Smith. London and New York: Lawrence and Wishart.
31 Schön (1983) p. viii.
32 Regulations for Awards at the Glasgow School of Art, in the 2001 *Calendar* of University of Glasgow and subsequent issues.
33 Harrison, Andrew (2002) 'Shared Judgements', in *Research into Practice*, Conference proceedings. University of Hertfordshire, http://www.herts.ac.uk/artdes/simsim/rtos/

Afterword

On beyond research and new knowledge

James Elkins

The book you have just read has a distinctly English perspective, because the key terms *research* and *new knowledge*, which occur throughout the book, are generated by the administrative language of UK universities. My first purpose in this Afterword will be to consider other ways of thinking about the relation between the studio and the university.

This book can also be read, somewhat against the grain, as a barometer of thinking about the university as a whole. As such, it is both timely and useful: I wonder if there is a relation more vexed, less satisfactorily theorised, and more seldom solved than the relation between studio art departments and other departments in the university. The kind of abstract talk that is used to articulate the parts of the university – talk about theory, discipline, knowledge, research, method, field – is stretched and distorted when it is applied to studio art. Those distortions have a lot to say about the sources of coherence of the university in general, because they reveal the kind of work that words like theory are normally intended to do. My second purpose in this Afterword is to suggest how the kind of writing collected in this book can be read with that larger subject in mind.

Why research and new knowledge?

To a reader outside the United Kingdom and Australia, it may seem strange that in order to validate studio art within the university it is necessary to speak about the production of visual art as a kind of research that results in new knowledge. Why do we want to start thinking about visual art as if it were a science? And what is the new knowledge produced by an artist like Picasso? A curious literature has sprung up to justify, adapt, and amplify the concepts of research and new knowledge.

It needs to be said that the initial impetus behind the terms research and new knowledge is purely economic. In the UK, Australian and Irish systems, university departments receive money and allowances to hire more teachers based on the levels of their students. Undergraduate students count relatively little, MPhil students more (the MPhil is an untaught master's), MA students still more, and PhD students most of all. It therefore makes good fiscal sense to implement PhD programmes. Studio art departments have been able to do this by subscribing to the standardised language that governs the addition of new disciplines: they have to be conceptually independent, and they have to add to knowledge through new research.[1] That last term, research, also has a technical meaning: budgets and hiring are quantified not only by student

numbers, but by the number of conference papers, books and essays each faculty member produces. (It will surprise readers outside the UK system that departments actually keep track of the total number of pages each faculty member has generated. The bookkeeping involved is monumental.) So research itself carries the specific denotation of a quantified volume of production in refereed journals, academic presses and conferences. Recently in the United Kingdom the Research Assessment Exercise and the Arts and Humanities Research Council have formally adopted research and new knowledge, making them unavoidable in the working of the university.

Indeed, a whole cottage industry of theorising has sprung up with the intention of adapting research and new knowledge to fit the studio context.[2] This literature has been around for some time – it first appeared in the 1970s – and so it has come to seem natural, as if research and new knowledge were as necessary to the consideration of studio art as terms like *techne, eidos* and *mimesis* are to theories of representation.

There are several consequences to the naturalisation of research and new knowledge. It prompts authors to distort their own arguments by forcing them to fit concepts that seem neutral and inevitable, but are in fact incommensurate with the authors' own ideas. Among authors who set out to avoid the research model, there is also a tendency to conflate the terms research and knowledge with science – an unhelpful compression that is nicely epitomised in a book called *The New Production of Knowledge: The Dynamics of Science and Research in Contemporary Societies*.[3] (It is unhelpful because it crushes the sciences and engineering into a methodological monolith, perpetuating the idea that scientific research is itself a well-defined term.)

I should mention that I refer to what happens in visual art departments as 'studio art instruction', which seems more straightforward than expressions such as practice-based research or creative practice research. In that latter expression, for example, the term creative has a contested history (including a recent period in which creativity has been treated sceptically in the artworld, and taken up mainly in psychology); the word practice begs the question of its opposite, which would have to be theory; and the term research comes directly from the discourse many authors in this book want to question. Practice-based research, an expression Christopher Frayling mentions in the Foreword, is a near-synonym with the same problems. Studio art instruction has at least the virtue of pointing to the physical difference between seminar rooms and studios, and of marking the central aim of the endeavour: art. It omits the written component of the PhD and DCA (the latter is the doctorate in creative art; together these are the two UK versions of the studio-art PhD) but at the same time it doesn't assume that the written component is research. More or less neutral terms, it seems to me, are a good first step in thinking outside the administrative box.

Purposes of the texts

As in any edited volume, the contributors are speaking in some measure at cross-purposes, addressing slightly different questions using sometimes very different methods. They have at least these four partly different purposes:

First, to rewrite the ideas of research or new knowledge to fit their new occasions. The most direct response to the research model is to try to adjust the term without abandoning it. The claim that 'knowledge in action' involves 'thinking through art' can make sense only within a tradition that begins with Heidegger and continues through

Gaston Bachelard, Maurice Merleau-Ponty and Hubert Damisch: it would not make sense outside that trajectory, and so it cannot be a general assumption and although it seems true enough to say that intuition makes practice creative practice, surely it stretches the meaning of the word research to conclude that intuition also makes creative practice research, that is to say, the programmatic generation of new knowledge in a defined field.

One might speak of art as adding to understanding, however. That has its own problems: what, one wonders, does not add to our understanding of the world? Even if I repeat what someone else has said verbatim, I am still adding to our cumulative understanding of the world. Still, understanding is promising because it has a much deeper and broader intellectual history, going back to nineteenth-century German discussions of *Verstehen*. (Anything that will open the door and let research escape seems hopeful to me.)[4]

Another way to redefine new knowledge might be Paul Ricoeur's idea that 'metaphoric language . . . provides new knowledge, but in a way that makes us arrive at it through the work of interpretation'.[5] A problem here might be that the genealogy of Ricoeur's hermeneutics, which includes Hans-Georg Gadamer and Wilhelm Dilthey, is used in the humanities but is not an uncontested way of thinking about interpretation; a model based on Ricoeur would therefore be in need of further argument. In general I do not find it promising to tinker with research or new knowledge: they get in the way, and they are too diffuse and too distant from art practice to be much use.

Second, to bypass the terms research and new knowledge and give the theory of studio art instruction concepts and methods that are more appropriate to its object. Several of the authors in the book address this issue. To rethink other basic terms of art education, especially writing and the nature of the essay (which is curiously undertheorised given its problematic position in the humanities), seems to me very promising, as do discussions concerning concepts of space, concepts of the Real (in Žižek and Hal Foster) and Lacanian and Levinasian concepts.

One purpose of each of the chapters in this book is to find a voice for studio art in the university, and to that extent they share a problem, because the concepts they utilise tend to apply to several disciplines. Frayling's description of the artist/academic as someone doing their best with existing kinds of knowledge and passing that knowledge on could – really, should – apply to everyone in a university. The Real, for instance, is to some degree native to the criticism of visual arts, but psychoanalytic theories of the Real have been deployed in many fields. Vocabulary used, in one instance at least, has also been employed in literary criticism and theology. (I don't mean that these texts aren't tailored to visual art, but just that they cannot be used to define studio art specifically.)

A second issue with this approach is political. I imagine that one purpose of this book is to find a force, an imprimatur or status or intellectual weight for the theory of visual art instruction that will be analogous to the operation of theory in neighbouring disciplines such as literary studies, philosophy (European), sociology and anthropology. For that purely political reason it is important that each new theory connects with existing theories in other fields. It will matter a great deal that the new theory appears well researched to specialists in that theory, and that it be shown to be connected at pertinent points to existing writing. To put it in practical terms: the authors collected here should expect, or want, to be cited and discussed by scholars in the relevant

disciplines, not because such a response would be the best measure of the new work (the new work will form its own public, and adapt to its own purposes), but because interest on the part of the wider university is a condition for being taken to have a position – and finally, a discipline – that speaks to existing concerns.

Several of the most imaginative chapters in this book share the difficulty of appropriate citation. Indeed, it might be hard to find them a hearing either among academics unconvinced of the place of studio art, or among specialists in the scattered sources employed. Several of the chapters here could be described as artists' statements: the very genre that writes its own exclusion from 'serious' academic discourse. My moral here is that writers who set out to locate concepts that might be apposite for visual art instruction need to be especially careful that their contributions are specific to visual art instruction.

Third, to reconcile the conceptual (taken as the place of reflection about artworks) and the non-conceptual (taken as the experience of artworks). I note two forms of this purpose, which differ in their initial assumptions and in their subsequent elaboration. In the first form, if the nonconceptual experience of art is taken as aesthetic, then the problem of the place of studio art can be posed as a version of Kantian aesthetics, and so distinguished from conceptual judgement. This form of the conceptual–non-conceptual divide is played out in various ways in this book. In larger terms, it might be asked whether a reconciliation of form and content, or aesthetic response and cognition, is sufficient for understanding the current forms of studio art instruction. The relation between Kantian aesthetics and conceptual judgement can be relevant in discussions of studio instruction, but it might not be the best way to address the problems raised in this book: it might answer some related question, such as: 'When we worry about the aesthetic and the conceptual, what is the best way forward?' That question may not have a necessary relation to the questions at issue in studio art PhDs.

In the second form, if whatever is understood as non-conceptual, aesthetic or non-rational in art is taken to be fundamentally inseparable from whatever belongs to discourse, when the writer's interest may be in showing the compatibility, interpenetration, interdependence, or fundamental unity of the two fields. Texts that argue in this way tend to begin from Derrida's sense of *écriture* and I would wonder if these issues, central as they are to many discussions in the humanities, have the capacity to pose or solve the issues that drive studio art instruction.

Authors who work in one way or another across the conceptual–non-conceptual divide cite a very wide range of authors to support their proposals. Part of the difficulty in this approach is knowing which dichotomy is being addressed, and how the opposed pairs are taken to be synonyms of one another. Certainly one challenge for adjudicating the conceptual and the non-conceptual is reining in the synonyms to which they give rise.

Finally, to move outside of theory by speaking in the name of practice, giving practice a voice distinct from theory's voices. Some of the authors are untheoretical in the specific sense that they are interested in providing examples of practice rather than reconceptualisations. Such writing proceeds by examples, building old arguments using new materials and is an interesting way forward: provided, I think, that it does not present itself as a contribution to theory in any recognised sense – because then any eccentric range of references, and the absence of crucial sources, would again put

such writing at the margins of academic interest. An alternative is the research report, employing reflective, critical research strategies in a scientific spirit. There are times and places when studio art instruction really does become research-based practice. Bridget Riley is perhaps the clearest and best known exponent of such research. That particular kind of art practice – I think it derives ultimately from the Bauhaus – is an example of a kind of work in which the research and new knowledge models fit nearly perfectly. This is writing which is conceptually clear and rhetorically persuasive even though it does not aim to be a new or reworked theory of any sort.

Those four orientations, present in this book, ramify and are repeated elsewhere, but they are a fair sample of the state of thinking on the subject. I have arranged them from most to least beholden to the UK research paradigm, though they could have been arranged in many other ways – a fact that speaks to the newness of the field, and the wide-ranging work that it encompasses.

I will conclude with several thoughts that apply to this new field of research.

How can a theory of practice be judged?

One consequence of a new field, whose writing has not yet had the pliable constraints formed by conventions, is that it can be hard to know how the work might be defended or justified. For example, can concepts of space be seen as appropriate contributions to the ontological content of fine art research, complementing its epistemological content? Is it desirable to balance the artist's traditionally high quotient of epistemological findings with ontological ones (contributed by spatial concepts)? How can we know that significant practice-as-research is contingent on successful reconciliation of the epistemic and ontic states of the practical research project? Why couldn't it be equally successful to let the ontological languish, or to play off an imbalance between the two sides? I am not disagreeing with the adoption of spatial terms or ontological concerns, but I wonder where the theory comes from that justifies interest in reconciling or balancing the two sides. That theory, the one that drives the theory explored in this context, is elusive: as it well might be given the elusiveness of the entire project of theorising art practice in these ways. I note this without elaborating; it is a common issue in any field that is finding its bearings: theories in this book are heuristic, as they should be, but that also means they do not always operate like the sources they cite. Perhaps that is a sign of studio art's rootlessness.

Why does the university resist?

There is no doubt that studio art is marginalised in university life. But what exactly is the cure? Reading these texts, one might get the impression that a critical mass of writing might help reattach studio art practice to the university. Yet it is important to guard against the assumption that new discourses, concepts, theories, or methods can meliorate the problem. I have suggested that the conceptual–non-conceptual dichotomy might not be the right answer to the questions posed by studio art, and that kind of reservation applies more broadly.

A new poetics involving 'thinking with our feelings' (see p. 190) and 'imagination's own forms of authority' (see p. 192) may smuggle in an answer to the question as to why the university resists a poetics or a new form of knowledge. I find that universities,

as they are embodied in actual deans and faculty committees, do not resist studio art because of its lack of theory, even though university rhetoric can make it seem that is the case. In my experience deans actually resist a lack of hierarchical instruction: what keeps studio art on the margins is its apparent lack of stepwise, graduated knowledge in college-level courses – knowledge that could be assessed (in the UK term) or graded (in the North American term). This sense of knowledge has nothing to do with the new knowledge model: it is simply a matter of testable, discrete, hierarchically arranged skills and facts. In my experience, when that impediment is removed so is the resistance: and that also means that it may be misleading to say that universities are waiting for theory, or resisting creativity *per se*, or devaluing visuality. I mention this here because it is a comparatively pragmatic, low-level concern that is largely absent from this book.

To the extent that deans I have known are dubious about studio art departments because they seem to lack something that could be called theory, their doubt could be alleviated not by discovering new theories but by acknowledging the issue as an open problem whose negotiation would form the very basis of a studio art department. I find it heartening that in this book, there is a call for 'an open acknowledgement of our "inevitable inadequacy"' (p. 193). Something of that kind could be a viable starting place for a new discipline – one that would be engaged in questioning its place more systemically, more systematically, than in certain established disciplines. Taking doubt of that kind as a founding gesture, a studio art department could find a very broad consensus among the humanities and sciences – a consensus that might be dramatically reduced or eliminated if the department were founded on any number of specific theorists or theories, from Nietzsche to Della Volpe.

How difficult the problem really is

Like the authors in this book, I am engaged in finding ways to argue that fine art production has a place in the university. The problem is immensely difficult, as the chapters in this book testify. A token of that difficulty is that few of the authors address the day-to-day experience of making – its exact pedagogy, its methods, knacks and skills, its feel, but that experience, rather than ways of conceptualising the product of the experience, is at the root of the incommensurability of studio art production and university life. Several chapters in this book could be taken as a description of a strange activity that is finished and requires conceptualisation. But in studio art classes, in the university, the process is not finished – and in fact the process itself is the subject of the classes. There is little of the feel of the studio in this book, little of the specificity of charcoal, digital video, the cluttered look of studio classrooms (so different from science labs, and yet so similar), the intricacies of Photoshop, the look of slurry, the muttered comments in life-drawing classes, the chaos of the foundry, the heat of under-ventilated computer labs. Most of this book is reflection after the fact. This is a simple point, and each of the authors is well aware of it. But I think this is where the real conceptual difficulty lies: it is hard enough to find the right words for visual art, but harder still to take the making along with the talk about the making.

Let us continue to theorise the studio and the university, but not think that the problem is adequately addressed until we have found ways of talking about the relation

of university life and the act of making art, as opposed to the variegated and often fascinating ways of talking about the relation between the university and finished *art*.

Envoi

A subject as complicated (and interesting) as this can have no conclusion. I will end with two practical proposals.

First, if you live in the United Kingdom or Australia, and the RAE and AHRC are inescapable, provide the university with the appropriate texts and then simply ignore what you've written. Words like research and knowledge should be confined to administrative documents, and kept out of serious literature. The field is too large, and too full of promise, to be hobbled by narrow and inappropriate administrative jargon.

Second, consider the possibilities of unusual combinations of theses and art. In Australia PhDs and DCAs in studio art are being awarded to students whose non-studio field is chemistry or ecology. Since art is such a mysterious thing – it's so poorly understood even by those of us who study it – there is no reason to exclude even the most eccentric, unjustified combinations: painting and food processing, installation art and restorative dentistry, video and economics . . . the possibilities seem endless, as they should be.[6]

Acknowledgements

This is an abridged version of a longer essay, edited by Katy Macleod and Lin Holdridge. The original, with discussion of individual chapters in this book, will appear in *Printed Project* edited by James Elkins, published by the Sculptors' Society of Ireland, in 2005. The full text is also available from the author via www.jameselkins.com

Notes

1 For an introduction see www.ahrc.ac.uk/research. Further introductory references are in Timothy Emlyn Jones' and Kerstin Mey's contributions (Chapters 16 and 14).
2 In addition to sources cited in Jones' Chapter 16, see the text cited in Renwick's note 5 (p. 181). I make these remarks in friendly disagreement with Jones; we are collaborating on several projects, beginning with a conference on the studio-art PhD Jones' chapter is also to be reprinted in an issue of the Irish-based *Printed Project*, published by the Sculptor Society of Ireland, which I am editing on the subject of studio-art PhDs.
3 Gibbons, M., Limoges, C., Nowotny, H., Schwartsman, S., Scott, P. and Trow, M. (1994) *The New Production of Knowledge: The Dynamics of Science and Research in Contemporary Societies*. London: Sage.
4 Frayling, C. (1996) 'Nourishing the Academy', *Drawing Fire* 1 (3): 16–22.
5 Ricoeur, Paul (1991) *From Text to Action: Essays in Hermeneutics II*. London: Athlone p. 88.
6 My own contribution to this subject, an article called 'On the Possible Combinations of Combined Scholarly and Creative PhD Degrees', is forthcoming in the *Journal of Aesthetic Education*, and also in the Irish occasional journal *Printed Project*.

Bibliography

Abbott, Edwin Abbott (1991 [1884]) *Flatland: A Romance of Many Dimensions*. Princeton, NJ: Princeton University Press.

Adcock, Craig (1983) 'Marcel Duchamp's Notes from the Large Glass: An N-Dimensional Analysis', *Studies in the Fine Arts, Avant-Garde*, no. 40. Ann Arbor, MI: UMI Research Press (revision of the author's thesis, Cornell University, Ithaca, NY).

Adorno, Theodor (1984) *Aesthetic Theory*. London: Routledge and Kegan Paul.

Alberti, L-B. (1991) *On Painting*. Trans. Cecil Grayson. Harmondsworth: Penguin.

Aristotle (1976) *Ethics*. Trans. J. A. K. Thomson. London: Penguin.

Aristotle (1996) *Poetics*. Trans. Malcolm Heath. London: Penguin.

Armstrong, John (2000) *The Intimate Philosophy of Art*. London: Allen Lane.

Armstrong, P., Lisbon, L. and Melville, S. (eds) (2001) *As Painting: Division and Displacement*. Columbus, OH: Wexner Center for the Arts; Cambridge, MA: MIT Press.

Arnheim, Rudolf (1969) *Visual Thinking*. Berkeley, CA and London: University of California Press.

Arnold, D. and Iversen, M. (eds) (2003) *Art and Thought*. Oxford: Blackwell.

Bakhtin, Mikhail (1981) *The Dialogic Imagination: Four Essays*. Ed. M. Holquist. Trans. C. Emerson and M. Holquist. Austin, TX: University of Texas Press.

Bakhtin, Mikhail (1984) *Problems of Dostoevsky's Poetics*. Trans. and ed. Caryl Emerson. Manchester: Manchester University Press.

Bal, Mieke (2001) *Louise Bourgeois' Spider: The Architecture of Art-writing*. Chicago and London: University of Chicago Press.

Baldwin, Thomas (ed.) (1993) *Selected Writings*. London and New York: Routledge.

Banchoff, Thomas F. (1990) *Beyond the Third Dimension*. New York: Scientific American Library.

Barthes, Roland (1977) *Image Music Text*. Trans. S. Heath. London: Fontana.

Barthes, Roland (1984) *Camera Lucida: Reflections on Photography*. London: Fontana.

Barthes, Roland (1986) 'The Reality Effect', in *The Rustle of Language*. Oxford: Blackwell.

Baudrillard, Jean (1988) *The Ecstasy of Communication*. Trans. B. Schutze and C. Schutze. Ed. S. Lotringer. New York: Semiotext(e).

Bauman, Z. (1992) *Intimations of Postmodernity*. London: Routledge.

Benjamin, W. (1973) *Illuminations*. Trans. Harry Zohn. London: Fontana.

Bentley, P. J. and Corne, D. W. (eds) (2002) *Creative Evolutionary Systems*. San Francisco, CA: Morgan Kaufmann; London: Academic.

Berlin, I. (1876) *Vico and Herde*. London: Chatto and Windus.

Berry, P. and Wernick, A. (eds) (1992) *Shadow of Spirit: Postmodernism and Religion*. London: Routledge.

Best, Steven and Kellner, Douglas (1997) *The Postmodern Turn*. New York: Guilford Press.

Betterton, R. (ed.) (2004) *Unframed Practices and Politics of Women's Contemporary Painting*. London: I. B. Taurus.

Biggs, Iain (ed.) (2004) *Between Carterhaugh and Tamshiel Rig: a borderline episode*. Bristol: Wild Conversations Press.

Bizell, Patricia (1992) *Academic Discourse and Critical Consciousness*. Pittsburgh, PA and London: University of Pittsburgh Press.

Blanchot, Maurice (1982) *The Two Versions of the Imaginary: The Space of Literature.* Lincoln, NE and London: University of Nebraska Press.

Bloom, Harold (1973) *The Anxiety of Influence: A Theory of Poetry.* London and New York: Oxford University Press.

Bohm, David (1980) *Wholeness and the Implicate Order.* London: Routledge.

Bonola, Robert (1955) *Non-Euclidean Geometry.* New York: Dover.

Bordwell, David (1989) *Making Meaning: Inference and Rhetoric in the Interpretation of Cinema.* Cambridge, MA: Harvard University Press.

Bordwell, David (1997 [1985]) *Narration in the Fiction Film.* London: Routledge.

Brisson, David W. (1978) *Hypergraphics: Visualizing Complex Relationships in Art, Science and Technology.* AAAS Selected Symposium 24. Boulder, CO: Westview Press.

Brody, Hugh (2000) *The Other Side of Eden: Hunters, Farmers and the Shaping of the World.* Vancouver: Douglas and McIntyre.

Brooks, Peter (1992 [1984]) *Reading for the Plot: Design and Intention in Narrative.* Cambridge, MA and London: Harvard University Press.

Brunette, Peter and Wills, David (eds) (1994) *Deconstruction in the Visual Arts.* Cambridge: Cambridge University Press.

Bryson, Norman (1983) *Vision and Painting: The Logic of the Gaze.* London: Macmillan.

Bryson, N., Holly, M. and Moxey, K. (1991) *Visual Theory: Painting and Interpretation.* Hanover, NH and London: Wesleyan University Press of New England.

Buchanan, R., Doordan, D., Justice, L. and Margolin, V. (eds) (1999) *Doctoral Education in Design.* Pittsburgh, PA: Carnegie Mellon University.

Bullock, Alan and Trombley, Stephen (eds) (1999) *The New Fontana Dictionary of Modern Thought,* 3rd edition. London: HarperCollins.

Cairns-Smith, A. G. (1985) *Seven Clues to the Origin of Life.* Cambridge: Cambridge University Press.

Carpenter, Edmund and McLuhan, Marshall (eds) (1970) *Explorations in Communication.* London: Jonathan Cape.

Cassirer, E. (1980) *The Philosophy of Symbolic Forms,* Volume 1, *Language.* New Haven, CT and London: Yale University Press.

Castells, Manuel (1997) *The Power of Identity.* Oxford: Blackwell.

Cazeaux, Clive (ed.) (2000) *The Continental Aesthetics Reader.* London: Routledge.

Cilliers, Paul. (1999) *Complexity and Postmodernism: Understanding Complex Systems.* London: Routledge.

Cixous, Hélène and Calle-Gruber, Mirelle (1997) *rootprints.* London and New York: Routledge.

Clair, Jean (1977) *Duchamp et la photographie.* Paris: Editions du Chêne.

Clifford, James (1997) *Routes: Travel and Translation in the Late Twentieth Century.* Cambridge, MA: Harvard University Press.

Collins (1994) *Collins English Dictionary,* 3rd updated edition. Glasgow: HarperCollins.

Copley, Stephen and Edgar, Andrew (eds) (1993) *Selected Essays.* Oxford: Oxford University Press.

Coxeter, H. S. M. (1973 [1963]) *Regular Polytopes,* 3rd edition. New York: Dover.

Crary, Jonathan (1990) *Techniques of the Observer: On Vision and Modernity in the Nineteenth Century.* Cambridge, MA and London: MIT Press.

Croce, B. (1979) *Estetica in Nuce.* Bari: Laterze.

Crowther, P. (1993) *Critical Aesthetics and Postmodernism.* Oxford: Oxford University Press.

Damisch, Hubert (1994) *The Origin of Perspective.* Cambridge, MA and London: MIT Press.

Davie, George (1991) *The Scottish Enlightenment and Other Essays.* Edinburgh: Polygon.

Davies, D. (2004) *ART as Performance.* Oxford: Blackwell.

Dawkins, Richard (1987) *The Blind Watchmaker.* London: Longman Scientific and Technical.

Debord, Guy (1994) *The Society of the Spectacle.* Trans. D. Nicholson-Smith. New York: Zone Books.

Deleuze, Gilles (1994 [1968]) *Difference and Repetition.* Trans. Paul Patton. London: Athlone Press.

Deleuze, Gilles and Guattari, Felix (1994) *What is Philosophy?* Trans. G. Burchell and H. Tomlinson. London: Verso.

Della Volpe, Galvano (1973) *Opere,* 6 volumes. Rome: Editori Riuniti.

Dennett, D. C. (1991) *Consciousness Explained*. London: Penguin.

Dentith, Simon (ed.) (1995) *Bakhtinian Thought: An Introductory Reader*. London: Routledge.

Derrida, Jacques (1978) *Writing and Difference*. Trans. Alan Bass. London: Routledge.

Derrida, Jacques (1982) *Margins of Philosophy*. Trans. Alan Bass. Brighton: Harvester Press.

Derrida, Jacques (1987) *The Truth in Painting*. Trans. Geoff Bennington and Ian McLeod. Chicago: University of Chicago Press.

Derrida, Jacques (1993) *Memoirs of the Blind: The Self-Portrait and Other Ruins*. Trans. Pascale-Anne Brault and Michael Naas. Chicago: University of Chicago Press.

Derrida, Jacques (1998) *Of Grammatology*. Trans. Gayatri Spivak. Baltimore, MD: Johns Hopkins University Press.

Derrida, Jacques and Ferraris, Maurizio (2001) *A Taste for the Secret*. Trans. Giacomo Donis. Cambridge: Polity Press.

Derrida, Jacques and Stiegler, Bernard (2202) *Echographies of Television: Filmed Interviews*. Trans. Jennifer Bajorek. Cambridge: Polity Press.

Descartes, René (1996) *Selected Philosophical Writings*. Trans. John Cottingham, Robert Stoothoff and Dugald Murdoch. Cambridge and New York: Cambridge University Press.

De Ville, N. and Foster, S. (eds) (1994) *The Artist and the Academy: Issues in Fine Art Education and the Wider Cultural Context*. Southampton: John Hansard Gallery.

Diderot, Denis (1978) 'Lettre sur les sourds et muets', in *Œuvres complètes de Denis Diderot*, Volume 4. Paris: Herman.

Duchamp, Marcel (1975) *Duchamp du Signe*. Paris: Flammarion.

Dufrenne, Mikel (1973 [1953]) *The Phenomenology of Aesthetic Experience*. Trans. E. S. Casey. Evanston, IL: Northwestern University Press.

Duvenage, Pieter (2003) *Habermas and Aesthetics: The Limits of Communicative Reason*. Cambridge: Polity Press.

Eagleton, T. (1983) *Literary Theory*. Oxford: Basil Blackwell.

Eco, Umberto (1989) *The Open Work*. Trans. Anna Cancogni. Cambridge, MA: Harvard University Press.

Ehrenzweig, Anton (1967) *The Hidden Order of Art: A Study in the Psychology of Artistic Imagination*. Berkeley, CA: University of California Press.

Eisenstein, S. (1949) *Film Form: Essays in Film Theory*. Trans. Jay Leyda. New York: Brace Harcourt Jovanovich (and London: Denis Dobson, 1968).

Eiser, R. J. (1995) *Attitudes, Chaos and the Connectionist Mind*. Oxford: Blackwell.

Elkins, James (1997) *The Object Stares Back: On the Nature of Seeing*. San Diego, CA: Harvest.

Elkins, James (1998) *On Pictures and the Words that Fail Them*. Cambridge: Cambridge University Press.

Elkins, James (2000) *Our Beautiful, Dry, and Distant Texts*. New York and London: Routledge.

Emmer, Michele (ed.) (1993) *The Visual Mind*. Cambridge, MA and London: MIT Press.

Eysenck, Michael and Keane, Mark (1995) *Cognitive Psychology: A Student's Handbook*, 3rd edition. Hove, UK: Erlbaum (UK) Taylor and Francis.

Fairbairn, Gavin J. and Winch, Christopher (1991) *Reading, Writing and Reasoning: A Guide for Students*. Buckingham and Philadelphia, PA: Open University Press.

Feyerabend, P. (1987) *Farewell to Reason*. London: Verso.

Flusser, Vilém (1994) 'Die Geste des Schreibens', in Vilém Flusser, *Gesten. Versuch einer Phänomenologie*. Frankfurt/Main: Fischer Taschenbuchverlag.

Flusser, Vilém (2000) *Kommunikologie*. Frankfurt/Main: Fischer Taschenbuch.

Foster, Hal (1996) *The Return of the Real*. Cambridge, MA: MIT Press.

Foster, R. F. (2003) *W. B. Yeats: A Life – The Arch-Poet 1915–1939*. Oxford: Oxford University Press.

Foucault, Michel (1993) *Die Ordnung der Dinge*. Frankfurt/Main: Suhrkamp.

Fraser, J. (1977) *An Introduction to the Thought of Galvano Della Volpe*. London: Lawrence and Wishart.

Frayling, C. (1993) 'Research in Art and Design', RCA Research Papers 1(1). London: Royal College of Art.

Freud, Sigmund (1991) 'Mourning and Melancholia', *Penguin Freud Library, Volume 11, On Metapsychology: The Theory of Psychoanalysis*. London: Penguin.

Fuller, R. Buckminster (1975) *Synergetics: Explorations in the Geometry of Thinking.* New York: Macmillan.

Gablik, S. (1984) *Has Modernism Failed?* London: Thames and Hudson.

Gadamer, H-G. (1976) *Hegel's Dialectic: Five Hermeneutical Studies.* Trans. P. Christopher Smith. New Haven, CT and London: Yale University Press.

Gadamer, H-G. (1989) *Truth and Method.* Trans. J. Weinsheimer and D. G. Marshall. London: Sheed and Ward.

Gadamer, H-G. (1990) *Reason in the Age of Science.* Cambridge, MA and London: MIT Press.

Gans, Eric (1993) *Originary Thinking: Elements of Generative Anthropology.* Stanford, CA: Stanford University Press.

Gell, A. (1998) *Art and Agency: An Anthropological Theory.* Oxford: Clarendon Press.

Gevers, Ine and van Heeswijk, Jeanne (eds) (1997) *Beyond Ethics and Aesthetics.* Nijmegen: Uitgeverij SUN.

Gibbons, M., Limoges, C., Nowotny, H., Schwartsman, S., Scott, P. and Trow, M. (1994) *The New Production of Knowledge: The Dynamics of Science and Research in Contemporary Societies.* London: Sage.

Goodman, Nelson (1969) *Languages of Art: An Approach to a Theory of Symbols.* London: Oxford University Press.

Goodman, Nelson and Elgin, Catherine Z. (1980) *Reconceptions in Philosophy and the Other Arts and Sciences.* London: Routledge.

Grainge, Jack (1999) *The Changing North.* Edmonton, Alta: Canadian Circumpolar Institute Press.

Gramsci, Antonio (1971) *Selections from the Prison Notebooks of Antonio Gramsci.* Ed. and trans. Q. Hoare and G. Nowell-Smith. London and New York: Lawrence and Wishart.

Gray, Christopher (1961 [1953]) *Cubist Aesthetic Theories.* Baltimore, MD: Johns Hopkins University Press.

Graziose, Lisa (1997) *Mark Dion, Lisa Graziose, Miwon Kwon, Norman Bryson.* London: Phaidon.

Gregory, R. L. (1970) *The Intelligent Eye.* London: Weidenfeld and Nicolson.

Guattari, F. (1995) *Chaosmosis: An Ethico-Aesthetic Paradigm.* Sydney: Power.

Guthrie, W. K. C. (1981) *History of Western Philosophers.* London: Cambridge University Press.

Hand, Sean (ed.) (1989) *The Lévinas Reader.* Oxford: Basil Blackwell.

Harrison, C. and Wood, P. (eds) (2002) *Art in Theory 1900–1990: An Anthology of Changing Ideas.* Oxford: Blackwell.

Hausman, Carl (1984) *A Discourse on Novelty and Creation.* Albany, NY: SUNY Press.

Heidegger, Martin (1962 [1927]) *Being and Time.* Trans. John Macquarrie and Edward Robinson. London: SCM Press.

Heidegger, Martin (1975) *Early Greek Thinking.* Trans. David Farrell Krell and Frank Capuzzi. New York: Harper and Row.

Henderson, Linda Dalrymple (1983) *The Fourth Dimension and Non-Euclidean Geometry in Modern Art.* Princeton, NJ: Princeton University Press.

Herbert, R. L. (1964) *Modern Artists on Art.* New York: Prentice-Hall.

Heusser, Martin (ed.) (1999) *Text and Visuality: Word and Image Interactions III.* Amsterdam: Rodopi.

Heywood, Ian and Sandywell, Barry (eds) (1999) *Interpreting Visual Culture: Explorations in the Hermeneutics of the Visual.* London: Routledge.

Hillman, James (ed.) (1980) *Facing the Gods.* New York: Spring.

Hillman, James (1981) *The Thought of the Heart.* New York: Spring.

Hirst, Paul H. (1974) *Knowledge and the Curriculum.* London: Routledge and Kegan Paul.

Hodgkiss, Phillip (2001) *The Making of the Modern Mind: The Surfacing of Consciousness in Social Thought.* London and New York: Athlone.

Hoeller, K. (ed.) (1993) *Merleau-Ponty and Psychology.* Atlantic Highlands, NJ: Humanities Press.

Ingraham, Catherine (1998) *Architecture and the Burdens of Linearity.* New Haven, CT: Yale University Press.

Inwood, Michael (1997) *Heidegger.* Oxford and New York: Oxford University Press.

Jäger, L. and Stanitzek, G. (eds) (2002) *Transkribieren: Medien/Lektüre.* Munich: Fink.

James, William (1892) *Psychology.* Cleveland and New York: World Books.

Jay, Martin (1984) *Adorno*. London: Fontana.

Jay, Martin (1994) *Downcast Eyes: The Denigration of Vision in Twentieth-Century French Thought*. Berkeley, CA: University of California Press.

Joachim, H. (ed.) (1951) *Aristotle: The Nicomachean Ethics. A Commentary by H. Joachim*. Oxford: Clarendon Press.

Joyce, J. (1922) *Ulysses*. Paris: Shakespeare & Co.

Kabakov, Ilya (1989) *Ten Characters*. London: Institute of Contemporary Arts.

Kaku, Michio (1999 [1994]) *Hyperspace: A Scientific Odyssey through the 10th Dimension*. Oxford: Oxford University Press.

Kamper, Dietmar and Wulf, Christoph (eds) (1989) *Looking Back at the End of the World*. Trans. David Antal. New York: Semiotext(e).

Kant, Immanuel (1970) *Critique of Pure Reason*. Trans. N. K. Smith. London: Macmillan.

Kant, Immanuel (1987) *Critique of Judgment*. Trans. Werner S. Pluhar. Indianapolis, IN: Hackett.

Kay, Sarah (2003) *Žižek: A Critical Introduction*. Cambridge: Polity Press.

Kearney, Richard (ed.) (1996) *Paul Ricoeur: The Hermeneutics of Action*. London: Sage.

Kearney, Richard (1998) *Poetics of Imagining: Modern to Postmodern*. Edinburgh: Edinburgh University Press.

Kemp, Martin (1990) *The Science of Art: Optical Themes in Western Art from Brunelleschi to Seurat*. New Haven, CT and London: Yale University Press.

Kress, Gunther (2003) *Literacy in the New Media Age*. London and New York: Routledge.

Kronenburg, Robert (1999) *Transportable Environments: Theory, Context, Design and Technology*. London: E and FN Spon.

Kuenzli, Rudolf E. and Naumann, Francis M. (1989) *Marcel Duchamp: Artist of the Century*. Cambridge, MA: MIT Press.

Lacan, Jacques (1994 [1977]) *The Four Fundamental Concepts of Psycho-analysis*. Trans. Alan Sheridan. London: Penguin.

Latour, Bruno and Weibel, Peter (eds) (2002) *Iconoclash: Beyond the Image Wars in Science, Religion, and Art*. Karlsruhe, Germany: ZKM (Centre for Art and Media); Cambridge, MA: MIT Press.

Le Poidevin, Robin (2003) *Travels in Four Dimensions: The Enigmas of Space and Time*. Oxford: Oxford University Press.

Lessing, G. L. (1984 [1766]) *Laocöon or The Limits of Painting and Poetry: With Incidental Illustrations on Various Points in the History of Ancient Art*. Trans. Edward Allen McCormick. Baltimore, MD and London: Johns Hopkins Paperbacks.

Lévinas, Emmanuel (1969) *Phenomenology of Eros, Totality and Infinity*. Pittsburgh, PA: Duquesne University Press.

Lévinas, Emmanuel (1995) *Existence and Existents*. Trans. Alphonso Lingis. Dordrecht, Boston, MA and London: Kluwer Academic.

Leyton, M. (1992) *Symmetry, Causality, Mind*. Cambridge, MA: MIT Press.

Li, M. and Vitányi, P. (1993) *An Introduction to Kolmogorov Complexity and its Applications*. New York: Springer-Verlag.

Lingis, Alphonso (1994) *Imperative Surfaces, Foreign Bodies*. New York and London: Routledge.

Lingis, Alphonso (1996) *Sensibility, Face-to-Face*. Atlantic Highlands, NJ: Humanities Press.

Llewelyn, John (2000) *The HypoCritical Imagination: Between Kant and Lévinas*. London: Routledge.

Lodge, David (2002) *Consciousness and the Novel*. London: Secker and Warburg.

Lomax, Y. (2000) *Writing the Image: An Adventure with Art and Theory*. London: I. B. Taurus.

Lyotard, Jean-Francois (1984) *The Postmodern Condition: A Report on Knowledge*. Trans. Geoff Bennington and Brian Massumi. Minneapolis, MN: University of Minnesota Press.

McEwen, Indra Kagis (1997) *Socrates' Ancestor: An Essay on Architectural Beginning*. Cambridge, MA: MIT Press.

Maclagan, David (2001) *Psychological Aesthetics: Painting, Feeling and Making Sense*. London and Philadelphia, PA: Jessica Kingsley.

Mandelbrot, B. B. (1983) *The Fractal Geometry of Nature*. Oxford: Freeman.

Manovich, Lev (2001) *The Language of New Media*. Cambridge, MA: MIT Press.

Margolis, Joseph (1980) *Art and Philosophy*. Brighton: Harvester Press.

Margolis, Joseph (2000) *What, After All, is a Work of Art?* University Park, PA: Pennsylvania State University Press.

Martin, F. David (1981) *Sculpture and Enlivened Space: Aesthetics and History.* Lexington, KY: University Press of Kentucky.

Massumi, Brian (2002) *Parables for the Virtual: Movement, Affect, Sensation.* Durham, NC and London: Duke University Press.

Medawar, Peter (1967) *The Art of the Soluble.* London: Methuen.

Medawar, Peter (1984) *The Limits of Science.* New York: Harper and Row.

Megill, Alan (ed.) (1994) *Rethinking Objectivity.* Durham, NC and London: Duke University Press.

Melville, S. and Readings, B. (eds) (1995) *Vision and Textuality.* Durham, NC: Duke University Press.

Mey, K. (ed.) (2005) *Art in the Making: Aesthetics, Historicity and Practice.* London: Peter Lang.

Misgeld, D. and Nicholson, Graeme (eds) (1992) *On Education, Poetry, and History: Applied Hermeneutics.* Albany, NY: SUNY Press.

Mitchell, W. J. T. (1986) *Iconology: Image, Text, Ideology.* Chicago and London: University of Chicago Press.

Nerlich, Graham (1994) *The Shape of Space*, 2nd edition. Cambridge: Cambridge University Press.

Nietzsche, Friedrich (1968) *The Will to Power.* Trans. W. Kaufmann. London: Weidenfeld and Nicolson.

Nietzsche, Friedrich (1980) *Sämtliche Werke, Kritische Studienausgabe.* Berlin: Gruyter.

Norris, Christopher (1990) *What's Wrong with Postmodernism? Critical Theory and the Ends of Philosophy.* London: Harvester Wheatsheaf.

Oakeshott, M. (1981) *Rationalism in Politics and Other Essays.* London: Methuen.

Oakeshott, M. (1990) *On Human Conduct.* Oxford: Clarendon Press.

Onorato, Ronald J. (1997) *Blurring the Boundaries: Installation Art 1969–1996.* San Diego, CA: Museum of Contemporary Art.

Panofsky, Erwin (1991) *Perspective as Symbolic Form.* Trans. C. S. Wood. New York: Zone; originally published as (1927) 'Die Perspektive als Symbolische Form', *Vortrage der Bibliothek Warburg 1924–25.* Leipzig and Berlin.

Paris, G. (1990) *Pagan Grace.* New York: Spring.

Payne, Antonia (ed.) (2000) *Research and the Artist: Considering the Role of the Art School.* Oxford: Ruskin School of Drawing and Fine Art, University of Oxford.

Paz, Octavio (1990) *Marcel Duchamp: Appearance Stripped Bare.* Trans. R. Phillips and D. Gardner. New York: Arcade and Little, Brown.

Pelto, Pertti (1978) *Consequences of Economic Change in the Arctic.* Edmonton, Alta: Boreal Institute for Northern Affairs, University of Alberta.

Perec, Georges (1997) *Species of Spaces and Other Pieces.* Trans. John Sturrock. London: Penguin.

Pirenne, Maurice (1948) *Vision and the Eye.* London: Pilot Press.

Pirenne, Maurice (1970) *Perspective, Painting and Photography.* Cambridge: Cambridge University Press.

Plato (1980) *The Republic*, 2nd edition. Part VII: *The Philosopher Ruler: The Simile of the Cave.* Trans. and introduction Desmond Lee. Harmondsworth: Penguin.

Plato (1987) *Theaetetus.* Trans. R. A. H. Waterfield. London: Penguin.

Polanyi, Michael (1967) *The Tacit Dimension.* London: Routledge and Kegan Paul.

Proust, M. (2002 [1913–27]) *In Search of Lost Time.* Trans. Christopher Prendergast and others. London: Allen Lane.

Pudovkin, V. I. (1960 [1949]) *Film Technique and Film Acting.* New York: Grove.

Reiss, Julie H. (1999) *From Margin to Center: The Spaces of Installation Art.* Cambridge, MA and London: MIT Press.

Riach, Alan and Grieve, Michael (eds) (1992) *The Selected Poetry of Hugh MacDiarmid.* Manchester: Carcarnet Press.

Richter, I. A. and Richter, J. P. (eds) (1970) *The Literary Works of Leonardo da Vinci.* Compiled and edited by J. P. Richter from the original MSS, 2 volumes. London: Phaidon.

Ricoeur, Paul (1991) *From Text to Action: Essays in Hermeneutics II.* Trans. K. Blarney and J. Thompson. London: Athlone.

Robbin, Tony (1992) *Fourfield: Computers, Art and the Fourth Dimension.* Boston, MA: Little, Brown.

Rodowick, D. N. (1997) *Gilles Deleuze's Time Machine.* Durham, NC and London: Duke University Press.

Rucker, Rudolf van B. (1986) *The Fourth Dimension and How to Get There.* London: Penguin.

Russell, Bertrand (1980 [1912]) *The Problems of Philosophy.* Oxford and New York: Oxford University Press.

Russell, Bertrand (1992 [1948]) *Human Knowledge: Its Scope and Limits.* London: Routledge.

Ryle, Gilbert (1984 [1949]) *The Concept of Mind.* London: Hutchinson.

Sanouillet, Michael and Peterson, Elmer (eds) (1989) *The Writings of Marcel Duchamp.* New York: Da Capo.

Sartre, Jean-Paul (1963) *Nausea.* Trans. Robert Baldick. London: Penguin.

Sartre, Jean-Paul (1972) *The Psychology of the Imagination.* London: Routledge.

Sartre, Jean-Paul (1989 [1943]) *Being and Nothingness: An Essay on Phenomenological Ontology.* Trans. Hazel E. Barnes. London: Routledge.

Schön, Donald (1991) *The Reflective Practitioner: How Professionals Think in Action.* Aldershot: Arena.

Schopenhauer, Arthur (1969) *The World as Will and Representation.* Trans. E. F. J. Payne. New York: Dover.

Scruton, Roger (1983) *The Aesthetic Understanding.* London: Methuen.

Shannon, C. E. and Weaver, W. (1963 [1949]) *The Mathematical Theory of Communication.* Urbana, IL: University of Illinois Press.

Sharff, Stefan (1997) *The Art of Looking in Hitchcock's Rear Window.* New York: Limelight.

Shearman, J. (1992) *Only Connect . . . Art and the Spectator in the Italian Renaissance.* Princeton, NJ: Princeton University Press.

Sheridan, Noel (1996) *NCAD 250: Drawings, 1746–1996.* Dublin: National College of Art and Design.

Simms, K. (2003) *Paul Ricoeur.* London: Routledge.

Smart, J. C. C. (ed.) (1964) *Problems of Space and Time.* New York: Macmillan.

Smith, P. and Wilde, C. (eds) (2002) *A Companion to Art Theory.* Oxford: Blackwell.

Snyder, John (1991) *Prospects of Power: Tragedy, Satire, the Essay and the Theory of Genre.* Lexington, KY: University Press of Kentucky.

Sommer, Robert (1972) *Design Awareness.* Austin, TX: Holt, Rinehart and Winston.

Stiles, K. and Selz, P. (1996) *Theories and Documents of Contemporary Art: A Sourcebook of Artists' Writings.* Berkeley, CA: University of California Press.

Sturken, Maria and Cartwright, Lisa (2001) *Practices of Looking: An Introduction to Visual Culture.* Oxford: Oxford University Press.

Swift, J. and Swift, J. (eds) (2002) *Disciplines, Fields and Change in Art Education. Volume 4: Soundings and Reflections.* Birmingham: ARTicle Press.

Taylor, Mark C. (2001) *The Moment of Complexity: Emerging Network Culture.* Chicago and London: University of Chicago Press.

Taylor-Wood, Sam (2002) *Sam Taylor-Wood.* Göttingen: Steidl for the Hayward Gallery.

Todorov, Tzvetan (1995 [1978]) *Genres in Discourse.* Cambridge and New York: Cambridge University Press.

Valyus, N. A. (1966) *Stereoscopy.* New York: Focal Press.

Wade, N. J. (ed.) (1983) *Brewster and Wheatstone on Vision.* London: Academic Press.

Ward, Colin (1990) *Talking Houses.* London: Freedom Press.

Warhol, Andy and Hackett, Pat (1980) *POPism: The Warhol '60s.* New York: Harcourt Brace Jovanovich.

Warnock, M. (1976) *Imagination.* London: Faber and Faber.

White, Kenneth (1983) *The Blue Road.* Edinburgh: Mainstream.

Willing, Victor (1984) *Victor Willing: A Retrospective Exhibition 1952–85.* London: Whitechapel Art Gallery.

Wilss, Wolfram (ed.) (1981) *Übersetzungswissenschaft.* Darmstadt: Wissenschaftliche Buchgesellschaft.

Wittgenstein, L. (1975 [1940]) *Philosophical Remarks*. Oxford: Basil Blackwell.
Wolff, Janet (1995) *Resident Alien: Feminist Cultural Criticism*. Cambridge: Polity Press.
Wolfram, Stephen (2002) *A New Kind of Science*. Champaign, IL: Wolfram Media.
Wollheim, Richard (1968) *Art and its Objects*. New York: Harper and Row.
Žižek, Slavoj (1989) *The Sublime Object of Ideology*. London: Verso.
Žižek, Slavoj (ed.) (1992) *All You Ever Wanted to Know about Lacan (but were too afraid to ask Hitchcock)*. London and New York: Verso.
Žižek, Slavoj (2002) *Welcome to the Desert of the Real*. London: Verso.

Journals, conference proceedings, PhD submissions, unpublished material

Annales d'Esthetique 34, Athens, 1995.
Architectural Design 60 (9–10), 1990.
Arctic 39(1), 1986.
Arctic 50(3), 1997.
Art Bulletin XXII, 1940.
Artlink 21(4), 2001.
Arts and Humanities in Higher Education 2(2), 2003.
Bougourd, Jeni, Evans, Stuart and Gronberg, Tag (eds) (1998) *The Matrix of Research in Art and Design Education*. London: The London Institute.
British Journal of Sociology of Education 17(4), 1996.
CAA Board of Directors (1991 [1977]) *MFA Standards*. New York: College Art Association.
Cilibrasi, R., Vitányi, P. and de Wolf, R. (2003) *Algorithmic Clustering of Music*, http://arxiv.org/abs/cs.SD/0303025
Clair, Jean (1978) 'Opticeries', *October* 5: 101–12.
Davey, N. (1994) 'Theoros, Ästhetik, und Hermeneutik', Heidelberg Hermeneutics Seminar, *Kunst als Aussage, das philosophisches Seminar, Heidelberg Universität*, 8 July (unpublished).
Domus 671(April), 1986.
Drawing Fire 1(3), 1996.
Durling, David and Friedman, Ken (2000) *Foundations for the Future: Doctoral Education in Design*. Conference proceedings, La Clusaz, France. Stoke-on-Trent: Staffordshire University Press.
Edinburgh Review 88 (Edinburgh: Polygon), 1992.
Edinburgh Review 90 (Edinburgh: Polygon), 1993.
English in Education 27(2), 1993.
Environment and Behavior 19(2), 1987.
Exchange 2000 Conference, Watershed Media Centre, Bristol, at www.media.uwe.ac.uk/exchange_online/exch2_article2.php3
Fuchs, Michel (ed.) (1994) *Cycno: Image et Language, Problèmes, Approches, Méthodes* 11(1), Centre de Recherche sur les Ecritures de Langue Anglaise, Université de Nice.
Hanrahan, Siún (2001) *Guessing*. Belfast: Golden Thread Gallery.
Hay, K. G. (1990) 'Italian Materialist Aesthetics', PhD thesis, University of Wales, 1990 (unpublished).
Hay, K. G. (1995) 'Bertrando Spaventa and Italian Hegelianism', Paper for the Graduate Research Seminar, Department of Cultural Studies, University of Derby (unpublished).
Holdridge, L. (2000) 'Qualitative research into student experience of the PhD', University of Plymouth (unpublished).
International Journal of Art and Design Education 23(2), 2004.
International Journal of Art and Design Education 20(3), 2001.
Journal of Aesthetics and Art Criticism 56(2), 1998.
Journal of Consciousness Studies 4(5–6) www.imprint.co.uk/jcs.html
Journal of Consciousness Studies 6(6–7), 1999.
Journal of Design Science and Technology, 2004–5.
Journal of Philosophy 91, 1994.
Journal of Religion 76, 1996.

Journal of the British Society for Phenomenology 24(3), 1993.

Journal of the Warburg and Courtauld Institutes XXXXIV, 1981.

Journal of Visual Art Practice 1(1), 2001.

Kelemen, Josef and Sosík, Petr (eds) (2001) *Advances in Artificial Life: Proceedings of Sixth European Conference on Artificial Life* (Prague, September). Berlin and London: Springer.

Lawson-Smith, M. (1996) *'Re-positions of an art practice'*, MPhil thesis, University of Plymouth in Exeter (unpublished).

Legat, Allice and Zoe, Sally Ann (2000) *Tlicho Traditional Governance*. Dogrib Treaty 11 Traditional Knowledge Project, Rae-Edzo.

Leonardo: Journal of the International Society for the Arts, Sciences and Technology 33(4), 2000.

Lewis, Róisín (2002) *Palimpsest*. Dublin: Kevin Kavanagh Gallery.

Macleod, K. (2000) *The Function of the Written Text in Practice-based PhD Submissions* http://www.herts.ac.uk/artdes/research/papers/wpades/voll/macleod2.html

Macleod, K. and Holdridge, L. (2003) *The Doctorate in Fine Art: A Study of Eight Exemplars*. (Funded by the Arts and Humanities Research Council, pending publication).

Macleod, K. and Holdridge, L. (2004) 'The Doctorate in Fine Art: The Importance of Exemplars to the Research Culture', *International Journal of Art and Design Education* 23(2): 156–68.

Macleod, K. and Holdridge, L. (2004) 'The Enactment of Thinking, Theoros III', University of Dundee papers. *Journal of Visual Art Practice* (pending).

Macleod, K. and Holdridge, L. (guest eds) (2002) *Journal of Visual Art Practice* 2(1–2).

Mooney, Jim (1999) *Research in Fine Art by Project: General Remarks toward Definition and Legitimation of Methodologies*. Middlesex University (pending publication).

Nature, June 1999.

New Left Review 22(July–Aug.), 2003.

New Left Review 25(Jan.–Feb.), 2004.

O'Riley, T. (1998) 'Representing Illusions Space, Narrative and the Spectator in fine Art Practice', PhD thesis, Chelsea College of Art and Design, The London Institute (unpublished).

October 5 (summer), 1978.

Paragraph (1996) UCL and University of Edinburgh.

Parallax 1(2) (Leeds), 1996.

Philosophical Transactions of the Royal Society of London CXXVIII, 1838.

Piccinini, Patricia (2002) Edited transcript of interview by Julie Copeland on ABC Radio National *Sunday Morning* programme, 26 May 2002, available at http://www.abc.net.au/arts/visual/stories/s597714.htm

POINT Art and Design Research Journal 7, 1999.

Proceedings of the National Research Conference Art and Design in Education. Brighton: Fribble Information Systems with National Society for Education in Art and Design, 1991.

Quality Assurance Agency for Higher Education (2002) *Subject Benchmark Statements Academic Standards – Art and Design*, www.qaa.ac.uk/crntwork/benchmark/phase2/artanddesign.htm

Research into Practice, Conference proceedings. University of Hertfordshire, http://www.herts.ac.uk/artdes/simsim/rtos/

Rivista di filosofia 3(July–September), 1951.

Royal College of Art Research Papers 1(3), 1994–5.

Royal College of Art Research Papers, London: RCA, 1993–4.

Semiotica 1431(4), 2003.

Shakeshaft, Paul and Perutz, Vivien (2002–3) 'Assessing Critical and Contextual Understanding in the Final Year of the BA Fine Art Degree Course'. Anglia Polytechnic University for the ADC-LTSN (unpublished).

Swift, J. (ed.) (2000) *BROADSIDE 5*. Birmingham: University of Central England.

Teaching Art and Design History: Working with Students with Disabilities, London: AAH, 2003, http://www.thinkingwriting.qmul.ac.uk

The History of Photography 8/4(October/December), 1984.

UK Council for Graduate Education (1997) *Practice-Based Doctorates in the Creative and Performing Arts and Design*. London: UK Council for Graduate Education.

Walrus Feb.–Mar. 2004.